Picturing the New Negro

CultureAmerica

Karal Ann Marling and Erika Doss
SERIES EDITORS

Picturing the New Negro

Harlem Renaissance Print Culture and Modern Black Identity

Caroline Goeser

UNIVERSITY PRESS OF KANSAS

Published by the University Press of Kansas (Lawrence, Kansas 66045),
which was organized by the Kansas Board of Regents and is operated and
funded by Emporia State University, Fort Hays State University, Kansas
State University, Pittsburg State University, the University of Kansas,
and Wichita State University

Library of Congress Cataloging-in-Publication Data

Goeser, Caroline.

Picturing the New Negro : Harlem Renaissance print culture and
modern black identity / Caroline Goeser.

p. cm. — (Culture America series)

Includes bibliographical references and index.

ISBN 0-7006-1466-4 (cloth : alk. paper)

1. African Americans in art. 2. Illustration of books—New York (State)—
New York—20th century. 3. Magazine illustration—New York (State)—
New York—20th century 4. African American illustrators—New York
(State)—New York. 5. Harlem Renaissance. I. Title.

NC961.7.A37G64 2006

760'.04499730496073—dc22

2006026236

British Library Cataloguing-in-Publication Data is available.

Printed in the United States of America

10 9 8 7 6 5 4 3 2 1

Contents

CONTENTS

Preface and Acknowledgments

Recent studies have clarified the critical role visual imagery played during the Harlem Renaissance. For example, David Bailey and Richard Powell posit the centrality of Harlem Renaissance visual production, from painting, sculpture, photography, and graphic arts, to the performing arts and film.[1] Their important reconsiderations of Harlem Renaissance visual culture demonstrate varied visual forms as crucial sites in which artists refashioned ideas about blackness and black identity. However, beyond the exhibitions that have included magazine and book illustrations and isolated studies of black artists' illustrations, the field of art history has generally failed to appreciate the broad impact of the medium of illustration during the Harlem Renaissance.[2] By contrast, *Picturing the New Negro* assesses the central importance of the varied and dynamic production of illustration in creating a modern black expression in interwar America. Largely predating the paintings and sculptures associated with the Harlem Renaissance, this significant body of work highlights the early interplay of visual art and literary production in print culture beginning in the later teens and early twenties.

Focused on this interplay, *Picturing the New Negro* joins recent literary studies by Anne Carroll and Martha Nadell that look at relationships between texts and visual images in Harlem Renaissance publications.[3] While both consider well-known printed works, including the Harlem issue of *Survey Graphic*, Locke's *New Negro*, and *Fire!!* magazine, this study provides a wider overview of illustrated Harlem Renaissance print culture. Further, as an art-historical study that also considers text, it privileges the visual medium of illustration, understanding its varied forms and content in new ways, while also exploring the divergent means with which Harlem Renaissance illustrators followed or circumvented their texts.

Picturing the New Negro also seeks to complicate the interracial associations that animated Harlem Renaissance illustrated print culture. The interracial connections among authors, publishers, and intermediaries in Harlem Renaissance works issued by mainstream publishing houses have proven particularly intriguing for some scholars but sources of offense for others, who found those

relationships primarily exploitative of black authors.[4] The interracial subtext becomes even more intriguing when considered in light of the roles of black and non-black illustrators. To be sure, mainstream publishers exploited black artists, but they also exploited white artists. And, despite the negative dynamics, equally fertile interracial relationships emerged that demonstrate unexpected arrangements, such as black author Countee Cullen acting as intermediary and sponsor of white illustrator Charles Cullen in the later 1920s.

Understanding its geographical limitations, I retain the term "Harlem Renaissance" to describe this body of illustration and print culture, which emerged largely from Harlem and New York–centered publishing venues and which drew on Harlem as a print nexus that attracted and distributed illustrative and textual production from artists in a variety of locations. For publications that issued from different cities, such as *Black Opals,* the little magazine from Philadelphia, or books published in Washington, D.C., through Carter Woodson's Associated Publishers, Harlem was nonetheless an important center from which advertisements and reviews of the publications could disseminate.

Picturing the New Negro asserts the importance of illustration as a modernist medium that connected art and commercial culture. Aside from the ground-breaking study of American artists and advertising by Michele Bogart and Rebecca Zurier's consideration of illustrations in the *Masses,* the medium of illustration has received decidedly short shrift in art-historical scholarship.[5] Helping to fill this lacuna, my work amplifies the studies of American art that have sought to understand interwar modernism in part through connections with industrialism, design, and advertising.[6] Also responding to recent trends in art history and cultural studies, my work examines notions of modernism between the wars by characterizing Harlem Renaissance illustration as indicative of the racial diversity that we now perceive at the heart of American modernist art and culture.[7] Further complicating previous conceptions of artistic modernism, my study reveals the products of American illustration, created by Harlem artists as well as mainstream graphic artists, as indicative of the stylistic diversity that animated modern American art of the early twentieth century.[8]

In reading the illustrations themselves, I consider the images as semiotic signs that carried clearly coded cultural meanings for their viewers. I believe this method makes particular sense for the medium of illustration, most assuredly among those illustrations that appeared on magazine covers and book jackets to effectively capture the reader's attention. In these designs, many of the illustrators created types of hieroglyphic pictograms that would communicate basic concepts quickly and at a distance, becoming iconic touchstones of

cultural meaning. I further draw on studies of word and image that carry special resonance for the embedded relationships between illustrations and texts, which may reveal a peaceably integrated whole or, by contrast, a struggle for authority.[9] Finally, the theoretical work of Walter Benjamin has been particularly useful in my study of Harlem Renaissance illustration. His analysis of mechanical reproduction has allowed me to perceive illustration as a modern form that, together with prints and film, flourished in the presence of a mass audience and, therefore, engaged with modern politics. His study also permits me to understand the modern reader or viewer as perpetually distracted, requiring visual stimulation of considerable force to wrest her from preoccupation.[10] In addition, his study of translation informs my position on the process of illustration as a creative act, rather than a slavish imitation of, or supplement to an "original" text.[11]

Accordingly, I conclude that, rather than mere appendages to journal articles or novels, Harlem Renaissance illustrative images actively participated with the printed texts in a double-voiced narrative. Admittedly, some illustrations had no textual counterpart, such as Roscoe Wright's *Crisis* cover illustration titled *Negro Womanhood* (see fig. 68). In the context of the NAACP journal and informed by W. E. B. Du Bois's editorial method, Wright's image was a visual narrative that expressed the tribulations of contemporary black women through comparison to the suffering of Christ. As such, Wright's illustration contained its own textual strivings. Other illustrations resulted from careful reading and interpretation of the texts they accompanied. As in Douglas's *Home to Harlem* dust jacket (see fig. 1), the artist chose a specific episode to illustrate while also wanting to express elements of the novel's entirety. In so working, these illustrators simultaneously created evocative images that pointed to larger issues outside of any given text.

In the double-voiced narrative of Harlem Renaissance illustration, some graphic artists circumvented the texts they illustrated. When black artists created images for non-black-authored texts that carried racist overtones, those visual images often served to subvert the printed text. For instance, faced with illustrating Vachel Lindsay's hackneyed poem "The Congo," which claimed authority as "a study of the Negro race," James L. Wells both followed the text and deviated from it. Some of his images in the 1929 reprinting of Lindsay's poem in the *Golden Book Magazine* illustrated stereotyped views of "natives" in the jungle (see fig. 83). By contrast, Wells also included images that would find no textual parallel. In one scene, a number of African heads, masks, and figurines are crowded together, as if in a display case at an ethnographic museum (see fig. 84). This image has the effect of correcting and satirizing the Hollywood

movie-set view of African life in Lindsay's poem. Thus, Wells subverted the author's text, seemingly accommodating its negative stereotypes of black identity while at the same time parodying the perpetrator of racist conventions.

The first half of this study provides the reader with an overview of Harlem Renaissance illustration and its critical reception. The first chapter is a case study of the most prolific Harlem Renaissance illustrator, Aaron Douglas. It addresses the range of Douglas's illustrations, from his early magazine and book illustrations to his more mature dust jacket designs. I deploy Richard Dyer's evocative notion of "in-betweenism" to reinterpret Douglas's illustrations, suggesting a new approach to his work, appreciating it as a visual strategy that enabled Douglas to negotiate conventional polarities that kept black Americans in the role of the primitive Other, and therefore premodern. Douglas also developed an in-betweenist strategy in negotiating his divergent roles as a commercial illustrator and an aspiring professional painter. In his dust jacket designs, he balanced his roles as artist, interpreter of text, and merchandiser in creating some of the most dramatic designs in book illustration of the 1920s and early 1930s.

The second and third chapters provide the reader with an overview of the many and varied examples of Harlem Renaissance illustrations in magazine venues and books. I consider these publications within the context of American print culture, which at this time experienced enormous growth in response to a nascent consumer culture. Chapter 2 looks at the broad range of Harlem Renaissance commercial and little magazine illustrations, mapping out the diversity in styles—from realism to Art Deco—and themes—from racial uplift to vernacular expression—that these illustrations contributed to modern print culture. I trace the influence of the varied editors of these publications, from Du Bois to Charles Johnson to Wallace Thurman, interrogating the ways in which they incorporated imagery with text.

In examining Harlem Renaissance illustrated books in Chapter 3, I consider the complexity of interracial relationships that animated publications issued from the mainstream firms and provide a rare discussion within the context of Harlem Renaissance publishing of Carter Woodson's books issued through the Associated Publishers. I further consider modern connections between the illustrations and publishers' advertising campaigns as well as the range of methods publishers and illustrators developed to sell "race."

The fourth chapter looks at the critical reception of Harlem Renaissance illustration, noting the dearth in response to the medium in both the black and mainstream presses. For black critics and artists, a politics of illustration emerged, in which the medium wielded a double-edged sword as an unprece-

dented opportunity for exposure and recognition while also representing a mode of servility to a text that carried special liability for African Americans whose newly modern and self-determined identities as artists seemed precarious in the face of mainstream commercial culture.

The second half of the book explores critical themes that animated Harlem Renaissance illustrations. In identifying an example of the American search for a usable past, Chapter 5 considers Harlem Renaissance illustrators' strategies to remake the past in order to assert African American modernity. One key method uncovered and reclaimed an ancestry in ancient Egypt, which served to provide the visual foundation for larger social efforts aimed at ensuring meaningful participation for African Americans in the modern American economy. However, the artists differed in their assignation of gender to the modern African American consumer, with male artists privileging men in modern professions, and women creating alternative images of fashionable female consumers. Following the trends in the nascent black beauty culture, women artists developed a restrictive modern, middle-class, brown-skinned type, which effectively worked the interstices between white standards of beauty and new "bronze" ideals, but which provided no cultural or commercial model for dark-skinned or working-class women.

Chapter 6 asserts that, in their religious images, Harlem Renaissance illustrators refashioned the Judeo-Christian tradition as black, thereby transforming ancient religious episodes into personal and modern narratives with political and social relevance. While some artists reinterpreted black religious identity within the pages of the Judeo-Christian scriptures, others connected Christ's experience of suffering with the modern oppression of black Americans. In response to the horror of contemporary lynching, some artists and writers created modern black Christs on the model of lynched African American youths, who stood as scathing political critics of southern injustice.

Chapter 7 considers the interdependent relationships between race and sexuality in the work of Richard Bruce Nugent and Charles Cullen, looking specifically at their contributions to the understudied volume *Ebony and Topaz*, edited by Charles S. Johnson. As the most "taboo" contributions to this collection of essays, short stories, and illustrations, their work engaged with themes of mixed-race identity, gay sexuality, and transvestitism. Utilizing figures that could be read as double-sexed and double-raced, their figures also resisted fixation as particular types, which corroborated Johnson's editorial message, running counter to other contemporary black editors, in proclaiming "no set pattern" to modern black identity; rather, its distinguishing characteristic lay in its multiplicity.

The final chapter comes full circle to look again at the work of Aaron Douglas, specifically considering a set of his illustrations that relate to a series of linoleum cuts by James L. Wells. In these cases, both illustrators created images for non-black-authored texts, which to varying degrees exhibited racist implications. In coping with their illustrative predicaments, both artists adopted the strategies of minstrelsy to circumvent the texts they illustrated. In "stealing back" the minstrelsy form, each artist transformed the minstrel mask from a symbol of nonsensical behavior to a modern sign of parody and instrument of satire.

Before embarking on the body of my text, I would like to reveal something of my own relationship to this material. At its earliest stage, predating my dissertation, this study took its first form as a colloquium paper in the spring of 1996 at the Rutgers Center for Historical Analysis, where I was a graduate fellow among scholars and students of varied disciplines working on projects related to the broad theme of religion. As the only art historian in the group, I nevertheless found a receptive community, one in which I freely explored religious issues that, until fairly recently, had been largely avoided in scholarship in art history and cultural studies. I also felt as though I had "come home," in a sense, as I was grappling with religious subjects that, in one form or another, had animated many fruitful conversations with my parents, my father a minister and professor at a Lutheran seminary, and my mother the daughter of a Presbyterian minister. Having experienced my family's unusually open and critical engagement with religious issues, it is perhaps not surprising that I developed a relationship with organized religion that is fraught with some conflict. Yet, when I encountered the Harlem Renaissance illustrations, poems, and literature that had developed an alternative depiction of religion, I felt a deep connection. For there, Harlem Renaissance artists subverted the dominant Judeo-Christian religious tradition by creating black figures of Adam and Christ who, each time they were apprehended by the reader, invoked a recommitment to social justice. Therefore, rather than with kinship or race, it was through a kind of familial religious link that I found my first relationship to Harlem Renaissance print culture, and from there, discovered the multiplicity of its attractions.

I cannot express adequately my gratitude for the advice, support, and good cheer I continue to receive from my dissertation advisor at Rutgers University, Matthew Baigell. He knows that in this book I'm just "passing it on." I also thank Joan Marter, Phyllis Mack, and James Smalls, who provided careful reading and insightful suggestions while I was writing my dissertation. I am also grateful for the generous support through the years of W. Jackson Rushing III

and Lauren Soth. To readers of this manuscript, Mary Ann Calo, Erika Doss, Theresa Leininger-Miller, and Jeffrey Stewart, I extend heartfelt thanks for assessments and recommendations for changes shared with me at various stages, which have strengthened my study immeasurably. I have also benefited greatly from the suggestions of Thomas Wirth and Roderick Quiroz, whose careful readings of sections of my manuscript have given me tremendous insight. I also extend sincere thanks to Renate Reiss, whose generosity and expertise have helped me immeasurably.

In the School of Art at the University of Houston, I am grateful for the support of my art history, art, and design colleagues, staff members, and students. I am particularly grateful to the Small Grants Program at the University of Houston for funding a generous subvention for this publication, and to the Women's Studies Program for a Faculty Summer Fellowship in 2002.

I have been fortunate to receive a Postdoctoral Fellowship from the Center for Humanistic Inquiry at Emory University in 2003–04, and I extend special thanks to Director Martine Watson Brownley for her support of my work. While in Atlanta, I had the great good fortune to work with Randall Burkett, Curator of African American Collections at the Manuscript, Archives, and Rare Book Library, Emory University; I thank him for the chance to brush with the wealth of his knowledge and breadth of the collections at Emory. I am also grateful for support from the Henry Luce Foundation/American Council of Learned Societies, which awarded me a Dissertation Fellowship in American Art in 1996–97. I would also like to thank the Rutgers Center for Historical Analysis, where I held a graduate fellowship in 1995–96. There, I benefited from the wisdom of Phyllis Mack and James B. Gilbert.

My seventh chapter on *Ebony and Topaz* appeared first in *American Periodicals* (15, 1 [2005], 86–111). For their sound advice and suggestions for improvement, I thank the guest editors of this issue, Suzanne Churchill and Adam McKible. The last section of my sixth chapter on religious illustrations appeared first in the *International Review of African American Art* (19, 1 [2003], 18–27). For their careful revisions, I thank the guest editor of this issue, Joyce Robinson, and the IRAAA editor, Juliette Harris. Many thanks to these journals for their permission to reprint my articles here.

I have received tremendous help and hours of hard work from Joy Tober in the Visual Resources Library at the University of Houston, who digitally scanned a large portion of the images reproduced in this book, and I am grateful to Merriann Bidgood and Stephanie Hite for their help and support as well. Indeed, I cannot thank the three of them enough for their professionalism and good cheer. I also thank Joseph Lazzaro for his technical expertise. I am also

grateful to Teresa Burk at the Manuscript, Archives, and Rare Book Library, Emory University; June Can at the Beinecke Rare Book and Manuscript Library, Yale University; Margaret Tenney at the Harry Ransom Humanities Research Center, University of Texas at Austin; and staff members at the Schomburg Center for Research in Black Culture, New York Public Library; and the Houston Public Library for their help in arranging for digital scans to be made of illustrations in their collections. I am also grateful to Mark Lacy for his careful digital photography of illustrations at Houston Public Library.

I extend my gratitude to Michael Briggs, editor-in-chief at the University Press of Kansas, for his kindness and insight, and to Kalyani Fernando, Hilary Lowe, Susan McRory, and Susan Schott for their many hours of hard work. I also thank Nancy Scott Jackson for shepherding this project through the early stages at UPK before she accepted her current position at the Spencer Museum at the University of Kansas.

I save for last heartfelt thanks to my family: to my husband, Allen Douglas, whose love and extraordinary insight into my work are woven into the fabric of this study; to my mother, Isabelle Goeser, for her constant love, kindness, and generosity; and to my father, Dr. Robert Goeser, for leaving me with a lifetime of love, wisdom, and visceral memories.

Picturing the New Negro

Introduction:
Making Black Modern
in the Medium of Illustration

Our problem is to conceive, develop, establish an art era. Not white art
painted black. . . . Let's bare our arms and plunge them deep deep
through laughter, through pain, through sorrow, through hope,
through disappointment, into the very depths of the souls of our people
and drag forth material crude, rough, neglected. Then let's sing it,
dance it, write it, paint it. Let's do the impossible. Let's create something
transcendentally material, mystically objective. . . .
Spiritually earthy. Dynamic.[1]
Aaron Douglas

Most of us, old and young, know something of Alice in Wonderland, but
who can say that with us who are the older ones, our delight in that
incomparable bit of play-acting did not take its start from Tenniel's
illustrations? Without the authentic Alice, the Duchess, the Mad Hatter
and the Cheshire Cat as he conceived them could even that simplest and
subtlest of fairy stories have exercised its perennial spell?[2]
Elisabeth Luther Cary

Writing to Langston Hughes in 1925, Aaron Douglas declared that he would no
longer make "white art painted black"; instead he called for a new community
of artists to embark on a "dynamic" enterprise in creating art that would be
both "mystical" and "objective," "spiritual" and "earthy." Using paradoxical lan-
guage, Douglas called for a modern black artistic expression that would com-
prise a rich amalgam of seeming opposites. Douglas and his Harlem
Renaissance colleagues worked to construct a dynamic black identity that drew
anew on an ancient past to participate with vigor in shaping contemporary
American culture. From the pens of Douglas and other artists, illustration was
the visual medium that figured most prominently in the early stages of the

I

movement in the 1910s and 1920s and that was most intimately connected to the major engine of the Harlem Renaissance—its print culture.

Writing about the history of illustration in 1932, the art critic Elisabeth Cary described the formative role that illustrations could wield in shaping the reader's experience with a text. She even ventured to posit that without John Tenniel's evocative drawings of the grinning Cheshire Cat or the ridiculously garbed Mad Hatter, Lewis Carroll's delightfully bizarre tale might not have taken hold, as it has, in the imagination of so many readers. The power of the *Alice in Wonderland* illustrations stems in large part from the fact that many of the subsequent editions of Carroll's books have retained Tenniel's representations. Harlem Renaissance publications, however, often did not retain their illustrations when reprinted. Indeed, magazine reprints frequently failed to reproduce the publications' vibrant cover illustrations, and new book editions eliminated their original dust jackets, animated with the bold and dynamic illustrations that had attracted so many readers in the 1920s and 1930s.

As an antidote to such historical amnesia, this book explores a moment when Harlem Renaissance magazines and books, with their integral illustrations intact, rested in the hands of avid readers. It returns to the time when illustrator and writer Gwendolyn Bennett said she had "seen the pale blue jacket with its discreet white printing" of one popular book "in more brown arms than I have ever seen any one other book."[3] It evokes memories of the moment when John Davis exclaimed, after reviewing a book and closing its cover, how "refreshing" it was "to look once again at the brilliant colored jacket of Aaron Douglas."[4]

Indeed, literally hundreds of illustrations—by Douglas, Bennett, James Wells, Laura Wheeler, Richard Bruce Nugent, Winold Reiss, Miguel Covarrubias, and many other illustrators associated with the period—circulated on the covers and pages of Harlem Renaissance publications. Disseminated broadly in African American journals and on the jackets and pages of books, their illustrations eclipsed in number and distribution the comparatively scant exhibition exposure afforded African American painting and sculpture during this period. Further, as a hybrid medium that connected visual imagery with literary text and commercial enterprise, illustration participated more fully than the more traditional visual media in the burgeoning modern consumer economy.

In creating modern images of black identity, these illustrators joined with writers, editors, and performing and visual artists in the experiment now known as the Harlem Renaissance, at the time referred to more generally as the Negro Renaissance. During this period from the late 1910s into the 1930s, these creative individuals variously came to newfound appreciation for African

American identities, conceiving the New Negro who offered vital contributions to modern culture and commerce.[5] While Harlem was in many ways the geographical hub of these new attitudes, the movement was not limited to New York. Creative activity in expository writing, literature, and the arts extended to other major urban areas in the Midwest, as well as to cities in the Black Atlantic—a term popularized by Paul Gilroy for black diasporic centers on the Eastern Seaboard and in Europe and the Caribbean islands.[6] Still, for illustrators as well as writers, Harlem was a vital nexus where people gathered and from which their artistic production often disseminated. Like writers, many African American illustrators found their way to the new black metropolis during the 1910s and 1920s. Some came from the Midwest, including Aaron Douglas (originally from Topeka) and E. Simms Campbell (St. Louis). Others came from closer regions, as did Richard Bruce Nugent from Washington, D.C. A significant interracial dynamic also animated the group of Harlem illustrators, with non-black illustrators working in Harlem and other neighborhoods in New York. The most prominent non-black artists associated with the movement were Winold Reiss, from Germany, and Miguel Covarrubias, from Mexico. Several lesser-known Euro-American illustrators also worked closely with Harlem writers, including Charles Cullen and Prentiss Taylor.

For many illustrators, however, Harlem was not their home but a virtual community to which they contributed from a distance. In Boston, Roscoe Wright sent illustrations to Harlem, while also publishing work in local venues. Similar arrangements obtained for Alan Freelon in Philadelphia and Charles Dawson in Chicago. Other artists spent significant time in Paris, including Laura Wheeler, Gwendolyn Bennett, and Albert Smith, who each had illustrations published in Harlem's magazines. At the end of the 1920s, both Lois Jones and James Wells had accepted teaching posts at Howard University in Washington, D.C., but continued to contribute illustrations that circulated in Harlem's print culture.

Harlem Renaissance artists saw their illustrations issued in a variety of publications, from African American periodicals such as *Crisis* and *Opportunity: Journal of Negro Life* to little magazines such as *Fire!!* and the *Saturday Evening Quill*. They also appeared in books published by Carter Woodson, the black publisher who founded the Associated Publishers, as well as volumes issued by mainstream publishers, including Knopf, Harper and Brothers, and the Boni brothers. Although this large body of art has been minimized in arthistorical scholarship, illustration was the earliest visual medium to appear in the context of the Harlem Renaissance. Starting in the 1910s, Laura Wheeler and Albert Smith began contributing illustrations to the *Crisis,* the journal of

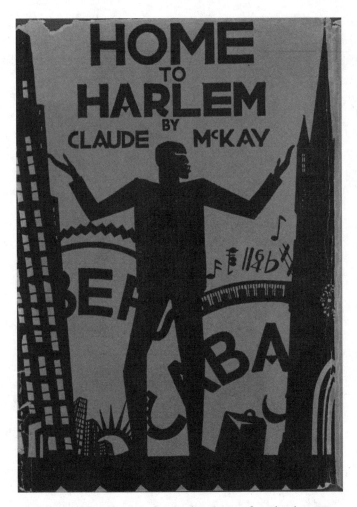

Figure 1. Aaron Douglas, dust jacket design for Claude McKay, *Home to Harlem* (New York: Harper and Brothers, 1928). Yale Collection of American Literature, Beinecke Rare Book and Manuscript Library, Yale University.

the National Association for the Advancement of Colored People (NAACP), and in 1920, Wheeler began illustrating books for mainstream publisher Harcourt Brace. Illustration also received wide exposure as a print medium that circulated substantially among black and non-black readers. By contrast, Harlem Renaissance painting and sculpture developed, for the most part, later in the 1920s and 1930s, and these artistic forms of expression gleaned far less

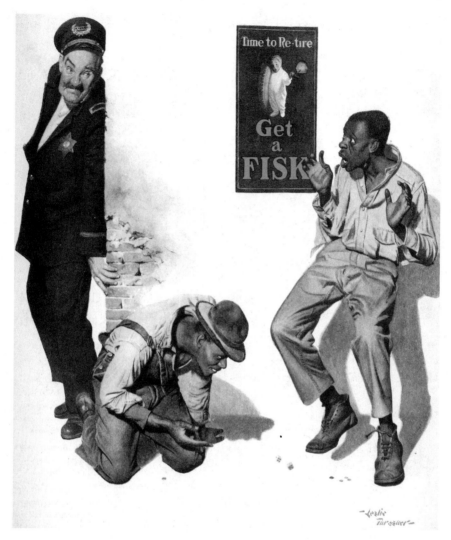

Figure 2. Leslie Thresher, Fisk Tire Company advertisement, *Saturday Evening Post* (January 8, 1927). Houston Public Library.

public exposure. With few gallery venues open to black artists, exhibitions of Harlem Renaissance painting and sculpture reached a very limited audience until the Harmon Foundation began to exhibit their work in the later 1920s.[7]

Taking varied and often divergent approaches, Harlem Renaissance illustrators shared the goal of providing newly modern visual representations of African American figures that stood against negative stereotypes. Dismissing

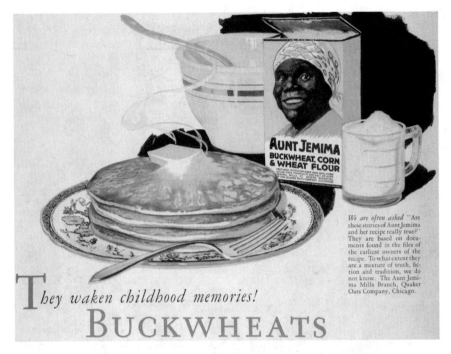

Figure 3. Quaker Oats Co., advertisement for Aunt Jemima Buckwheat, Corn and Wheat Flour, *Ladies' Home Journal* (January 1928). Houston Public Library.

the derogatory images of servile black figures that circulated ubiquitously in American visual culture, New Negro illustrators pictured black identity as newly independent and self-reliant. For example, in his dust jacket for Claude McKay's 1928 release of *Home to Harlem,* Douglas introduced a single silhouetted figure—McKay's protagonist Jake, who has come home to Harlem from travel abroad (fig. 1). Defying stereotypes of servant "uncles" or gambling black buffoons (fig. 2), Douglas pictured Jake as an emancipated free agent in the modern city. The figure points to two buildings as if to ask of himself, "Which way shall I go?" Far from the irresponsible buffoon, Douglas's modern black figure embodies the vital process of self-determination.

Circumventing the stereotypes of the mammy (fig. 3) or the tragic mulatta, women illustrators often created images of sophisticated brown-skinned African American women, whose fashionable clothing and hairstyles marked them as fully engaged with modern consumerism and beauty culture. Joyce Carrington, for example, created a *Crisis* cover image of a young African American woman sporting a stylish bob and chic neo-Egyptian jewelry (fig. 4). Connecting with the faddish Egyptomania of the period, Carrington's figure also

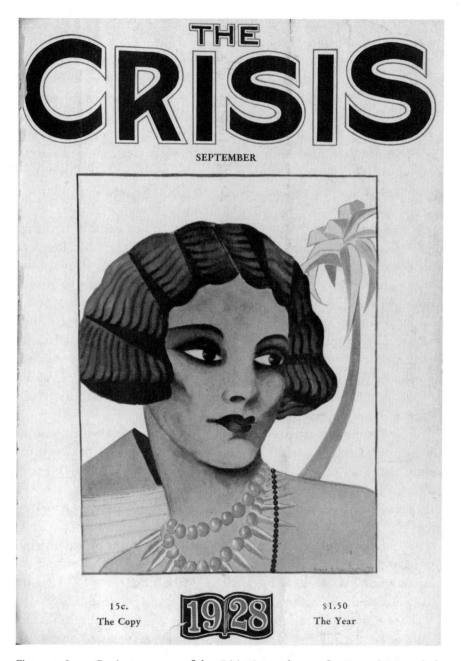

Figure 4. Joyce Carrington, cover of the *Crisis* (September 1928). General Research & Reference Division, Schomburg Center for Research in Black Culture, The New York Public Library, Astor, Lenox, and Tilden Foundations.

demonstrates modern standards of "bronze" beauty emerging in the nascent African American culture of fashion and cosmetics.

Other artists used humor to parody stereotypes of black primitivism. In his series *Drawings for Mulattoes,* Richard Bruce Nugent provided a satirical account of the "evolution" of mulattoes from the primitive jungle to the modern city. In *Number 2* (see fig. 78), he purposely confused the origins of mixed race identity by showing a Janus-like head with the black profile transgressively taking the form of a "civilized" ancient Greek head with an aquiline nose, and the white profile assuming the facial attributes and tightly curled hair of an African "primitive." By mocking the outmoded stereotypes at the heart of primitivism, Nugent's parody became a sign of his modernity.

Some artists favored depicting distinctive black artistic forms then gaining capital in modern American culture, especially blues and jazz music. Resisting the mode of racial uplift, which tended to privilege middle-class identity, these artists embraced the modern contributions of working-class African Americans in urban and rural regions. In his illustrations for Sterling Brown's *Southern Road,* E. Simms Campbell developed a vernacular style of boldly silhouetted and exaggerated forms that approximated the crooning blues tunes and dialect lyrics animating Brown's poetry (fig. 5). Though his images flirted with distorted stereotypes of black physiognomy, his vernacular stylization provided a modern gloss on older pejorative images with an alternative embrace of distinctive forms of black creativity.

These illustrators joined other New Negro editors and writers in confronting the negative associations of blackness embedded not only in visual culture but in language. For example, Charles S. Johnson, editor of *Opportunity,* reminded his readers in 1928 of the negative linguistic associations with the color black that African Americans faced daily:

> Anyone interested in the connotation of words will find ample material upon which to reflect, in the analogical consistency of blackness and unpleasantness, whiteness and pleasantness in the familiar literature. Here are some of them: *As black* as a nigger, a slo, coal, a crow, the devil, Lucifer, . . . a chimney sweep, a toad, . . . pitch, soot, . . . sin, evil, night. . . . On the other hand, we have this sort of thing: *As white* as a lily, alabaster, driven snow, foam, innocence, milk, . . . truth, . . . a swan, a lamb, . . . Heaven. . . .[8]

He concluded his editorial by charging young African American writers to revise the signification of blackness: "The advent of Negroes to the field of letters promises the most salutary results in breaking up some of these long, and

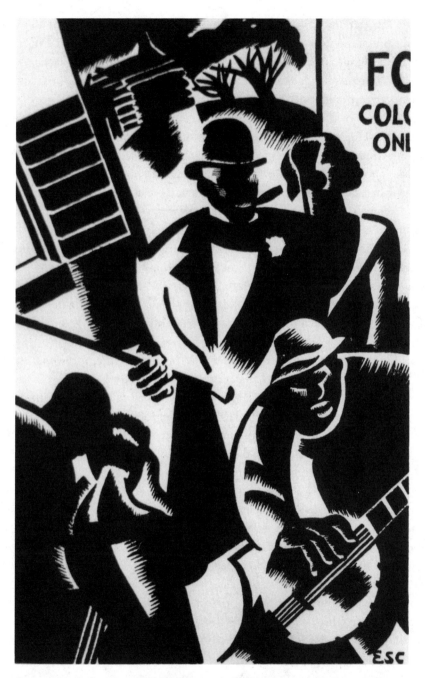

Figure 5. E. Simms Campbell, illustration in Sterling Brown, *Southern Road* (New York: Harcourt Brace, 1932), frontispiece for Part 2. Carter G. Woodson and Association for the Study of African American Life and History Library, Manuscript, Archives, and Rare Book Library, Emory University.

hoary associations." He then quoted lines written by black poets who were al-
ready amending negative linguistic associations, including a line by Langston
Hughes: "While night comes gently, / Dark like me."[9] Hughes's tactic, how-
ever, was not to abandon familiar associations altogether. Instead, he changed
the negativity. In his poem, the night was no longer scary, or a harbinger of evil
and the unknown. The night was soft and gentle, and with those positive char-
acteristics Hughes could compare it anew to African American identity.

When it came to challenging assumptions about blackness, however, visual
artists found themselves in a difficult position, not only in countering negative
stereotypes, but in fighting some members of the black middle classes who re-
jected depictions of dark pigmentation. For example, when the German artist
Winold Reiss teamed with African American philosopher and critic Alain
Locke to provide a new visual representation of black American figures for the
influential volume *The New Negro,* objections to his imagery arose from some
bourgeois readers. The young Aaron Douglas expressed to his fiancée Alta
Sawyer the power of Reiss's pastel drawings of dark-skinned figures to chal-
lenge conventional standards of beauty (see fig. 45):

> I have seen Reiss's drawings for the *New Negro.* They are marvelous. Many
> colored people don't like Reiss's drawings. We are possessed, you know,
> with the idea that it is necessary to be white to be beautiful. Nine times out
> of ten it is just the reverse. It takes lots of training or a tremendous effort to
> down the idea that thin lips and straight thin nose is the apogee of
> beauty. . . . So when you see these pictures by Reiss please don't look for so
> called beauty. It ain't there. But there is powerful lot of art.[10]

Illustrators faced additional concerns beyond the reevaluation of blackness
and standards of African American beauty. Working in the modern medium of
illustration that connected art and commerce, Harlem Renaissance illustrators
garnered unprecedented visual exposure while also having to contend with
questionable commercial practices in the publishing industry. Douglas's bold
dust jacket illustration for McKay's *Home to Harlem* (fig. 1) can stand as an
iconic example of the varied issues New Negro illustrators addressed. As a
work of art that also functioned to advertise the book, his image embodied
modern design techniques as well as merchandising savvy. Following the
tenets of modern packaging, he employed one-dimensional, silhouetted shapes
in a dramatic pattern across the page, which would not interrupt the flat sur-
face of the wrapper. He further drew on contemporary forms of art and adver-
tising in selecting an Art Deco lettering style and employing a stylized

skyscraper at left as emblems of modernity. Acting as merchandiser, he created a kind of proto-film still in staging a specific event in McKay's text, while also providing a variety of clues about the novel's themes. On the one hand, Douglas illustrated an episode in which McKay's protagonist, Jake, was strolling down a street at the edge of Harlem, with apartment buildings on one side and a Protestant church on the other, demarcating the "respectable" white neighboring community. On the other hand, Douglas's image pointed to larger issues McKay addressed, such as the conflict between the religiosity of some characters and the earthly delights of others, who embraced Harlem's "vices."

Douglas's generalized silhouettes also allowed Jake's image to rise above the specificity of McKay's novel, permitting Jake to represent broadly a newly modern black identity. With his suitcase close at hand, the African American figure stands as a migrant to urban cities, who calls to mind the migration of African Americans from rural to urban regions but also the migration of many writers and artists to Harlem. As such, Jake represents a black American free agent, newly independent, able to make his own choices in the urban north. Resisting a simplified depiction of racial and moral identity, however, Douglas cast Jake as an interstitial figure whose specific characteristics could not be fixed, his silhouetted body hovering physically and philosophically between the buildings and the broader concepts of morality and vice.

As the first best-seller by an African American writer, McKay's novel garnered wide circulation and publicity. Accordingly, Douglas's cover image circulated extensively on the book itself and in newspaper and magazine advertising designed by the book's publisher, Harper and Brothers. In addition, Harpers staged a highly unusual promotional campaign, in which they enlarged Douglas's jacket cover into a six-foot replica and hired William Robinson, a sixty-eight-year-old black driver, to wheel it around the city in his horse-drawn carriage (fig. 6). While Douglas's jacket cover received unprecedented exposure in this promotional effort, the disjuncture between the outmoded carriage and Douglas's image—an African American figure fully engaged with urban modernism—is somewhat jarring. It suggests, perhaps, that Harpers could only imagine advertising a black novel by trading on the stale stereotype of an "Uncle Tom," who marveled at "all de swell automobiles" he saw while guiding his horse and carriage through New York's bustling city streets (as reported by *Publishers Weekly*).[11]

Though Douglas's jacket design clearly attracted a wide audience, through broad circulation and prominent placement in advertising campaigns, it was nonetheless the product of the contingent medium of illustration. As a modern form, illustration evoked fertile connection between art and the nascent con-

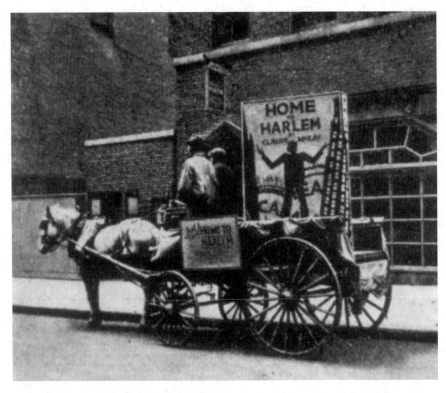

Figure 6. Photograph of William Robinson carting six-foot replica of Douglas's *Home to Harlem* dust jacket, in *Publishers Weekly* (April 14, 1928).

sumer market, yet it remained attached to its textual and merchandising context, which at times hindered the creative independence modern African American artists desired. Accordingly, Harlem Renaissance artists maintained varied attitudes toward the medium, fraught as it was with wide-ranging opportunities for recognition accompanied by the perils concomitant with a contingent artistic form. Some artists, like Douglas and Lois Jones, saw their work in illustration and commercial venues as stepping-stones toward more prestigious commissions in painting. Douglas held conflicting attitudes toward illustration, particularly in its relationship to commercialism. While he created book jacket designs with specific commercial dimension, he nonetheless held advertising illustration in great disdain. For example, he complained in the mid 1920s: "I have been ducking these commercial people. Literally running from money . . . I'm sharpening my teeth for the meat, not scraps and bones."[12] Also in the mid 1920s, Jones drew on her training at the Designers Art School of Boston to produce work in illustration and textile design. Simi-

larly conflicted about her commercial work, she felt rewarded that her textile designs were gaining popularity in the New York area. However, she lamented that in shop displays, "only the name of the design, printed on the borders of the fabric, was known, never the name of the artist who created it. That bothered me because I was doing all this work but not getting any recognition. And I realized I would have to think seriously about changing my profession if I were to be known by name."[13] Tritobia Benjamin has noted that such experiences "served as an incentive for Jones the designer to become Jones the painter."[14]

E. Simms Campbell and James Wells willingly gravitated to illustration and commercial commissions. Campbell produced work exclusively in illustration, always possessing a "yearning to do magazine illustrations, covers, cartoons, caricatures."[15] From his first commission to decorate a commercial sign for a St. Louis grocer, Campbell capitalized on the fertile modern relationships between business, advertising, and art.[16] His ready embrace of the commercial art status seemed to allow him a more fluid range of publication opportunities than other African American artists in both black and mainstream commercial magazines, including such mass-market periodicals as *Esquire* and the *Saturday Evening Post*. Wells embraced graphic work for reproduction in print venues, partly because it was in demand by a thriving publishing business during this period. But he also held specific sensibilities about graphic art, which, by contrast to "isolated fine art images," had the potential to cut across elitist barriers.[17] In 1928, he shared his ideas about the broad accessibility of the woodcut, which one of the African American journals recounted in a short article:

> Mr. Wells is now most interested in the uses to which woodcuts, a form of art dating back as far as 1400 A.D., can be put. He is especially interested in the adaptation of woodcut to commercial design. . . . The development of the art has evolved a varied application for it, woodcuts now having a part in almost every phase of graphic art. They are used as book decorations, for textile designs, as illustrations, as magazine covers, for holiday greetings, posters, and wall decorations.[18]

Wells relished the democratic potential of the woodcut to blur what he felt were unnecessary boundaries between fine and commercial art. Significantly, he maintained interest in the print media of woodcut and linoleum cut throughout his career, while also creating easel paintings.

Wells's commentary makes clear the connection between the media of illustration and printmaking: in their reproducibility, illustrations and prints

share crucial traits. While many Harlem Renaissance illustrators used pen and ink in their drawings, which would then be reproduced photographically in various print venues, some utilized printmaking techniques. Printmaking experienced particular resurgence in the 1930s, especially with government support. As Helen Langa demonstrates, the print was conceived during the New Deal era as an especially democratic form, making art available to a wide public.[19] With social commentary often at the heart of the printmaker's goal, leftist politics readily animated the subjects treated by American artists in their prints. Precedents for visualizing a political critique of mainstream American society can be found in such radical magazines of the early twentieth century, such as the *Masses* and the *New Masses,* to which Wells contributed regularly. In their strident political critique of American injustice and prejudice, Harlem Renaissance illustrations and political cartoons should be considered part of the broad artistic context for the political prints of the 1930s.

An Overview of Harlem Renaissance Illustrations and Their Reception

Strategizing from Spaces Between:
Aaron Douglas and the Art of Illustrating

Aaron Douglas was the most prolific of the Harlem Renaissance illustrators. Starting in 1925, when he arrived in Harlem, he began contributing drawings to the primary black journals, *Crisis, Opportunity,* and *Messenger,* as well as producing illustrations for Alain Locke's major collection, *The New Negro,* Charles S. Johnson's important but often overlooked compilation *Ebony and Topaz,* and the cover and interior drawings for two radical little magazines, *Fire!!* and *Harlem.* The major publishing firms issuing Harlem Renaissance volumes, particularly Alfred Knopf and Harper and Brothers, also frequently employed Douglas for dust jacket designs. His interior illustrations for Viking's publication of James W. Johnson's *God's Trombones* are considered among the best of his illustrative work.

Douglas has also received the most scholarly attention of the Harlem Renaissance illustrators, and his graphic work is by now somewhat familiar to the viewing public, particularly with the international exhibition of his illustrations in *Rhapsodies in Black: Art of the Harlem Renaissance* (1997) and the Studio Museum presentation of *Challenge of the Modern: African-American Artists 1925–1945* (2003).[1] His work is recognizable also because of the distinctive illustrative style and subject matter that he developed in 1925, as he integrated himself into the Harlem literary community and as a student of the modern illustrator, designer, and painter Winold Reiss. From 1925 to 1930, Douglas consistently perfected his bold graphic representation of angular, silhouetted black figures in highly abstracted settings, sometimes filled with stylized plant forms, at other times suggesting tall city buildings, often including both kinds of surroundings. Through the years, critics and art historians have assessed Douglas's silhouetted compositions variously, from Langston Hughes's expression of wonder in response to his "strange black fantasies,"[2] to James Porter's

disparaging critique of the artist's "imagined exotic character of Negro life."³
Richard Powell has coined the most evocative and useful term for Douglas's
"experiments with a kind of 'Afro-Deco' art vocabulary,"⁴ which helps in under-
standing the complexity of the artist's seemingly simplified forms, which draw
on a variety of sources, from African masks and sculpture to the pervasive Art
Deco used by American artists, designers, and advertisers. However, in their
responses, Hughes, Porter, and Powell share language that suggests an ineffa-
bility in Douglas's work, which seemed to them strange, fantastical, imagined,
exotic, and neither exclusively African or Art Deco, but both.

Their language approximates Douglas's own words, exclaimed to Langston
Hughes in 1925, to suggest ideas for a new kind of visual and literary expres-
sion that the two young artists might explore: "Let's do the impossible. Let's
create something transcendentally material, mystically objective. Earthy. Spiri-
tually earthy. Dynamic."⁵

Embodying qualities normally conceived as opposites, Douglas's language
called for a modern, "dynamic" artistic expression that would be both "tran-
scendental" and "material," "mystical" but also "objective," at once "spiritual"
and "earthy." This chapter will use Douglas's paradoxical lines as a way of un-
derstanding his remarkable contributions as an American artist working in the
modernist medium of illustration to refashion outmoded forms of racial repre-
sentation.

Douglas's graphic art of the 1920s and early 1930s similarly conflated basic
markers of identity that had normally been characterized as contradictory. For
example, in his June 1926 cover of *Opportunity*, Douglas created a modern and
dynamic representation of African American identity formation (fig. 7). At the
center of his composition, he positioned a large figure. At right, he has ren-
dered a plant with stylized leaves. At left, he has organized a set of layered im-
ages from a sunburst low on the horizon in the background, to mountains that
take the form of Egyptian pyramids, to city buildings in the foreground. In the
center, his figure sits on an ambiguous mass that could indicate a rock or an ar-
chitectonic form. The journal's date is inscribed on a superimposed rhombus
that resembles a keystone that might carry the inscription of a building's date
of erection. As flat shapes with sparing detail on the cover of a commercial
magazine, his forms held an iconic function as symbols to denote basic con-
cepts that could be deciphered quickly by the reader. Read symbolically then,
his stylized plant suggests the larger category of nature, whereas the icons at
left suggest the dawn of civilization and the transmission of culture from an-
cient Egypt to modern-day America.

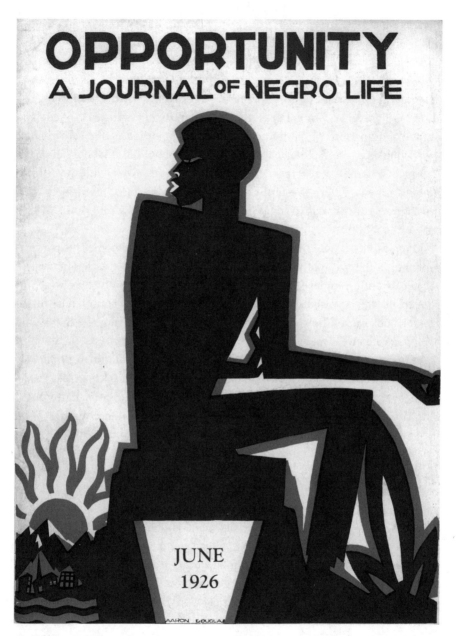

Figure 7. Aaron Douglas, cover of *Opportunity* (June 1926). Collection of the author. Reprinted by permission of the National Urban League.

Read in its totality, Douglas's image has communicated a message of racial uplift, in which the rise of Western civilization serves as a model for the erection of a new black civilization that would draw on reclaimed ancient Egyptian roots in Africa. However, the image gains greater complexity when considering the location of the dark figure between icons of civilization and nature. By situating his figure in a liminal space between nature and culture, his body and limbs extending toward nature, his head and thoughts turned toward civilization, Douglas has defied normative expectations about black identity in 1920s America. Whereas stereotypes associated blacks exclusively with the African jungle and whites with Western civilization, Douglas transgressively crossed the nature/culture divide to suggest hybrid origins for black Americans in both nature and culture.

Douglas faced a predicament in creating a modern method of racial representation in the realm of print culture in the 1920s. In his letter to Hughes, he wrote of wanting to develop new forms of artistic expression; "Not white art painted black," he insisted.[6] Yet, within the context of the commercial magazine or book jacket, how could he develop a new racial language that would communicate effectively to his wide, mixed-race audiences but separate itself from the stereotypical images of black Americans that continued to pervade print culture? Particularly in advertising, racist images of blacks permeated the pages of mass-market magazines, from the slovenly, gambling buffoons in Fisk Tire Company ads (fig. 2) to the servile mammy Aunt Jemima (fig. 3). In the face of these demeaning images, Douglas created a new racial type that carried the possibilities of both recognition and transformation.

In understanding Douglas's method of racial typification, it will be helpful to examine the current theoretical writings of Richard Dyer. While his investigation considers modes of gay representation in art and film, it nonetheless holds resonance for Douglas's illustrative work. Understanding distinctions between representations of race and sexuality, Dyer begins his analysis with the acknowledgement that sexual orientation differs from race because it cannot be seen outwardly in a person's physical attributes. For this reason, the identification of gay figures in art and film almost always requires that they conform visually to certain types that the viewer can recognize "literally at first glance."[7] In reviewing several familiar types, Dyer identifies the "in-betweenist" figures most familiar to viewing audiences as the dyke or the queen.[8] He notes that these figures typically carry outward signs, like clothing, hairstyles, and cosmetics, which suggest a position in between male and female identity. The signs can be obvious, like a dyke's "mannish" suit, or very subtle, such as the "crimped, set look" of a queen's hairdo.[9] On the one hand, in-betweenist types

have usually been presented as "tragic, . . . despicable, . . . or ridiculous figures" in falling short of either male or female categories of identity, which are thereby made all the more rigid.[10] On the other hand, because these types are so recognizable, they are open to manipulation, and often "through a paradoxical inversion," their meanings can change and disrupt rigid classifications of gender.[11] Therefore, while these types often draw on and perpetuate negative associations with gay identity, in the hands of gay artists or viewers, inbetweenist types can be refashioned to empower new forms of self-determined representation.

Dyer's theoretical observations allow certain aspects of Douglas's representational method to stand out in relief. In his illustrations, Douglas used typification, not because he had to make race visible, but in order to create a racial type that could be grasped quickly by the preoccupied modern reader whose attention required quick capture. He created his new type using bold, simplified forms predominantly in silhouette. In choosing the silhouette, he followed his contemporaries in modern illustration and jacket design, who found these flat shapes best suited to the printed page. Beyond issues of design, however, Douglas used the silhouette as an expedient transmitter of information about his new racial type. On the cover of *Opportunity*, Douglas's reader perceived a male figure silhouetted in very dark blue with red outlining against a light pink background. She quickly recognized him as a black type because of his dark skin, but also through his familiar facial features, which she readily associated with black identity: large lips and flared nostrils (accentuated in white to add dimension), a jutting jaw and projecting forehead. At the same time, Douglas revised the familiar type by using the flat silhouette, which clarified the contours of the form while refusing to specify particular internal information. For example, the silhouette would not allow the reader to discern the specific hue of the figure's skin. Beyond the indication of a pant leg, the silhouette hid the figure's clothing, refraining to disclose further details. Was he partly nude? Just as the silhouette drew the reader in to perceive a familiar type, the ambiguous form concealed as much as it revealed.

Douglas also revised the familiar black type by according it an "inbetweenist" status, to use Dyer's evocative term. By locating his figure between shorthand representations of nature and culture, Douglas refashioned stereotypical imagery that associated black identity exclusively with nature. From a new position in between nature and culture, and "through a paradoxical inversion," Douglas's modern racial type possessed two seemingly unrelated racial characteristics at the same time, which disrupted stereotypically binary distinctions between the African and Caucasian races.

This chapter will explore two arenas in which Douglas employed an in-betweenist strategy in his illustrative work. The first was in his engagement with the popular theme of primitivism, which animated a broad range of Harlem Renaissance print culture. The second was in his creation of illustrative work that occupied a place between art and the commercial market. Douglas's varied strategies as an African American artist in developing alternative forms of primitivism represent an important and neglected chapter in the study of primitivism and modern art. And his efforts as an illustrator working the divide between art and commercialism contribute significantly toward understanding illustration in Harlem Renaissance and American visual culture as a powerful modernist medium that has too often been overlooked.

A NEW AMERICAN PRIMITIVISM

Aaron Douglas arrived in Harlem in 1925, inspired by news of the cultural awakening of the New Negro Renaissance. There, he hoped to participate in effecting the "spiritual emancipation" of the New Negro, in the words of African American philosopher Alain Locke.[12] He had grown up in Topeka, Kansas, and received his B.A. in fine arts from the University of Nebraska in Lincoln in 1922. After teaching art for two years at Lincoln High School in Kansas City, he went east to Harlem. Having been trained to master a realist painting style at the University of Nebraska, Douglas assumed he would continue in this stylistic vein, with plans for further study in Paris.[13] When he arrived in Harlem, however, he was unprepared for the pressure he felt from both black mentors and white patrons to stay in Harlem and adopt a new primitivism in his work.[14] In an interview later in life, Douglas remarked about the advice he had received from mentors prompting him to change his subject matter and stylistic approach during his first months in Harlem. "I wanted to do something else," he remembered, "but gradually, they insisted so vehemently that I finally thought that maybe there is something to this thing. This primitive thing."[15] Tracing his shift from "something else" to "this primitive thing" can be approached visually by comparing his earliest *Opportunity* drawing with his *Opportunity* cover of June 1926. The *Opportunity* drawing of September 1925, illustrating a poem by Georgia Douglas-Johnson titled "The Black Runner" (fig. 8), pictured a fit African American male athlete, clad in a loincloth, running forward into the viewer's space carrying a rolled parchment indicating a diploma in his hand. Following her text, the figure is "stripped for the race" with his "forehead to God" and his "feet in the dust."[16] As the poet attached double meaning to "the

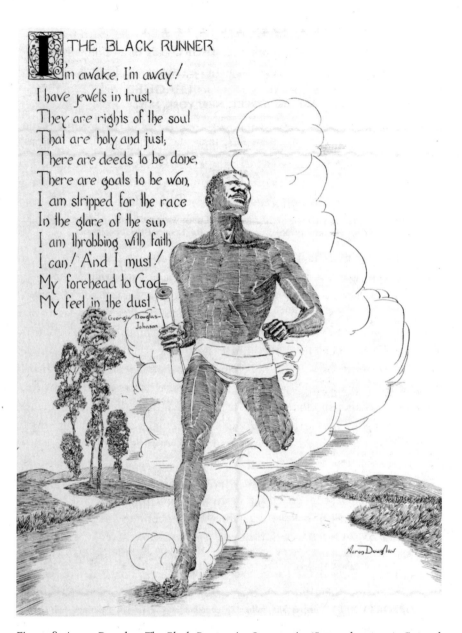

THE BLACK RUNNER

I'm awake, I'm away!
I have jewels in trust,
They are rights of the soul
That are holy and just;
There are deeds to be done,
There are goals to be won,
I am stripped for the race
In the glare of the sun
I am throbbing with faith
I can! And I must!
My forehead to God—
My feet in the dust.

Georgia Douglas-Johnson

Figure 8. Aaron Douglas, *The Black Runner,* in *Opportunity* (September 1925). General Research & Reference Division, Schomburg Center for Research in Black Culture, The New York Public Library, Astor, Lenox, and Tilden Foundations. Reprinted by permission of the National Urban League.

race," Douglas's runner races athletically as a representative of the black race. He is idealized physically—a counterpart to an ancient Greek athlete, though also recognized for his intellectual capacity, marked by the diploma he carries. Here, Douglas and the poet have utilized the central Harlem Renaissance theme of racial uplift, presenting a "New Negro" awakened to self-awareness with potential for great achievement. Stylistically, Douglas's male figure is rendered in a fully volumetric fashion, revealing toned musculature beneath the figure's taut skin. Attesting to his training at the University of Nebraska and subsequent practice, he has pictured the runner in exerted motion, showing his mastery of human anatomy and foreshortening, while also comfortably situating the athlete in a three-dimensional space defined by a landscape setting and a receding path.[17]

By contrast, in his cover of *Opportunity* (fig. 7), Douglas revealed a shift in subject and stylistic treatment that would signal a new primitivism in his work. In this image, Douglas has presented a far less realistic figure than his *Black Runner*. This figure's flat abstracted form indicates Douglas's articulation of a new racial type, with highly generalized features that nonetheless read quickly as Africanist: the small head, the jutting jaw, the lips that swell and protrude. However, Douglas obscured further clues to the figure's identity with the mask-like treatment of the head, which suggests an iconic reference to an African mask rather than a specific person. The body itself is masklike, obscuring details of volumetric human flesh. Adding to the ambiguity is the setting, which, as noted, on the one hand suggests a remote African jungle and on the other, the dawning of ancient and modern civilizations. The image defies precise categorization, falling instead between modalities rather than into them. Douglas's figure can best be described as hybrid—not from either the past or present, from nature or culture, but somewhere in between.

In shifting toward "this primitive thing," Douglas "craft[ed] a voice out of tight places," in the words of Houston Baker.[18] How could he create a modern primitivist discourse in his art, when at every turn he was reminded of the conflations so many Americans made between "Negro" and "primitive" identity, particularly in mainstream print culture? In venues from advertisements to popular books, blacks were too frequently represented as brutish savages or docile primitives. In more progressive assessments of black identity, non-black writers would often reveal a romantic nostalgia for the noble savage, wishing that contemporary blacks fully retained what they defined as their innate primitive heritage. For example in 1926, Paul Guillaume and Thomas Munro lamented in their *Primitive Negro Sculpture*, "The primitive negro, untouched by civilization, is almost a creature of the past. As the outside world establishes

contact with him, investigates his ways, he changes before its eyes into a new being, a compound of the old and new . . . the partly civilized black."[19] Colin Rhodes, Mariana Torgovnick, and other cultural historians have clarified the conventionally binary construction of Western primitivism that directed Guillaume and Munro's attitudes, in which the primitivist ethnographer or artist as the modern observer studied or emulated the production of what they determined were primitive cultures, with readier access to nature, the spiritual, and uninhibited emotional and sexual expression. In wanting to maintain this binary system, Guillaume and Munro joined several non-black patrons of the Harlem Renaissance, like Charlotte Mason, in wanting black Americans to remain "uncorrupted by European or European American civilization,"[20] to avoid the regrettable "compound of the old and new."[21] How, then, could Douglas carve out a modern role as a primitivist when he and other contemporary black Americans were urged themselves to be pure primitives?[22]

Douglas realized that he could profit from a new order, in which he might trade on stereotypes that labeled blacks as America's primitives, while also revising those stereotypes to form his own modern primitivist discourse. In changing his artistic direction in 1925–1926, Douglas developed a new American primitivism, which became his multifaceted strategy to complicate the ways in which Euro-Americans had codified such categories as civilization to exclude black America. By collapsing the Western polarity between the civilized primitivist and the "savage" primitive, he subversively held a role as both primitivist and primitive. In his graphic art, primitivism no longer constituted a longing for what was outside civilization or what had been lost. It connoted instead that black Americans could contribute to modern American culture by reconnecting the primitive and civilized, the past and present, from a strategically interstitial position as a welcome "compound of the old and new."

Douglas's method in creating a new primitivist discourse sprang from what he felt was the unique position of the black collective in American culture, which he articulated formally in a 1927 article published in the *New York World:* "The American Negro is peculiarly situated. His race is in the midst of a highly cultured people who have lost a certain amount of primitive impulses. . . . The Negro has greater rhythm and flexibility than his white brother and in such an environment his artistic contributions are neither like the farm hand nor the man on Fifth Avenue."[23]

Rather than discarding associations between primitive and black American identities, Douglas characterized the Negro as that which Guillaume and Munro lamented, a "compound of the old and new," who retained some of the "primitive impulses" his "white brother" had lost, and whose artistic expression

entered into the fray of modern American culture as a new form that could find exclusive association neither with the working classes nor urban elites. Douglas crafted a savvy statement for publication in the mainstream press in 1927, which synthesized the varied artistic examples and forms of advice he received from non-black patrons and teachers, as well as black leaders and writers, in his movement toward a new primitivism in his illustrative work.

One impetus toward a new primitivism came in the form of strong encouragement to explore his African "roots" from his German art teacher, painter and designer Winold Reiss, as well as the African American critic and philosopher Alain Locke. They both felt that, as an African American artist, Douglas was uniquely poised to learn from the precedent of African art. Reiss was among the first to persuade Douglas to "look at African sculpture and develop an African American interpretive design style based on African motifs."[24] However, Douglas recounted his reluctance and fear as he first began to make his own artistic interpretations of African art at Reiss's suggestion:

> I clearly recall his impatience as he sought to urge me beyond my doubts and fears that seemed to loom so large in the presence of the terrifying specters moving beneath the surface of every African masque and fetish. At last I began little by little to get the point and to take a few halting, timorous steps forward into . . . the unknown. I shall not attempt to describe my feelings as I first tried to objectify with paint and brush what I thought to be the visual emanations or expressions that came into view with the sounds produced by the old black song makers of antebellum days, when they first began to put together snatches and bits from Protestant hymns, along with the half remembered tribal chants, lullabies, and work songs.[25]

In beginning to interpret the meanings African art held for him, Douglas made notable connections. He readily associated the "African masque and fetish" with the "sounds produced by the old black song makers," believing that their songs carried into modern America an instinctive blending of "half remembered tribal chants" and "work songs." Here, in Reiss's studio, Douglas began to perceive what he felt was a continuous primitive expression that emanated from Africa to the working-class American South.

Reiss probably encouraged Douglas to engage with other forms of ancient art from Africa as well, including ancient Egyptian art. Reiss himself was inspired by ancient Egyptian sculpture in his pastel portraits of black types, and he held in his library Hedwig Fechheimer's 1922 publication, *Kleinplastik der Ägypter,* which he may have shared with his young student.[26] Later in life,

Douglas expressed his indebtedness to ancient Egyptian art in his early illustrative work, and Egyptian motifs played a crucial role in his formation of a new primitivism.[27]

Among Douglas's African American advisors and colleagues, a dialectic emerged on how to assess and define African American cultural origins. Were they remote, in a highly civilized ancient Africa, or were they closer to home among members of the working classes in the American South and the urban streets? In either case, were these cultural origins to be defined as primitive? Rather than siding with a particular position in this debate, Douglas used his strategy of "in-betweenism" to explore a variety of possibilities.

One side of the dialogue emerged from the pen of Alain Locke in *The New Negro*, who reasoned that Americans had gotten confused in assigning the term *primitive* to African culture: "What we have thought primitive in the American Negro—his naïveté, his sentimentalism, his exuberance and his improvising spontaneity are . . . neither characteristically African nor to be explained by his ancestral heritage. They are the result of his peculiar experience in America and the emotional upheaval of its trials and ordeals."[28]

Instead, he defined the "characteristic African art expressions" as "rigid, controlled, disciplined, abstract, heavily conventionalized," and the "spirit of African expression" as "sophisticated, laconic and fatalistic."[29] Locke believed that by returning to the discipline and sophistication of African art as their model, black visual artists could create a newly racialized artistic expression that would evoke their richly civilized ancestry in Africa and demonstrate parity with the artistic legacy of European culture.

By contrast, African American writer and poet Langston Hughes expressed a different opinion. He tired of Locke and others who drew endless comparisons between white and black cultures. As generative as African culture was for Hughes, working-class forms, including demonstrative religious practices and music like the blues, represented black expression free from self-consciousness and were what young black artists should emulate: "But then there are the low-down folks, the so-called common element, and they are the majority—may the Lord be praised!. . . . they do not particularly care whether they are like white folks or anybody else. Their joy runs, bang! into ecstasy. Their religion soars to a shout."[30]

Rather than serving to prove parity, the religious shout and blues music distinguished the beauty and difference of African American expression. Replacing Locke's rigid and disciplined African prototype, the expression of this "so-called common element" would provide contemporary African American artists with an authentic voice, in Hughes's opinion.

Hughes and other poets, however, often became conflicted about the place of Africa in the diaspora. On the one hand, for Hughes, black artistic forms, especially in music, held the potential to connect remote experiences in Africa with the urban cabarets. As he wrote, "jazz to me is one of the inherent expressions of Negro life in America: the eternal tom-tom beating in the Negro soul."[31] On the other hand, he resented his white patron Charlotte Mason's desire for him to connect with his "primitive" African roots:

> She wanted me to be primitive and know and feel the intuitions of the primitive. But, unfortunately, I did not feel the rhythms of the primitive surging through me, and so I could not live and write as though I did. I was only an American Negro—who had loved the surface of Africa and the rhythms of Africa—but I was not Africa. I was Chicago and Kansas City and Broadway and Harlem.[32]

For the poet Countee Cullen, the notion of Africa represented a similar source of conflict, which on the one hand signified an esoteric idea from which he felt quite alienated, and on the other represented a distant but nagging remembrance of primitive sensuality. Beginning his renowned poem "Heritage" with a question, "What is Africa to me?," Cullen responded with opposing images that, on the one hand, his mind could barely engage with "Africa? A book one thumbs / Listlessly, till slumber comes," while on the other hand, he could not seem to stop hearing the "Great drums beating through the air," or feeling his primitive "dark blood dammed within."[33]

In creating a new approach to the question of primitivism, Douglas effectively drew on the varied conceptions of primitive and African identities available to him among his advisers and colleagues to fashion a new in-betweenist primitive type that drew together surprising, normally opposing qualities in one figure. In a variety of images, beginning with his early illustration *Sahdji*, published in Locke's *New Negro* (1925), Douglas pursued a hybrid representation of African types as sharing generic tribal and ancient Egyptian features.[34] The next year, in his *Krigwa Players Poster* (fig. 9), appearing in the *Crisis* to publicize W. E. B. Du Bois's little theater group, Douglas pictured a pastiche of visual symbols that tells the reader to see black American origins quickly as both tribal African and ancient Egyptian. He has presented the central seated figure in harmony pictorially with the abstracted natural elements that surround it: a palm and smaller plants at left and right, and a river in the foreground. This figure possesses a masklike face and hoop earring, while also

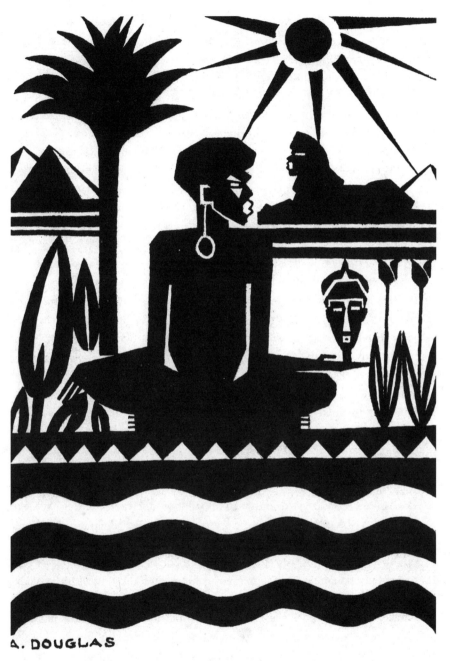

Figure 9. Aaron Douglas, *Krigwa Players Poster*, in the *Crisis* (May 1926).

holding a mask, and reads as a conventional tribal African type. By contrast, the
two pyramids at left, the sphinx at right, and the arrangement of objects along
separate horizontal registers trigger associations with ancient Egyptian art. He
has also rendered his central figure in a manner that recalls ancient Egyptian
figuration. With shoulders set parallel to the picture plane and the head shown
in profile, the seated figure assumes a composite pose utilized in ancient
Egyptian painting and relief sculpture.[35] The parallel, wavy bands below sug-
gest reference generally to rivers in the African jungle at the same time that
they draw more specific association with the Nile, especially with his stylized
representations of papyrus plants growing on her banks.

Another example of Douglas's hybrid African forms may be found in his
Invincible Music: The Spirit of Africa, published in a 1926 issue of the *Crisis.*[36] In
this composition, a seated figure plays a large kettledrum in a lush jungle set-
ting. The figure seems to grow out of the drum, as the drumstick appears to ex-
tend the figure's arm, suggesting a "natural" relationship between figure and
music. While the wavy parallel gray bands in the upper right corner allude to a
meandering river, or perhaps smoke from a nearby fire, at the same time they
seem to visualize the sound waves of the music itself.[37] In this manner, Doug-
las has visually associated the "spirit of Africa" with primal sounds and fecund
nature, prompting the *Crisis* reader to see Africa as precivilized. The rows of
vegetation at left—stylized black leaf forms that could double as warriors'
shields with abstracted white carvings on them, underscore Douglas's visual
construction of a warring African "tribal" culture. However, he has also ren-
dered his drummer in the composite pose of ancient Egyptian art. In addition,
the figure's hair resembles a headdress typically worn by male figures in an-
cient Egyptian sculpture.[38]

In his bold black cover design on red paper for the radical little magazine
Fire!!, Douglas more closely fused the tribal and ancient Egyptian aspects of
Africa (fig. 10). Here, he has conceived the cover as a set of images that play off
one another in black and red. The black form reads as a masklike African head.
Its stylized facial features and hoop earring appear in red, along with the maga-
zine's title superimposed at the top of the cover. At the bottom of the cover, an
ancient Egyptian sphinx is overlaid onto the masklike head. This visual inter-
play sets the head and sphinx in a relationship of symbiosis. Whereas Douglas
placed his two conceptions of Africa face to face in his *Krigwa Players Poster,* the
tribal and ancient Egyptian are interlocked in his *Fire!!* cover, visually incom-
plete if separated. Perhaps more emphatically in his *Fire!!* cover than the other
drawings, Douglas visually conveyed the integral linkage between the "tribal"
and "civilized" faces of Africa.

Figure 10. Aaron Douglas, cover of *Fire!!* (November 1926). Manuscript, Archives, and Rare Book Library, Emory University.

Douglas's visual revision of African roots supplied an important corrective to stereotypes that Africans were primitives with no past, halted permanently at a childlike evolutionary stage. While he created simplified, recognizable types that carried associations for the viewer, he drained the pejorative associations

of primitive stereotypes in three ways. First, he created sleek, elegant types with hoop earrings and full lips. They stood in stark contrast to the brutish visual stereotypes of primitive savages and cannibals that perpetuated in American visual culture. Instead, he·filtered conventional African stereotypes through his experience of African art to create a new type that was elegant, stylized, and as Amy Kirschke has noted, possessed some of the characteristics of African sculpture, as for example the thin eye slits of Dan masks from the Ivory Coast.[39] Second, however, Douglas's figures remained types and did not carry the specificity of their models in African art. Instead, they sent quick messages to the reader of generic tribal African identity. As Douglas remarked in 1927, "While it is absurd to take African sculpture and literally transplant it and inject it into Negro American life, we can go to African life and get . . . understanding, form and color and use this . . . in . . . an expression which interprets our life."[40] Third, by placing quickly perceived references to ancient Egyptian culture side by side with generalized tribal African types that are nude and wear hoop earrings, Douglas has suggested complicated origins for Africans that were not relegated to the timeless African jungle but included the civilization of ancient Egypt.

Douglas's new primitivism also had relevance for his modern black figures. Charting a newly complicated ancestry in Africa that balanced "primitive impulses" (in Douglas's words) with civilizing forces, the artist characterized modern black figures as distinctive from their non-black counterparts in connecting with their past in Africa and making it relevant for the contemporary moment. Continuing to apply his in-betweenist conceptual framework on a *Crisis* cover in 1927, Douglas presented *The Burden of Black Womanhood* (fig. 11). In a manner similar to his 1926 *Opportunity* cover (fig. 7), a large female figure stands between two distinct settings as she holds a giant orb overhead. Her gesture reminded viewers of the burden of all contemporary black women, but she also made connection with antiquity. In lifting a globe overhead, she alludes to the Greek god Atlas as well as Egyptian deities, such as the sky goddess Nut; she therefore suggests ancestral connection as well as modern identity. Likewise, she rises in a visual space that exists literally in between the distant past and the present. Douglas represented the past at left in a scene of mountainous nature, which evolves as a timeline winding around and underneath the composition, coming into view again in the far right. There, Douglas has placed a small log cabin nestled in abstracted trees, which lead to the timeline's termination in a fully evolved modern American city with its factory and tall buildings. Read in its totality, the image suggests that despite the burden contemporary black women carry, which they share through time with illustrious

Figure 11. Aaron Douglas, *Burden of Black Womanhood*, cover of the *Crisis* (September 1927). Yale Collection of American Literature, Beinecke Rare Book and Manuscript Library, Yale University.

ancestors, the women's suffering and endurance allows them connection be-
tween the ancient past and the modern moment, as uniquely interstitial mod-
ern healers.

While his *Burden of Black Womanhood* was a generalized image, using an
allegorical female figure to represent the black female collective, Douglas also
drew more specific modern figures who could effect connection between an
African past and the modern moment. In several illustrations, he privileged
working-class blacks as conduits between the past and present. For example,
he made a striking set of pen-and-ink illustrations for selections from Langston
Hughes's *Weary Blues* poetry, printed in *Opportunity* in 1926. All five illustra-
tions accompanied poems by Hughes that engaged with contemporary blues
music, and in these compositions, Douglas's silhouetted Afro-Deco style took
on a vernacular edge to interpret the dialect lyrics of Hughes's poetry. Two of
Douglas's scenes gave graphic representation to the music itself. For example,
in *Play de Blues* (fig. 12), Douglas extended black parallel wavy bands like visible
sound waves from the top of the blues pianist's upright piano, which the
cabaret performer watches and to which she sways and sings, in Hughes's
words, "Black gal like me / 'S got to hear a blues / For her misery."[41] In *Weary
as I Can Be*, Douglas pictured Hughes's protagonist on the banks of a river,
who sings in the poet's words, "Goin' down to de river / Deep an' slow,—/
Cause there ain't no worries / Where de waters go."[42] Douglas's blues singer
watches the river flow below, while the sound waves of his blues tune drift by
in the upper right corner.

Water and music were generative forces in Douglas's illustrations, which
facilitated his blues singers' connection between the past in Africa and the
modern moment. His shorthand signs for music appeared in his *Invincible
Music*, animating the upper right section with wavy bands; and a river flowed
beneath his African figure in his *Krigwa Players Poster* (fig. 9). Also for Hughes,
water, like music, was a connective element, uniting ancient experiences in
Africa and contemporary events in the United States. In his poem, "The Negro
Speaks of Rivers," Hughes likened rivers to "the flow of human blood in hu-
man veins," which could connect his experience as a black man of "bath[ing] in
the Euphrates when dawns were young," to the time when he "looked upon the
Nile and raised the pyramids above it," to his apprehension of the Mississippi,
whose "muddy bosom turn[ed] all golden in the sunset."[43]

For Douglas, however, some working-class folks remained unable to act as
conduits between the African past and the modern urban environment be-
cause of their entrenched relationship to the experience of slavery in the Amer-
ican South. In this vein, he created an evocative illustration for black

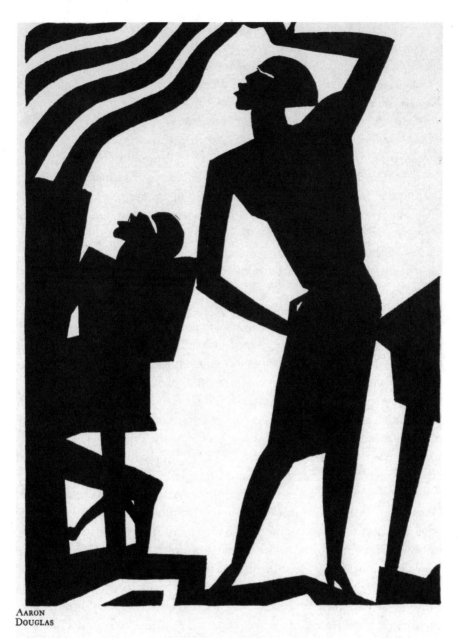

AARON
DOUGLAS

Play De Blues

Figure 12. Aaron Douglas, *Play de Blues*, illustration for Langston Hughes, "Misery," in *Opportunity Art Folio* (December 1926). Yale Collection of American Literature, Beinecke Rare Book and Manuscript Library, Yale University. Reprinted by permission of the National Urban League.

playwright John Matheus's *'Cruiter*, published in Alain Locke and Montgomery Gregory's 1927 collection *Plays of Negro Life: A Source-Book of Native American Drama*.[44] In response to Matheus's lines in dialect, Douglas created a vernacular image, in which primitivist forms and signs of the segregated South clashed (fig. 13). While Matheus named the play for a white "recruiting agent for a Northern munitions factory," his main protagonist was Granny, whom he described as "aged seventy-seven, a typical Negro 'Mammy.'"[45] She has raised her grandson Sonny, who, with his wife, Sissy, still lives in Granny's "Negro cabin"[46] in Georgia at the time of World War I. Sonny has met the white recruiting agent, who promises him a job in Detroit and support for his family if they come with him. While Sonny and Sissy embrace the idea of migrating north, Granny feels ties to the life she has led in the South, despite her experience of oppression as a former slave, and ultimately decides to stay.

Defying Matheus's characterization of her as a typical "Mammy," Douglas has depicted her as a sleek, black silhouette, who holds her suitcase in the center of the composition. She faces the signs of her life in the old South: her cabin nestled in a landscape at right and her chickens and rooster in the foreground. At left, Douglas has arranged two architectural icons: a fragmented view of her cabin below and a slice of a tall building above. A stream of billowing smoke emits from the cabin's chimney and connects with the tall building, while an attenuated and fragmented primitivist mask at far left draws both buildings together. In Douglas's scene, Granny's confined life as a former slave in Georgia seems to prevent her from realizing an escape from that life and from experiencing the fluid progression from Africa to log cabin to American city that the artist has pictured so seamlessly at left.

In each of these broadly ranging primitivist illustrations, Douglas problematized stereotypes that blacks were innately primitive and therefore precivilized and premodern. He accomplished this by situating black figures as in-betweenist or interstitial, with origins in Africa between the "tribal" and the "civilized," and with modern identities that could uniquely connect the past with the present in the modern, urban environment. In this way, he collapsed conventional polarities that served to distinguish between black primitive identity and white civilization and urban culture. He further complicated the connection between an African past and the urban present by suggesting that the experience of slavery had gravely interrupted the flow of African culture to the modern environment. However, his assertion of a timeless connection between the past in Africa and modern black identity brushed with stereotypes that blacks had readier access to a primitive past.

'CRUITER

Figure 13. Aaron Douglas, *'Cruiter,* in Alain Locke and Montgomery Gregory, eds., *Plays of Negro Life* (New York: Harper and Brothers, 1927). Courtesy of Special Collections, University of Houston Libraries.

Indeed, on several occasions, Douglas engaged with more conventional forms of primitivism, a trend that he sometimes shared with other black artists and writers. For example, on a 1928 cover of the *Crisis*, Allan Freelon drew *A Jungle Nymph*, a conventionally primitive scene of a nude black woman in a lush, jungle setting, her nudity a sign of her close relationship with nature.[47] In an *Opportunity* cover of the same year, Lois Jones painted a watercolor portrait of three primitive figures wearing facial paint and exotic jewelry and carrying a decorative warrior's shield.[48] In these scenes, the artists offered no visual correctives to black primitive identity and thereby upheld conventional stereotypes.

While Douglas would not embrace these stereotypes so completely, he nonetheless supplied supportive illustrations for several conventionally primitivist texts. For example, black author Arthur Huff Fauset wrote the short tale "Jumby," which Douglas illustrated in *Ebony and Topaz*, the collection of literature, essays, and art compiled by Charles S. Johnson. In Fauset's story, Jean-Marie lived on an island in the Caribbean. Her skin a "pale amber brownness," she considered herself separate from the dark island inhabitants but also feared that she might return atavistically to her native roots.[49] Douglas's illustration captured the climax of Fauset's tale, when, in a fever, Jean-Marie imagined that she had to confront the hideous God Jumby, who took the form of a leopard. As they entered into a menacing dance, Jean-Marie further imagined being bitten by a cobra, whose venom burned and swelled her body, whereupon she awoke from her nightmare, relieved.

In a layered gouache drawing, Douglas contrasted the silhouetted, sophisticated form of Jean-Marie with the contorted Jumby in leopard skin. Her elegant form defied the many stereotypes that sexualized black primitive women. Instead, Douglas gave her a sleek body, suspended in graceful movement, with hands ending in stylish flamelike points. Nonetheless, Douglas drew little distinction between Jean Marie and the God Jumby, in the sense that they both danced atavistically to beating drums and the "wild . . . hissing of the snares and rattles."[50]

For the little magazine *Harlem*, Douglas contributed a full-page illustration of two silhouetted lovers in the moonlight, surrounded by a jungle landscape.[51] It accompanied Langston Hughes's primitivist short story, "Luani of the Jungles," a piece contrasting "a weak-looking little white man" to his African wife, Luani, whom the little man likened to "a delicate dark statue carved in ebony . . . beautiful and black like the very soul of the tropics."[52] As a product of the jungle, Luani could not abide by her white husband's monogamy. So, she took an African chief's son as her lover, humiliating the possessive white man,

who nonetheless longed for her and always returned to her after leaving in anger. The story is told from the perspective of "a Hughes-like narrator," who hears the story from the white man's perspective, which allows Hughes to both engage with but also distance the atavistic theme.[53] While Douglas's illustration also seems conventional in its voyeuristic view of primitive love, his primitive mask at left acts as a specter watching Luani and her black lover, suggesting an artifice that mimics the remove of Hughes's narrator.

Perhaps Douglas's most romanticized embrace of a conventionalized primitivism took place in his illustrations for *Black Magic* by French author Paul Morand, published in translation in the United States by Viking in 1929. Some African American critics disparaged Morand's tales, such as Aubrey Bowser, who decried, "His formula is atavism. . . . His argument is that blood will tell."[54] However, Douglas provided faithful illustrations of Morand's stories. From scenes of African natives worshipping fetish carvings to images of primitive Africans dancing uninhibitedly before huge exotic masks, Douglas seemed to fully embrace the atavistic tales Morand had composed.

Just as the poets Hughes and Cullen felt conflicted about relationships between primitivism and black identity, sometimes affirming a remembered past in Africa, at other times asserting separate modern personas, Douglas's attitudes toward primitivism shifted in his illustrative commissions. Despite his occasional reiteration of conventional forms of primitivism, his many other efforts to complicate the primitivism with which black Americans had to contend represent key components in his ongoing campaign to make black identity modern.

BETWEEN ART AND THE MARKET

In his seminal essay "The Work of Art in the Age of Mechanical Reproduction," Walter Benjamin characterized the most modern art forms as those that involve reproduction, citing specifically prints, illustrations, and film. In these reproducible forms, he suggests that the "aura" of traditional works of art, like painting and sculpture, is replaced with the capacity for mass availability and consumption.[55] However, he asserts that, unlike the painter or sculptor, the creator of reproduced works must contend with a modern, "absent-minded" observer who is perpetually distracted and therefore requires a bold message to pull them from their preoccupation.[56]

For modern creators of reproducible forms, which circulated more widely than works existing only as originals, the market became one of the primary

means to reach the distracted observer, or consumer. In Douglas's book advertisements and dust jacket illustrations, he worked from the peculiarly modern position between art and the market to attract preoccupied consumers. To capture their attention, he worked as a merchandiser in utilizing his illustrations as creative interfaces between the text and the potential readers, hoping to effect a bona fide purchase. Employing his economical, silhouetted imagery to depict key moments in a text or advertising message, he relied on his keen interpretive powers to transform the written word into dynamic visual art.

In developing an artistic language that would function both creatively and as effective merchandising, Douglas drew on the experience of his teacher, Winold Reiss, whose own production successfully blurred distinctions between art and the commercial market. With major commissions ranging from the interior design of New York restaurants to the graphic design of brochures for large companies, Reiss set an example for Douglas as a modern designer.[57] Using bold, Art Deco silhouettes and a flair for dramatic lettering in his graphic design commissions, Reiss imparted valuable lessons to Douglas on visual merchandising. For example, in his brochure cover design for the Steinway and Sons piano company (fig. 14), Reiss utilized a few, carefully chosen graphic signs to excite the prospective consumer. His bold, sans-serif Bauhaus lettering inscribed the text, "The Making of a Steinway," with ultramodern styling, and his iconic image of the grand piano silhouetted before a giant sunburst visually proclaimed Steinway's product at the dawn of a new modern era in fine piano manufacture. In his work and teaching, Reiss cultivated in Douglas an appreciation for good design that would permeate the arts inclusively, from painting to the decorative arts and book design. To this end, both Reiss and Douglas participated in the International Exposition of Art in Industry held at Macy's Department Store in New York in 1928, which similarly sought to highlight expert styling in a range of objects, from paintings to industrial design.[58]

In this section, I consider Douglas's interstitial place between art and the market by looking at his illustrative work for book publishers, which always involved a component of advertising. Several questions animate this study. For instance, how did Douglas balance his roles as creative interpreter of text and advertiser to potential consumers? How did his imagery reflect his in-betweenist position? And, how did he negotiate between publisher and author in creating these illustrations? I look first at a commission for two drawings that dealt with the marketing of black primitivism, and then I consider five of Douglas's most arresting dust jackets, which served to interpret visually the books they adorned, while also providing a kind of film still to market the books' most compelling themes.

Figure 14. Winold Reiss, cover of brochure by Ralph Bartholomew, *The Making of a Steinway* (Steinway, NY: Steinway & Sons, 1923). Collection of the author. Reprinted with permission of the Winold Reiss Estate.

Douglas's first specifically commercial commission came from Alfred Knopf, who asked him to create two pen-and-ink drawings for use in advertising Carl Van Vechten's scandalous novel of 1926. The understandably controversial title, *Nigger Heaven,* created a stir among black and non-black readers.

Appropriating black slang, Van Vechten's title referred to segregated theater balconies that provided restricted seating for African American audiences. Creating his first drawing for ads that would run primarily in the non-black mainstream press, Douglas clarified Van Vechten's title.[59] He flanked his composition with two silhouetted figures resembling statues that might have adorned an Art Deco theater (fig. 15). They hold up a black horizontal band containing Van Vechten's title, which also forms a theater balcony filled with an African American audience. Douglas left the central section of his illustration blank, in order to allow space for the ad copy, which Knopf inserted in a full-page layout in the trade journal *Publishers Weekly*. His copy confirmed that the booksellers reading this publication would be introducing Van Vechten's novel to non-black readers: "Between the covers of this unusual novel you will be selling your customers a new world."[60]

Knopf ran Douglas's second advertising illustration primarily in the black journals in response to the critical debate surrounding Van Vechten's book, which traded on forms of black primitivism (fig. 16). Critics either loved or hated Van Vechten's novel, which described vividly the collision of two forms of life in Harlem: the refinement of the cultured black middle classes and the sultry, sordid world of Harlem's cabarets. One reviewer in the staid black newspaper *New York Amsterdam News* wrote snidely about Van Vechten's "breach of the peace," which would be well received by "Harlem's new and nocturnal aristocracy of 'brains' and booze," but "to the rest of us it seems strange that one of the professional experts on the Negro should select a selling title which gives such offence to all self-respecting Negroes."[61] By contrast, Wallace Thurman prophesied in *Fire!!*, "Harlem Negroes, once their aversion to the 'nigger' in the title was forgotten, would erect a statue on the corner of 135th Street and Seventh Avenue, and dedicate it to this ultrasophisticated Iowa New Yorker," who had written about Harlem's "lewd hussies and whoremongers."[62] In light of this critical debate, and particularly to deemphasize the theme of black primitivism for middle-class black readers, Knopf sought to sanitize Van Vechten's novel in the ad that circulated in the black presses, emphasizing the uplifting theme of a black man and woman trying to climb the ladder of success in a society plagued by prejudice. In a reassuring, almost syrupy tone, the ad's copy maintained that the book told "a story of two lovers, climbing Jacob's ladder under the shadows of Harlem."[63]

In his second illustration, built around a central opening for Knopf's sanitized narrative, Douglas made few references to Van Vechten's novel, save its title (fig. 16). In placing the words "Nigger Heaven" at the top of his drawing, he adopted the author's metaphor for Harlem as the segregated theater balcony at

Figure 15. Aaron Douglas, advertising illustration for Carl Van Vechten, *Nigger Heaven* (New York: Alfred A. Knopf, 1926), in *Publishers Weekly* (June 26, 1926).

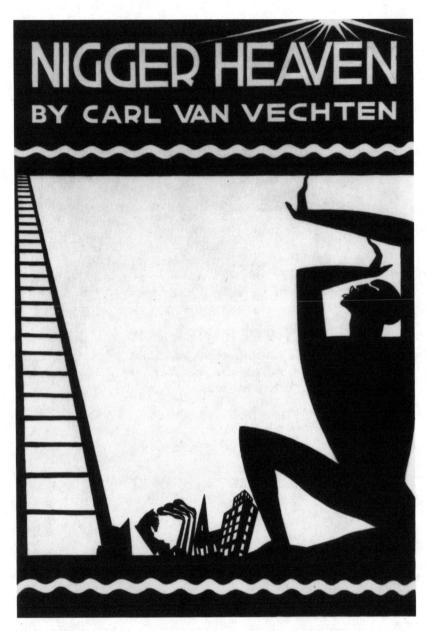

Figure 16. Aaron Douglas, advertising illustration for Carl Van Vechten, *Nigger Heaven* (New York: Alfred A. Knopf, 1926). Yale Collection of American Literature, Beinecke Rare Book and Manuscript Library, Yale University.

the top of the island of Manhattan.[64] However, in following Knopf's caption in the main body of his illustration, Douglas circumvented Van Vechten's novel, which he claimed never to have read.[65] Indeed, his drawing functioned less to advertise the book and more as a general promotional image for Harlem, linking its ancient heritage with its modern identity. His composition balanced an elegantly silhouetted black Jacob at right with an ascending ladder at left, each supporting Van Vechten's title above. Between the ladder and figure of Jacob, Douglas arranged a set of small icons that juxtapose Harlem's ancient heritage with evidence of its modernity. Just to the right of the ladder, Douglas placed an ancient pyramid in front of an Egyptian sphinx in profile. These icons face modern city buildings, which include a factory with smokestacks, a church, and a skyscraper. With deceivingly simple and suggestive forms, Douglas has created a complex image that promoted Harlem's myriad faces. While the ancient pyramid and sphinx allude to Harlem's illustrious past in Egypt, the dancing Jacob and his ladder suggest black dance and music, specifically the Negro spiritual "Climbing Jacob's Ladder." In Douglas's shorthand visual language, Harlem's ancient heritage gave rise to its inhabitants' participation in modern urban culture and fostered modern black expression, ranging from working-class slang to black music. Once again, Douglas has claimed an interstitial identity for black Americans, effectively connecting ancient origins with distinctive modern contributions to American culture. His dynamic portrayal of black identity ingeniously united messages of racial uplift and parity, espoused by Alain Locke, with Langston Hughes's radical assertion of black difference.

In his many dust jacket illustrations, Douglas developed a highly successful design style that constituted effective merchandising. In 1931, artist and designer Helen Dryden observed adroitly that during the 1920s American book jackets had evolved into a sophisticated form that blended modernist poster design and commercial packaging. She commented insightfully, "Now every book is fast becoming a poster for itself, its own most effective form of advertising." In a variety of ways, Douglas showed his mastery of this form, in some cases connecting with the advertising campaign of the publisher, in others finding just the right imagery that would suggest the range of events in the book. As Dryden said, the jacket "ought to give some indication of what the book is about, even if in an abstract way, enough to arouse the buyer's interest and curiosity and make him want to read the volume." [66] Indeed, in formulating his jacket designs, Douglas carefully digested the novels' plots and themes, finding the most telling images to arouse the reader's curiosity and to economically encapsulate the author's ideas.

In five of his most dramatic dust jacket designs, Douglas capitalized on his conceptual framework of in-betweenism in depicting black figures who drew their modern agency from their interstitial status, both in their physical placement and in their psychic potential. In these jacket designs, Douglas worked carefully with the text to devise a meaningful image that would direct the viewer's attention to the author's most provocative themes. In the case of his jacket cover for the 1927 Knopf publication of James Weldon Johnson's *Autobiography of an Ex-Coloured Man*, Douglas prepared carefully for his design with a thorough reading of Johnson's book (fig. 17). As he wrote to the author before executing his drawing:

> It is my good fortune to have the privilege again of helping in the publication of one of your books. The publishers have asked me to design a jacket for the Autobiography of an Ex-Coloured Man. I have just finished reading the book and I am carried away with amazement and admiration. Your depth of thought, breadth of vision, and subtlety and beauty of expression awakens in me the greatest admiration.[67]

Thoroughly familiar with the text, Douglas illustrated a particular passage in Johnson's text, near the end of his story about a light-skinned African American man who has struggled with the decision of whether or not to attempt to pass for white:

> I finally made up my mind that I would neither disclaim the black race nor claim the white race; but that I would change my name, raise a mustache, and let the world take me for what it would; that it was not necessary for me to go about with the label of inferiority pasted across my forehead. . . . So once again, I found myself gazing at the towers of New York, and wondering what future that city had in store for me.[68]

Using this passage as his guide, Douglas has placed Johnson's protagonist in a seated position, "gazing at the towers of New York." He achieves modern agency through his interstitial position between two distinct settings—the natural forms at left and the urban buildings at right, a visual metaphor implying for the reader that Johnson's protagonist possesses the power of choice. Douglas has also represented the figure as a cunningly ambiguous, dark silhouette, which captured Johnson's misleading stance as the author of a fake autobiography. While Johnson's protagonist is known for his light skin, Douglas has silhouetted the figure in black, which suggests sardonically that, despite his

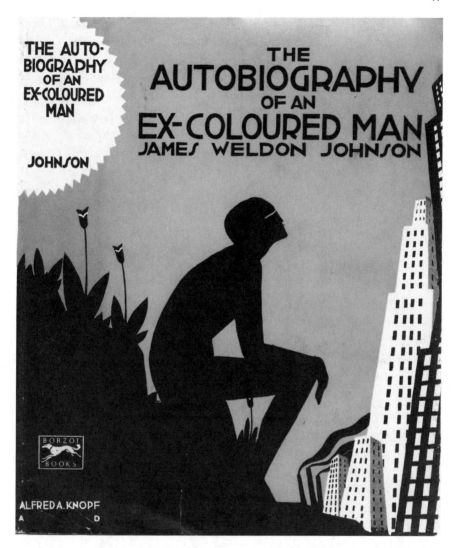

Figure 17. Aaron Douglas, dust jacket design for James W. Johnson, *Autobiography of an Ex-Coloured Man* (New York: Alfred A. Knopf, 1927), copyright. Reprinted by permission of Alfred A. Knopf, Inc., a Division of Random House, Inc. Used by permission of Alfred A. Knopf, a division of Random House, Inc. Harry Ransom Humanities Research Center, The University of Texas at Austin.

passing for white, he will always remain black. However, even more than other black types from Douglas's pen, this figure remains almost fully ambiguous, with no distinctive facial features and no clothing specified. He remains an enigma, his identity ultimately hidden, as was the author's.[69]

In his book jacket illustrations for Rudolph Fisher's *The Walls of Jericho* (1928) and Claude McKay's *Home to Harlem* (1928), Douglas's figures also play the roles of their author's contemporary protagonists, while at the same time they portray Harlem life as involving a dialectic between primitivism and the modern, or between vice and purity. Rather than choosing one over the other, however, the interstitial figures act as agents of connection, ultimately negating the opposition between two forces normally understood as antithetical.

In his cover for *The Walls of Jericho,* he situated Rudolph Fisher's protagonists, the strapping piano mover Shine and the maid Linda, between the tall buildings of the modern city at right and the slim profile of a primitivist mask at left (see fig. 42). Douglas's mask and tall buildings are at once at odds with one another, but at the same time part of a fluid dialectic enunciating the dynamic character of Harlem life, which encompasses a vernacular working-class culture and a more decorous, bourgeois lifestyle. These two cultures meet in the relationship of Shine and Linda. In illustrating their encounter on the cover, Douglas has emphasized their differences while at the same time suggesting their kinship. On the one hand, Douglas has divided his composition distinctly, allying the working-class Shine with the primitive mask and the middle-class Linda with the urban tall buildings. Further, he seems to have illustrated a particular moment in Fisher's text, when Linda pleads with Shine not to take out revenge on a man he believes has wronged her. On the other hand, Douglas's cover image suggests parody in its amplification of Shine's hulking physique and emotionless demeanor and its exaggeration of Linda's frail frame and cloying dependence. For, at the heart of Fisher's novel lie the true emotions of these lovers, which each has covered up and which finally boil over at the climax. Linda says to Shine, "You're kidding yourself. You're not hard." She continues, "You're not hard or mean or tough or any of those things. You're just scared."[70] Shine responds, "Well, you kid yourself too sometimes, Lindy."[71] Admitting that she has adored his advances but hated his refusal to tell her his feelings, she says to Shine, "And now look at me . . . making believe I'm ashamed when I'm not a doggone thing but mad."[72] As an emotionally protective measure, each character has assumed stereotypical behavior associated with their gender, which Douglas in turn has imaged.

His mask and buildings also reflect the satirical tone of Fisher's novel, which poked fun at white philanthropists. Linda's employer, on the one hand, delighted in the "primeval" behavior of blacks who were "unspoiled by civilization,"[73] but on the other hand maintained that "to live beside them" in the city would be "quite another matter."[74] By separating the "primitive" and "civilized" at opposite sides of his composition, but simultaneously emphasizing their

connection in the lives of black Harlemites, Douglas mocked the philanthropic hypocrisy of prominent non-black patrons.

Also directing parody at Fisher's text, Douglas utilized his silhouettes of Shine and Linda to gloss over the distinctions in their skin color that Fisher took pains to describe. As dark black, flat forms, they hide the particular hues of Shine's dark skin and Linda's olive skin, riffing on the stereotypical association of dark skin with working-class status and light skin with bourgeois identity.

In his jacket design for McKay's *Home to Harlem,* Douglas similarly accorded the author's hero Jake an interstitial placement between a modern tall building at left and an old Gothic church at right (see fig. 1). Again, Douglas suggested one particular episode in McKay's novel, while at the same time conveying the author's overarching themes. As Robert Russ has observed, *Home to Harlem* is "a study in contrasts."[75] For example, it compares the character of Jake, a working-class black American who speaks in dialect, with Ray, an educated Afro-Caribbean who has to take menial jobs to further his education. It distinguishes the events of coming home to Harlem and taking leave of Harlem, while also revealing Ray and Jake's simultaneous intoxication with and disgust for the city. It further contrasts but blurs distinctions between those who enjoy the sordid, sexy excitement of Harlem's nightlife and others who find Harlem's inhabitants "ungodly" and "savage."

Douglas found a specific episode at the end of the novel particularly evocative and used it to animate his cover image. Jake has been reunited with his love, Felice, and they take the opportunity to walk down "Block Beautiful" on 130th Street, a section on the edge of Harlem where white residents had retained some of the nicest flats in New York City. "The black invasion was threatening" the block from all directions, McKay told his reader, but the "desperate, frightened, blanch-faced, the ancient sepulchral Respectability held on." And nearby, "giving them moral courage, the Presbyterian church frowned on the corner like a fortress against the invasion." But that sign of morality could not stop the "groups of loud-laughing-and-acting black swains and their sweethearts [who] had started in using the block for their afternoon promenade. That was the limit: the desecrating of that atmosphere by black love in the very shadow of the gray, gaunt Protestant church!"[76]

Using an in-betweenist format, Douglas incorporated the Presbyterian church in Gothic style at right, counterbalancing the composition with one of Harlem's tall buildings at left. Placing McKay's protagonist in between the two buildings with his suitcase by his side, Jake gestures toward them as if to make a choice: whether to leave Harlem or stay, whether to choose one way of life or another. Upon closer inspection, however, Jake ultimately mocks the dualities

between the purity and vice the buildings seemingly demarcate. For, in the liminal zone between tall building and church behind Jake, two arc shapes join the opposing buildings. The arcs are formed by word fragments that refer to popular activities in Harlem: the gambling game of Numbers, and Cabaret entertainment. Is Jake pointing to two opposing forces, or is he parting city buildings as if curtains on a stage to expose the aspects of Harlem life some would rather keep hidden? By asking this question, the layered quality of Douglas's drawing becomes apparent, in which the words "Numbers" and "Cabarets" hover behind the veneer of the tall building and church. By placing these activities in a space behind and between the icons of good and evil, Douglas suggested the fluidity of interpretation surrounding Harlem's nightlife that McKay had addressed and that reviewers of his novel debated. Thus, the duality between good and bad building, which Jake seemingly demarcates, is collapsed. He reveals his joke in his pose. With arms outstretched evenly, his head turns toward the church at right, but his knee bends toward the tall building at left. His pose is one of balance and poise, never choosing, always hovering in between.

In using sardonic wit, Douglas engaged with McKay's satirical writing, in which he often used Jake's wily sense of humor to mock the God-fearing classes—not just the respectable whites, but also the blacks who felt themselves superior to Harlem's vices. For example, Jake satirized his landlady, whose piety acted as a veneer for her own vice. She would typically complain, "All you younger generation in Harlem don't know God." She continued her tirade, "All you know is cabarets and movies and the young gals exposing them legs a theirs in them jumper frocks." Though she chastised Jake for *his* drinking, he later revealed her hypocrisy, "The landlady stahted warning me against sin with her mouth stinking with gin."[77]

McKay's parody of religiosity, particularly in the icon of the gothic church, must have held particular resonance for Douglas. In a letter to Langston Hughes in 1925, he made a similarly sardonic swipe at those white Americans who could not find a religious architectural style that would resonate with the modern world: "Let's laugh at our 'Nordic' overlords who . . . build churches, cathedrals, hollow, soulless, voiceless. Who build 12th century cathedrals (St. John the Divine N.Y.C.) in 20th century America."[78]

In disparaging the "soulless" voices of religiosity on both sides of the color line, Douglas and McKay called for a modern black expression that acknowledged the dynamic contradictions of modern life with comic satire rather than tragic judgment.

By the early 1930s, Douglas had developed a more complex visual technique in his dust jacket illustrations, in which he used two-color printing to

layer dark and light silhouettes. In these designs, Douglas frequently incorporated a darkly silhouetted observer in the foreground, who watched a pivotal episode from the book that played out again in the character's memory at the story's end. In choosing evocative images to whet the reader's appetite, Douglas again employed an in-betweenist strategy in visualizing a reverie in the text that would connect the modern moment with the remembered past.

For Arna Bontemps's *God Sends Sunday*, Douglas created one of his most memorable jacket designs that illustrated the protagonist's reverie while also providing clues to events throughout the book, to pique the reader's curiosity (fig. 18). Using darkly silhouetted forms in the foreground, Douglas illustrated Bontemps's protagonist Little Augie. Dressed in tails and holding a top hat, he sits in the lower left as an older man who has seen far better days. Looking up toward a scene faintly silhouetted in several hues of pink, he remembers a dance he shared with his mistress when he was a successful jockey at the turn of the century. He in his satin suit, matching top hat, and cane, she in her "plum-colored" dress and "petticoats gold," they both danced the "elaborate strut" of the cakewalk at the Cotton Flower Ball in St. Louis.[79] As an older, poorer man, Augie nonetheless brought his aging fancy clothes with him each time he jumped a freight train to a new adventure, and it was through dress that he imagined he could overcome his small size to make an auspicious impression.

On the one hand, Douglas illustrated a specific moment in the narrative when, as an old man, Augie attended a dance in Los Angeles. "Watch[ing] calmly from the sidelines" in his faded finery, Augie "thought of the night he walked with Della Green at the Cotton Flower Ball. That had been a real come-off. That was what he called a dance. It was fancy."[80] But, as if composing a modern film still, Douglas staged the scene to include markers of the full plot, with the musical notation suggesting the dance music but also the blues he so loved to sing, the freight train that would keep him on the move, and his wicker suitcase, always at the ready. It seems likely that Douglas directed the choice of color in printing the jacket, as it suggested the "plum-colored dress" that Augie had so carefully chosen for Della. The faded pink silhouettes also worked well as veils of memory against which the stark black silhouettes of the modern moment stood out in further relief.

In 1930, Douglas created another one of his most stunning dust jackets for Langston Hughes's first novel, *Not Without Laughter,* a title that reflected its central theme of blues music, which for Hughes evoked "ironic laughter mixed with tears."[81] Douglas's intricately silhouetted jacket design, printed in dark green and salmon pink, introduced the reader to Hughes's main characters—

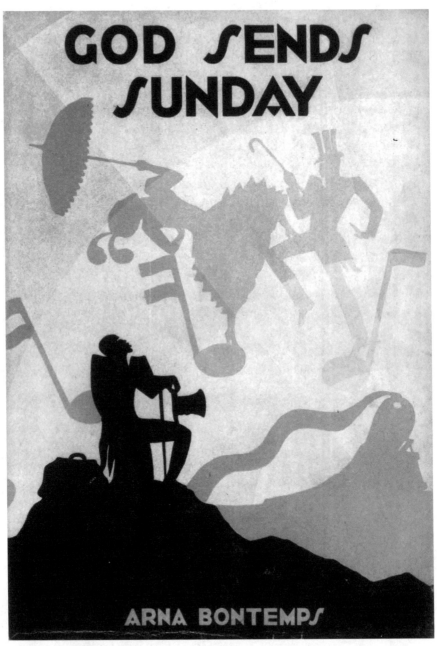

Figure 18. Aaron Douglas, dust jacket design for Arna Bontemps, *God Sends Sunday* (New York: Harcourt Brace, 1931). Matt and Evelyn Crawford Library, Manuscript, Archives, and Rare Book Library, Emory University.

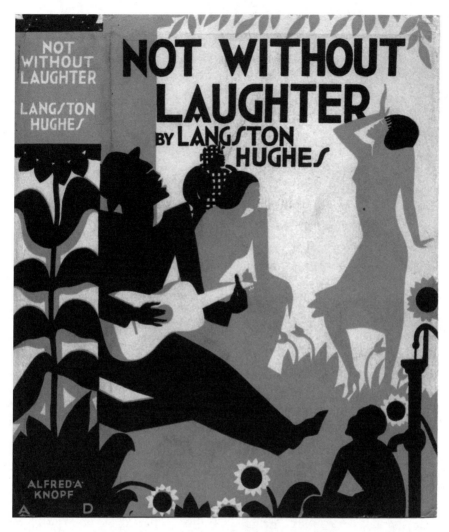

Figure 19. Aaron Douglas, dust jacket design for Langston Hughes, *Not Without Laughter* (New York: Alfred A. Knopf, 1930), copyright. Reprinted by permission of Alfred A. Knopf, Inc., a Division of Random House, Inc. Used by permission of Alfred A. Knopf, a division of Random House, Inc. Harry Ransom Humanities Research Center, The University of Texas at Austin.

working-class family members who sit outside their small-town Kansas home (fig. 19). Jimboy sits at left strumming a guitar and singing a blues tune. Across from him at right, his sister-in-law, Harriett, dances lithely to the music. Her sister, Jimboy's wife, Annjee, sits next to her husband, and her mother, Hager, stands behind Annjee with a kerchief on her head, wearing an apron.

Observing the scene from below is the young protagonist, Sandy, the son of Jimboy and Annjee. As a foreground silhouetted observer, he occupies a position similar to the elder Augie in Douglas's jacket for Bontemps's book.

Douglas has illustrated a key episode in Hughes's novel, which traces the lives of these family members as Sandy grows from a young child to a high school student. In Chapter 5, titled "Guitar," Sandy's errant father, Jimboy, had come home from his wanderings. One Monday evening he picked up his instrument and began to sing with "his rich low baritone voice giving birth to the blues." In Jimboy's pose, Douglas caught Hughes's description, "Long, lazy length on the kitchen-door-sill, back against the jamb, feet in the yard, fingers picking his sweet guitar." Harriett, whom Jimboy had taught to sing and dance the blues when she was a little girl, decided to "chime" in, "standing under the ripening apple-tree, in the backyard." She called out, "'O, play it, sweet daddy Jimboy!' She began to dance." And, despite her mother's protestations, for she was a devout Christian who had no use for the blues, "Harriett kept on, her hands picking imaginary cherries out of the stars, her hips speaking an earthly language quite their own." Annjee sat uncomfortably next to her husband, feeling overshadowed by her sister, and Sandy, "who sat on the ground," drank it all in.[82] Hughes evoked the episode again at the end of the novel, when the two sisters and Sandy reminisced about the time "when Hager and Jimboy and all of them had lived together, laughing and quarreling and playing the guitar."[83] After Hager had died and Jimboy had left, they remembered their family collective through the image of communal music.

Cheryl Wall has noted that the blues lines Hughes used to begin his "Guitar" chapter, "Throw yo' arms around me, baby, / Like de circle round de sun," suggest the "collective yearnings and feelings" that blues music invokes.[84] Similarly, Douglas used a loosely circular arrangement of his figures to emphasize their sense of community even in the face of their disagreements. And, in showing the young boy's receptivity to his whole family, from his grandmother's morality and the grittier excitement of his father and Harriett's lifestyles, Douglas pictured Sandy with his head cocked upward, leaning forward, excited to watch the drama of his family life unfold.

Once again in this jacket, as in other illustrations, Douglas employed the dark green and salmon pink to defy the skin colors Hughes had particularized in his novel. Sandy, whose light hair prompted his nickname, was as light as his father, and yet they both appear silhouetted in dark green. The sisters, who possessed dark complexions, wear pink skin in Douglas's composition. Only for Hager did Douglas retain Hughes's assignment of dark skin color. In using color more arbitrarily, the artist may have made more expressive and less de-

scriptive associations. In coloring the father, son, and grandmother a dark green, he may have found the contrasting strong personalities of Jimboy and Hager the most formative for the young Sandy, who blends their strengths in his nascent form.

Working as a modern artist, interpreter of text, and merchandiser, Douglas successfully blurred distinctions between art and commercialism by extending extraordinarily powerful methods of modern design to his advertising and dust jacket illustrations. Beyond sensitive textual interpretation and effective advertising, the artist used his commercial work to advance his efforts to refashion black identity in modernist terms. Mirroring the artist's modern situation between art and the market, Douglas's black protagonists occupied interstitial positions on the covers of Harlem Renaissance books, as individuals with modern agency in their power to choose and to remember.

CONCLUSION

When Aaron Douglas decided to "go primitive" in his graphic art in 1925–26, he embarked on a subversive venture, which seemed to quell his patrons' appetites for primitivism, while at the same time radically redefining primitive identity. By developing an in-betweenist strategy to shift the primitive from exclusive association with nature to a fluid position between nature and culture, Douglas drained primitive identity of its pejorative, precivilized status. Instead, primitive identity was a gift that African American people could bestow on modern American culture. Repeatedly in his illustrations, he insisted that nature and culture were not antithetical in the experiences of African American people, and further, that black Americans could bridge the rupture white civilization had imagined between nature and culture. That his primitivism was not always consistent, at times embracing more conventional stereotypes, suggested the thorny nature of the subject for African American artists and writers in the 1920s. For it seemed that primitivism was one "mountain" that black artists had to confront consistently, either choosing to reject it outright, to reformulate it, or to embrace certain aspects of it before moving into their own creativity.[85]

In his merchandising illustrations, Douglas continued to work strategically to capitalize on his modern position between artistic production and commercial consumption. As in his primitivist mode, he refused static polarities in his commercial imagery, instead communicating the dynamism of modern black identity, which ran the gamut between working-class blues singers and bour-

geois race leaders but could not be reduced to pat representations of race or class. As he recognized, modern African Americans could "do the impossible"; they were "transcendentally material, mystically objective. . . . Spiritually earthy. Dynamic."[86]

From Racial Uplift to Vernacular Expression:
Commercial and Little Magazine Illustrations

At the heart of Harlem Renaissance literary and visual production, the African American magazines gave early exposure to writers and visual artists. The *Crisis* and the *Messenger* were the first of the African American commercial magazines to solicit literary contributions and visual imagery from young artists, and when *Opportunity* began its publication in 1923, it soon began to specialize in poetry, short stories, and visual art. The noncommercial little magazines, including *Fire!!* and the *Saturday Evening Quill*, afforded black illustrators an unfettered forum to pursue more boldly creative work and less licensed forms of racial representation. These black journals became the primary publishing venues for African American illustrators, and their editors provided them a crucial arena for artistic experimentation in which to begin to form modern, self-determined representations of African American identity and culture.

In arriving at a new African American modernism that stood powerfully against outmoded stereotypes of black identity, New Negro illustrators differed markedly from one another in their choice of styles and themes. The most modern looking illustrations embraced new graphic modes, such as Art Deco, whereas other illustrations appeared more conventional in form, employing line drawings or etchings with traditional shading and perspective systems. In these diverse compositions, artists further embraced a multiplicity of themes, each with distinctive contributions to the project of modern African American representation. Some artists created scenes of racial uplift, espousing didactic messages about the vital gifts black Americans had bestowed on modern American culture. Other artists developed vernacular modes of expression in response to distinctive black forms of music and entertainment, with particular focus on scenes of Harlem's cabarets. In sharing firm rejection of pejorative characterizations of black Americans that found ubiquitous circulation in

mainstream American print culture, each of these illustrative modes and themes represented important modern reinterpretations of racial identity.

This chapter considers the broad array of New Negro illustration that found publication in varied magazine venues during the 1920s and early 1930s. I interrogate how the illustrations were utilized in the magazines and how the various editorial policies may have shaped the philosophical and physical context of the imagery within the publications. To aid in this effort, I provide an overview of these illustrations within separate discussions of the magazines that published them. This overview is by no means exhaustive but intended as an introduction to this large body of illustrative work. In sections on the *Crisis, Opportunity,* and the *Messenger,* I consider the magazines' editorial focuses and the ways in which each publication featured and integrated illustrations. In looking at the images, I explore the wealth of modernist illustrative production by many stylistic innovators, including those often neglected, like James L. Wells, Charles Cullen, and E. Simms Campbell, who worked in a variety of modes, from Art Deco to a modern vernacular. Rather than privileging stylistic innovation, however, I also account for the illustrative work of artists like Laura Wheeler and Albert Smith, who utilized conservative stylistic features while exploring themes relevant to the central project of racial uplift.

In the next section, on the African American little magazines, I integrate discussion of the radical publication *Fire!!* with the lesser-known, more measured creative journal the *Saturday Evening Quill,* suggesting the range of artistic production in these noncommercial venues. As unusual specimens of illustrated Harlem Renaissance print culture, these periodicals were reviewed in the press as complete works of art, with critics providing rare commentary on their visual contributions. While critics either loved or hated the scandalous artistic production in *Fire!!,* the *Quill* received strong reviews from critics who favored its tamer artistic expression in comparison to the overt sexuality of *Fire!!* Imagery functioned very differently in each periodical, in subject and style but also in relationship to text. While, for the most part, *Fire!!'s* illustrations served no text but underwent aesthetic emancipation as separate works of art in full-page layouts, the *Quill* illustrations functioned in relationship to their text, both in their visual placement, often embedded within textual columns, and in their incorporation of printed captions. Again, rather than polarizing one method of illustration as innovative and the other conservative, I ask how each contributed to a larger modernist project.

In the final section on Harlem Renaissance illustrations in non-black mass-market and literary magazines, I focus on the illustrations in *Vanity Fair* by Miguel Covarrubias and the drawings in *Survey* and *Forum* by Winold Reiss.

While these artists variously created evocative, modernist portrayals of African American culture, they became the primary visual interpreters of black writing in these periodicals in the mid- and later 1920s. By contrast, very few black artists received opportunities to publish their illustrative work in these venues, as generally editors preferred using the work of popular non-black artists to act as a creative interface between their largely non-black readers and the prose and poetry of black writers.

THE CIRCULATION OF HARLEM RENAISSANCE
MAGAZINE ILLUSTRATIONS

With a robust magazine publishing industry in the United States, the artists associated with the Renaissance had many more opportunities to find work in illustration than to sell or obtain commissions in painting and sculpture. In addition, by publishing their work in Harlem's journals and in the mainstream magazines, graphic artists participated in a mass-market economy, thereby making their work accessible to a much larger public than could painters and sculptors, whose work circulated principally through exhibitions. Harlem Renaissance illustrations circulated considerably throughout New York and other American cities between 1920 and the early 1930s. The illustrations published in the two major African American journals received steady national distribution, with the circulation of the *Crisis* averaging about 50,000 during the 1920s.[1] Its rival, *Opportunity,* reached a circulation of only 11,000 in 1927; however, it became known for its literary and artistic focus.[2] The *Messenger*'s circulation was still less at approximately 5,000 during the 1920s.[3] The little magazines had even fewer readers. However, when one takes into account the common wisdom that each magazine passed to at least four readers, these modest circulation statistics could well have risen by four-fold or more.[4] The Harlem Renaissance illustrations that circulated in *Vanity Fair* and the other mainstream journals had much wider exposure, as these journals often reached circulations of one million or more during this period.[5] Therefore, with persistent circulation in a variety of venues, the illustrations by Harlem Renaissance artists remained in the public eye far longer than the paintings and sculpture in the isolated public library, private gallery, or Harmon Foundation exhibitions.

The specific readership of the African American journals is more difficult to gauge, particularly with regard to race and class. Given the *Crisis* and *Opportunity*'s emphasis on integration and their association with their organizational boards, which were at times largely white, these magazines aimed their mes-

sages at both black and white readers. For example, some scholars have posited *Opportunity*'s audience to include substantial numbers of white readers, perhaps between 30 and 40 percent.[6] While the readers of *Crisis* and *Opportunity* were probably primarily middle-class, W. E. B. Du Bois claimed a significant working-class black readership for the *Crisis*.[7] By contrast, the *Messenger*'s readership was culled largely from black union members, and its articles regularly appealed to issues affecting the working classes from the outset of its publication in 1917, and as the organ for the Brotherhood of Sleeping Car Porters from 1925 to 1928.[8]

AMERICAN MAGAZINE ILLUSTRATIONS

The periodicals considered in this study emerged at a time in American culture when illustrated commercial magazines flourished, providing millions of eager American readers with an informational and entertaining leisure-time activity. Mass-market magazines had become especially popular in the 1890s, when prices were reduced to about 10 cents an issue because of less expensive production costs. In the early twentieth century, when magazines began to depend more heavily on advertising revenue, they could increase their production costs, while retaining the same low newsstand prices. By the 1920s, many of the commercial magazines were lavishly produced, with brightly colored cover designs and elaborate full-color advertising peppered throughout the issues. Circulations soared, first with the reduction in newsstand prices, and then with the introduction of color printing, so that by 1920 "printings of a million copies per issue were not uncommon."[9]

From the mid-nineteenth century, when the illustrated weeklies first appeared, illustrations boosted circulation numbers for mass-market periodicals. Americans clamored for visual stimulation in commercial magazine illustrations in the early twentieth century, and accordingly, the most popular illustrators received handsome compensation for their work. For example, Rowland Elzea recounts that "in 1903 . . . Charles Dana Gibson . . . signed a contract with 'Collier's' magazine to draw 100 drawings over a period of four years for $100,000," an astronomical sum for any artist of that period.[10] While most illustrators worked with magazines on a contract basis and received modest payment for their isolated commissions, their illustrations nonetheless remained in high demand through the 1920s and even, to a certain extent, into the 1930s, despite the financial disruption of the Depression.

Figure 20. Frank Hoffman, "Jim, I don't know why I love you, but I do—desperately," illustration for Edmund Ware, "The Hard Guy," in *Ladies' Home Journal* (February 1928). Houston Public Library.

During the 1910s, 1920s, and 1930s, artists created magazine illustrations using a variety of stylistic approaches, depending on the illustration's ultimate destination. For mass-market magazines, such as *Collier's*, artists like J. C. Leyendecker often conceived stylish, modernist cover designs that grew out of the "American Poster Renaissance of the 1890s."[11] At the same time, other artists created nostalgic scenes of Americana, as in the renowned paintings by Norman Rockwell reproduced on the covers of the *Saturday Evening Post*. More frequently, however, the interior illustrations accompanying fiction in these magazines tended to be "emotionally overwrought" and "came to resemble today's soap operas."[12] Some artists used pencil or pen and ink in highly charged compositions embedded in the columns of type that typically illustrated a line from the text.

For instance in a 1928 issue of *Ladies' Home Journal*, Frank Hoffman captured the passionate exchange of a young couple in *"Jim, I don't know why I love you, but I do—desperately,"* (fig. 20). With a flair for melodrama, Hoffman employed a dramatic frozen tableau to emphasize the couple's romantic embrace,

and his highly charged hatch marks in the figures' clothing and surrounding garden setting added to the scene's emotional intensity.[13]

Contributing to the visual cacophony in the mass-market magazines, over-wrought fiction illustrations were often juxtaposed with more *moderne* advertising illustrations, frequently printed in lavish full-color reproduction. For instance, in another 1928 issue of *Ladies' Home Journal,* Martex advertised a line of "modernist" towels designed by "famous artists" including Winold Reiss (fig. 21).[14] The accompanying pen and gouache illustration depicts a fashionable young woman just out of the bath, drying herself using a Martex towel with a stylized border design of ducks in shimmering water, which is complemented by the modernist interior design of her chic bathroom.

In mass-market cultural magazines like *Vanity Fair,* artistic contributions tended to match the sardonic sense of humor that animated Frank Crowninshield's editorials and other textual contributions. Comical caricatures and cartoons typically adorned the interior pages along with elaborate advertising illustrations, while modernist covers by the magazine's favorite illustrators often satirized contemporary political figures, for example, Miguel Covarrubias's caricature of Mussolini on a 1932 cover. In the related, though less commercialized literary magazines, like *Bookman, Forum,* and others, illustrations tended to be tamer than the overexcited mass-market fiction illustrations, while often including humorous illustrations and caricatures by Herb Roth and others. On occasion, these magazines published modernist woodcuts or engravings that would decorate a page as a separate artistic contribution without relation to the text. Further, the more modest advertising illustrations did not visually outweigh the "art" illustrations in these venues, and generally, text and image were carefully balanced in aesthetic layouts, which benefited from concurrent design advancements in book illustration and the little magazines.

In magazines with a more specific philanthropic focus, such as *Survey Graphic* and *Survey Midmonthly,* which specialized in social reform, the prints and drawings were often integrated with text, photography, and diagrams in pleasing, albeit reserved page designs. For example, in 1927, articles on secondary education carried illustrations by schoolchildren, interspersed aesthetically with surrounding text.[15] In another issue, photographs of refugees from a flood on the Mississippi animated columns of text on the disaster.[16] In many respects, it is magazines like *Survey* that most closely approximated the function and appearance of the primary African American journals of the Harlem Renaissance, *Crisis* and *Opportunity,* which also sought to integrate art, literary texts, and expository pieces on social reform.

Figure 21. Artist unknown, advertisement for Martex towels, in *Ladies' Home Journal* (January 1928). Houston Public Library.

THE *CRISIS*

From the beginning of its publication, a variety of images animated the pages and covers of the *Crisis*.[17] Editorial staff utilized photographs liberally to highlight the educational accomplishments and social endeavors of talented black Americans. Photographs, cartoons, and drawings further functioned to emphasize the social and political concerns of the magazine's editor, W. E. B. Du Bois, and its sponsoring organization, the NAACP. Reaching the highest circulation of the major African American magazines, the *Crisis* also began its publication first, making its initial appearance in November of 1910. From the start, Du Bois considered the "objective of this publication" as centered on the need to

"show the danger of race prejudice, particularly as manifested . . . toward col-
ored people."[18] Starting with the first issue, his editorials formed the nucleus of
the journal. With acerbic wit and a lively, penetrating prose style, these articles
addressed the most pressing political and social questions, from lynching to
education to the place of religion in black life. While the NAACP board of di-
rectors often reacted strongly against Du Bois's outspoken editorial dominance
of the journal, the readership seems to have readily consumed his vociferous
opinions, at least through 1919 when the journal reached its peak circulation of
around 100,000. In just one year, however, circulation figures dropped precip-
itously to around 65,000 in 1920. Abby Johnson and Ronald Johnson suspect
that readers at this time "were lured away by competing periodicals," particu-
larly the growing black newspapers, which were more densely illustrated than
the Crisis.[19]

Images, however, played a major role in the Crisis. Beginning in the Decem-
ber issue of 1913, "Pictures" were listed at the top of the journal's table of con-
tents, from cover art to photographs and political cartoons to drawings
accompanying literary contributions, assuming pride of place before the listing
of articles.[20] This privileging of visual imagery seems a savvy recognition that
illustrations represented a major selling point for American readers thirsty for
visual stimulation in their periodicals. Further responding to readers' desires,
many of the Crisis photographs functioned as status symbols of prominent
middle-class blacks who engaged in formal social events or who had just mar-
ried. Their successful lifestyles were further documented through photography
in spreads on middle-class black residential neighborhoods or luxurious black
homes in major American cities. In the special October issues on children,
charming photographs of babies and children of all ages reminded readers of
the promising future that lay in their small hands. Similarly, the education is-
sues, produced each July or August, featured a plethora of photographic por-
traits of graduating B.A.'s, M.A.'s, and Ph.D.'s, achieving important national
stature as educated citizens of the United States.

Many of the Crisis covers were adorned with photographic images of young
African American women.[21] Carrying the message of racial uplift, some of the
photographs pictured women who had achieved important milestones, such as
graduating from programs at major universities. Others presented women
who wore the latest fashions and sported the most modern bobbed hairdos,
suggesting links between modern fashion and economic achievement. Often-
times, the names of the photographed women went unmentioned so that they
stood as representative types. However, the medium of photography func-
tioned in a documentary mode to offer "proof," as Carolyn Kitch observes, that

real African American women had successfully entered the fray of American education, commerce, and beauty culture.[22]

Beyond reasons of sales appeal and status reflection, Du Bois employed photographs and other kinds of printed images to underscore his editorial messages. In his political commentary, he would often employ religious narratives, as he found them particularly fertile comparative devices in communicating the depth of black experiences of suffering, or in arguing for rightful black participation in modern society. In the December 1919 issue of the Crisis, Du Bois compellingly integrated image and text in a modern Christological narrative, refashioned in black. On the cover, a photograph by C. M. Battey illustrated a staged scene of a contemporary black Madonna wearing a string of pearls and a shawl over her head, looking down at her dark child.[23] In his related editorial, Du Bois recounted "The Gospel According to Mary Brown," a young black woman who gave birth to God's son, whose "skin was black velvet."[24] Toward the center of the issue, Du Bois included the reproduction of a contemporary Belgian painting, titled The Three Wise Men of Our Day, illustrating the "sons" of the three kings of the Bible—a "Senegalese, Indian, and Arab"—adoring a contemporary baby Jesus.[25] In an article, "The Real Causes of Two Race Riots," Du Bois decried a recent and brutal lynching—a practice the NAACP would a year later denounce as the nation's "greatest shame."[26] The editor included a graphic photograph, which he scathingly titled, "The Crucifixion at Omaha."[27] It is by now a well-known image, which features a ghoulish crowd of white men eagerly watching the burning corpse of William Brown on September 28, 1919, in this Midwestern city.[28] By integrating prose and imagery in this issue of the Crisis, Du Bois orchestrated a persuasive argument that contemporary black life and experiences could stand metaphorically as modern-day incarnations of the biblical holy family and Christ's passion.

Du Bois also utilized the political cartoons of Albert Smith to augment his messages in Crisis articles and editorials. Smith contributed his cartoons and illustrations to the Crisis and Opportunity while living in Paris, where he moved in 1920 after formal art training at the National Academy of Design in New York.[29] With similar political views to the Crisis editor, Smith often provided visual analogues to Du Bois's editorials. For example in 1920, one of Smith's cartoons appeared on the second page of Du Bois's article "The Social Equality of Whites and Blacks" (fig. 22). In Smith's image, southern judges, lawyers, and a jury watch a black man plead before the court in ragged clothes, shackles, and chains. However, with headphones covering the ears of each of the southern figures, they remain deaf to the black man's cry for justice. Smith's plaintive image served to underscore Du Bois's manifesto, in which he decreed, "The

Figure 22. Albert Smith, "They Have Ears but They Hear Not," in the *Crisis* (November 1920).

Crisis believes absolutely in the Social Equality of the Black and White and Yellow races and it believes too that any attempt to deny this equality by law or custom is a blow at Humanity, Religion and Democracy."[30] Emphasizing Du Bois's citation of religion, Smith chose an apt verse from the biblical book of Psalms as the caption for his cartoon chastising the inequitable justice system in the American South: "They have ears but they hear not."[31]

In his cartoons and illustrations, Albert Smith was one of a number of *Crisis* artists who combined conservative illustrative styles with important modern messages about racial injustice, self-determined black identity, and class and gender distinctions within African American communities. This dualism between stylistic conservatism and modern content holds especially true for the artist who contributed the largest number of drawings to the *Crisis:* Laura Wheeler (later Waring). In examining her illustrations for the magazine, it is important to resist the temptation to judge her work antimodern because of its traditional styling. Recent art-historical scholarship has argued similarly that the Ashcan artists in New York have been wrongly omitted from modernist art discourse due to their largely conventional painting styles. Beyond issues of style, their lively scenes of immigrant communities were unparalleled in engaging with issues of class and ethnicity in the modern urban environment.[32] In a related sense, Wheeler's drawings, with their delicate pen-and-ink lines and precise details, seem at first highly conventional, more closely associated with the popular fiction illustrations in mainstream magazines than with the modern Art Deco compositions of Aaron Douglas. However, in the late teens and early twenties, she emphasized important new themes that few African American artists would then broach, for example, gender and class differences within African American communities and women's political activism.

Wheeler's first drawings for the *Crisis* accompanied stories penned by Jessie Fauset, whom she had befriended in France in 1914–15 while supported by a Cresson Traveling Scholarship following her graduation from the Pennsylvania Academy of Fine Arts.[33] Fauset, who would play a major role at the *Crisis* as literary editor, often wrote of young, light-skinned African American women, and Wheeler also came to specialize in illustrations of this character type. For Fauset's short story "Mary Elizabeth," in a 1919 issue of the *Crisis,* Wheeler drew an image of Mrs. Pierson, a young, light-skinned African American woman seated in a bourgeois interior with her elderly dark maid Mary Elizabeth by her side. Her drawing elaborated on Fauset's tale, which juxtaposed the young northern wife and her maid, who had migrated from the South. To suggest the divergent classes and lifestyles of these women who share only a tenuous racial bond, Wheeler's young wife gazes distractedly out

the window of her well-appointed domestic space, while the elderly Mary Elizabeth, with her faded hat and broom, appears as a mysterious interloper.

In other kinds of literary submissions, Wheeler took a different tack to don the mantle of racial uplift. In these sober scenes, distinctly black figures, often unusually resilient women, rose above oppressive circumstances. For instance, her 1920 illustration for Willis Richardson's didactic play, *The Deacon's Awakening* (fig. 23), presented the play's protagonist, an erect black middle-class woman who has become politically active in encouraging black women to accept their newly won right to vote.[34] Her daughter Ruth is seated to her right. Attending college under her mother's sponsorship, she stares steadily at her father, who does not approve of her seeking education. Wheeler has illustrated the moment in Richardson's play when the mother says defiantly to her husband, "Ruth is not coming out of college." Her political activism and Ruth's education represent modern attributes that black women were beginning to attain. Their unwavering gazes and confident body language betray their determination in the face of the family's outdated and diminished patriarch. While utilizing her characteristically delicate pen-and-ink lines, Wheeler has emphasized in detail and shading the dark skin, facial features, and hands of this black family, leaving their clothing and surrounding props minimally sketched. In this way, she provided an important new representation of black figures in 1920 that could effectively counteract harmful black stereotypes. Her method anticipated the modern pastel portraits of black leaders by Winold Reiss in *The New Negro*, in which he carefully specified dark skin and black physiognomy, while rendering clothing in a few sketched strokes.[35]

For several of her cover designs for the *Crisis*, Wheeler developed a more stylistically modern approach, in which she borrowed freely from Aubrey Beardsley's delicate Art Nouveau style, as well as the decorative designs that graced the covers of *Cosmopolitan*, *Vogue*, and other mainstream women's magazines. Wheeler deftly inserted a black presence into this mainstream beauty culture through her elegant black, silhouetted female figures. For example, in her April 1923 cover, *Egypt and Spring* (fig. 24), Wheeler seemingly embraced the modern styling but also the exoticism of Beardsley's Orientalist silhouettes. At the same time, through her reclamation of ancient Egypt, here symbolized by the precisely detailed angle harp, Wheeler introduced a theme that would gain resonance with other New Negro illustrators later in the 1920s, suggesting the illustrious heritage in Egypt that could segue powerfully into a claim for participation in America's modern culture. In her chameleon-like posture, willingly shifting stylistic emphases depending on the illustrative task, Laura Wheeler is an underappreciated artist whose illustrations bear greater scrutiny.

Figure 23. Laura Wheeler, "Ruth Is Not Coming Out of College," illustration for Willis Richardson, *The Deacon's Awakening*, in the *Crisis* (November 1920).

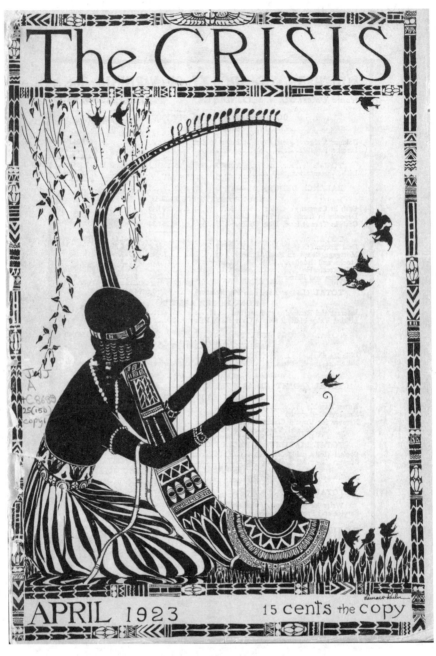

Figure 24. Laura Wheeler, *Egypt and Spring,* cover of the *Crisis* (April 1923). Yale Collection of American Literature, Beinecke Rare Book and Manuscript Library, Yale University.

By the mid-1920s, Du Bois had begun to embark on a more pointed literary and artistic focus for the magazine. With its new sponsorship of prizes for literature, poetry, plays, illustrations, and essays announced first in 1924, the *Crisis* attracted many submissions by visual artists, including Aaron Douglas, Albert Smith, and Hale Woodruff, and by writers, including Langston Hughes, Gwendolyn Bennett, Marita Bonner, and Willis Richardson. The *Crisis* published the top prizewinning selections from these contests, as well as the second- and third-place prizewinners and the honorable mentions, providing a significant quantity of new literature and visual art to fill the pages of subsequent issues.

In his articles and editorials of this period, Du Bois proclaimed outspoken assessments regarding the ideal mode of artistic expression for black American artists. In 1926, he argued that black artistic creation was of necessity a political act driven by the quest for social justice: "The apostle of Beauty thus becomes the apostle of Truth and Right not by choice but by inner and outer compulsion. Free he is but his freedom is ever bounded by Truth and Justice; and slavery only dogs him when he is denied the right to tell the Truth or recognize an ideal of Justice."

In his determination that art must effect movement toward political freedom, Du Bois uttered the well-known lines, "Thus all Art is propaganda and ever must be, despite the wailing of the purists. . . ."[36] Rather than serving to reduce art to propaganda, in the context of his whole argument, Du Bois uttered these lines as a directive to African American artists to balance creativity with commitment to social justice and political action.

Beyond this political directive to young artists, Du Bois dogmatically prescribed a narrow set of subjects he felt best captured the finest aspects of black life. In several issues of the *Crisis* during 1926, Du Bois staged a "symposium," in which he solicited responses from a variety of black and non-black artists to a series of questions he had composed regarding "The Negro in Art: How Shall He Be Portrayed."[37] He took no pains to disguise his attitudes, asking, for instance, the loaded question, "Does the situation of the educated Negro in America with its pathos, humiliation and tragedy call for artistic treatment at least as sincere and sympathetic as 'Porgy' received?" Or even more pointedly, "Is not the continual portrayal of the sordid, foolish and criminal among Negroes convincing the world that this and this alone is really and essentially Negroid . . .?"[38] To his credit, Du Bois published wide-ranging responses to his queries, but by printing the telling questions in each issue of *Crisis* that carried the symposium, he made explicit his censorial attitudes toward the portrayal of black identity in modern artistic representations.

Accordingly, illustrations that were socially and politically contingent, while also favoring black middle-class subjects, frequently found publication on *Crisis* covers. Not only did these works embody Du Bois's artistic philosophy but they corroborated the journal's news of the exceptional accomplishments of middle-class African Americans. While these illustrators typically worked in realist modes, they emphasized the modern strivings of black Americans to become bona fide citizens in the American national democracy. For instance, in Albert Smith's traditional etching, *A Negro Family under the Protection of the NAACP,* a well-dressed, middle-class couple proudly displays their young son to the reader.[39] Smith has accentuated the couple's pride in placing the young son at the apex of a triangular family group. Rising above him, an allegorical figure nestles the young son in her arms. She represents the magazine's sponsoring organ, which economically and politically protects this fine black family, striving for full national citizenship.

Similarly, Bernie Robynson's *Progress* for the July 1928 cover balanced a conservative style with a modern message (see fig. 55). Dominating his composition with a classically garbed black female figure who blows into a long trumpet, Robynson calls attention to the industrious activities of black Americans in the arts, sciences, and popular culture, represented in the lower foreground in front of a cityscape. These small figures conduct scientific experiments, graduate from school, perform in dance, music, and the visual arts, and play sports. Robynson's image is a classic expression of racial uplift, promulgating the important contributions to contemporary American culture by talented African Americans. While his style was not especially innovative, his incorporation of specific icons of successful black professional and economic enterprise within the artistic space of his composition represented a modern fusion of art and commercialism. Significantly, his image also connected art and social contingency in representing black American strivings to become bona fide American citizens with a vital stake in the national democracy.[40]

Also working closely with Du Bois, Aaron Douglas became an important artistic force at the *Crisis.* Starting in 1926, the young artist published a number of his illustrations in the magazine. His striking scene of black shepherds following the star toward Bethlehem on the December 1926 cover (see fig. 66) worked in tandem with Du Bois's editorial, titled "Peace," a full-page creative manipulation of scripture. Injecting a modern voice into the ancient narrative, Du Bois wrote, "*And lo, the angel of the Lord,* Mahatma Gandhi, *came upon [the shepherds],* brown and poor *and the glory of the Lord shone round about them and they were sore afraid.*"[41] Responding to Du Bois's modern transforma-

tion of the familiar story, Douglas's image of "brown and poor" shepherds animated an ancient narrative with contemporary, political relevance. With his signature Deco silhouettes in this and his other 1926 illustrations, Douglas was among the first artists to contribute a fully modernist style to the pages of the *Crisis.*

The artist's station within the magazine expanded in 1927, when he assumed the official position as "art critic" of the journal. Rather than providing a monthly column or regular reviews of art or illustration, Douglas seems to have performed his task as art critic through changes to the magazine's graphic design. In March, when he was first credited with his new title in the masthead, the journal shifted to a larger format and more spacious layouts of text and image. Beginning that month, readers also found the addition of a full-page frontispiece illustration in each issue, which took the form of a political cartoon, a drawing or print, a reproduction of a painting or sculpture, or a photograph. If these changes in fact represented Douglas's suggestions, we can surmise that he aimed for a more aesthetically pleasing product, with an emphasis on full-page visual contributions. This is consistent with his own visual production in the *Crisis,* in which he published only full-page illustrations on the interior and covers through January of 1930.

Beginning in 1927, the *Crisis* published cover illustrations and frontispieces by a group of very talented young African American artists in newer, more modern stylistic modes than in the earlier years. Some artists created modern cover designs inspired by Africanized forms. In his March 1928 cover, Roscoe Wright repeated two forms, which he called an "African witch mask and fetish" (fig. 25). He knit his two-dimensional, boldly silhouetted figures into a decorative pattern, using dotted lines in arc shapes. His text boxes, with their decorative borders, and his geometric lettering further enhanced his patterned design. Similarly, Raymond Jackson's boldly silhouetted Art Deco Africanist figure on his February 1930 cover suggests the influence of African sculpture.[42] Other artists, like Celeste Smith in her frontispiece *Excelsior,* created modernist compositions, utilizing the angular, fragmented Cubist forms then animating American advertising.[43]

Starting in March of 1929, however, many of the *Crisis* covers began to assume a more standardized format, with staged photographs of women and children predominating on the covers in the 1930s. While Du Bois retained his job as editor, he finally resigned in 1934, certain that he could never revive his creative control of the journal, which had by then become less a political and literary venue and more exclusively an organ of the NAACP.[44]

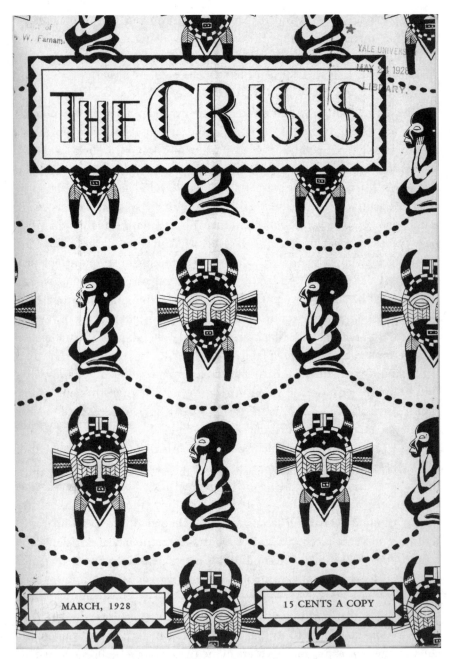

Figure 25. Roscoe Wright, *African Witch Mask and Fetish Design,* cover of the *Crisis* (March 1928). Yale Collection of American Literature, Beinecke Rare Book and Manuscript Library, Yale University.

OPPORTUNITY

Opportunity, the journal of the National Urban League, began publication in 1923 under the editorship of Charles S. Johnson. Trained as a sociologist, Johnson nonetheless perceived the mission of the monthly journal as balanced between inquiry based on "objective fact" and "creative self-expression." [45] From the start, he enlisted images in his hybrid goal to promote fact-based study and individual artistic expression. While he often used photographs to emphasize the "objective" social conditions black Americans faced in urban and rural environments, over the years he increasingly opened space for drawings and prints that functioned as stand-alone art on the covers and in frontispieces, or as integrated with text in the body of the journal. [46] Rather than dominating the journal with his editorial presence, as had Du Bois, Johnson allowed his contributors an unusual autonomy in their artistic expression. In a 1926 editorial, he pledged, "What is most important is that these black artists should be free, not merely to express anything they feel, but to feel the pulsations and rhythms of their own life, philosophy be hanged." [47]

During the first two years of its publication, photographs constituted the primary images in *Opportunity*. Johnson used them most often as documentary evidence in articles on a variety of subjects, including the social conditions of urban black workers, the individual achievements in education of middle-class blacks, as well as the benefits of racial contact between white and black children. Photographs also served to illustrate specific events, such as the Urban League conferences in cities throughout the United States, or even, on occasion, the parades of Marcus Garvey's Universal Negro Improvement Association. This visual material sought to normalize and broaden a visual understanding of blacks in America, emphasizing Johnson's editorial policy "to provide . . . a constant source of information on the many angles of the race situation upon which too little is known," as well as "to encourage among Negroes themselves . . . a disposition to see enough of interest and beauty in their own lives to rid themselves of the inferior feeling of being a Negro." [48]

By January of 1925, Johnson utilized a larger variety of images to augment the journal's creative development and graphic design. As at the *Crisis*, *Opportunity* also sponsored contests in 1925, 1926, and 1927 for literature and art, which boosted the journal's commitment to the arts. [49] In January 1925, Winold Reiss provided a bold, decorative primitivist mask illustration for the cover and decorative headings for interior sections that would appear in each subsequent issue. [50] Based on primitivist mask and simplified vegetal forms, these headings injected the journal's graphic design with a newly modern, racialized fla-

vor. Toward the end of 1925, Johnson began employing Reiss's student, Aaron Douglas, to provide illustrations for the journal, and his artistic imprint shaped the covers and pages of *Opportunity* for several years. While his first contributions to the magazine in 1925 were realistic drawings, his subsequent designs evinced his turn toward primitivist styles and vernacular subjects. Early experiments with his new primitivist mode, like *Roll, Jordan, Roll,* appeared in the November 1925 issue, visually embedded in two-columned articles on African American spirituals and songs. In 1926, as Johnson received more creative literary contributions, Douglas's increasingly simplified, vernacular pen-and-ink drawings were published alongside poetry by Langston Hughes in aesthetically organized page designs that integrated text and image.

In publishing Douglas's drawings as illustrations that were both embedded in and interpretive of their surrounding text, Johnson clearly valued the artist's visual gloss on the written word. For example, Douglas's illustration of the Negro spiritual "I Couldn't Hear Nobody Pray" appeared on the first page of Arthur Huff Fauset's November 1925 review of Howard Odum and Guy Johnson's *The Negro and His Songs.* Fauset's review began with a lament, "The pity of it is that all who read this splendid volume must content themselves with the mere seeing. Negro song," he continued, "is not something to be looked at; to appreciate it and understand it you must hear it." He further bemoaned that in print, the spirituals appeared "in cold type . . . [as] words, . . . and what crude vehicles are words for suggesting the pulsations, the quiverings, and the trippings of the soul!"[51] As if to quell Fauset's lament with a kind of visual voice for the printed page, Douglas's illustration features an African American figure who, with arms and mouth open wide with song, conjures his God, pictured large in the upper left. Using rhythmic, silhouetted forms evocative of sound, Douglas provided a printed visual expression that worked the interstices between the "cold type" and the vivid music.

Johnson's confidence in the viability of artistic imagery to augment creative text blossomed in the October 1926 issue of *Opportunity,* in which he featured the art and poetry of Douglas and Hughes as the dominant contributions. Douglas's gouache illustration accompanied Langston Hughes's poem "Feet o' Jesus" on the cover, preparing the reader for their joint artistic expression in the interior. Johnson clearly conceived of their contributions on an equal footing, titling their double-paged spread of poetry and illustrations, "Two Artists: Poems by Langston Hughes, Drawings by Aaron Douglas." Hughes contributed five poems and Douglas five related drawings (see figs. 12 and 26). These illustrations were sized to the blocks of text containing Hughes's poems, so that each contribution maintained an equivalent visual weight. His illustra-

tions were also interspersed with Hughes's poetry to integrate text and image in the page designs. From this visual layout, the reader understood the collaborative relationship between artist and poet. While Douglas illustrated lines from Hughes's poetry, he employed abstracted and evocative forms that moved beyond literal translation of the text. He faced a somewhat similar challenge in illustrating Hughes's blues poetry that he had in interpreting Fauset's review of the book of Negro songs. But here, Hughes's blues lyrics warmed the page considerably, with Douglas augmenting them through visual images that suggested the rhythms and sounds of the blues in performance, while also picturing some of the poet's most vivid lines. For example, in Hughes's "Bound No'th Blues," the poet suggested the monotony the lonely migrant experienced through the repetition of his blues lines:

> Goin' down de road, Lord,
> Goin' down de road.
> . . .
> Road's in front o' me,
> Walk . . . and walk . . . and walk.
> I'd like to meet a good friend
> To come along an' talk.[52]

In his accompanying drawing, *On de No'thern Road* (fig. 26), Douglas also suggested the drudgery of the migrant's task, walking with a heavy load down an endless road that curls far into the distance. In his bold Art Deco composition of the migrant on his way to a northern city, Douglas used stylized, rhythmically patterned silhouetted forms in crafting a modernist visual counterpart to Hughes's vernacular blues phrasing.

To capitalize on the successful collaboration of Douglas and Hughes, Johnson published a deluxe folio edition of their work, which he marketed in the Christmas issue as the *Opportunity Art Folio*—a "gift" with "lasting value along with its uniqueness."[53] Each illustration and poem, originally published in the October issue, was now lavishly printed on separate sheets of large paper. Douglas designed a new cover sheet for the folio edition, creating a poster-portrait of himself and Hughes using totemic images formed from the letters of their names and Africanist figural and decorative forms. While he rather humbly made his totemic image shorter than that of Hughes, he represented their artistic collaboration as a joint venture in Afro-Deco graphic design, suggesting each artist's intention to create a newly racialized idiom in their own print medium.

Douglas's striking *Opportunity* covers from 1926 and 1927 further reveal his dynamic poster style, incorporating bold letters and dramatic silhouettes,

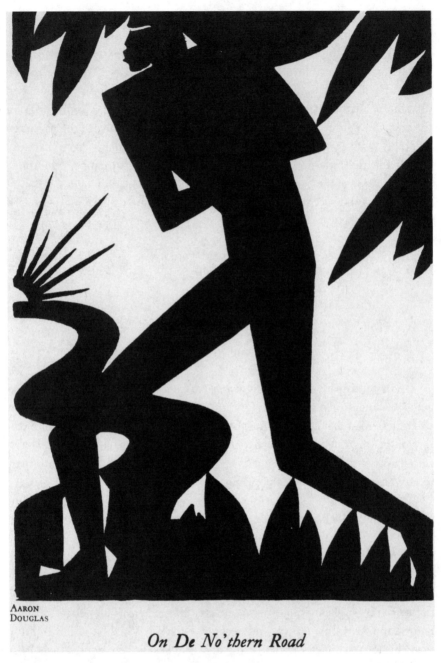

AARON
DOUGLAS

On De No'thern Road

Figure 26. Aaron Douglas, *On de No'thern Road,* illustration for Langston Hughes, "Bound No'th Blues," in *Opportunity Art Folio* (December 1926). Yale Collection of American Literature, Beinecke Rare Book and Manuscript Library, Yale University. Reprinted by permission of the National Urban League.

well suited to the persuasive visual requirements of the magazine cover. These designs often found successful balance between a didactic message and modern aesthetic form. For example, Douglas's May 1927 cover illustration of a Mangbetu woman took substantial artistic license with a documentary photograph from the Exposition de la Croisière Noire by George Specht (fig. 27).[54] On the one hand, it served as a reminder of black America's rich ancestral heritage in Africa. On the other hand, Douglas measured the drawing's didacticism with artistry in his exaggeration of the horizontality of the figure's face and headdress, which he emphasized against a two-dimensional, orange and black design allusive of African textiles.

While *Opportunity* featured some work in traditional, realistic modes, like that of Albert Smith, it more frequently published work by artists who experimented with more modernist graphic styles then permeating American print culture. Working in this vein, Gwendolyn Bennett contributed a cover illustration for the July 1926 issue with a scene of a contemporary black woman in fashionable dress, swaying to the beat of imagined music (see fig. 57).[55] Behind her in a stylized horizontal band, three nude black female figures pose in a jungle landscape, two engaged in an uninhibited "primitive" dance. As in many of the archaizing tendencies of Art Deco illustration and advertising, Bennett borrowed from the example of ancient Attic black-figure vases in placing her silhouetted figural decoration in a white band on a black ground.

In 1928, *Opportunity* featured the modernist illustrations of Lois Jones and James L. Wells. Both were young art students during that year—Jones at the Designers Art School of Boston and Wells in the department of fine arts at Columbia Teachers College. Jones's cover design in October 1928 featured a landscape painting in watercolor or gouache, which had been inspired by Japanese art (fig. 28). An all-over, stylized painting of small Japanese figures enjoying a dramatic waterfall, with sections repeated three times (once in reverse), her cover image sprang from her work at that time in modern textile design, in which she often gravitated toward Asian themes.[56] Favoring instead the print media of woodcut and linoleum cut, Wells contributed two bold black-and-white cover images in 1928 (the July cover is shown in fig. 54). Carefully balancing dark masses with areas of white, Wells also betrayed his strong training in design at Columbia, where the specter of the late Arthur Wesley Dow still held sway in the department's curriculum.[57]

Johnson also featured the modernist work of two artists whose more "taboo" production found no representation in the *Crisis*. Black artist and writer Richard Bruce Nugent and white draughtsman Charles Cullen contributed drawings for covers and interior pages that engaged with the theme of primi-

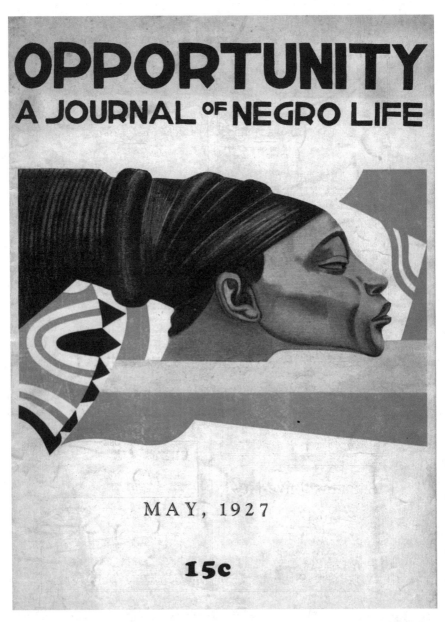

Figure 27. Aaron Douglas, *A Drawing from the Exposition de la Croisière Noire Booklet,* cover of *Opportunity* (May 1927). Collection of the author. Reprinted by permission of the National Urban League.

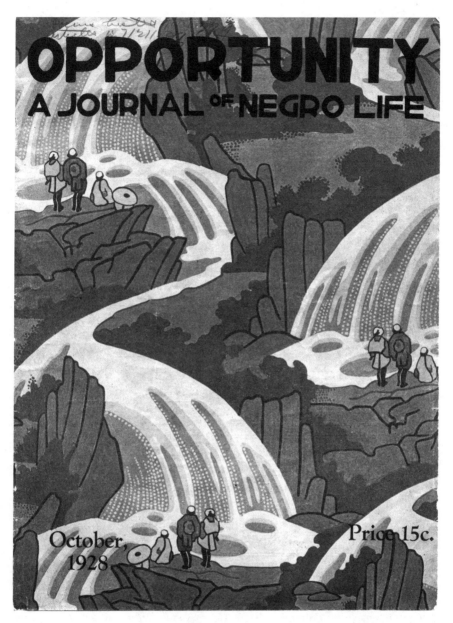

Figure 28. Lois Jones, cover of *Opportunity* (October 1928). Camille Billops and James V. Hatch Archives, Manuscript, Archives, and Rare Book Library, Emory University. Reprinted by permission of the National Urban League. Lois Mailou Jones Pierre-Noel Trust.

tivism, but from a satirical vantage with undertones of gay sexuality. For exam-
ple, Nugent's primitivist figures were featured on the March 1926 cover and in
the interior of the October 1927 issue.[58] In each case, they appeared in front of
campy jungle settings—a phallic palm tree in the first and crossed stalks of
bamboo in the other. With primitivist markings and full lips that look decidedly
cosmetic, they read on one level as men in drag. Similarly, Charles Cullen used
parodic signs of primitive identity in his illustration for Antonio Jarvis's poem,
"Bamboula Dance," from a glistening nude black figure wearing an elaborate
feather headdress in a foreground jungle setting to a leering totemic head in
the background.[59] Using themes from his illustrations for Countee Cullen's
books, Charles introduced a gay male subtext to this illustration by suggestively
pairing the primitivist black male with a white figure of Christ crowned with
thorns, the couple sharing a meaningful glance and embrace. In including
slightly risqué imagery that could be read differently by various readers,
Charles Johnson took very seriously his editorial policy to open space for unin-
hibited artistic expression. In this regard, his method stood in stark contrast to
that of W. E. B. Du Bois at the *Crisis,* who remained highly critical of artists who
utilized sexually explicit imagery.

Cullen was just one among several white artists who found representation
in the pages of *Opportunity.* Beyond his initial decorative headings, Winold
Reiss contributed his sensitive pastel portrait of Countee Cullen in 1925 and of
Langston Hughes in 1927, both introducing special features on their poetry.
Johnson also presented to his readers the illustrations of Euro-American artist
Mahlon Blaine for John Vandercook's *Black Majesty* (Harper and Brothers,
1928).[60] Appearing most frequently in the later 1920s and early 1930s, the de-
tailed drawings of white artist Cyrus LeRoy Baldridge added further variety to
the covers and frontispieces of *Opportunity.* In collaboration with writer Caro-
line Singer, Baldridge published *White Africans and Black,* illustrated with
many pages of his drawings of people he met in various regions of Africa. In
her *Opportunity* review of the book, Doris Kirkpatrick praised the artist's "facile
strokes" that expressed the individuality of African people, from "Creole" to
"Kru," rather than feigning one generalized type. "There is no typical African,"
Kirkpatrick asserted defiantly, "the Africans vary in shape of skull, length of
limb, color of body and even temperament as the hybrid Americans of our own
country vary from each other."[61] In contrast to the many primitivist portrayals
of African figures by Harlem Renaissance illustrators, Baldridge's drawings
provided an alternative specificity.

After Johnson left his post as editor of *Opportunity* in 1928, cover designs often fell into the hands of E. Simms Campbell. Arriving in New York in the late 1920s from St. Louis, the young Campbell began his career in advertising firms, preferring to specialize in commercial work. He quickly impressed *Opportunity*'s new editor, Elmer A. Carter, who from the start admired the precocious artist's "air of confidence."[62] Soon after his arrival to New York, Campbell contributed illustrations regularly to *Opportunity* but also obtained commissions from the mainstream humor magazines, including *Life* and *Judge*. He would later become a notable illustrator for *Esquire* and contribute illustrations to the *Saturday Evening Post*.

The range of his work may be discerned in his *Opportunity* illustrations. He provided his first cover illustration in 1929—a portrait of an attractive young light-skinned woman, titled *Thelma*, not unlike the illustrations and photographs in the earlier *Crisis* covers. Wholly different were his later covers and interior illustrations, in which he employed bold, graphic, angular Art Deco forms in vernacular scenes of black workers or black religious narratives. For example, in his September 1930 cover, four stylized black workers walk together, gaining solidarity in their close proximity, with the smokestacks of a factory behind to provide a visual icon of their work (fig. 29). In theme, the image connected with the *Messenger* covers of the later 1920s, but in form, his graphic style responded to the bold black-and-white images of workers by James L. Wells and Louis Lozowick in the little magazine the *New Masses*. In another manner altogether, Campbell created domesticated scenes of charming black youths that provided counterparts to the homey *Saturday Evening Post* covers of Norman Rockwell.[63] With little recognition today, Campbell achieved important success in the 1930s as an illustrator who did not scorn the label of commercial art and as an artist who, chameleon-like, adopted a variety of stylistic modes for disparate print venues.

During the 1930s, Carter featured illustrations by several African American artists who would later become notable American painters and collage artists. In addition to featuring sketches by James Porter and Ernest Crichlow, *Opportunity* published early drawings by Romare Bearden, including a cover illustration of New York's tall buildings in 1932 and a page of sketches from New York's Eighth Avenue market in 1935.[64] Given the importance of magazine illustrations in Bearden's modern work in collage, his early experience in *Opportunity* must have had an important impact on his subsequent engagement with this print medium.

Figure 29. E. Simms Campbell, cover of *Opportunity* (September 1930). Camille Billops and James V. Hatch Archives, Manuscript, Archives, and Rare Book Library, Emory University. Reprinted by permission of the National Urban League.

THE *MESSENGER*

The *Messenger* started publication in 1917, founded by A. Philip Randolph and Chandler Owen, with "the express purpose of promoting a socialist" agenda.[65] Despite its editorial shifts over the years, for most of its short history, the journal maintained ardent support of the American worker. Not surprisingly, therefore, many of its cover illustrations engaged creatively with the theme of work, and interior imagery often comprised satirical political cartoons.

Adam McKible has defined three editorial phases of the magazine's production.[66] During its earlier years, under the editorship of Randolph and Owen, it maintained a strong connection with socialist politics while also leveling critique at working wages and conditions, and the editors often took the opportunity to censure what they felt were the accommodationist policies of the NAACP. During the early 1920s, the magazine shifted editorial control and focus "toward boosterism for the African American bourgeoisie,"[67] with very different concerns from the earliest editorials, which were now directed at "property worth and professional standing."[68] The last phase comprised the years between 1925 and 1928, when Randolph's involvement with the Brotherhood of Sleeping Car Porters effected the *Messenger*'s transformation into a union organ.

While at the *Messenger* there was no single editor shaping the magazine's format and direction, George Schuyler was a frequent editorial force and contributor, who provided a foil to the aspirational attitudes of both the *Crisis* and *Opportunity* editors. In criticizing American culture at large, as well as the Negro Renaissance leaders, he recognized in 1925 that black residents of Harlem could rarely move beyond positions of menial labor: "Fact is, the Negro of New York is very largely restricted to working as a porter, cook, elevator operator, messenger, laborer, musician, chauffeur, laundress, maid, cook, dishwasher, stevedore, waiter and janitor. Negroes doing other kinds of work are the exception."[69]

Rather than privileging associations between black and middle-class identity, Schuyler addressed the more politically pressing links between blacks and working-class status. Many of the *Messenger*'s illustrations similarly connected these two markers of identity.

During the middle period of focus on the black bourgeoisie, when the magazine functioned in part as a kind of society page, the *Messenger* often featured photographic covers in soft focus of alluring young African American women, not unlike those printed on covers of the *Crisis*. With its return to leftist politics in 1925, the magazine typically featured imagery that sustained a political critique. For example, Wilbert Holloway of Pittsburgh frequently contributed a

page of political cartoons titled "Aframerican Snapshots," which poked fun at
white management or wittily contrasted stereotypes of working-class blacks
with members of the black bourgeoisie.[70]

On its covers during these years, the magazine often featured gripping im-
ages of men at work, for example, Aaron Douglas's *Steelworkers* in 1927. As the
artist whose work appeared most frequently on the covers, Wilbert Holloway
created pleasant pen-and-ink drawings of mail carriers and chefs, as well as
more politically charged images of union workers and tunnel builders. In 1927,
Grace Clements contributed a particularly striking Deco-inspired cover with
boldly silhouetted, fragmented forms that illustrated toiling southern black
workers bending arduously from their waists to the ground to pick cotton (fig.
30). Providing an unusual alternative to the images of males at work, Clements
displayed a male and female worker picking cotton side by side. In the fore-
ground, the cropped hand of another female worker reaches toward a decep-
tively decorative cotton plant, ripe for the picking. In the beauty of the worker's
hand against the cotton, as well as the decorative arch of the bent workers, the
theme of labor is monumentalized and given romantic dimension.

LITTLE MAGAZINE ILLUSTRATIONS

The African American little magazines provided writers and visual artists with
noncommercial venues to explore a less licensed creative production than in
the more commercialized magazines. In these periodicals, writers and artists
tended to investigate black subjects with less concern for propaganda or social
reform and more attention to aesthetic structure. As Alain Locke wrote elo-
quently in the little magazine *Harlem,* in 1928, "Negro things may reasonably
be a fad for others; for us they must be a religion. Beauty, however, is [their]
best priest and psalms will be more effective than sermons."[71]

Black editor Wallace Thurman set his "experimental" little magazine *Fire!!*
in further opposition to the *Crisis* or *Opportunity* in asserting, "It was not inter-
ested in sociological problems or propaganda." Rather, he argued, "It was
purely artistic in intent and conception."[72]

While scholarship has tended to focus on the more politically and sexually
radical black little magazines *Fire!!* and *Harlem,* which each survived for only
one issue, other little magazines with more measured creative production
flourished for several years during the later 1920s.[73] For example, *Black Opals*
in Philadelphia specialized in poetry by black artists, and it featured illustra-
tions on its covers and interior pages by Allan Freelon, Lois Jones, and James L.

Figure 30. Grace Clements, *The Cotton Pickers,* cover of the *Messenger* (November 1927). Manuscripts, Archives, & Rare Books Division, Schomburg Center for Research in Black Culture, The New York Public Library, Astor, Lenox, and Tilden Foundations.

Wells. Printed in a small format, its illustrations filled full pages and did not bear relationship to the text but stood as independent artistic works. In this venue, artists and poets contributed racialized selections, but just as often they published creative pieces without racial content, often relating generally to na-

ture or to a particular landscape, as in Freelon's peaceful woodcut of a large tree in a field of rolling hills.[74]

Examined as a whole, the Harlem Renaissance little magazines form a diverse body of creative production. Indeed, writers in the black presses encouraged readers to think inclusively about these publications and the groups that produced them. As a contributor and guest editor for several little magazine issues, Gwendolyn Bennett reported in *Opportunity* on the activities of the younger Negro artists in various cities throughout the nation who formed clubs and published little magazines. Informing her readers of a new "group of creative workers" in Topeka, Kansas, calling themselves "Book and Bench," she announced their plans to publish "a year-book, entitled *Urge*." She continued, "The number grows. . . . The Quill Club in Boston, The Ink-Slingers in California and Black Opals in Philadelphia . . . to say nothing of the many groups in New York."[75] She also reported on the interchange planned between the Black Opals in Philadelphia and the Quill Club in Boston, hoping that in the future "both of these groups with one or two of New York's younger, newer Negroes will get together and go visit the *Ink Slingers* in California."[76]

In acknowledging Bennett's call for dialogue among these little magazine artists, while also highlighting the diversity in creative production among them, I compare in this section the illustrative work in *Fire!!* with the imagery published in Boston's *Saturday Evening Quill*. Without privileging one as radical and therefore more modern and innovative than the other, I ask how each contributed to the specialized artistic production of the black little magazines. Before exploring this comparison, however, I want to situate these publications within the larger context of American little magazines.

As alternative, noncommercial literary and art journals, often with a leftist political bent, the American little magazines provided writers and artists unfettered publishing venues, and their physical production incorporated new aesthetic standards in graphic design.[77] With modernist covers incorporating bold typefaces and often irreverent imagery, *Little Review* and *Broom*, among others, made a striking visual impact. As Suzanne Churchill and Adam McKible have noted, however, little magazines were far from heterogeneous types of publications, with some trending toward "aesthetic experimentation," others advancing "political radicalism," and still others combining these approaches.[78] Each publication also incorporated imagery differently. In *Dial* and *Broom*, for example, illustrations usually functioned as separate artistic contributions that stood side by side with poems and prose. For instance, on one page of *Broom* in a 1922 issue, a poem by Yvor Winters was paired in an aesthetic page design with a woodcut of an abstracted female figure by Max Weber, which did not in-

terpret the poem, but rather participated with the block of text in an aestheti-cally equivalent relationship.[79] On other occasions in *Broom*, illustrations filled full pages, with complete independence from the text. In the little magazines with a leftist political bent, like *New Masses*, illustrators often contributed visual material on themes related to the American worker. One of *New Masses*' most loyal and talented illustrators, the Russian immigrant Louis Lozowick created bold, Art Deco compositions depicting Americans at work and utopian views of the American industrial landscape. Despite the political thrust of the journal, editors and contributors paid careful attention to aesthetic layouts, indeed de-veloping some of the smartest page designs of the American little magazines.

On occasion, Harlem Renaissance artists and writers contributed to the American little magazines. James L. Wells, for example, was a frequent con-tributor to *New Masses;* his monumental image of a weathered sharecropper stands out as one of his finest linoleum cuts published in the journal.[80] Other little magazines published special "Negro" issues, such as the poetry magazine *Palms,* edited by Idella Purnell and published in Guadalajara, Mexico.[81] Through the aegis of Countee Cullen, this special issue of black American po-etry came out in October 1926. With a more political agenda in 1931, *Contempo* published an issue devoted to the Scottsboro case in Alabama, in which nine black youths were falsely accused of raping two white women. Black artist Zell Ingram's arresting black Christ appeared on the journal's front page (see fig. 71), illustrating Langston Hughes's scathing poem, "Christ in Alabama."[82]

Within the diversity of American little magazines, *Fire!!* found place as an aestheticized product with a political focus on black working- and rural-class life. Its editor, Wallace Thurman, reflected on the journal a year after its first and only publication in 1926: "Its contributors went to the proletariat rather than to the bourgeoisie for characters and material. They were interested in people who still retained some individual race qualities and who were not to-tally white American in every respect save color of skin."[83]

Indeed, in her *Fire!!* contributions, written in a new vernacular style based on spoken dialects, Zora Neale Hurston explored the lives of blacks in the South: folks suffering under "Jim Crow" laws or work-worn women battling abusive men.[84] Langston Hughes found inspiration for his *Fire!!* poems among black elevator operators and gamblers in an old railroad car.[85] But, more than through investigation of the "proletariat," *Fire!!* contributors militantly pursued subjects that reflected racial and sexual difference. Richard Bruce Nugent's dar-ing "Smoke, Lilies, and Jade," recounted a tale of a bisexual man who engaged in a steamy sex scene with his male lover. At the same time, Nugent's story also attested to the journal's aestheticism, in its stream-of-consciousness style and

in its obsessive descriptions of vivid colors, from the protagonist's "ivory [ciga-
rette] holder inlaid with red jade and green," to the "blue smoke" he blew from
his lips, to his dead father's skin, which had turned "a transparent green."[86]

Aaron Douglas's searingly militant cover of *Fire!!* (see fig. 10) introduced
the reader to the radical creative endeavor by these young black artists to issue
"a cry of conquest in the night, warning those who sleep and revitalizing those
who linger in the quiet places dozing."[87] Printed in black ink on red paper, a
stern Africanist head wearing one hoop earring is superimposed with the form
of an ancient Egyptian sphinx. While engaging with the primitivist, silhouetted
images he employed in other venues, this cover design possessed a graphic
strength that did indeed arrest the attention of his readers. In the next image,
the reader met Richard Bruce Nugent's frontispiece drawing facing the initial
story in *Fire!!*, Wallace Thurman's "Cordelia the Crude" (fig. 31). The image and
story coalesced to shock the reader, presenting her with a debased image of a
primitive streetwalker and a tale of an urban prostitute at the outset of the pub-
lication, purposely rejecting the somber themes of racial uplift and social re-
form that animated *Crisis* and *Opportunity*.

While Nugent's image stood alone as a separate, full-page work of art, as
was true of all the illustrations in *Fire!!*, it nonetheless commented on Thur-
man's scandalous but poignant story of a young Harlem girl, a rebellious teen-
ager originally from the South, whose promiscuous sexual encounters led to a
life of prostitution.[88] Leaning against a palm tree, Nugent's primitive female
figure reveals her naked body, once voluptuous, as Thurman's Cordelia, now
sagging with age and presumed debauchery. Her tightly curled hair stands on
end in direct contrast to the suave, middle-class men and women with smooth
coiffures gracing the covers and pages of *Crisis*. Though in a primitivist setting,
Nugent's figure leans against the tree as a prostitute might pose beside a street-
lamp, as if predicting the appearance of an aged Cordelia. Nugent's and Thur-
man's contributions stand as evidence of the equivalent status illustrators and
writers negotiated in *Fire!!* Neither dependent nor completely autonomous,
each artist provided integral contributions that made up a unified aesthetic
whole, which Countee Cullen felt "represent[ed] a brave and beautiful attempt
to meet our need for an all-literary and artistic medium of expression."[89]

Toward the center of the issue, Douglas's three contour drawings appear
without textual reference. Defying classification as works almost entirely
unique in his oeuvre, they are delightfully comic in giving form and slight ex-
aggeration to a black preacher, artist (fig. 32), and waitress. With uncharacteris-
tic specificity, Douglas's drawings seem to form a kind of chronological series.
The preacher represents an outmoded figure, often stereotyped in mainstream

Figure 31. Richard Bruce Nugent, untitled illustration facing Wallace Thurman, "Cordelia the Crude," in *Fire!!* (November 1926).

images but also critiqued by some black Americans as inept in effecting social reform. By contrast, the artist and waitress signify more modern characters— the well-dressed artist suggests modern professional identity, and the waitress alludes to new inspiration for younger black artists in working-class life. Doug-

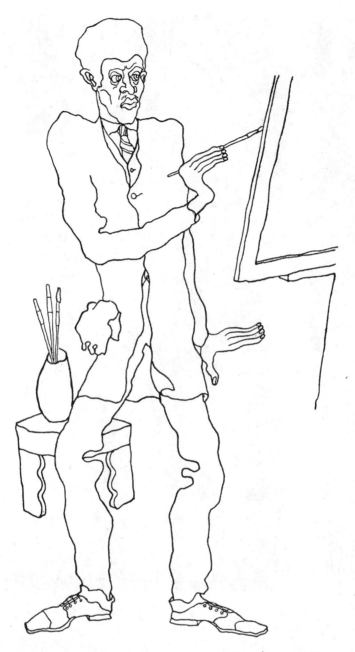

Figure 32. Aaron Douglas, untitled contour drawing, in *Fire!!* (November 1926).

las's image of the artist, however, does not glorify the role but instead, in its gentle self-mockery, provides comic relief to the images of racial uplift in the *Crisis*. As a figure dressed smartly in a three-piece suit and tie, he engages in the activity of painting at an easel, its messiness acknowledged only by the rag in his pocket. Instead, he primly presses all of his fingers together and dabs cautiously at his canvas, as if worried he might soil his fine clothes in the process.

Especially in the interior *Fire!!* illustrations, Douglas and Nugent conveyed irreverent attitudes toward race that clashed with the more dignified imagery in *Crisis* and *Opportunity* and acknowledged alternative connections with overt sexuality and working-class subjects. For its sexual promiscuity, critics either praised or condemned *Fire!!* in unusually inclusive reviews that acknowledged illustrations as well as text. In a *New Republic* article, Thurman admired the audacity of Douglas's "advanced modernism and raw caricatures of Negro types" and Nugent's "interest in decadent types and the kinks he insists on putting upon the heads of his almost classical figures." He added caustically, "Negroes, you know, don't have kinky hair; or, if they have, they use Madame Walker's straightening pomade."[90]

Other critics drew comparisons between *Fire!!* and the *Saturday Evening Quill*, a little magazine published annually in Boston between 1928 and 1930. Calling the *Quill* "a magazine aiming at real literary expression,"[91] as opposed to the debased representation he associated with *Fire!!*, Aubrey Bowser lamented:

> There can be no true cultural center without a medium of expression, and this is lacking in Harlem. One magazine, aptly colored red, was started (and finished in one issue) a few years ago; it was more of a prostitute's trade journal than a literary magazine. . . . *The Saturday Evening Quill*, an annual issued in Boston by a group of Negro writers, has appeared for the third time. Each time it appears it is better than the last. . . . For three years *The Saturday Evening Quill* has set a fine example. When will Harlem follow it?[92]

What seemed so appealing about this new periodical in comparison to *Fire!!*? Perhaps the cover of the second issue of the *Quill* in 1929 can shed some light (fig. 33). Drawn and designed by Roscoe Wright, the image integrates Deco typefaces with an elegant, modern drawing of a pen in an inkwell that carries the reflection of light from a window and sits on a shelf bearing a geometric design that can be associated with Art Deco or Africanist motifs. The pen cuts across the cover on a diagonal, dividing areas of type, but also uniting

Figure 33. Roscoe Wright, cover design for the *Saturday Evening Quill* (April 1929). Yale Collection of American Literature, Beinecke Rare Book and Manuscript Library, Yale University.

the entire cover design. The quill pen stands as a visual emblem of the Quill Club and could be associated with both writing and drawing—these activities held as equals through the sign of the pen. Thus, the cover image referred primarily to the creative act, with the racialized or Africanist decorative motif finding a secondary place. And, perhaps of greatest importance for Bowser,

nowhere in this cover design, or in the interior, would a reader find the overt sexuality that the critic had reviled in *Fire!!*

Though Bowser set the *Quill* in a polar relationship with *Fire!!*, its contributors did not make a similarly reductive comparison. In fact, in concert with *Fire!!* contributors, the *Quill* writers and artists wanted to "present original work . . . to *themselves*," without regard of the journal's critical reception. However, rather than obtaining patrons, as did *Fire!!* contributors, the Quill Club members "paid for their little folly out of their own pockets and purses," thereby truly "indebted only to themselves."[93] In content, however, the *Quill* writers and artists approached quite different themes from those enunciated in *Fire!!* Among the prose and poetry offerings, almost none were written in dialect, and many focused on the lives of middle-class blacks. A number of literary contributions did not concern themselves specifically with issues of race but expressed subjects more generally related to nature, with many of the poems evoking religious themes.

Roscoe Wright provided the lion's share of the illustrations, which more clearly related to the text than in *Fire!!*, either through textual captions or placement within the columns of text. As opposed to his cover image, which remained racially neutral, his interior illustrations explored racial identity as it connected with gender and class. His most interesting interior representations portrayed two very different women. The first was a full-page illustration appearing opposite Ralf Coleman's one-act play *The Girl from Back Home*. It illustrated Coleman's protagonist, Della Harvey, a young woman living in Harlem with her lover, "Jazz" Barrett, a gambler and ladies' man. Very fashionably dressed, from her delicate shoes to her garters and short dress, to her bobbed hair and cap, Della leans against her lover's desk talking on the telephone. With a caption referring the reader to an exact line of text, the illustration shows Della peering off toward her lover, while she speaks to her childhood sweetheart, Lee. By this moment in the play, the reader has learned that Della has grown tired of "Jazz," who refuses to marry her, instead cheating on her at every occasion. From Wright's illustration, which pictures a suitcase at Della's feet, the reader senses she is ready to leave Jazz. In the text, the reader learns that by chance, at a Harlem nightclub, Della has run into Lee, now a successful doctor who wants her to return with him to their small hometown to marry and start a family. She remembers, "I was a decent girl once, back home. . . . And I had ideals once. Wanted to be a wife—a real one—with a home and kids—legitimate ones."[94] In reconnecting with Lee, Della has the chance to return to a "decent" small-town life, away from the "corruption" of Harlem's urban environment. In Wright's illustration, Della's fashionable dress and the

telephone—signs that usually demarcate modern trappings—here take on connotation as impediments with morality and familial community. The suitcase, another sign that has elsewhere suggested black migration to the cities, here suggests a method of escape from Harlem to a quieter, homespun existence.

By contrast, Wright contributed a very different portrayal of a laundress for his own story, "Washwoman." His illustration and text represented an unusual exploration of working-class identity in the *Quill*. Rather than his full-page illustration of Della, this image appeared embedded at the center of the story's first page with his text surrounding it. In the image, Wright's protagonist, a middle-aged Amy Lewis, slaves over a tub of laundry and suds. For the past five years she has worked in this way to support herself but also her lover, whose living and medical school expenses she has financed. Assuming that he would marry her when he earned his degree, she was horrified to learn that he had cheated on her and become engaged to a society woman in New York. In the end, Amy has a kind of revenge on the doctor by interrupting his wedding and revealing his deceit, whereupon he and his new wife must move to South America to avoid the embarrassment of his past improprieties.

In his illustration, Wright has accorded a standard of beauty to his working-class female figure rarely adopted at this time, privileging the strength in her arms and torso, and sensitively depicting her work-worn facial features, which, along with her hair, are more highly racialized than in his first *Quill* illustration. In these details, he has emphasized her self-sufficiency as a woman who has worked hard to gain economic independence. On the one hand, the image depends on the text as a physically integrated visual interpretation, by contrast to the full-page illustrations with minimized textual connection in *Fire!!* On the other hand, in joining markers of race with gender and class, Wright's illustration and story found consonance with some of the working-class women in *Fire!!*, suggesting threads of connection between these little magazines that both sought creative independence.

HARLEM RENAISSANCE ILLUSTRATIONS
IN MAINSTREAM PERIODICALS

Far fewer Harlem Renaissance illustrations made it into the mainstream mass-market magazines than were included in the black commercial and little magazines, and those that did find inclusion were most often produced by non-black artists Miguel Covarrubias and Winold Reiss, to accompany text by black writers. In these venues, illustrations introduced a largely white readership to vari-

ous aspects of African American identity and became tools in bridging the racial divide between reader and writer. For some magazine editors, like Frank Crowninshield at *Vanity Fair,* the main objective in introducing images of black Americans was to provide light-hearted entertainment. For other editors, like Paul Kellogg of *Survey,* positive images of African American people aided in the periodical's overarching ideal of philanthropy and social reform.

In late 1924 and early 1925, *Vanity Fair* and *Survey Graphic* agreed that a new phase had begun in African American life, each using the clarion call "Enter the New Negro" to announce the inauguration. However, each periodical used the phrase to very different ends. *Vanity Fair* was the first to employ the epithet in a double-page spread of Miguel Covarrubias's illustrations of black American types, with captions penned by the "Anglo-African Caribbean" writer Eric Walrond (fig. 34).[95] In eight small vignettes, Covarrubias created modern caricatures of new African American types based on his observations of those who frequented or performed at Harlem's cabarets, while Walrond provided captions in dialect. For example, Covarrubias's strutting dandy, dressed colorfully in a bowler hat, tails, polka-dot tie, and spats, primps and grins widely for the viewer (fig. 34, bottom center), while Walrond's caption playfully informs:

See dis Strutter! Tu'n mo' tricks 'n a monkey, dis boy kin. Jess like that, jess like that. And he don't give a doggone if them Broadway stars do come on uptown where he is at, and see him do he stuff, and den go on back downtown and strut his stuff as if they jess got it natchely.[96]

By exaggerating the figure's facial features and pose, Covarrubias caricatured his appearance in a manner that subtly favored comic expression over demeaning portrayal. In his caption, Walrond commented satirically on the authentic black performance of this "strutter" in the face of whites, whom he has cast as mimics rather than originators.

The banner headline running at the bottom of the double-page spread informed the magazine's bourgeois white readers, "Enter, The New Negro, a Distinctive Type Recently Created by the Coloured Cabaret Belt in New York." In keeping with Crowninshield's desire for the magazine "to be light-hearted from cover to cover,"[97] a sardonic passage penned by one of *Vanity Fair*'s staff writers further introduced the new phenomenon:

The effortless New York public, revolving always with the fairest wind, has recently discovered a new brand of Negro entertainer. Not the old type, of course. The lullaby-singer has gone. Also the plantation darkey. And, out of

8 A. M. ON LENOX AVENUE
"Got a job fo' you, Coolie."
"Nigger, keep still! I bin in New
York gwine on to twenty years
now and I ain't nevah had no job.
Go on 'bout yo' bizness. As
Ah was tellin' yo', Lovey, Ah had
five to win and two for a place. . ."

**2 A. M. AT "THE CAT AND THE
SAXOPHONE"**
"Boy, do that thing! Tell 'em about
me! You tell 'em, sister. Be yourself,
now! 'S pretty, too, Ah mean she
ain't ugly. Oh! Kiss me, papa!
You're pretty from the ground up"

THE effortless New York public, re-
volving always with the fairest wind,
has recently discovered a new brand of
Negro entertainer. Not the old type, of
course. The lullaby-singer has gone. Also
the plantation darkey. And, out of the
welter of sentimentality which the old
types created, the Negro now emerges as
an individual, an individual as brisk and
as actual as your own next-door neighbour.
He no longer has to be either a Pullman
car porter, or over-fond of watermelons,
in order to be a successful type on our
stage. He is a personality, always, and
frequently an artist. A bright light has
recently been turned upon him.
The first all-coloured show, *Shuffle Along*,
written, produced and acted by Negroes,
was presented the season before last on

Broadway, and immediately became a sen-
sation. Since then we have seen its suc-
cessors, *Runnin' Wild*, *Chocolate Dandies*,
Honey, and *Dixie to Broadway*. We have
also seen a great number of Negro cabarets
which have flared up in every part of New
York, from the fashionable districts to the
Harlem black belt—all flourishing under
white, or partial white, patronage.
In the accompanying sketches, Miguel
Covarrubias, the young Mexican artist,
has miraculously caught the somewhat
exotic spirit of the new Negro, as he is
seen to be, both on the stage and in the
more characteristic moments of his life
around the cabarets. The captions for
these eight drawings were written by
Eric D. Walrond, a talented Negro poet.

See dis Strutter! Tu'n
mo' tricks 'n a monkey,
dis boy kin. Jess like
that, jess like that. And
he don't give a doggone
if them Broadway stars

do come on uptown
where he is at, and see
him do he stuff, and den
go on back downtown
and strut his stuff as if
they jess got it natchely

Figure 34. "Enter, The New Negro," with illustrations by Miguel Covarrubias and cap-
tions by Eric Walrond, in *Vanity Fair* (December 1924). Houston Public Library.
Reprinted by permission of the Miguel Covarrubias Estate.

the welter of sentimentality which the old types created, the Negro now emerges as an individual, an individual as brisk and as actual as your own next-door neighbour. He no longer has to be either a Pullman car porter, or over-fond of watermelons, in order to be a successful type on our stage.[98]

With wit and self-mockery, the editorial taunted the non-black reader with the proximity of new black Americans as individuals, who could emerge "as your own next-door neighbour" or as a new actor "on our stage." Nonetheless, the short editorial couched the New Negro as a new brand of stage entertainment for non-black audiences, a commercializing trope that was also reflected in the page designs. On each page, Covarrubias's caricatures were organized in a loosely circular formation interspersed with blocks of text, as was the case with his other caricatures published in the magazine. But this was also the format the *Vanity Fair* art director would use for more commercial pages, such as for a collection of "Smart Winter Overcoats for Town and Country" or a spread with photographs of the latest luxury automobiles.[99] Therefore, with this editorial and layout, non-black readers could regard the entrance of the "New Negro" as a commodified form for their entertainment and consumption.

The phrase "Enter the New Negro" also appeared as the title of Alain Locke's major editorial for the March 1925 issue of *Survey Graphic,* a journal devoted to social work and reform.[100] Its editor, Paul Kellogg, arranged with guest editor Locke to publish this special issue, titled "Harlem: Mecca of the New Negro." Several months later, Locke's article would form the initial essay in his expanded collection of essays, poetry, and art, *The New Negro,* published by Albert and Charles Boni.

Kellogg set the tone for the special issue of *Survey Graphic* in his short editorial at the beginning of the issue. "If The Survey reads the signs aright," he predicted, "a dramatic flowering of a new race-spirit is taking place close at home—among American Negroes, and the stage of that new episode is Harlem."[101] As had the *Vanity Fair* editorial, Kellogg's passage referred to black Americans as taking the "stage," however less for the purposes of entertainment and more to demonstrate a new psychological mindset to *Survey*'s non-black professional and philanthropic readers. Locke continued to address *Survey*'s constituency in his "Enter the New Negro":

The Sociologist, The Philanthropist, the Race-leader are not unaware of the New Negro, but they are at a loss to account for him. He simply cannot be swathed in their formulae. For the younger generation is vibrant with a

new psychology; the new spirit is awake in the masses, and under the very eyes of the professional observers is transforming what has been a perennial problem into the progressive phases of contemporary Negro life.[102]

To provide visual interpretation of the emancipated New Negro for *Survey*'s readers, German artist Winold Reiss contributed many portraits of individuals, as well as African American types. Once again, as in *Vanity Fair,* a non-black artist was commissioned by a non-black editor to introduce black American figures to a primarily non-black readership. However, Reiss's portraits contrasted starkly with Covarrubias's caricatures. In one section of the issue, titled "Harlem Types: Portraits by Winold Reiss," the German artist's pastels, *A Boy Scout, A Woman Lawyer,* and other black types were arranged around columns of text by Locke (fig. 35).[103] Rather than portraying cabaret entertainers, Reiss chose urban working-class and professional subjects in this section. His modern portraits gave mimetic form to the figures' heads and bodies, while only sketching loosely the details of their clothing. His somber sitters reflected the tenor of Locke's commentary, which asserted, "Caricature has put upon the countenance of the Negro the mask of the comic and the grotesque, whereas in deeper truth and comprehension, nature or experience have put there the stamp of the very opposite, the serious, the tragic, the wistful."[104] For Locke, it was more important to introduce non-blacks to African American figures who took themselves seriously, rather than the all-too-familiar comic stereotypes of Covarrubias. Further, "for the Negro artist," whom Locke characterized as "still for the most part confronting timidly his own material," Reiss's portraits of dark-skinned types carried "a particular stimulus and inspiration in this redeeming vision."[105] In Locke's estimation, Reiss's work powerfully transformed negative visual associations with dark skin and represented a newly modern vision that stood in contrast to the "racial expression which," Locke felt, "was only experimental" in the work of contemporary black illustrators, like Laura Wheeler.[106]

Locke further revealed what he believed was Reiss's subject position in his short biography of the artist, where he extolled, "What Gauguin and his followers have done for the Far East, and the work of Ufer and Blumenschein and the Taos school for the Pueblo and Indian, seems about to be done [by Reiss] for the Negro and Africa."[107] Here, he cast African American types as members of the folk, or even primitives, who would gain visual recognition through Reiss's brush as had the Tahitian islanders through Gauguin's paintings. In his "Harlem Types," however, Reiss revealed less an attitude of nostalgia toward primitive life and more a speculation that black Americans were in the midst of

WINOLD REISS, son of Fritz Reiss, the landscape painter, pupil of Franz von Stuck of Munich, has become a master delineator of folk character by wide experience and definite specialization. With ever-ripening skill, he has studied and drawn the folk-types of Sweden, Holland, of the Black Forest and his own native Tyrol, and in America, the Black Foot Indians, the Pueblo people, the Mexicans, and now, the American Negro. His art owes its peculiar success as much to the philosophy of his approach as to his technical skill. He is a folk-lorist of the brush and palette, seeking always the folk character back of the individual, the psychology behind the physiognomy. In design also he looks not merely for decorative elements, but for the pattern of the culture from which it sprang. Without loss of naturalistic accuracy and individuality, he somehow subtly expresses the type, and without being any the less human, captures the racial and local. What Gauguin and his followers have done for the Far East, and the work of Ufer and Blumenschein and the Taos school for the Pueblo and Indian, seems about to be done for the Negro and Africa: in short, painting, the most local of arts, in terms of its own limitations even, is achieving universality.

A Boy Scout

A woman lawyer

Girl in the white blouse

Figure 35. Winold Reiss, "Harlem Types": A Boy Scout, A Woman Lawyer, Girl in the White Blouse, in Survey Graphic (March 1925). Reprinted with permission of the Winold Reiss Estate.

a transformation from a folk or primitive state to a fully Americanized identity. His first type, *Congo: A Familiar of the New York Studios,* retained an exotic primitive element, with its "Afro" hairstyle and head floating without the context of a body or clothing.[108] Turning the page, however, the reader was confronted with Reiss's drawings of urban types, like *Girl in the White Blouse* (fig. 35), whose hair, combed upward in back, retained the primitive element of *Congo,* while her fashionable blouse suggested her modern, urban status. Turning the page again, the reader saw a full-page pastel portrait of a suave *College Lad,* dressed impeccably in a three-piece suit and having used pomade to flatten and straighten his curly hair—now fully integrated into an urban American style.[109] Therefore, rather than following Locke's accompanying text that assessed Reiss as the new Gauguin, the artist mirrored more closely Locke's "Enter the New Negro" essay, in which he asserted the urbanization of contemporary African Americans, who were no longer a separate "problem" but "an integral part of the large industrial and social problems of our present-day democracy."[110]

By contrast to Locke, Langston Hughes wished to capture the distinctive beauty of black working-class music, without worrying about how this expression compared to non-black American culture. White editors of literary magazines, for example Henry Leach of the *Forum,* often seized on the work of writers like Hughes, whose distinctive expression of black cultural forms had strong appeal for their primarily non-black readership. Again, at this early date, Leach called upon Reiss to illustrate the poetry of Hughes when it was published in *Forum,* as it was in the August 1925 issue. Here, the *Forum* editors featured Hughes's poem "The Weary Blues," stating their intention to publish the poem as "an example and encouragement to other Negro poets," on the occasion of Hughes's receipt of the first poetry prize in the recent *Opportunity* literary contest.[111] With a largely non-black readership, however, the editors also introduced Hughes's poetry to readers as yet unfamiliar with his work, and they chose the popular Reiss to provide a creative interface between poet and reader.

By contrast to his pastel portraits, Reiss's drawing accompanying Hughes's poem evinces a very different mode, in which he developed a modernist visual vocabulary to match the distinctive styles of black music that had inspired Hughes (fig. 36). Using angular forms in a broadly Cubist as well as Art Deco style, Reiss embroidered visually on Hughes's imagery and vernacular blues phrasing. Details including Hughes's blues club setting, with its "pale dull pallor of an old gas light," and the piano player's "ebony hands on each ivory key," his "rickety stool," and the "thump, thump, thump" of "his foot on the floor," found creative visual manifestation in Reiss's drawing. Further, Reiss gave

Figure 36. Winold Reiss, *The Weary Blues,* illustration for Langston Hughes, "The Weary Blues," in the *Forum* (August 1925). Reprinted with permission of the Winold Reiss Estate.

modernist, fragmented form to the "syncopated tunes" that emerge graphically from the blues singer's mouth in the foreground and that "echoed through [the singer's] head" when "he went to bed" in the background.[112]

With Reiss and Covarrubias often acting as visualizing intermediaries between black writers and a non-black readership in the mainstream magazines, black artists received far fewer opportunities to contribute illustrations to these publications. On rare occasions, Aaron Douglas and James L. Wells received commissions for illustrations in the magazines *Theatre Arts* and *Golden Book,* and Douglas and Richard Bruce Nugent had drawings reproduced in *American Monthly* on one occasion.[113] However, these opportunities represented exceptions. This was particularly disappointing for Douglas, as Frank Crowninshield had intimated that he would publish some of Douglas's illustrations in *Vanity Fair.* But this never came to pass, as the editor continued to favor Covarrubias's cabaret scenes in his features on black art and culture.[114]

In addition the mainstream newspapers often overlooked Douglas's illustrations in their reviews of Harlem Renaissance books. Despite the fact that his dynamic dust jacket designs were available for reproduction, the *New York Times* often chose to illustrate its reviews of the latest literary contributions related to the Harlem Renaissance with alternative visual imagery. For example, in reviews of Van Vechten's *Nigger Heaven* and McKay's *Home to Harlem,* the *Times* published unrelated illustrations by Covarrubias rather than the drawings available for each book by Douglas.[115] And in a review of James Weldon Johnson's *God's Trombones* and Eva Jessye's *My Spirituals,* the *Times* reproduced only the illustrations by the obscure folk artist Millar of the Roland Company for the latter publication, discounting Douglas's modernist *God's Trombones* compositions.[116]

CONCLUSION

This overview demonstrates the diversity of modernist representation that animated New Negro magazine illustrations, which ranged broadly in stylistic treatment and thematic content. Reflecting the editorial policies and artistic philosophy of Du Bois at the *Crisis,* Bernie Robynson created a stylistically conservative cover image in 1928 that nonetheless expressed its modernity in proclaiming a socially contingent artistic expression (see fig. 55). In its identification of black American professionals and artists as American citizens on the threshold of the American urban environment, with its churches and smokestacks pictured on the horizon, Robynson's image demanded a symbi-

otic relationship between black art, commercialism, and social justice. Responsive instead to Charles S. Johnson's commitment to the freedom of artistic expression in the pages of *Opportunity*, Aaron Douglas explored a collaborative artistic relationship with Langston Hughes in giving modernist, vernacular form to the distinctive black working-class musical expression of the blues (fig. 26). Reflecting the political concerns of the *Messenger*'s various editors, Grace Clements's bold Deco cover image stood as a monumental modern tribute to black workers in the South, with unusual attention to the plight of female as well as male laborers (fig. 30).

With increased license for creativity, the black little magazine illustrators expressed more wide-ranging attitudes toward modern racial representation. On the one hand, the *Fire!!* artists conceived of modern racial identity as inextricably bound to class, gender, and sexuality. In their sardonic posturing, salacious wit replaced aspirational rhetoric, with Richard Bruce Nugent's primitivist prostitute providing a modern parodic response to the controversial theme of black primitivism (fig. 31). On the other hand, the *Saturday Evening Quill* artists refused limitation to racialized themes, instead understanding modern black art and poetry as free to explore a variety of creative directions. This liberated attitude is embodied in Roscoe Wright's cover image of a quill pen, which suggests the creative potential of the *Quill* artists, without prescribing race as the fundamental component of their modern black expression (fig. 33).

As non-black interpreters of African American identity in the mainstream magazines, Miguel Covarrubias and Winold Reiss also contributed to the diversity in expression of modern black identity. As Covarrubias specialized in often irreverent, modernist caricatures that flirted with but also circumvented demeaning visual stereotypes (fig. 34), his method of racial representation was consonant with the imagery in the radical little magazine, *Fire!!* Reiss, by contrast, explored a variety of modern racial types, from the sober American citizens in *Survey Graphic* (fig. 35), connecting with the *Crisis* images of racial uplift, to the modernist blues musician in *Forum* (fig. 36), resonant with Aaron Douglas's modernist blues singers in *Opportunity*. However, with black illustrators largely restricted from these mainstream magazine venues, the black commercial and little magazines provided an immeasurably vital arena for black artists to explore a self-determined, modern expression within the context of Harlem Renaissance print culture.

"Worth the Price of the Book":
Dust Jacket and Book Illustrations

In a promotional blurb for Paul Morand's *Black Magic,* published by Viking in 1929, Carl Van Vechten declared, "The beautiful illustrations by Aaron Douglas alone are worth the price of the book."[1] Indeed, book publishers realized the appeal of illustrations, often emphasizing them in their advertising, and they also recognized the power of dust jacket imagery to persuade a potential reader to purchase a book. While reviewers of books rarely mentioned the visual components of a volume, on occasion they concurred that illustrations enhanced the aesthetic and monetary value of the book they adorned.

This chapter provides an overview of illustrations and dust jacket designs associated with Harlem Renaissance books. From the perspective of the various publishing firms that issued these volumes, I examine how illustrations functioned to enhance the books as commercial products and as interpretations of modern black culture. How did publishers utilize illustrations in their advertising campaigns, and what methods did they develop to address racial identities in their merchandising? What do the relationships between illustrators, authors, and publishing house staff tell us about the production of these illustrations? Within the constraints of these relationships, I have found that illustrators devised creative methods for effective visual marketing—an important tool in revising old stereotypes and creating forceful new representations of modern black identity.

While the African American periodicals afforded a variety of artists occasion to publish their illustrative work, fewer black artists gleaned opportunities to illustrate Harlem Renaissance books, in part due to the dearth of black-operated publishing houses to match the efforts of *Crisis* and *Opportunity.* The primary African American publisher of illustrated volumes, Carter G. Woodson,

consistently provided James L. Wells and Lois Jones the chance to illustrate books on black history and culture, issued through the Associated Publishers in Washington, D.C. Otherwise, black illustrators struggled to break into the fray of artists employed by the major publishing houses in New York. In fact, Aaron Douglas, E. Simms Campbell, and Laura Wheeler were the only black artists to illustrate Harlem Renaissance volumes issued by these venues. The illustrated books issued by these firms, however, provide a rich example of the interracial relationships that often animated Harlem Renaissance print culture. At Alfred Knopf, for example, the white writer and music critic Carl Van Vechten acted as intermediary between Knopf and Langston Hughes, and also initially between the publisher and Aaron Douglas. Beyond Van Vechten's intercession, Douglas and Knopf developed a fruitful business relationship, resulting in a number of illustration commissions for the young artist. Both Knopf and the Boni brothers frequently hired the Mexican artist Miguel Covarrubias to illustrate books by black authors, as well as publishing books of this artist's caricatures of African American cabaret life. And at Harper and Brothers, the white editor Eugene Saxton hired both Aaron Douglas and white illustrator Charles Cullen to decorate books by black authors Countee Cullen and Alain Locke. He also worked closely with the African American NAACP secretary Walter White to promote Harpers' Harlem Renaissance books.

These interracial networks of publishers, intermediaries, authors, and illustrators were complex. Some involved uneven power relationships, entailing exploitation of black writers and artists by white intermediaries and publishers. Others indicated black sponsorship of white artists in the face of unyielding white publishers. Still others involved strong kinships forged across racial barriers, despite uneven hierarchical arrangements, that came to stand as a new modern model of fertile racial interaction.

BACKGROUND ON MODERN AMERICAN BOOK ILLUSTRATION

Harlem Renaissance illustrators contributed to a growing body of American book illustration during the 1920s and 1930s—a period that is often neglected in the few scholarly treatments of the medium.[2] The "Golden Age" of illustration at the turn of the century is often touted as the best and most productive period in American illustration, when American book publishers spent lavishly on full-color illustrations by Howard Pyle, Maxfield Parrish, and many others. Indeed, a number of Golden Age illustrators continued production into the

1920s, including Parrish, Elizabeth Shippen Green, and N. C. Wyeth. How-
ever, the medium of book illustration underwent a major transformation in the
1920s and early 1930s, both stylistically and philosophically.

While varying forms of book illustration were practiced widely, a select
group of artists began to work in self-consciously modern modes both in the
styles of their illustrations and in new relationships to text and graphic design.
Probably the best-known American illustrator to "go modern" was Rockwell
Kent, who maintained status as a painter as well as a fine book illustrator, also
producing commercial illustrations for magazines.[3] He developed a sharp, styl-
ized representational style that drew from the simultaneously archaizing and
modern, streamlined qualities of the popular Art Deco. An example of his dis-
tinctive woodcut style, *Land Legs,* from his self-authored book, *Voyaging South-
ward from the Strait of Magellan,* displays his keen interest in stylized figural
and landscape forms, made to appear frozen in time with his regularized paral-
lel hatch marks (fig. 37). He often created illustrations for limited edition books
issued by major firms, such as Random House, as well as specialty houses, like
Lakeside Press in Chicago.

Joining Kent among the varied modernist book illustrators in New York
were significant numbers of immigrant artists, for example, John Vassos, orig-
inally from Greece. His futuristic gouache cityscapes in *Ultimo,* which he wrote
with his wife, Ruth, and his surreal illustrations for Oscar Wilde's *Salome* con-
tributed ultramodern imagery to the New York book publishing scene in the
later 1920s. In addition, a number of illustrators specialized in drawings for
the burgeoning field of children's literature, with the fantastic illustrations of
animals by Boris Artzybasheff and Wanda Gag immensely popular in the
1920s and 1930s.

Among the broad range of American illustrators of this period, varied atti-
tudes emerged regarding methods of illustration. Some traditional illustrators
continued the well-practiced approach, creating detailed, conventionally realis-
tic scenes in response to one line of text, which would form the picture's cap-
tion. For example, in 1928, N. C. Wyeth created elaborate paintings in response
to single lines of James Boyd's text for the children's book *Drums.* The paint-
ings were reproduced in full color on coated stock. *The Horse Race,* for exam-
ple, showed a typically dramatic and suspenseful scene of two horses running
neck-and-neck.[4] Using what was considered a more modern method, Rockwell
Kent provided a series of pen-and-ink illustrations for a 1928 Random House
publication of Voltaire's *Candide* (see fig. 50).[5] Never divorced from the body of
text, Kent's delicate black-and-white illustrations knit the text into their de-
signs. Working as a modern illuminated manuscript artist, Kent embroidered

Figure 37. Rockwell Kent, *Land Legs*, in Rockwell Kent, *Voyaging Southward from the Strait of Magellan* (New York: G. P. Putnam, 1924). By permission of the Plattsburgh State Art Museum, Rockwell Kent Collection, bequest of Sally Kent Gorton.

the initial letters of each text section with figures in a landscape and confined his more expansive illustrations to fields at the bottom of the page. With Kent's illustrations printed on the same paper as the text, they maintained visual integrity between words and image. However, Kent's imagery was not bound by a textual caption and could maintain expressive autonomy from its text.

While the style of Kent's spare line drawings evoked some of the streamlined characteristics of the fashionable Art Deco, their most modern aspects within the context of book illustration involved keying them to the weight of the typeface and page designs. In a growing body of critical writing on the medium of book illustration, a number of artists articulated these integrated attitudes toward graphic design and illustration as truly modern. For example, Guy Pène du Bois asserted, "The modern book . . . illustration must be built . . . to fit [its] setting. . . . The illustrator's print must be made to harmonize with an assemblage of text."[6] In determining the most effective modern reproductive techniques to maintain harmony between text and illustration, many artists favored the line engraving over the halftone reproduction. While the halftone technique allowed for grayscale and color reproduction, essential for the lavish color illustrations in Golden Age books of the turn of the century, its nuances were best caught if printed on paper of coated stock, which would interrupt the aesthetic flow from image to text. For the modernists in graphic design, the line engraving was the only reproductive process that could most successfully match the printed page, with its "lattice-work of type," as W. A. Dwiggins called it. "To attempt to weld halftone and type into a harmonious whole," he argued, "is as futile as to attempt to combine in the same design the mesh of burlap and the reticulations of a fly's eye."[7]

Dwiggins's remarks found publication in the catalogue of an exhibition, *Fifty Books,* sponsored by the American Institute of Graphic Arts (AIGA) in 1926. The following year, the AIGA mounted its first exhibition of American Book Illustration. These exhibitions and their catalogues represented an important professional recognition of achievements in modern book illustration and design by a new organization, founded in 1914 and by the mid-1920s gaining artistic prominence. Their exhibitions recognized some of the best modern illustrators, such as Miguel Covarrubias, Rockwell Kent, John Vassos, Wanda Gag, and on one occasion, Aaron Douglas.[8] The AIGA exhibitions were reviewed by notable critics, from Edward Alden Jewell to Elisabeth Luther Cary, and their awards were often mentioned in publishers' advertisements for illustrated books as a mark of both artistic excellence and sales appeal.[9]

While opportunities for work in book illustration abounded in the 1920s and 1930s, publishers were not spending as lavishly on color reproduction as

they had at the turn of the century. This deficit emerged at the same time that more commissions for illustration began to materialize in commercial venues, especially from "mass-market magazines and advertisers."[10] Some artists capitalized on illustration's position within the interstices of art, print, and commercial culture, their success often dependent on their work in advertising.[11] While many artists, like Kent, regarded commercial illustration on an equal footing with fine art production, others distinguished between fine and commercial art, categorizing the medium of illustration as only commercial.[12] Some artists, like Irving Politzer, readily embraced the commercial label, advertising his skills and availability as a dust jacket designer in *Publishers Weekly* want ads.[13] By contrast, N. C. Wyeth retained the attitudes of turn-of-the-century artists in perceiving a division between his work in illustration, which he considered too commercial, and the artistic freedom of his work as a painter.[14]

By necessity, illustrators who created dust jacket designs more readily embraced commercialization. By the 1920s, book jackets had become key marketing tools in window displays, on bookshop shelves, and on the books themselves to attract potential readers. In 1931, the illustrator and commercial artist Helen Dryden reflected on the changes in book jacket design in the hands of modern illustrators. Originally "intended to keep the bindings clean," Dryden exclaimed that by 1931, dust jackets had "grown so alluring and satisfying that one takes pains to keep *them* intact" (my emphasis). She realized the emergent hybrid nature of the dust jacket during the 1920s as both "packaging" that "prompts sales," and "poster" art that "can be read quickly and at a distance." Dryden evaluated the book jacket as a challenging project in design involving the interweaving of lettering and image. Also requiring the artist's keen intellect, the jacket "ought to give some indication of what the book is about, even if in an abstract way, enough to arouse the buyer's interest and curiosity and make him want to read the volume." Astutely aware of the new medium's fusion of stimulating visual design with commercial enterprise, she noted, "A bookseller's window is now one of the gayest sights," concluding, "Now every book is fast becoming a poster for itself, its own most effective form of advertising."[15]

In finding the most suitable forms to capture the attention of potential buyers, modern illustrators often gravitated to the silhouette in their jacket designs of the 1920s and 1930s. Favored also in textile design, ceramics, and varied forms of packaging, the silhouette worked well because it would not interrupt the design surface of the jacket with an illusionistic image. Silhouettes also simplified forms to bold, solid shapes and essential contours, which allowed

the viewer quick perception. Jacket designers employed silhouettes for varied kinds of books, from Carroll Snell's covers for literary fiction to Irving Politzer's fashionable jackets for popular mystery novels.[16] With the artists' distinctive signatures often incorporated into their designs, the jackets worked to advertise not only the books but also their designers' artistic and commercial talents.

MODERNITY OF HARLEM RENAISSANCE BOOK ILLUSTRATION

Partly from his training with Winold Reiss, but also by virtue of his knowledge of modern developments in American book illustration and design, Aaron Douglas adopted an ultramodern stylistic approach to dust jacket design and lettering, utilizing the silhouette as a marker of contemporary design. Charles Cullen, an important non-black illustrator of Harlem Renaissance books, developed a distinctively delicate pen-and-ink style in his illustrations that he keyed sensitively to the typeface and page designs of Countee Cullen's books. In each case, Douglas and Cullen utilized these modern stylistic methods to promote new images of racial identity that countered prevailing derogatory images. The most ubiquitous purveyor of black stereotypes in American books was Octavus Roy Cohen, whose Florian Slappery series capitalized on the outmoded stereotypes of black minstrelsy. Dressed in outlandish garb and constantly speaking in malapropisms, Slappery entertained many readers throughout the 1920s and 1930s. A variety of illustrators gave visual form to Cohen's Slappery stories, including J. J. Gould and Margaret Freeman.[17] In *Black to Nature,* Freeman perpetuated particularly derogatory visual stereotypes, with black figures in ridiculous poses and demeaning blackface.[18] Cohen's work was consistently pilloried in the black presses. For example, the staid *New York Amsterdam News* critics referred to his characterizations of black Americans as "the monstrosities in the manner of Roy Cohen."[19] From Wallace Thurman's scathing pen came the searing dismissal of "a dialect farce committed by . . . Octavus Roy Cohen to increase the gaiety of Babbitts."[20] And yet, *Publishers Weekly* issued an illustrated full-page ad for Cohen's *Florian Slappery Goes Abroad* on one of its 1928 covers, warning booksellers to "rush your reorders" as the "first printing" had been "exhausted!"[21] These written and visual stereotypes acted as specters of the worst aspects of American racism that, within the cacophonous diversity of American print culture, brushed with the pages of Harlem Renaissance production.

AMERICAN PUBLISHERS OF ILLUSTRATED HARLEM
RENAISSANCE VOLUMES

The illustrated Harlem Renaissance volumes were produced beginning in the 1920s, when the American publishing industry experienced tremendous growth and significant changes. With the emergence of new publishing firms like Harcourt Brace, Albert and Charles Boni, and Alfred Knopf, the stodginess of the Boston-centered industry gave way to daring new pursuits by the young publishing entrepreneurs in New York.[22] One of their priorities was to publish fiction from a more pluralistic vantage, emphasizing the ethnic literature of various European regions, such as Russia, Ireland, and the Scandinavian countries.[23] In keeping with this trend toward ethnic expression, along with the growing interest of non-blacks in African American culture and music, several mainstream firms began publishing black literature and poetry in the 1920s. Concomitant with this activity were the efforts of the black American scholar Carter G. Woodson to educate primarily black readers about their history in Africa and the United States through books published by his non-profit agency, the Associated Publishers. Together, these firms provided Harlem Renaissance artists with unique opportunities for the articulation of racialized visual forms within the burgeoning field of American book illustration.

Harlem Renaissance illustrated books circulated extensively. Books published through Carter G. Woodson's Associated Publishers aimed at and probably attracted primarily black readers. Several of these volumes, for example, Willis Richardson's *Plays and Pageants from the Life of the Negro*, illustrated by James L. Wells, functioned also as texts for schoolchildren and youth organizations, which increased their circulation. While a large portion of Woodson's readers likely belonged to the middle classes, evidence from an itinerant bookseller suggests that working-class blacks also valued Woodson's publications, using hard-earned savings to purchase them.[24]

Of the books issued by white-owned publishing houses, many received broad circulation. For example, with readers flocking to Claude McKay's *Home to Harlem*, published by Harper and Brothers in 1928, Gwendolyn Bennett praised McKay's achievement. "Heralded by loud hurrahs on the lips of all the critics," she extolled, "it has within a month's period achieved a place on the New York *World*'s list of best-sellers."[25] The mainstream trade journal *Publishers Weekly* announced, "eleven thousand copies . . . were sold during the first two weeks in New York alone."[26] Aaron Douglas's dust jacket not only adorned each copy of the book but figured extensively in Harpers' advertising cam-

paigns in publications ranging from *Publishers Weekly* to *Opportunity*, the *Crisis*, and the *Messenger*.

Aside from isolated best-sellers, many illustrated volumes went through a number of printings, sustaining their circulation, including James W. Johnson's *God's Trombones*, illustrated by Aaron Douglas. Originally published by the Viking Press in 1927, it had entered into its sixth printing by 1932. In addition, several publishers issued books in revised editions with greater emphasis on illustration. For example, *The New Negro: An Interpretation*, edited by Alain Locke, appeared in a revised edition in 1927 with additional illustrations by Douglas.[27] Similarly, Harpers issued a revised edition of Countee Cullen's *Color* in 1928 that included new illustrations by Charles Cullen.

Distribution of the illustrations can be measured in part through book circulation statistics, but these data require augmentation by considering how the illustrations functioned to promote the publications. In this regard, one cannot underestimate the enormous marketing function and circulation potential of the illustrated book jacket, which gained notable public exposure on the book itself as the reader carried it about, in bookstore displays, and within the context of print advertising. The pages of *Publishers Weekly*, in addition to other commercial and literary magazines including *Opportunity* and the *Crisis*, carried publishers' advertisements that consistently reproduced jacket designs in single or double-page spreads as successfully arresting visual aids in the project of promotion. These designs were further incorporated into publishers' circulars and broadsides that served as additional advertising tools to attract potential booksellers and readers. Book illustrations also frequently adorned reviews of Harlem Renaissance books in a variety of print venues. Through these broad networks of circulation, book and jacket illustrations entered into the popular visual culture of the period, and it is perhaps through this circuitry that Harlem Renaissance illustrators gained some of their greatest exposure.

ASSOCIATED PUBLISHERS

One of the few African American publishing firms, the Associated Publishers issued many illustrated books and school texts on African and black American history, with interior and jacket illustrations functioning within an educational context.[28] The indefatigable Carter G. Woodson of Washington, D.C., founded the Associated Publishers in 1921, having in 1915 established the Association for the Study of Negro Life and History, which issued sociological studies on black American life.[29] A dedicated advocate for educating African Americans

about their history and culture, Woodson is most often ignored in discussions of Harlem Renaissance print culture. Yet his many projects, involving scholarly research and publications, as well as textbooks for children and youth, contributed substantive new material to readers interested in African American history and culture. Beyond studies of black life and history in the United States, Woodson also published volumes on Africa and the Caribbean, and during the 1930s, he engaged in projects to better understand working-class black culture.[30]

To my knowledge, Woodson commissioned only black illustrators to create the jackets and interior decorations for books issued by the Associated Publishers and the Association for the Study of Negro Life and History. In 1923, he employed *Crisis*'s leading illustrator, Laura Wheeler, to provide the dust jacket design for Robert Kerlin's *Negro Poets and Their Poems*. Working in her most modern mode, which she utilized also in several *Crisis* covers (see fig. 24), Wheeler drew a delicately silhouetted composition with lyrical Art Nouveau foliage surrounding a silhouetted ancient Egyptian female figure setting birds free from an ornamental cage in the lower left. The image worked well with Woodson's didactic aims, as it suggested an illustrious ancient tradition upon which Negro poets could build in their modern work, while also implying a new freedom that black Americans were beginning to experience in the arts.

For other books, Woodson hired local Howard University art professors James L. Wells and Lois Jones as illustrators. In 1930, Wells reused *The Farmer*, one of his *New Masses* illustrations, for the dust jacket of Woodson's *The Rural Negro*,[31] and he designed a dynamic set of urban images for the cover of *The Negro Wage Earner*, by Lorenzo J. Greene and Woodson, both books published through the Association for the Study of Negro Life and History. These publications reflected Woodson's new interest in the rural and working classes, which nicely dovetailed with Wells's ongoing leftist concerns as a contributor to the *New Masses*.

The imagery Wells developed for *The Negro Wage Earner* jacket stemmed stylistically from the bold Deco compositions of Louis Lozowick and other illustrators for the *New Masses;* these artists crafted visual responses to America's industrial urban landscape. However, Wells created his industrial scenes as the arena for black workers. On the front of his jacket, Wells presented a multilayered urban scene with tall buildings, industrial smokestacks, train engines, and workers on train tracks at right (fig. 38). In the foreground, he depicted a bust-length view of an African American man who wears a tie, suggesting the managerial positions black wage earners had attained, in keeping with Greene and Woodson's broad aim to chart "the development of the

Figure 38. James Lesesne Wells, dust jacket design for Lorenzo J. Greene and Carter G. Woodson, *The Negro Wage Earner, left:* front cover; *right:* back cover (Washington, D.C.: Association for the Study of Negro Life and History, 1930). Harry Ransom Humanities Research Center, The University of Texas at Austin. Printed with permission of the Estate of James Lesesne Wells.

Negro in the various occupations in the United States since 1890."[32] On the back of the jacket, Wells reused a captivating vignette of an African American waiter standing on an ancient pyramid in a throng of various tall city buildings, which he had earlier contributed to *New Masses.*[33] Bending his knees, ready to maneuver through the city and his demanding work, he carefully balances a serving tray carrying replicas in miniature of the urban buildings that surround him. On the one hand, the image reveals the outrageous discrepancy between African Americans' ancient heritage in Egypt and their contemporary status in urban America in 1930. On the other hand, it calls to mind the black men Egypt's pharaohs enslaved to erect the mammoth pyramids. The image also alludes to the integral roles of African American wage earners, who deftly bolstered the urban economy, as this man metaphorically "serves up" the urban environment.

Beyond additional jackets for scholarly books, Wells illustrated an important collection intended for use in high schools and youth organizations.[34] Titled *Plays and Pageants from the Life of the Negro,* the book included a selection

of short dramatic presentations suitable for youth productions.[35] Similarly, Lois Jones designed jackets for adult books on black American history, but she specialized in illustrations for children's books issued by the Associated Publishers.[36] These books for children and youth formed part of Woodson's strategy to aim his edifying messages about black history and culture not only at an adult audience but particularly toward children, "arguing that the black self-image was shaped before adolescence."[37] Illustrations, therefore, were important tools in shaping a child's self-image. One of the first Associated Publishers children's books Jones illustrated, Gertrude McBrown's *Picture-Poetry Book,* purposefully interwove poems and images. A playwright, poet, and elementary school teacher, McBrown stated in the preface to the book her belief that "the appreciation of pictures motivates reading." She further explained: "Each poem of this book, then, is preceded by a picture. The picture stirs in the child certain emotions, creating for him impressions which serve as an incentive for expression. In many cases the pictures will stimulate children to create and illustrate their own poems."[38]

Indeed, McBrown relied on Jones's illustrations to complete the poetry for her child readers. When isolated from their images, the poems read broadly as generic observations of young middle-class Americans, without consideration of race. For example, McBrown's "Jack Frost" reads simply:

When I went to sleep last night
Jack Frost dressed the world in white;
Now ev'ry bush and ev'ry tree
Point white-gloved fingers right at me.[39]

Only Jones's accompanying illustration, picturing a little boy with darkened skin and black curly hair, marked the two-page spread of text and image as distinctly racial. Using Jones's image as her guide, the child reader could insert herself into McBrown's "world in white," which now described an American space that included black middle-class children.[40]

While it is important to consider the Associated Publishers as part of the publishing engine that produced Harlem Renaissance print culture, it represented an unusual enterprise in comparison to the growing, profit-making New York firms. Jacqueline Goggin's biography has traced Woodson's ongoing struggles to raise necessary funds from white philanthropic foundations and black supporters for his publishing causes.[41] Despite his financial burdens, however, he understood the value in advertising his books through flyers and brochures for booksellers and potential readers, though rarely in the commer-

cial or trade magazines. In these promotional tools, illustrations served as key visual attractions. For example, Jones's dust jacket illustration and frontispiece for McBrown's *Picture-Poetry Book* adorned a promotional brochure for the book (fig. 39). Her thirty-six illustrations that accompanied the book found emphasis in the brochure copy, with testament to their delight among child readers. Another Associated Publishers flyer advertised a collection of eight books as "A Useful Library of Negro Literature."[42] Under this headline, the flyer featured a photograph of the books all in a row on a shelf, with their dust jackets displaying illustrations by Wells and others. Pictured in this way, the books formed a visual alternative to such renowned series as the Harvard Classics, also advertised as a formidable set, or the Literary Guild of America books, similarly promoted as an impressive shelf of decorated books.[43] In the Associated Publishers flyer, the shelf of books functioned in the imagination of the potential buyer as carrying the status of a distinctive New Negro library.

HARCOURT BRACE

Alfred Harcourt and Donald Brace founded Harcourt Brace in 1919, and the firm became the first mainstream publishing house to issue illustrated Harlem Renaissance books. While its lists did not include the largest number of Harlem Renaissance illustrated volumes, it nonetheless published several books from 1920 to 1932 with wide-ranging types of illustrations. With strong connections to the African American literary community from the start, Harcourt and Brace received early assistance from Joel Spingarn of Columbia University, who had close ties to the NAACP and W. E. B. Du Bois at the *Crisis*.[44] Therefore, their early publication of *The Upward Path: A Reader for Colored Children* was not surprising, given its co-compilation by Mary White Ovington, then chair of the NAACP's board.[45] The reader was created especially for black children, with stories penned by black authors.

Laura Wheeler provided the illustrations for the reader, which included stories like "His Motto," focusing on industrious African American youth who demonstrated their powers of invention and determination. Here, Wheeler's carefully detailed illustration in pen and ink sensitively portrayed a young African American man, who demonstrated to his skeptical white boss a wireless telegraph machine of his own construction. In style, her drawing corresponded to her *Crisis* illustrations that privileged themes of racial uplift without verging toward modern design. However, as a delicate drawing reproduced as a line engraving, her illustration sensitively blended with the book's typeface.

The Picture Poetry Book

By GERTRUDE PARTHENIA McBROWN

with 36 illustrations by
LOIS MAILOU JONES

The moment you look at this book you will like it. Gertrude Parthenia McBrown's poems will become popular with the children. They will find great delight in the thirty-six illustrations by Lois Mailou Jones. They will love the boys and girls at play, "The Wise Owl," "The Brown Mouse," "The Kind Witch," "Bunny Rabbit," "My Dog," the delightful fairies and brownies and mischievous elves.

COMMENTS

"I have enjoyed the pictures and poems. They are delightful."—DR. HENRY NEUMAN, *Brooklyn Society for Ethical Culture.*

"They are real children's poems. The author thinks and feels with the child; she has expressed the child's experiences in poetry and rhyme."—PROFESSOR ERNEST R. GROVES, *University of North Carolina.*

"The pictures and poems are beautiful."—DR. OTELIA CROMWELL, *Miner College, D. C.*

"Students and teachers enjoyed Miss McBrown's poems."—*Southern Workman,* *Hampton Institute, Hampton, Virginia.*

82 pages $1.10 by mail

THE ASSOCIATED PUBLISHERS, Inc.
1538 Ninth Street, N. W. **Washington, D. C.**

Figure 39. Lois Jones, illustrations for promotional brochure for Gertrude McBrown, *The Picture-Poetry Book* (Washington, DC: Associated Publishers, 1935). Carter G. Woodson and Association for the Study of African American Life and History Library, Manuscript, Archives, and Rare Book Library, Emory University. Lois Mailou Jones Pierre-Noel Trust.

While this illustration filled a single page, her other, smaller drawings were integrated into the pages of text. As none of her drawings carried specific captions, restrictively incorporating a line from the text, Wheeler was free to interpret the short stories creatively.

In 1926, Harcourt Brace published *Primitive Negro Sculpture,* a volume by Paul Guillaume and Thomas Munro on African sculpture, illustrated with photographs of works in the collection of the white philanthropist Albert Barnes. In a pristine, aestheticized layout, the art director devoted full pages to the photographs of Barnes's African sculpture, using them as examples of the sculptural production from the different regions in Africa explored by Guillaume and Munro. The book intersected with Harlem Renaissance print culture in interesting ways. As a product endorsed by Barnes, with his extensive connections to Harlem Renaissance cultural leaders, the book circulated as part of the widespread attempt to reevaluate African and African American cultures. Therefore, Harcourt Brace courted the readers of *Opportunity* with an advertisement for the book, emphasizing its "forty full-page illustrations." However, both the ad and the book reflected the conflicting attitudes the authors and Barnes shared toward African cultures. For example, the ad copy read: "This exotic art flourished unknown centuries ago in Africa. During the last few years its peculiar beauty has been a disturbing, almost revolutionary influence on European painting, sculpture, and architecture. The secret of its aesthetic principles, which is revealed in this book, is the clue to understanding much of present-day art."[46]

While Harcourt Brace emphasized Guillaume and Munro's high estimation of African sculpture as "revolutionary," the publishers nonetheless characterized African art as "exotic" and possessing "secret . . . principles" that only these Western authors could decipher for the contemporary reader, suggesting the publisher's patronizing attitudes as well as the authors' primitivist stance with respect to African art.

Harcourt Brace brought out another, even more problematic, illustrated book in 1929, W. C. Seabrook's *The Magic Island.* It intersected with Harlem Renaissance print culture by way of negative critical reviews of its illustrations in black magazines. On the one hand, W. E. B. Du Bois wrote favorably of Seabrook's "story of Haitian life and religion," and he estimated that the *Crisis* readers would enjoy the author's sensitive textual analysis. However, he scorned the book's illustrations: "It is accompanied, for reasons which only God knows, by distressingly ugly and crude caricatures conceived by Alexander King."[47] On the one hand, it is important to consider Du Bois's criticism in the

context of his prevailing attitude toward comic imagery, as he decried all carica-
ture unequivocally, whether from the pen of King or Covarrubias. On the other
hand, King's illustrations did provide a debased counterpart to the aestheti-
cized photographs of stylized African sculpture in Guillaume and Munro's vol-
ume. With horrifically distorted physiognomy in his drawings of black men
and overtly sexualized images of black women, King brought his caricature to
the level of a demeaning stereotype.

In the early 1930s, Harcourt Brace issued two books with illustrations by
black artists that pointed in yet another direction. In these projects, Aaron
Douglas and E. Simms Campbell explored new visual vernacular styles that
diverged from earlier modes of racial uplift as quickly as they modified de-
meaning caricature. For Arna Bontemps's God Sends Sunday, Douglas created
one of his most memorable jacket designs (see fig. 18). Using his signature, sil-
houetted forms, Douglas illustrated Bontemps's protagonist Little Augie
dressed in top hat and tails. Seated in the lower left, he looks up to a scene
faintly silhouetted in pink—his memory of a dance he shared with Della,
dressed in her fancy petticoats. They both engage in the distinctive struts of the
cakewalk, their bodies' visual rhythms forming the vernacular centerpiece of
Douglas's cover design. In 1932, the firm published Sterling Brown's book of
poems, Southern Road. For each of the poet's four sections, E. Simms Campbell
provided black-and-white illustrations in pen and ink of black workers and mu-
sicians in the rural South. His third illustration, a boldly modernist composi-
tion, portrays musicians and dandies in a southern juke joint (see fig. 5). In the
upper right, a sign fragment reads: "For Colored Only." Normally a signal for
segregation and restriction, the sign becomes a mark of distinction in Camp-
bell's vernacular scene, where the artist has represented the black banjo player
as a modern figure who contributes a distinctive musical expression. With ex-
aggerated fingers plucking the fragmented instrument, Campbell's banjo
player represented a modernist alternative to familiar stereotypes of the enter-
taining black musician.

Harcourt Brace's illustrated volumes associated with the Harlem Renais-
sance run the gamut in modern visual representation from racial uplift to aes-
theticized photographic form to caricature to visual vernacular. This broad
range is also articulated in their Harlem Renaissance books without illustra-
tion, which included Du Bois's Darkwater, Claude McKay's Harlem Shadows,
and James Weldon Johnson's Book of American Negro Poetry.[48] By contrast, the
other mainstream publishing houses that issued Harlem Renaissance volumes
retained a greater degree of focus.

ALFRED A. KNOPF

One of the major publishing houses to issue Harlem Renaissance books, Alfred A. Knopf loyally sponsored the writing of Langston Hughes and Carl Van Vechten and the visual art of Miguel Covarrubias and Aaron Douglas. A willing risk-taker, the young Knopf published some of the most daring though also highly criticized books of the Renaissance, including Hughes's volumes of poetry, Van Vechten's *Nigger Heaven,* and Covarrubias's modernist caricatures of Harlem's cabaret life. He was also one of the first white publishers to commission Aaron Douglas, who created some of his most stunning dust jacket designs for Knopf's books. As can be surmised from this roster of writers and illustrators, some of the primary animating forces at Knopf were the interracial and interethnic connections among publishers, authors, intermediaries, and visual artists in producing these Harlem Renaissance volumes.

Of the young and popular New York publishing firms associated with the Harlem Renaissance, Knopf had the highest reputation for fine design for his Borzoi Books, named for the slim Russian wolfhound that would animate his logo. He hired the best designers, including W. A. Dwiggins and Bruce Rogers, to create published products that were unmatched. George Doran exclaimed, for example, that Knopf "not only made beautiful books but told the public they were beautiful books and thereby stimulated the public to require a more graceful format."[49] Indeed, Knopf trumpeted the quality of typeface, page design, and paper selection in each Borzoi Book, while also remaining active in every phase of production. As Sidney Jacobs, member of the production department in the later 1920s, asserted: "Every layout and design, including a final pasted-up folder of front-matter proof and typical text pages that eventually went to the printer as a pressroom guide, every jacket design, every binding layout and setup and sample cover had to be submitted to Alfred for approval."[50]

Illustrations played a key role in Knopf's books, as designer Robert Josephy emphasized in the firm's newsletter, the *Borzoi Broadside:*

> The illustrations in Borzoi Books and the paper jackets in which they are wrapped are planned with . . . care. An index of artists is kept, and when the book is planned the artist whose work is most suitable is called. Employment of the best engravers and color printers, and careful supervision of their work obtains the best possible results.[51]

Josephy's statement revealed Knopf's concern in choosing the "most suitable" illustrators for each project, as well as the most effective engravers and

printers to reproduce the illustrations. Indeed, his care was rewarded repeatedly, with many of Knopf's illustrated books winning AIGA awards in the 1920s and 1930s.

When in 1926 Knopf first published books associated with the Harlem Renaissance, the firm did not turn to the black illustrators who were then working for *Opportunity* and the *Crisis*. For the cover of Walter White's *Flight*, for example, Knopf used a modernist woodcut created in 1916 by E. McKnight Kauffer of fragmented birds in starkly silhouetted shapes creating a two-dimensional geometric pattern across the back and front of the jacket.[52] Knopf had Kauffer's image printed in periwinkle blue on thick mauve paper, with the title and author's name in bold black sans serif lettering. While the result was a powerful work of modernist design and artful packaging, Kauffer's image, which had been designed for a separate purpose, connected only with White's title and not the content of the book. Therefore, when approaching the jacket design for Langston Hughes's first book of poetry, *The Weary Blues*, Knopf commissioned the popular young Miguel Covarrubias to create the dust jacket design in response to Hughes's blues lyrics (fig. 40). Creating a shorthand visual notation in his jacket illustration, Covarrubias relied on a few cropped images—of a blues musician, a piano, and a lamp—to illustrate the title poem in Hughes's collection. The artist gave visual form to the poet's blues lyrics through exaggeration, particularly of the player's large, gnarled hands and distinctive black facial features. Though his portrayal verged toward caricature, Covarrubias imbued the player with a counteractive sensitivity and even dignity in his total musical absorption.

The publication of Hughes's book and Covarrubias's jacket design emerged largely through the agency of Carl Van Vechten as intermediary, and the circuitry of people involved in the commission reveal the interracial and mixed ethnic relationships often animating Harlem Renaissance print culture. An intimate of Alfred Knopf, the white, Iowa-born Van Vechten introduced Hughes's work to the ambitious Jewish publisher, and he also recommended Covarrubias, his Mexican artist-protégé, to adorn the dust jacket for the book of verse by the young African American poet. From letters exchanged between Van Vechten and Hughes, it becomes clear that Hughes had little choice in these affairs. For example, in May 1925, Van Vechten gushed to Hughes: "I wanted you to know immediately that Knopf was publishing your book. . . . I shall write the introduction and the cover design will be by Covarrubias. I hope you are happy about this, because I am."[53]

Hughes responded to Van Vechten with pleasure but also a good dose of humility: "I am glad Covarrubias is going to do the cover. I like his work and it

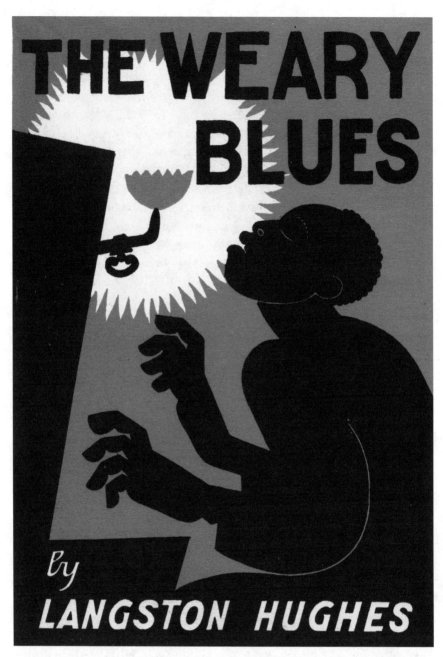

Figure 40. Miguel Covarrubias, jacket design for Langston Hughes, *The Weary Blues* (New York: Alfred A. Knopf, 1926), copyright. Reprinted by permission of Alfred A. Knopf, Inc., a Division of Random House, Inc. Used by permission of Alfred A. Knopf, a division of Random House, Inc. Harry Ransom Humanities Research Center, The University of Texas at Austin. Reprinted by permission of the Miguel Covarrubias Estate.

should go well with the book. And with your introduction,—what more do I need? As the old folks say: I'll have to walk sideways to keep from flying! All this is very fine of you."[54]

Despite his effusive response, Hughes had reservations about Van Vechten's introduction and Covarrubias's cover that he shared in an exchange of letters with his friend Gwendolyn Bennett, the young African American writer and artist working then in Paris. However, he seemed to worry less that Van Vechten was running the show and more that those black readers for whom his cabaret-inspired poetry might seem too sordid would appreciate neither the introduction of this white critic nor Covarrubias's caricature on the jacket. But Bennett returned a savvy response: "Never you mind about the colored people [not] liking the Covarrubias cover nor the Van Vechten introduction . . . you're not writing your book only for colored people. And if they who chance to have a kinship of race with you don't like your things . . . well, let them go hang!" (ellipses hers).[55]

The conditions surrounding the commission of Covarrubias's jacket design for Hughes's book give insight into the complicated relationships and strategies of the varied participants in Harlem Renaissance print culture during the mid-1920s. Power relationships in the publishing industry were clearly uneven, with black authors often beholden to white publishers or intermediaries like Van Vechten. Further, with few known black visual artists working in modern stylistic modes in the mid-1920s, artists like Covarrubias, who associated with influential white magnates of the New York publishing scene, obtained choice commissions to provide visual interpretation of modern black poetry and prose. But these interracial relationships were more complicated, for when it came to his poetry, Hughes clearly felt a kinship with Van Vechten that he could not find with all black readers. For, he and other black writers and illustrators faced varied attitudes toward their work within a wide-ranging African American readership. While their avant-garde black compatriots reveled in the vernacular expression of the black working and rural classes, the middle-class devotees of the *New York Amsterdam News* offered scathing critique of their cabaret-inspired artistic expressions.

For the primarily well-to-do non-black readers of *Vanity Fair*, however, Harlem's cabaret life seemed to hold universal appeal, and Knopf targeted this ready readership when bringing out Covarrubias's *Negro Drawings* in 1927. In this volume, the artist compiled his many sketches and caricatures of urban blacks, many of which had been published first in *Vanity Fair,* and the magazine's editor, Frank Crowninshield, provided an introduction. Covarrubias's drawings ranged from sensitive gouache compositions printed in color, such as

his *Negro Mother* frontispiece and Cuban *Woman with Basket*, to caricatured line drawings of comical black dandies, like *Sheik*, to jazzy female cabaret entertainers. As in his jacket for Hughes's *The Weary Blues*, these drawings generally balanced potentially demeaning caricature with lively comic expression on the one hand, and sensitive, almost loving portrayal on the other. They stood in stark contrast, for example, to Margaret Freeman's derogatory caricatures that adorned Roy Cohen's books of harmful black stereotypes.

However, Crowninshield's introduction for *Negro Drawings* was troubling, as it highlighted in stark relief the position Covarrubias had attained among many of New York's publishing gurus as the primary artist to give visual representation to black American culture. Writing the introduction in 1927, Crowninshield made the dubious assessment that Covarrubias "was the first important artist in America . . . to bestow upon our Negro anything like reverent attention—the sort of attention, let us say, which Gauguin bestowed upon the natives of the South Seas."[56] Here, the *Vanity Fair* editor revealed not only his characterization of Covarrubias as a primitivist, whose scenes of Harlem cabarets seemed to him like Gauguin's nostalgic paintings of "the natives of the South Seas," but also his ignorance of contemporary black American artists who were indeed paying "reverent attention" to Negro subjects.

Alfred Knopf, however, did not share Crowninshield's ignorance, for in the same year he published *Negro Drawings*, he also hired the young Aaron Douglas to design dust jackets for five Borzoi Books. Their business relationship had begun the previous year, again through the agency of Carl Van Vechten, when Knopf became aware of and hired Douglas to create illustrations for an advertising campaign for Van Vechten's "scandalous" novel, *Nigger Heaven*. This would represent the first among many commissions, in which the artist created at least seven dazzling, modernist jacket designs for a variety of books on Knopf's lists.[57] Knopf employed Douglas's work in several ways. For the *Nigger Heaven* ads (see figs. 15 and 16), he seems to have used the young black artist's Afro-Deco drawings generally as a means of authenticating the white writer's appropriation of black culture and "Harlemese." For books by black authors, including Hughes's *Fine Clothes to the Jew* and *Not Without Laughter* (see fig. 19), Knopf commissioned jacket designs by Douglas as a black artist who might match visually the racialized nature of the poetry and prose.

However, Knopf was unusual among New York publishers in recognizing that Douglas's talents in modernist jacket design could extend beyond the boundaries of race. He therefore asked the artist to design covers for several books by Euro-American authors who had not written about issues of racial identity, for example, Basil Woon's *The Frantic Atlantic*.[58] In this jacket design,

Douglas engaged with the modernist theme of transatlantic travel that many American artists approached during the interwar period (fig. 41). Using elegantly silhouetted forms, he invoked his readers' desire for a fashionable experience aboard a transatlantic ocean liner. His sleek ship with luxurious bands of smoke articulating the rolling bands of water below connected with market-

Figure 41. Aaron Douglas, dust jacket design for Basil Woon, *The Frantic Atlantic* (New York: Alfred A. Knopf, 1927), copyright. Reprinted by permission of Alfred A. Knopf, Inc., a Division of Random House, Inc. Used by permission of Alfred A. Knopf, a division of Random House, Inc. Harry Ransom Humanities Research Center, The University of Texas at Austin.

ing copy on the rear of the jacket, which touted Woon's book as the latest guide for an aspiring class of transatlantic travelers who wanted to know, "Who goes to Europe and why; How to choose your ship; Whom, and what sorts, you may meet on board."[59]

While Douglas's image related to other modernist dust jackets engaging with the theme of transatlantic travel, such as Jack Perkins's stylish image of a fragmented ocean liner for another of Knopf's books, it also resonated with his racialized drawings for the Crisis and Opportunity, which often utilized water imagery as a sign for diasporic connections between Africa and black America.[60] Just as African Americans had "known rivers," as Langston Hughes's poem conveyed, black Americans had also known ships, like the slave-carrying Amistad. Douglas may have considered his sleek vessel in this light as a modern corrective—a kind of veiled symbol of black American entry into modern commerce and deliberate transatlantic travel as American citizens.

In advertising the Harlem Renaissance volumes, Knopf's publicity department utilized the books' jacket designs as marketing tools. Using similar strategies as the other mainstream firms, Knopf took out ads in the Crisis and Opportunity announcing its Harlem Renaissance volumes that had been published most recently. For example, in an attractive, one-column format in the Crisis in 1926, Knopf advertised White's Flight and Hughes's Weary Blues using both dust jacket images as bold, eye-catching devices.[61] In 1927, the firm utilized Douglas's cover for James W. Johnson's Autobiography of an Ex-Coloured Man (see fig. 17) as the central feature of an Opportunity ad titled "The Negro," which announced Johnson's book grouped together with Van Vechten's Nigger Heaven and Hughes's two books of poetry.[62]

For the mainstream, mass-market magazines and trade journals, Knopf typically integrated Harlem Renaissance volumes into larger full- or double-page spreads advertising several books from the firm's lists. At the same time, the firm often couched these publications as bizarre, racial novelties that would seem both modern and "strange" to the largely non-black readers of these journals. Incorporating the Harlem Renaissance dust jackets into these advertisements, the firm sometimes manipulated the imagery to emphasize their advertising message. For example, in a spread in Publishers Weekly, Douglas's striking jacket for Rudolph Fisher's Walls of Jericho added modernist flair to a page also advertising Knopf's book by Wood Kahler, Early to Bed (fig. 42). In acquainting the reader with Kahler's book, advertising copy conveyed the novel as "the chronicle of a well-to-do young American's fantastic adventures among the destitute bohemians and expatriated Russians of Paris." Rather than describing the content of Fisher's novel, however, the advertising copy high-

Figure 42. Advertisement in *Publishers Weekly* (June 23, 1928), with Aaron Douglas, dust jacket design for Rudolph Fisher, *The Walls of Jericho* (New York: Alfred A. Knopf, 1928), upper left.

lighted the author's racial identity and touted that it "contain[ed] the first extensive appearance in print of a brand-new and strange American language—Harlemese."[63] Clearly, the firm felt it was introducing a "strange" and exotic novelty to *Publishers Weekly*'s largely non-black readers. To underscore this message, Knopf's publicity staff altered Douglas's jacket cover image in the advertisement by cutting the tall buildings at right. Without this corrective sym-

bol of urban culture, Douglas's partial image conveyed only the primitivist mask and figures at left, further fuel for the readers' perception of Harlem Renaissance production as "strangely" exotic.

HARPER AND BROTHERS

As at Knopf, interracial connections also marked the production of illustrated Harlem Renaissance volumes at Harper and Brothers. For example, the African American cultural leader Walter White acted as an intermediary on behalf of black writers with white editor Eugene Saxton, and black author Countee Cullen developed an unusual sponsorship of the white illustrator, Charles Cullen. Harpers' books comprise some of the most beautiful illustrated Harlem Renaissance volumes, with lavish interior illustrations and stunning dust jackets by Aaron Douglas and Charles Cullen, making their list the most expansive in this area, aside from Knopf's. In their advertising campaigns for these books, Harpers ran the gamut between messages of racial uplift in the black journals to coverage in the mainstream trade journals of outlandish promotional stunts built on demeaning racial stereotypes.

Unlike Knopf's new firm, Harper and Brothers had been operating for a century by the time of the Harlem Renaissance, and in order to keep apace with the energy of the younger publishing firms, Harpers hired Eugene Saxton in 1925 as editor-in-chief; he soon brought out alluring best-sellers.[64] When previously in the employ of George Doran, Saxton had become acquainted with Walter White, black author and secretary of the NAACP.[65] Once at Harpers, Saxton retained close ties with White and came to publish the work of several black authors, most notably Countee Cullen and Claude McKay.

Interracial relationships animated negotiations between editor, author, and illustrator in surprising ways in the case of Countee Cullen's books. The author developed an unusual partnership with Charles Cullen, a white artist who shared the author's last name only by coincidence. Gwendolyn Bennett clarified in her "Ebony Flute" column in *Opportunity* that Charles's father was "always interested in anyone whose name is Cullen," which prompted him to buy Countee's first book, *Color,* and send it to his son Charles.[66] Taken with Countee's poetry, Charles came to introduce himself to the poet and to persuade him to consider a working relationship. Their association revealed an unusual dynamic, in which the white artist looked to the black author for sponsorship.

In Charles's first commission at Harpers, he created a set of illustrations and a dust jacket design for Countee's *Copper Sun,* published in 1927. From

correspondence exchanged between Countee and Harpers' representatives, it becomes clear that Countee negotiated on Charles's behalf to obtain the illustration commission,[67] and he even urged the publishers to print "a deluxe edition," given his high estimation of Charles's fine illustrations.[68] Though the deluxe edition never materialized, Countee continued to act as intermediary between Charles and Harpers. In 1928, after prompting from Charles, Countee convinced Saxton to issue a revised edition of *Color* with new illustrations by the artist.[69] Then in 1929, Countee arranged for Charles to produce a series of drawings for his *Black Christ*. Beyond these negotiations, however, Charles would on occasion write to Countee to ask a favor, revealing his frequent need of cash. One time he asked, "Do you think I could dispose of some more of the originals of 'Copper Sun'?"[70] And, after *The Black Christ* had been published, Charles lamented, "I need work. Why don't you write another book. I would like to do fewer but better pictures."[71]

At first glance, the interchange between the Cullens seems to reveal a reversal of typical interracial relationships, in which white intermediaries would intervene on behalf of black writers or illustrators. However, the professional status of each Cullen was vastly different. Countee Cullen was well established at Harpers as an author whose books sold extremely well. He also held strong ties with the wider literary community, strengthened by his official post as managing editor at *Opportunity*, which afforded him further access to literary networks nationwide. Charles Cullen, by contrast, was a little-known artist who tried to survive on illustration work alone—a difficult prospect indeed. In contrast to the "Golden Age" of illustration at the turn of the century, when many illustrators were paid handsomely and publishing houses spent lavishly on full-color illustrations, during the 1920s and 1930s illustrators were generally not as highly compensated. With the exception of well-known artist-illustrators, like Rockwell Kent or Norman Rockwell, illustrators were paid nominal fees for book decoration.

Additional correspondence regarding Charles Cullen's illustrations for Countee Cullen's books at Harpers tells a particularly poignant narrative of the struggling white illustrator. In a letter to Countee, art director Arthur Rushmore revealed his primary concern to incur minimal expense in adding Charles's illustrations to the revised edition of *Color*. He stated in no uncertain terms, "we do not wish to spend more than $100.00 for the original drawings." Though Cullen's illustrations would surely enhance the value of this new edition, Rushmore stipulated the drawings should "not . . . increase the number of pages in any way" and "should not be too fine line or complicated . . . so that we shall not need to use a smoother stock than at present."[72] In later correspondence about

his illustrations for Countee's *Black Christ,* Charles wrote the author that Eugene Saxton "could only pay $200" for his original drawings. Charles continued, with considerable distress, "I spoke of a slight royalty so if the book was a big success I would at least be repaid. [Saxton] said that was in your hands. However, if I could complete the job soon and receive the $200 or part it would help as I spent two months with no return and am completely broke."[73]

In what seems to have been a fairly typical business relationship between a book illustrator and a major publishing house in New York in the 1920s, Charles Cullen had to coerce his author, editor, and designer to receive nominal consideration and modest payment. Despite his pains, he was an incredibly prolific artist, who provided the illustrations for Cullen's books of poems in the 1920s, while also illustrating a number of publications brought out by Henry Harrison, including issues of the *Greenwich Village Quill.*[74] For Cullen's books of poetry, Charles created many meticulously detailed compositions. For example, in *Copper Sun,* he illustrated Countee's signature love poems with romantic scenes of couples embracing. For his poems addressing racial subjects, Charles often incorporated an elegant nude black male figure into a scene that evoked classicizing features, such as an ancient urn reminiscent of the allusions of the Romantic poets, whom Countee Cullen so admired. Sometimes the figure appeared alone, at others he appeared in the company of a white woman or man, as if to suggest the interracial artistic partnership that Charles and Countee had forged.[75]

For Cullen's religious poem "The Litany of the Dark People," Charles included a drawing that portrayed an especially intimate relationship between the recurring nude black male and a visionary image of a white Christ, represented through dotted rather than solid lines (fig. 43). Charles's image fit the tenor of Countee's poem, which drew a privileged association between Christ and black Americans, who had experienced injustices similar to Christ's and therefore walked with him "toward Calvary." Not only has Charles captured the general theme of Countee's poem in his figure of Christ, who shelters the black figure with his cloak, he has responded to Countee's specific lines:

> Now that the past is left behind,
> Fling wide Thy garment's hem
> To keep us one with Thee in mind,
> Thou Christ of Bethlehem.[76]

To further unite Charles's imagery with Countee's text, art director Arthur Rushmore sized the illustration to fit on the second page of the poem below the

Figure 43. Charles Cullen, illustration for "Litany of the Dark People," in Countee Cullen, *Copper Sun* (New York: Harper and Brothers, 1927). Courtesy of Special Collections, University of Houston Libraries. Copyrights held by the Amistad Research Center, Tulane University, administered by Thompson and Thompson, Brooklyn, NY.

text. Therefore, through the image's placement and its reproduction as a line engraving, text and image are fully integrated, both visually and interpretively.

While Charles's delicate drawings beautifully suited Countee's elegant rhymed verse, Saxton commissioned Aaron Douglas to provide bolder, more specifically racialized decorations for two collections focusing on plays and poetry relating to African American culture. The first was Alain Locke and Montgomery Gregory's *Plays of Negro Life: A Source-Book of Native American Drama*, issued by Harpers in 1927. Employing more arresting Afro-Deco designs than Cullen's intricate Art Nouveau–inspired imagery, Douglas created full-page illustrations that maintained their own integrity, while also taking creative license in his interpretation of some of the plays.[77] He also created modernist book decorations, appearing as chapter headings throughout the book, with stylized images of ancient pyramids and primitivist masks.

In a figural all-over pattern for the dust jacket of the book, Douglas created an arresting, silhouetted pastiche of images from his interior illustrations, utilizing in particular three of his drawings for Eugene O'Neill's play, *The Emperor Jones*, which appeared toward the end of the collection (fig. 44). Using the figures and vegetation from these drawings, Douglas created a symmetrical design centered on the jacket's spine. Repeating the Emperor Jones figures several times, at varying angles and sometimes in reverse, Douglas also integrated several sunburst and skyscraper fragments from two of his other interior drawings. Finally, he introduced one of his signature mask forms to accentuate the spine and mark the design as Africanist. In its bold, Afro-Deco style, the jacket dazzled the viewer with its arresting black and white pattern, while also quickly emphasizing for the reader the specifically racial content of the plays in Locke and Gregory's volume.

Saxton also commissioned Douglas to decorate Cullen's anthology of poetry by black authors, *Caroling Dusk*, published by Harpers in 1927.[78] For this book, he created a stunning all-over pattern of silhouetted vines with stylized leaves into which are inserted circular forms that suggest birds' eyes. He repeated this pattern on the cover, on the end papers (printed in a luscious peach ink on white paper), and again as a background pattern for the title page. His decorative pattern held significance in the way that it transformed other modernist all-over graphic designs into distinctly Afro-Deco motifs. Several modern American graphic designers and illustrators specialized in generalized all-over patterns that could be reused for a variety of purposes, such as W. A. Dwiggins's distinctive patterns of abstract shapes for the dust jackets of Knopf's books.[79] Other illustrators created all-over imagery that could function dually as dust jacket and end paper designs, such as the charming array of silhouetted animals whimsically arranged by Boris Artzybasheff for Padraic Colum's children's book, *Creatures*.[80] To this kind of all-over patterning, Douglas contributed distinctive silhouetted vegetal and bird forms with a shorthand tropical flair that seem generically associated with Africa, in the same way that his silhouetted figures and plants in other compositions suggested loose connection to Africa. From his training with Winold Reiss and his own experimentation, he understood well that the objective in modern jacket design was not to expend energy on mimetic representation but to create bold, stylized forms that read quickly and persuasively from a distance. With a modernist, all-over design and generalized Afro-Deco forms, Douglas attracted the reader to the racialized poetry in Cullen's collection.

In advertising these volumes, Harpers often grouped books about African American life into full-page circulars that could be distributed to booksellers

Figure 44. Aaron Douglas, dust jacket design for Alain Locke and Montgomery Gregory, eds., *Plays of Negro Life* (New York: Harper and Brothers, 1927). Harry Ransom Humanities Center, The University of Texas at Austin.

and a variety of different mailing lists. While it is difficult at present to unearth many of these ephemeral advertising tools, we know that many were produced. Some took the form of a small brochure, like the one the Macaulay Company produced for Wallace Thurman's *The Blacker the Berry* featuring Douglas's distinctive drawing.[81] Others amounted to flyers that could be folded and mailed, or posted for display. For instance, plans were under way at Harpers in 1927 for a circular that would promote the Harlem Renaissance volumes in their list. Walter White suggested the idea to Eugene Saxton, with whom he often worked closely to promote Harpers' books by black authors. White wrote of his plans to Countee Cullen, in the young poet's official capacity as assistant editor at *Opportunity*:

> I had a long talk yesterday with Eugene Saxton, regarding ways of pushing your three books. I suggested preparation of an attractive circular on all three books, McKay's novel and the book of plays by Gregory and Locke, to be sent to a number of people. I then took up at the office here the matter of our addressing envelopes to our list of contributors (some 3100 in number)

and I am glad to say that I have succeeded in arranging this. Saxton imme-
diately took the suggestion. It is probable that you have at the Urban
League an additional list. I also suggested to Saxton that he print additional
copies of the circulars.[82]

The fruitful working relationships among White, Saxton, and Cullen repre-
sent nonhierarchical interracial networks that facilitated the promotion of
Harpers' Harlem Renaissance publications.

The "attractive circular" would probably have taken a form similar to the
full-page magazine advertisement that Harpers took out in *Opportunity*, which
included announcements of Cullen's three volumes and Locke and Gregory's
book of plays, but led with Claude McKay's *Home to Harlem* and white author
John Vandercook's *Black Majesty*, a history of the black slave revolt in Haiti. Not
only were these two books immensely popular, and McKay's book a best-seller,
but each had stunning dust jackets by Mahlon Blaine and Aaron Douglas with
representative imagery rather than all-over patterns, which reproduced well on
a small scale for visual stimulation.

This ad represents one effort in a multifaceted advertising campaign that
Harpers mounted for Claude McKay's *Home to Harlem*, in which Douglas's
jacket design played a central role. Here, Harpers aimed to attract *Opportunity*'s
readers by toning down the seamier side of McKay's novel and introducing it
with praise from Countee Cullen, who called it "a novel of Negroes by a Negro
in which the black man refuses to be a race problem."[83] But Harpers would
also capitalize on *Home to Harlem*'s grittier charms in the mainstream presses.
In a more salacious full-page ad in *Publishers Weekly*, Harpers highlighted
McKay's novel with the leading headline, "A Negro's own story of 'Nigger
Heaven,'" making connection with Van Vechten's "scandalous" novel.[84] In a
particularly outlandish stunt during the first weeks following *Home to Harlem*'s
publication, Harpers hired William Robinson, a sixty-eight-year-old African
American driver of a horse-drawn carriage, to place in his cart a 6-foot replica
of Douglas's dust jacket and drive it around neighborhoods in Manhattan,
Brooklyn, and Harlem (see fig. 6).[85] Robinson said that folks became so inter-
ested in Douglas's image that they were persuaded to go and buy a copy of the
book for themselves, and *Publishers Weekly* claimed the promotional stunt had
contributed to the huge sales of 11,000 copies during the first two weeks
alone.[86]

While it was not unusual for publishers to enlarge book jackets for window
displays, carrying the replica in a horse-drawn carriage amounted to spectacle,
even in New York.[87] Further, the contrast between Douglas's highly modern

jacket design and the outmoded horse and buggy suggested the disjuncture between the modernist product and an advertising stunt drawn from old stereotypes. In *Publishers Weekly*'s coverage of the event, Robinson's speech was transcribed in dialect. His description of one incident on his route through Manhattan spoke to the collision between old and new embodied in this promotional gimmick. Though he said he would stop at the traffic lights, the police would sometimes call out, "Come on Pop," and Robinson described how "dey lets me by right out in front o' all de swell automobiles."[88]

Perhaps finding their unsettling juxtaposition of black stereotype and modernist art an irrational promotional device, Harpers orchestrated a different stunt for McKay's next novel, *Banjo*. This time, instead of carting a replica of Douglas's new jacket design for this book, they "sent a wagon around New York carrying" a *real* "black French sailor strumming on a banjo" with a sign advertising McKay's book "On Sale Everywhere."[89] In this advertising scenario, Harpers promoted McKay's book using only stereotypical tropes—of an elderly black carriage driver and a black banjo player—without Douglas's "disruptive" modernist representation.

THE BONIS AND VIKING

The brothers Albert and Charles Boni founded their publishing firm in 1923.[90] Their connection with the Harlem Renaissance was much more tenuous than Knopf's or Harpers', but because they published Alain Locke's *The New Negro* in 1925, they carved a prominent, if limited, position among the Harlem Renaissance publishing houses.

With an arresting, minimalist image by Winold Reiss on the book's dust jacket, the reader opened the volume, passing Reiss's beautiful, pink on white, primitivist end paper designs, turning to the decorated title page and facing frontispiece by Reiss, printed in color (fig. 45). The reader had no doubt that this was a beautifully produced volume, in which illustrations and book decorations played a major role. From the outset, she was prepared to consider the visual components on an equal footing with the fiction and poetry by Rudolph Fisher, Langston Hughes, and Countee Cullen, and the essays by Locke, Jessie Fauset, Charles S. Johnson, and Albert Barnes.

Moreover, the visual imagery emphasized Locke's editorial message of newness and modernity that New Negroes were contributing to American culture. Reiss's bold lettering and graphic decoration on the title page communicated modernist styling, while his frontispiece illustrated a modern Madonna—an

Figure 45. Winold Reiss, *The Brown Madonna*, frontispiece illustration and decorated ti-
tle page for Alain Locke, ed., *The New Negro* (New York: Albert and Charles Boni, 1925).
Courtesy of Special Collections, University of Houston Libraries. Reprinted with per-
mission of the Winold Reiss Estate.

African American mother gently holding her black child. The artist's primi-
tivist Art Deco chapter headings further integrated graphic decoration and text,
while also adding a modernist flavor to the page designs. Further, his pastel
portraits gave visual form to the book's many contributors, while also develop-
ing a new appreciation for black skin and physiognomy. The young Aaron
Douglas also contributed six "drawings and decorative designs," several closely
interpreting their accompanying texts.[91] In addition, reproductions of three
drawings by Covarrubias of Harlem's cabaret life as well as some of the boldly
stylized African sculpture in Albert Barnes's collection graced *The New Negro*'s
pages. Several reviewers of the book commented on its intense beauty. In a rare
instance, Robert Bagnall *began* his review by praising all the illustrations, as
well as the book's binding, concluding, "The physical side of the book—utterly
apart from its reading matter, makes the volume a valuable possession—one to
be treasured."[92]

The collection represents the work of another important interracial partner-
ship. From the time of his earlier commission by Paul Kellogg to illustrate the

special Harlem issue of *Survey Graphic,* which formed the starting point for the Boni book, Winold Reiss developed a fertile relationship with Alain Locke, who sought a modern visual component for the nascent New Negro movement.[93] In his search, Locke significantly overlooked a number of black American artists, like Albert Smith and Laura Wheeler, who were then creating illustrations for the *Crisis* and other publications, because he felt that their work lacked innovation and suffered from "racial expression which was only experimental."[94] By contrast he exclaimed that Reiss, despite his "foreign" heritage, had developed a specifically racialized visual language, especially in his portraits, which gave new visual form and color interpretation to the varying skin tones of African Americans, from light brown to dark black. "By the simple but rare process of not forcing . . . a foreign convention upon a racial tradition," Locke wrote in 1925, "[Reiss] has succeeded in revealing some of the rich and promising resources of Negro types." He further claimed that Reiss searched "not merely for decorative elements, but for the pattern of culture from which [the design] sprang" in his effort to give visual form to "the racial and the local."[95] Therefore, for Locke, Reiss's distinctive, racialized interpretations of black contributions to American culture in his portraits and primitivist book decorations stood as modern visual markers of New Negro identity and could become "a path-breaking guide and encouragement to . . . the younger Negro artists" like Aaron Douglas and James L. Wells, who would soon play central roles in the illustration of Harlem Renaissance print culture.[96]

Also in 1925, Albert and Charles Boni published R. Emmet Kennedy's *Mellows: A Chronicle of Unknown Singers,* a book lavishly illustrated by Simmons Persons. The book charted the history of Negro spirituals and work songs from Louisiana, which the author also set down in musical notation. *Mellows* represented the efforts of this Euro-American ethnomusicologist to preserve forms of black American music that he had studied in various regions of the South. As Negro spirituals and other types of black music had formed an important section in Locke's *New Negro,* the Bonis decided to advertise these two volumes together as recent releases, courting readers in *Opportunity* and *Crisis* who had interest in *The New Negro.*[97]

While each book emphasized the cultural contributions of African Americans to American life, the Bonis' forced relationship between them was actually quite tenuous. By contrast to Locke's claim for the New Negro's modern American identity and distinctive cultural gifts to modern America, Kennedy charted the expression of "unknown singers," folk artists for whom he claimed no modern agency or even authorship. Instead, as a modern observer of folk life, he sought to faithfully record the vernacular musical expressions of the black

Figure 46.
Simmons Persons,
Clothes-Pole Man, in
R. Emmet Kennedy,
*Mellows: A Chronicle of
Unknown Singers*
(New York: Albert and
Charles Boni, 1925).

working classes in Louisiana, whom he characterized throughout his book as part of an older tradition. In providing a kind of visual documentation, Persons's realistic illustrations visualized for the reader Kennedy's transcribed fragments of folk culture and music. For example, one drawing (fig. 46) depicted the author's description of surviving traditions in New Orleans:

> Among the many quaint old customs which still prevail there, perhaps the most characteristic is the going about of the Negro street vendors with their plaintive, melodious cries by which they announce their wares. Many of the old families still adhere to the time-honored custom of having the weekly washing done in the back yards, thereby enabling the clothes-pole man to continue plying his simple trade, making his periodical visits to town with a bundle of long white ash clothes-poles on his shoulder. His cry is a sort of spasmodic ejaculation given in loud, deep tones.[98]

After this passage in Kennedy's text, musical notation appeared, transcribing the clothes-pole man's cry. Beneath the bar of music, Persons's illustration

visually recorded the "quaint old custom."[99] His romanticized scene of a folk tradition provided a stark contrast to the modernist illustrations by Reiss and Douglas in *The New Negro*, which gave new visual form and expressive agency to modern black individuals.

The following year, the Bonis published *Blues: An Anthology*, another book that aimed to transcribe black, working-class music.[100] This time, however, the black musicologist and bandleader W. C. Handy transcribed and edited the tunes, and he is credited as the first to put these blues melodies and songs to paper.[101] The book's organization was very different from that of *Mellows*. Rather than interspersing text, musical notation, and illustrations, *Blues* began with a textual introduction by Abbe Niles, while Handy's voluminous pages of music constituted the primary body of the volume. The first section of text included a frontispiece and eight full-page illustrations by Miguel Covarrubias, giving visual form to the modern blues musicians who played the tunes Handy had transcribed. Far from Persons's nostalgic views of southern folk, Covarrubias employed his signature mode of exaggeration in modernist caricatures that caught vividly the blues performances of singers and instrumentalists in Harlem's cabarets. As full-page illustrations separated from the musical notation, they both interpreted the tunes and garnered autonomous artistic expression, allowing the reader to experience something of the evocative blues performances Covarrubias had witnessed.

While these Boni books ranged in their approach to black subjects and their choice of cultural expression, they shared a sumptuous production, each with keen attention to illustration, design, and quality paper and printing. Fine design and production also characterized the limited number of illustrated Harlem Renaissance volumes at Viking Press, which had been established in 1925.[102] B. W. Huebsch, the primary editor of the new house, established a close relationship with James Weldon Johnson, publishing his *God's Trombones: Seven Negro Sermons in Verse* in 1927 and his *St. Peter Relates an Incident of the Resurrection Day* in 1930. These two books received critical acclaim and important awards for their illustrations and decoration by Aaron Douglas. *God's Trombones* included eight illustrations by the artist, which were highly awarded with rare inclusion in AIGA's American Book Illustration exhibition of 1927–28. *St. Peter* carried on its binding Douglas's illustration of a trumpeting angel from one of his *God's Trombones* illustrations. For its binding decoration and overall design, this book also won inclusion in an AIGA exhibition of the best fifty books of the year.

In 1929, Viking brought out another book with Douglas's illustrations, Paul Morand's *Black Magic*. Together with his *God's Trombones* illustrations, his *Black*

Magic compositions won him the most critical favor, and several reviewers characterized his gouache drawings for these books at Viking as increasing considerably the aesthetic and monetary value of their publications. W. E. B. Du Bois, for example, wrote of Douglas's *God's Trombones* images, "There are eight full page drawings, wild with beauty, unconventional, daringly and yet effectively done. There are few persons who can afford not to have this book in their library."[103] Similarly, as noted at the outset of the chapter, Carl Van Vechten judged that the artist's *Black Magic* illustrations "alone are worth the price of the book."[104]

Though the critical response to Douglas's illustrations was strikingly unified, the content of the books remained dichotomous. In *God's Trombones*, the African American author and musicologist James Weldon Johnson wrote a prayer and seven poetic sermons responding to various texts in the Bible, but filtered through the black preaching style, which he felt was a neglected American art form. In *Black Magic*, the French author Paul Morand composed eight fictional stories of black life in the United States, the West Indies, and Africa, which stemmed from his engagement with atavistic stereotypes that blacks, wherever they might be found, would always revert to primitive behavior. The books shared similarity, however, through their fine production at Viking, which highlighted their full-page, gouache illustrations by Douglas, each incorporating his signature silhouettes. In these compositions, he capitalized on the full gray scale the gouache medium allowed to bring a layered complexity to his imagery. In addition to Douglas's drawings, each book incorporated decorative lettering at the heading of each chapter and well-designed typeface and pages. With such high production values, the books' visual appearance carried as much weight as their texts, an attribute that won Viking distinctive awards and unusual critical attention.

CONCLUSION

From this overview, a clearer picture of Harlem Renaissance illustration has emerged in the context of American book illustration. Extending the modern styles of American dust jacket design and illustration, the boldly silhouetted forms of Aaron Douglas's primitivist images, E. Simms Campbell's vernacular compositions, and James Wells's working-class scenes embraced modern graphic trends while also creatively reformulating them to evoke distinctly racial expressions. Those illustrators, like Laura Wheeler or Lois Jones, who employed more realistic line drawings were nonetheless sensitive to the modern integration of image and typeface. They also devised interpretive strategies

to offer autonomous creative expressions that were not bound to the text alone. While Jones, for example, worked closely with McBrown's poetry to provide careful interpretation, she also moved beyond it to insert a racialized message. Harlem Renaissance illustrations look all the more modern when seen in the context of the demoralizing black stereotypes perpetuated in Octavus Roy Cullen's hackneyed books, and the complexity of Miguel Covarrubias's modernist caricatures stands out in further relief.

A broader understanding of Harlem Renaissance illustration in the context of the American publishing industry reveals that commissions for African American artists to design book decoration were more rare than magazine illustration assignments. While black illustrators received frequent commissions from Carter Woodson's Associated Publishers, the non-black publishing firms in New York drew on a racially and ethnically diverse group of authors, artists, and intermediaries in the production of their illustrated Harlem Renaissance volumes. While the relationships among authors, intermediaries, and publishers have gained scholarly attention, these associations become more complex when considering the contribution of the illustrators. These connections sometimes disclose white exploitation of black artists and authors, but they also divulge what were fruitful working relationships. Perhaps the most surprising revelations were Knopf's patronage of Douglas for dust jackets of non-black-authored texts without racial content and Countee Cullen's sponsorship of the struggling white illustrator Charles Cullen.

When it came to advertising Harlem Renaissance books, the publishers adopted various strategies that often depended on eye-catching illustrations. Carter Woodson, for example, appropriated the image of the well-heeled bookshelf teeming with handsome volumes that animated mainstream advertisements. For his Associated Publishers flyer, he created an alternative image of a distinctive New Negro library. The non-black houses tended to develop separate advertising tactics for the black journals and the mainstream, mass-market magazines with largely non-black readers, often unacquainted with Harlem Renaissance production. While developing an advertising message of racial uplift for the black journals, Knopf and Harpers typically relied on more salacious promotions to attract *Publishers Weekly*'s booksellers and other readers. In placing Douglas's dust jacket designs and Harlem Renaissance books within the context of stereotypical advertising copy or outlandish promotional stunts, Knopf and Harpers revealed that they were not averse to exploiting black artistic production in the name of shrewd marketing.

More often than not, however, these publishers realized the vital aesthetic and commercial value that good illustration afforded their books. Perhaps as

effective as a highly publicized promotional stunt, publishers' ads could boast of their books' distinctive illustrations, sure to add worth to any reader's library. And if a trusted cultural emissary attested to their value, all the better. When Carl Van Vechten exclaimed that Aaron Douglas's *Black Magic* illustrations "alone" were "worth the price of the book," Viking Press wasted no time in gracing their print ads with his laudable assessment. [105]

Critical Ambivalence:
Illustration's Reception in Print

Given the primacy of book and journal illustration in Harlem Renaissance visual culture of the 1920s and early 1930s, surprisingly few art and literary analyses of this work were published. The dearth of critical review was due in part to the medium itself, which found its place in the interstices between fine art and text, either overlooked by art critics or marginalized in book reviews as decoration deemed supplemental to the textual narrative. Interestingly, a small body of criticism on Euro-American illustrations emerged during this period in mainstream American newspapers, journals, and exhibition catalogues. Beyond isolated references, however, no comparable body of criticism emerged that addressed the prolific production of illustrations by the likes of Aaron Douglas, James L. Wells, Laura Wheeler, and E. Simms Campbell.

This chapter considers this lacuna by investigating the rare occasions when illustrations received recognition in the context of Harlem Renaissance print culture. As my point of departure, I consider the most expansive critical assessment of the illustrations associated with the Harlem Renaissance: Alain Locke's discussion of Douglas's illustrations for Eugene O'Neill's play *The Emperor Jones*. Locke's willingness to engage with the medium of illustration, however briefly, raises questions central to its reception as a serious art form, during a period in American culture when modern art was increasingly defined broadly as inclusive of painting, illustration, and varying forms of design and advertising. Yet his ultimate embrace of conventional artistic hierarchies guided his opinion that black artists would gain greater professional stature in the more established media of painting and sculpture, rather than in the interstitial print medium of illustration.

ALAIN LOCKE'S RECEPTION OF ILLUSTRATION

In enumerating young black artists' vivid contributions to modern African American artistic production in 1926, Langston Hughes summoned up "Aaron Douglas drawing strange black fantasies."[1] While his evocative phrase is now one of the best known references to Douglas's printed imagery, there were surprisingly few published appraisals of his book and magazine illustrations during the 1920s and 1930s, given his steady and prolific production. Alain Locke penned the most extensive critique of Douglas's illustrations in two captions published in the February 1926 issue of *Theatre Arts Monthly*. Locke first remarked on Douglas's illustration of the *Emperor Jones* (see fig. 87):

> In a striking series of interpretative designs based on Eugene O'Neill's *Emperor Jones*, the young Negro artist, Aaron Douglas, has recaptured the dynamic quality of that tragedy of terror. There is an arbitrary contrast of black masses and white spaces; and the clash of broken line becomes highly expressive in suggesting the proximate collapse of the Emperor's throne and the fear it inspires.[2]

Demonstrating keen aesthetic insight, Locke gave voice to the power of Douglas's symbolic techniques in this composition, in which the layered and fragmented forms seem thrown into motion, suggesting the imminent "collapse" of Jones's empire. In the caption accompanying Douglas's *Forest Fear*, Locke traced the force of Douglas's ability to merge design elements with dramatic sensibility (see fig. 88):

> The tropical jungle closing in on the defeated Brutus Jones is here suggested by Aaron Douglas with utter simplicity of means, yet with no sacrifice of psychological verisimilitude. There is a sharply defined sense of dramatic design—of drama in design. This power is one often missing among men of greater technical skill but less vivid imagination.[3]

While Locke judged the *Emperor Jones* illustrations as worthy objects for careful visual analysis, he nonetheless concluded this second caption on a slightly ambiguous note, emphasizing Douglas's relative inexperience as an artist. In this vein, he presaged an attitude Douglas himself would assume a year later in a letter to Countee Cullen. In listing his many illustration credits for a brief biography, Douglas self-effacingly worried "that a partial conclusion

on the basis of what little I have accomplished up to date would be quite premature."[4]

Yet, the question arises whether Locke and Douglas reflected actual concern about the artist's inexperience, or whether the critic and artist shared an ambivalence toward the medium of illustration itself. Certainly, Locke accorded the illustrations of Winold Reiss, Douglas, and Miguel Covarrubias a central role in his groundbreaking volume, *The New Negro*. In fact, in a section titled "Notes to the Illustrations," Locke paid tribute to Reiss's role in organizing and executing the decoration and illustration of the collection:

> The art lay-out of *The New Negro,* including cover design, decorative features and illustrations, represent the work of Winold Reiss, who has painstakingly collaborated in the project to give graphic interpretation of Negro life, freshly conceived after its own patterns. Concretely in his portrait sketches, abstractly in his symbolic designs, he has aimed to portray the soul and spirit of a people.[5]

In calling Reiss a collaborator in *The New Negro* project, Locke conceived of Reiss's art direction, book decoration, and illustration as vital contributions to the collection that aided in the reader's more complete understanding of "Negro life." Further indicating the critical work Locke believed possible of the medium, he predicted Reiss's illustrations of "Negro types" would become important source material for future artistic production:

> By the simple but rare process of not forcing an alien idiom upon nature, or a foreign convention upon a racial tradition, he has succeeded in revealing some of the rich and promising resources of Negro types, which await only upon serious artistic recognition to become both for the Negro artist and American art at large, one of the rich sources of novel material both for decorative and representative art.[6]

However, the thrust of this passage also suggests that Locke appreciated Reiss's illustrations for the lessons they could teach as much as for their artistry. Indeed, in his *New Negro* essay, "The Legacy of the Ancestral Arts," Locke expressed the didactic potential of these illustrations, claiming that Reiss's *New Negro* pastels and decorations had been "deliberately conceived and executed as a path-breaking guide and encouragement to this new foray of the younger Negro artists." He further assured that they were "not meant to dictate

a style to the young Negro artist, but to point the lesson that contemporary European art has already learned—that any vital artistic expression of the Negro theme and subject in art must break through the stereotypes to a new style, a distinctive fresh technique, and some sort of characteristic idiom." Here, Locke acknowledged his belief that Reiss's illustrations represented "guides" and "lessons" for "the younger Negro artists," and by implication that the medium of illustration could hold as one of its primary aims the purpose of instruction rather than pure aesthetics.

In his many essays on art, Locke further implied that black American artists would achieve their most significant artistic expression in formal paintings and sculpture rather than in the print medium of illustration. In *The New Negro*, Locke lauded Henry O. Tanner as "our Negro American painter of outstanding success," while also crediting the painting of Laura Wheeler and the sculpture of Meta Warrick Fuller and May Howard Jackson.[7] Judging their work, however, as "not highly original," Locke pointed to the younger artists, including Archibald Motley, Albert Smith, and Douglas, as embarking on what he called a new "racial school of art" that revealed "the promising beginning of an art movement."[8] In discussing their work, however, Locke omitted reference to their specific media, undoubtedly in part because each artist worked in varied forms. But, it seems fair to suggest that Locke's reluctance to name Smith a graphic artist or Douglas an illustrator implicates Locke's resistance to fix these artists' young careers to the graphic arts alone. Later, in a 1931 article, Locke openly applauded black artists' achievements in "design and decorative black-and-white media," paying tribute to Aaron Douglas as "the pioneer of the African Style," whose "book illustrations have really set a vogue for this style." Nevertheless, Locke felt that James L. Wells's prints and Douglas's illustrations had been surpassed by the "neo-primitivist" sculptural expression of Richmond Barthé and Sargent Johnson. "In fact it is my opinion," he concluded, "that sculpture will lead the way in this direction."[9]

Locke was unusual among American art critics in turning serious attention to the "black-and-white media," with specific articulation of illustration's merits. However, in the same way that Locke perceived in *The New Negro* that black culture had entered "its adolescence . . . and approach to maturity,"[10] he seemed to assess the production in illustration by Douglas and Wells as precocious but youthful experiments that would lay the groundwork for more substantive achievements in painting and sculpture.

CRITICAL RECEPTION OF
HARLEM RENAISSANCE ILLUSTRATION

How did Locke's assessments comport with other appraisals of illustration and its place in the artistic hierarchy in African American media and in the non-black mainstream press? Not surprisingly and without exception in both venues, critics and journalists reported more frequently on exhibitions of painting and sculpture than on illustrations in either books or magazines, and they generally held paintings and sculpture in greater esteem than works in illustration.[11] However, a small body of specialized criticism emerged in the *New York Times,* selected journals, and exhibition catalogues that addressed illustrations in mainstream publications with sensitivity and rigor, arguing for a uniquely modern form that embellished its text while maintaining its own autonomy as visual expression. Though almost without exception, this criticism did not include consideration of illustrations in publications associated with the Harlem Renaissance.

Equivalently, illustration rarely received attention in the black press. Attitudes toward the medium in this venue tended to be shaped by the more prevalent, hierarchical ranking of illustration on the periphery of artistic production and by the often marginal status of American illustrators during the 1920s and 1930s.[12] On the rare occasions when illustration was covered, the commentary would appear in the context of a book review, where a literary critic or journalist might inject incidental and passing reference to a book's illustration. For example, in his *Opportunity* review of Vandercook's *Black Majesty,* John Matheus remarked without further modification that the book had been "decorated with unusual drawings by Mahlon Blaine."[13] With even less focus on the illustrations, Eugene Gordon told his readers in his review of Taylor Gordon's *Born to Be,* "the most interesting feature of the book, aside from the drawings by Covarrubias, is the language in which it is written."[14] After insightful analysis of James Weldon Johnson's sermons in verse in her *New York Amsterdam News* review of *God's Trombones,* Mary White Ovington devoted only one sentence to Douglas's images: "The illustrations for the volume are done by Aaron Douglass [sic] and are almost as beautiful as the text."[15] In her review of Countee Cullen's *Copper Sun,* Ovington needed just two sentences to critique Charles Cullen's illustrations, though failing to designate attribution to the artist: "The book is profusely illustrated but the pictures fall far below the excellence of the verse. Countee Cullen needs a rare genius to interpret his deeply imaginative poetry."[16]

Though her preceding analysis of Countee Cullen's poetry had been specific and detailed, Ovington neglected to explain what prompted her negative assessment of Charles Cullen's illustrations. By contrast, Richard Bruce Nugent made favorable, albeit brief mention of Charles Cullen's pen-and-ink illustrations. "I have just finished *Copper Sun* by Countee Cullen," he declared in *Opportunity*, cursorily adding, "it is very charmingly illustrated by Charles Cullen." Given Nugent's own work in illustration, his unwillingness to further assess Cullen's "charming" drawings seems surprising, if not uncharitable.

Even fewer accounts of Harlem Renaissance illustration emerged in the non-black mainstream press. Typically in these venues, reviewers mentioned the work of Harlem Renaissance illustrators in a dependent clause, as for example in the laudatory *Forum* review of James Weldon Johnson's sermons in verse. "One can hear the mouth-filling eloquence of the old-time Negro preacher and see him pacing up and down with perspiration streaming from his brow as one reads *God's Trombones,*" the reviewer waxed eloquent, cursorily adding, "superbly illustrated by Aaron Douglas."[17] Other critics would typically conclude their reviews with a gesture toward the book's illustration. One writer added at the end of his review of Countee Cullen's *Copper Sun* in the *San Francisco Chronicle* that it was "a worthwhile book of verse, and not the least notable thing about the little volume is the series of fantastic, interpretative drawings by Charles Cullen."[18] In relegating their appraisals of book illustration to a mere appendage of their reviews, critics in publications from *Opportunity* to the *New York Times* implied that the art of illustration found no integral function within the publications associated with the Harlem Renaissance but was instead an attractive, or sometimes detractive, afterthought.

Because these reviewers of books often lacked the experience necessary for analyzing visual production, it is perhaps unfair to expect more than cursory analysis of illustration in their criticism. However, in isolated cases, some writers in the black press considered work in illustration at greater length. In her monthly *Opportunity* column, "The Ebony Flute," the visual artist and writer Gwendolyn Bennett gave newsy accounts primarily of Aaron Douglas's illustrations and jacket designs. For example in 1926 she boasted, "The *Publishers Weekly* says that Mr. Douglas' advertisement for [*Nigger Heaven*] in the current magazines is the best for the month of June." Later, in 1927, she recounted, "*Plays of Negro Life* by Alain Locke and Montgomery Gregory is out and indeed is a beautifully printed book. There are some rather wonderful photographs and also some fine decorations by Aaron Douglas."[19] In a lengthier passage that year, she informed readers:

Aaron Douglas grows in popularity as a designer of jackets for the new books. Along with the outer cover for *Fine Clothes to the Jew,* Langston Hughes' new book, he has done the jackets for *Little Pitchers* by Isa Glenn, the author of *Heat,* James Weldon Johnson's forthcoming volume of Negro sermons in verse, and *Max Havelaar* or *The Coffee Sale of the Netherlands Trading Co.* by Multatuli. . . . these latter two are very beautiful in color and will be for sale in the book-shops in February. [ellipsis hers][20]

Given Bennett's activities as a writer, art teacher, and visual artist who on occasion produced her own illustrations, one might have expected her to direct more critical attention to Douglas's illustrations. Instead, she reserved her interpretation of his artistic technique for his work in painting, as for example his murals for Club Ebony.

I went up to see the new night club with Aaron Douglas, for he has done the mural decorations . . . and right marvelous they are, indeed. . . . In warm blues oranges and yellows he has depicted the Negro from jungle days on up to the modern jazz era. The figures are done in the characteristic Douglas manner and are extremely well-suited to the club. [ellipses hers][21]

Here, Bennett engaged with the paintings visually, as opposed to her more informational recounting of Douglas's illustration credits. She further attributed to the mural figures "the characteristic Douglas manner," which suggests hers and the reader's familiarity with Douglas's style. Significantly at the time of Bennett's writing in 1927, she and her readers would have known Douglas's artistic style best not from his murals but from his illustrative work in books and magazines. Yet, only with his shift to the medium of painting did Bennett turn her critical eye and public pen to "the characteristic Douglas manner."

W. E. B. Du Bois used similar shorthand to describe Douglas's style, though principally in reference to his decorative illustrations. He concluded his review of both *Caroling Dusk* and *Plays of Negro Life: A Source-Book of Native American Drama* with the declaration, "Aaron Douglas has decorated both these volumes with his usual arresting skill," implying that his readers would readily know other examples of Douglas's deft illustrative techniques.[22] While Du Bois willingly wrote about the artist's "usual arresting skill" in reference to his illustrations, both Du Bois and Bennett resisted further, more probing discussion of what they found "usual" or "characteristic" about Douglas's artistic style. Could Douglas's ubiquitous illustrations have so thoroughly permeated the con-

sciousness of his viewers, were they so integrally linked to the products of Harlem Renaissance print culture, that neither Du Bois nor Bennett saw the need to submit them to singular critique?

When contributors to black American journals gave more attention to the subject of illustration, some considered beautifully illustrated publications as significant cultural products of the nascent Negro Renaissance. A number of writers gave special attention to Douglas's eight illustrations for James Weldon Johnson's *God's Trombones,* a book of poems based on black styles of preaching (see figs. 63, 65, and 67). In his review of *God's Trombones,* W. E. B. Du Bois reserved special praise for Douglas's illustrations, alluding to an important connection between illustration and the modern economy: "Beyond the beauty of the poetry, the outstanding thing in this book is the illustration by Aaron Douglas. There are eight full page drawings, wild with beauty, unconventional, daringly and yet effectively done. There are few persons who can afford not to have this book in their library."[23] Significantly, Du Bois shifted from the beauty and daring of Douglas's illustrations to the necessary asset the book would afford the reader's library, suggesting links between the book's beauty as an illustrated text and its value as a prized cultural and economic commodity—a frequent connection made by publishers in their advertisements.

Similarly, Robert W. Bagnall began his review of Locke's *The New Negro* by praising the book's unusual beauty and craftsmanship, further suggesting its worth as a handsome product: "It is a thing of rare beauty, a beauty almost prodigal. . . . Alain Locke is fundamentally an aesthete, and Winold Reiss' appreciation of the lovely is well known. These two have done a job worthy of themselves in this volume and the House of Boni can congratulate itself on turning out such a product."[24]

In his second paragraph, Bagnall specified the innovative decoration contained in Locke's volume, concluding even more markedly than Du Bois that the volume's physical appearance, including its decoration and illustration, lent appreciably to its market value as a cultural commodity and a sign of economic worth:

> The cover design is striking, the type fresh and bold, the margins wide, the decorative illustrations novel, the drawings and symbolic sketches of Aaron Douglas powerful and effective, the two studies by Miguel Covarrubias startling in their animation, and the sixteen portrait studies in color by Winold Reiss, beautiful and revealing. The physical side of the book—utterly apart from its reading matter, makes the volume a valuable possession—one to be treasured.[25]

Thus, in the visual analysis rendered by Du Bois and Bagnall, beautifully illustrated publications, as products of the nascent Negro Renaissance, were marked as significant economic and cultural commodities able to compete within the fray of modern commerce.

Other critics in the black press considered the aesthetic design of a publication, in which illustration became an equally viable means to successfully express the text's overarching themes. For example, in his analysis of the short-lived little magazine *Fire!!*, Countee Cullen characterized the medium of illustration as playing an integral role within the artistic entirety of the publication. He began by interpreting Douglas's cover as a crucial contribution to the success of the little magazine. "With its startlingly vivid Douglas cover in red and black," he exclaimed, "*Fire*, on the whole, represents a brave and beautiful attempt to meet our need for an all-literary and artistic medium of expression." He concluded, "The laurels of the issue, we think, ought to be divided between Aaron Douglas for his three caricatures and Zora Neale Hurston for her play *Color Struck*."[26] In pairing the achievements of illustrator and writer, Cullen evinced his belief that both image and word functioned equivalently to support the artistic whole.

In an *Opportunity* review of Locke's *The New Negro*, V. F. Calverton also interpreted Reiss's visual expression as an integral component in the volume's success: "In conclusion, two things remain; the excellent artistry of Winold Reiss and the inspiring guidance of Alain Locke. Without Winold Reiss the book would lack much of the color and life that it now has, and without Alain Locke the book would lack its orderliness and clarity."[27] Calverton characterized Reiss's illustrative contribution as one of vital importance, mentioned in the same breath with Locke's editorial skill.

Similarly, in her only expansive analysis of the medium of illustration, Gwendolyn Bennett appreciated the interwoven relationships of "Music, Poetry, Decoration and Book-binding" in Eva Jessye's *My Spirituals*, a collection of lesser-known African American songs from the St. Louis region, where Jessye had spent her youth. Bennett assigned special significance to the illustrations in Jessye's volume:

As though to give the final and authoritative gesture to the arts the book holds some thirty-odd wood-cuts by Millar of the Roland Company. Were these decorations not so skillfully fit into the mosaic of the beautiful whole they would vie with the spirituals themselves for prominence. Seldom has an artist caught so perfectly the character of the Negro. Seldom, too, has an artist so carefully preserved the tenor of an author's text.[28]

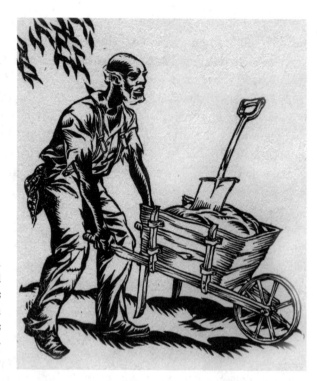

Figure 47.
Millar of the Roland
Company, *When Moses
Smote de Water,* in Eva
Jessye, *My Spirituals*
(New York: Robbins-
Engel, 1927).

Here, Bennett provided a sophisticated analysis of the ideal relationship she felt existed between the woodcuts of this presumed folk artist and the rest of the publication, which included Jessye's commentary and musical notation of the spirituals. She deftly analyzed Millar's sensitive portrayal of rural African American types, while also understanding what she perceived as illustration's special function to work integrally with the textual whole, rather than steal its own attention. Indeed, in illustrating Jessye's text, Millar situated his diminutive prints in a symbiotic relationship with the text and page designs. On a typical page introducing one of the spirituals, Millar floated his delicate woodcut of an African American farm hand in the upper left corner of the page, with the title of the spiritual in hollowed block letters providing visual weight in the lower right (fig. 47). Illustrating the cropped limbs of a tree brushing the elderly man's shoulders, Millar's fragmented composition held the reader's attention, at the same time that it submitted to the large open space of the overall page design.

Why would Bennett have reserved her insightful visual analysis for the work of a little-known illustrator rather than extending it to the work of her colleagues? Was she more comfortable assigning the role of ideal illustrator—who worked as sensitive collaborator rather than independent artist—to the enigmatic artisan instead of the emerging black artist?

In contrast to appreciating an illustrator's collaborative role, a few critics in the black press lauded an artist's independence from the printed page, especially when they deemed a text problematic. For example, when reviewing Isa Glenn's *Little Pitchers* of 1927—what John P. Davis proclaimed an uncommonly bad book—good illustration could serve as an emphatic foil. While complimenting this white author on her previous publications, such as *Heat,* Davis found her current book sadly missing the mark. He concluded his extremely negative review with a rare reference to the dust jacket illustration by Aaron Douglas: "When one has closed the book with somewhat of a feeling of nausea, it is refreshing to look once again at the brilliant colored jacket of Aaron Douglas. Mr. Douglas seems to be able to catch the spirit even of bad books. Let it be hoped that he has better books to illustrate in the future."[29]

In Davis's analysis, Douglas's "brilliant colored jacket" had risen above the mediocrity of the book it adorned, giving it pride of place as the dominating artistic force over its poorly conceived text. In successfully designing his jacket, Douglas maintained clear independence from the book's content (fig. 48). Superficially, he played visually with Glenn's title by embellishing on the saying "Sh! Remember the children, little pitchers have big ears," which the author invoked to describe her young narrator who heard only fragments of his parents' adult conversations. Beyond this visual reference, however, Douglas abandoned Glenn's text, instead using the cover design to further his experiments with Africanist forms, fragmented silhouettes, and new methods of rendering the human eye, here following the example of ancient Egyptian art.

Further recognizing illustration's potential power to circumvent a problematic text, Vera Fulton directed her attention to the drawings of a white artist rather than those by Douglas or his black colleagues. In her *Opportunity* review of the new issue of *Uncle Tom's Cabin* by Coward-McCann in 1930, the African American writer emphasized her disdain for Harriet Beecher Stowe's text by analyzing the new illustrations:[30] "This time James Daugherty has decorated it with pictures which show strength and originality when he relies on his own invention, but which are puerile atrocities when he adheres to the sentimental text. It is as though the slender grasping hand of Mrs. Stowe had reached down through these ninety years to pollute even the artist."[31] Particularly insightful in Fulton's analysis was her distinction between the times when Daugherty followed the text and those occasions when he deviated from it. Fulton deplored Daugherty's illustrations that supported Stowe's text, for they articulated the author's caricatured, stereotyped views of African American behavior.

On the other hand, Fulton implied that an illustrator, when especially inventive, could circumvent and comment on a bad or even racist text, thereby

Figure 48. Aaron Douglas, dust jacket design for Isa Glenn, *Little Pitchers* (New York: Alfred A. Knopf, 1927), copyright. Reprinted by permission of Alfred A. Knopf, Inc., a Division of Random House, Inc. Used by permission of Alfred A. Knopf, a division of Random House, Inc. Yale Collection of American Literature, Beinecke Rare Book and Manuscript Library, Yale University.

attesting to the power that illustration could wield upon the text it accompanied. Significantly, *Opportunity*'s editor, Elmer Carter, decided to reproduce one of Daugherty's especially effective illustrations on the cover of the March 1930 issue carrying Fulton's review (fig. 49). This powerfully rendered profile portrait represented Stowe's character Eliza as defiant and calculating, especially as she looked challengingly and even coyly toward the viewer through the cor-

Figure 49. James Daugherty, *Eliza*, in Harriet B. Stowe, *Uncle Tom's Cabin* (New York: Coward-McCann, 1930), reproduced on the cover of *Opportunity* (March 1930). General Research & Reference Division, Schomburg Center for Research in Black Culture, The New York Public Library, Astor, Lenox, and Tilden Foundations. Reprinted by permission of the National Urban League.

ner of her eye. In the Coward-McCann text, Daugherty's drawing appeared at the end of a chapter without a caption from Stowe's text, allowing its stark simplicity and strength of line to stand on their own. By contrast, his busily hatch-marked and sentimental drawing of Tom and Eva bore the caption, "Tom carried her frail little form in his arms resting on a pillow."[32] The drawing and text directed the reader's attention back to Stowe's "mawkish story," as Fulton called it, which had cast Tom for white readers as "the perfect Negro, docile, obedient, child-like in his trust and simplicity."[33] Maintaining independence from their texts, Douglas and Daugherty gained the acclaim of two black critics who applauded the autonomy they had established as illustrators. Rather than playing the role of accompanists alone, these draughtsmen had found a method of illustration that transcended slavish imitation of the "master" text.

RACIAL REPRESENTATION IN
HARLEM RENAISSANCE ILLUSTRATION

Critics remained divided, however, when illustrators exerted independence by developing modern methods of racial representation that verged on caricature. In response to Douglas's and Nugent's drawings for *Fire!!* and Miguel Covarrubias's many studies of black American and African types, heated debates arose about what constituted the most appropriate visual representation of black identity. In his scathing critique of *Fire!!*, Rean Graves of the *Baltimore Afro-American* barked, "Aaron Douglas who, in spite of himself and the meaningless grotesqueness of his creations, has gained a reputation as an artist, is permitted to spoil three perfectly good pages and a cover with his pen and ink hudge pudge."[34] In reviewing this kind of critical response to *Fire!!*, Wallace Thurman satirized the concerns of members of the black American bourgeoisie who expected themes of racial uplift in art and literature. "The American Negro feels that he has been misinterpreted and caricatured so long by insincere artists that once a Negro gains the ear of the public he should expend his spiritual energy feeding the public honeyed manna on a silver spoon," Thurman complained. He claimed that with such bourgeois readers *Fire!!*'s illustrative contributors were particularly "in disfavor," "Douglas because of his advanced modernism and raw caricatures of Negro types, Bruce [Nugent] because of his interest in decadent types and the kinks he insists on putting upon the heads of his almost classical figures. Negroes, you know, don't have kinky hair; or, if they have, they use Madame Walker's straightening pomade."[35]

Thurman reveled in Nugent's discordant classicizing of the "pickaninny" stereotype (see fig. 81) and Douglas's gentle mocking of the black preacher type in one of his contour drawings as part of a new cultural agenda to inject racial representations with variety, wit, and irreverence and to search for new types among the black working classes. While Countee Cullen also called Douglas's *Fire!!* drawings "caricatures," he nonetheless interpreted these compositions very differently. He valued the artist's "method of treating racial subjects in a successfully detached manner"—a quality Cullen often sought in his own poetry.[36] That two critics could come to such disparate conclusions about Douglas's set of contour drawings suggests that the gentle caricature he employed had successfully departed from mimetic representation, allowing a variety of artistic interpretations.

Adopting an even more stylized form of racial representation that many identified as caricature, Covarrubias received either accolades for his "highly modernistic renderings of dance types . . . in the negro cabarets in Harlem," or utter disdain for his "pictures of Negroes" that "look like geometrical figures rather than human beings."[37] Those who despised Covarrubias's work were primarily African American critics of an older generation, like Du Bois, who categorized his imagery as frivolous entertainment at best and demeaning caricature at worst. In reviewing Covarrubias's spread of illustrations for *Vanity Fair*, titled "Dark Denizens of Harlem Haunts," Du Bois colorfully described the artist's types, including the "corpulent blues singer, the waiter whose dancing feet are no menace to his well-filled tray, . . . the 'hard boiled' gambler and the lithe brown jazz dancer." But he concluded sarcastically that these images would amount to nothing more than "an unusually enjoyable five minutes' entertainment."[38] Judging the artist more harshly for his caricatures in Taylor Gordon's *Born to Be,* Du Bois declared, "I am frank to say . . . that I think I could exist quite happily if Covarrubias had never been born."[39] For Du Bois, the artist's distortion of black physiognomy connoted demeaning caricature, regardless of the degree of his exaggeration or comic dimension. Indeed, Du Bois seemed loathe to distinguish between the comic caricature of Covarrubias and what he identified as the "distressingly ugly and crude caricatures conceived by" the white artist Alexander King for W. C. Seabrook's *The Magic Island.*[40] In comparison to Covarrubias's stylizations of black cabaret types and his caricatures of white and black notables, King's illustrations bore no comedic component and portrayed figures of African descent as less than human.

By contrast, for Thurman, it was crucial to distinguish between different forms of caricature or stylization when it came to racial representation. He crit-

icized his readers for their inability "to fathom the innate differences between a
dialect farce committed by Octavus Roy Cohen," which characterized black be-
havior as buffoonish, and the more authentic "dialect interpretation done by a
Negro writer to express some abstract something that burns within his people
and sears him."[41] Thurman and other black critics repeatedly praised the au-
thenticity of Covarrubias's black representations, despite the artist's Mexican
ethnicity. For example, Thurman lauded Covarrubias for his "masterful" illus-
trations of "African types" in the *Adventures of an African Slaver,* while Countee
Cullen identified the artist's "uncanny feeling for the comical essence behind
those characters that he chooses to portray" in *Negro Drawings.*[42] In assuming a
typically nuanced position, however, Cullen distinguished between authenticity
and caricature in Covarrubias's "most interesting drawings" in this volume. In
"The Negro Mother and The Three Cuban Women, especially La Negrita,"
Cullen concluded, "honesty has not been subdued by caricature."

Because Covarrubias had established a strong reputation as a modernist
painter, illustrator, and caricaturist in both black and white artistic circles, his
work was exceptional among illustrators associated with the Harlem Renais-
sance in gaining significant attention from contributors to both the black and
mainstream presses. Among the white writers who praised his work, Ralph
Barton stated unequivocally that his illustrations for *Born to Be* were "simply
the finest book illustrations that have ever been produced on the North Ameri-
can continent."[43] Further underscoring a quality valued by black and white crit-
ics alike, Elisabeth Luther Cary admired Covarrubias's independence from
Canot's text in the *Adventures of an African Slaver.* She appreciated the artist's
"remarkable . . . designs" which had "turned rather sharply away from the au-
thor." "Snapping with vitality," in Cary's opinion, Covarrubias's illustrations of
"African faces" had successfully balanced "depths of secret experience and
sophistication."[44]

NON-BLACK CRITICISM OF MODERN ILLUSTRATION

Cary was one of several contributors to the *New York Times,* the *Dial,* and a vari-
ety of exhibition catalogues who formulated a broader, more integrated body of
theory and criticism concerning progressive illustration's vital contribution to
modern American art. Expanding on some of the themes addressed in the
black press, these critics appreciated the artistic whole that could materialize
through the collaboration of authors, publishers, and illustrators, with no one
part establishing visual dominance. They also valued an illustrator's au-

tonomous artistic expression, realizing that an illustration could not literally translate a text and might, indeed, accomplish independent expressive form. Finally, several critics made connections between book illustration and American commercialism.

Valuing above all else a publication's harmonious integration of typeface and illustration, L. B. Siegfried explained the trends in book decoration for 1927:

> Of the book as a whole it may be said that considerably more attention seems to have been given by publishers this year to the production of volumes in which pictorial, typographical and decorative elements are blended into a harmonious whole. Illustrations in an increasing number of cases have been considered not as illustrations only but as a part of the book which must be in harmony with other parts.[45]

In achieving such balance between the visual components of the publication, as well as between text and image, Edward Alden Jewell estimated the necessarily sensitive and even subsidiary role of the illustrator in his assessment of Rockwell Kent's illustrations for the 1928 Random House edition of Voltaire's *Candide* (fig. 50):

> Rockwell Kent here proves himself an illustrator of great distinction. He has, in these delicate drawings, closely followed the text, thus making his work serve as an embellishment that at no time carries the mind of the reader afield or causes him to consider these pictures as objects detachable from the page. So while it would be hard to praise too highly the artistic quality of these drawings, it is gratifying to find that Mr. Kent has remained in all cases true to the obligation assumed when he set to work on his arduous task of illustration.[46]

While critics agreed that illustrations should "closely follow" their texts, they also remained adamant that modern illustrators should enhance the written word with their own visual expression, which would not merely imitate language. For instance, J. Holroyd-Reece intimated his disdain for illustrators who contained their imagery by using a caption taken from a specific line in the text. Preferring less literalism and more metaphor, he distinguished between "the picture which tells the story" and the more subtle and preferable "picture which aims at indicating lightly and delicately the general atmosphere conveyed by the expression of the author." Of the latter pictures, he continued:

governor of Buenos Ayres?" Candide assured him on oath that nothing could be truer. Their tears began to flow once more. The Baron seemed never to grow tired of embracing Candide; he called him his brother, his saviour. "Ah! My dear Candide," said he, "perhaps we shall enter the town together as conquerors and regain my sister Cunegonde." "I desire it above all things," said Candide, "for I meant to marry her and I still hope to do so." "You, insolent wretch!" replied the Baron. "Would you have the impudence to marry my sister who has seventy-two quarterings! I consider you extremely impudent to dare to speak to me of such a fool-hardy intention!" Candide, petrified at this speech, replied: "Reverend Father, all the quarterings in the world are of no importance; I rescued your sister from the arms of a Jew and an Inquisitor; she is under considerable obligation to me and wishes to marry me. Dr. Pangloss always said that men are equal and I shall certainly marry her." "We shall see about that, scoundrel!" said the Jesuit Baron of Thunder-ten-tronckh, at the same time hitting him violently in the face with the flat of his sword. Candide promptly drew his own and stuck it up to the hilt in the Jesuit Baron's belly; but, as he drew it forth smoking, he began to weep. "Alas! My God," said he, "I have killed my old master, my friend, my brother-in-law; I am the mildest man in the world and I have already killed three men, two of them priests." Cacambo, who was acting as sentry at the door of the arbour, ran in. "There is nothing left for us but to sell our lives dearly," said his master. "Somebody will certainly come into the arbour and we must die weapon in hand."

Figure 50. Rockwell Kent, illustration in Voltaire, *Candide* (New York: Random House, 1928). By permission of the Plattsburgh State Art Museum, Rockwell Kent Collection, bequest of Sally Kent Gorton.

They are, as it were, illustrations which do not illustrate, though they are by no means mere decoration. They avoid direct interpretation; they do not 'illustrate' an incident, nor can they be related to any sentence, paragraph or chapter; they somehow convey and stimulate the general atmosphere of the book . . .; in short, the reader finds himself unconsciously ready to appreciate the story.[47]

In further distinguishing between literal translation and visual expression, Roger Fry asserted in the *Dial* that it was not feasible for an illustrator to duplicate an author's text in visual form. Instead, the illustrator would "embroider" on the author's language:

It seems to me that real illustration, in the sense of enforcing the author's verbal expression by an identical graphic expression, is quite impossible. But it may be possible to embroider the author's ideas, or rather to execute variations on the author's theme, which will not pretend to be one with the text but rather as it were a running commentary, like marginal notes written by a reader.[48]

Other critics, like Elisabeth Luther Cary, perceived the best illustrators as those who "felt the author's mental attitude and worked from within to give it the advantage of an additional language."[49] Similarly, in describing John Vassos's illustrative philosophy, the author Ruth Vassos contended that the image "should not be a repetition of a definite picture the author has drawn"; instead, "it must give the reader a further experience."[50]

In addition, several critics drew connections between book illustration and commercial art associated with advertising, perceiving a similar set of restrictions in each activity that ultimately allowed for significant creativity. Comparing the two artistic forms, Edward Alden Jewell proposed, "if limitations confront the commercial artist—limitations that . . . are essential to the success of the entire project—the same applies to artists who devote their talents to the illustration of books." Jewell was one among a number of artists and critics who lauded advertising art as possessing a "delightful freshness" that evinced an aesthetically and commercially profitable "reciprocal bond between commerce and art." Judging the best advertising art similarly to the best book illustration in working integrally with the total publication, Jewell claimed, "the most successful commercial artist is the artist who, without sacrificing his own peculiar character and charm, most smoothly merges his work in the scheme of the project as a whole."[51] Elisabeth Luther Cary further perceived that the

best illustrators and advertising artists contributed to a larger aesthetic project to deemphasize the growing technology in complex, full-color reproduction, instead favoring strengths in graphic design. "What high honor should be paid," she declared, "to the army of artists, publishers, advertising firms who disregard the alluring charms of the highly colored complicated appeal in favor of delicate force, individual pattern, the staying power of fine design."[52]

In this specialized body of criticism on modern illustration, critics held artists in high esteem who wove a fine line between illustrating as accompaniment and illustration as a second language. In their view, effective modern illustrators worked within the aesthetic limitations of the text and page designs, at the same time that their creativity emerged more freely in evolving the essence of the text into visual form, or in finding places within the text that allowed for autonomous visual expression. Some critics further perceived a shared relationship between illustrators and advertising artists in transforming the restrictive demands of their tasks into collaborative design projects that fostered interdependence between art, text, and American commerce.

MAINSTREAM CRITICISM AND HARLEM RENAISSANCE ILLUSTRATION BRIEFLY INTERSECT

While these writers were unusual in developing a body of criticism that situated illustration among the varied visual forms gaining resonance as modernist expression, they were predictable as contributors to the non-black mainstream press in omitting Harlem Renaissance print culture from their discourse. Therefore, almost without exception, Harlem Renaissance illustrators did not benefit from their assessments of illustration as a viable form of modernist artistic expression.[53] On one occasion, however, a mainstream critic assessed a 1927 exhibition of illustration that included Aaron Douglas's images for James Weldon Johnson's *God's Trombones*, published by the Viking Press. That exhibition was the second in a series of annual shows of American book illustration sponsored by the American Institute of Graphic Arts (AIGA). While the critic, Thomas Erwin, did not discuss specific illustrations, he pointed to new trends in modern illustration that he felt applied to all the works exhibited. In his "Introduction" to the exhibition catalogue, he touched on three themes that resonated among critics who turned their attention to modern illustration. First, he noted an important shift among modern illustrators who consistently resisted illusionism to better harmonize with typefaces

and page designs, and whose illustrations were printed on paper that matched the entire publication, rather than appearing on inserts of coated stock. "The old practice in America of illustrating novels with realistic halftone page inserts is now happily gone, or nearly so," Erwin uttered with relief, adding "it is encouraging to find more and more books in which the pictures are admirably keyed to the typography." Second, Erwin surmised the illustrator played a collaborative role in relationship to the text that distinguished itself from the work of other visual artists. "The successfully illustrated book is only achieved," he asserted, "when the illustrator is modest enough and artist enough to accept the role of accompanist or the commentator of the author. . . ." Third, despite the illustrator's role as "accompanist," the artist should nonetheless refrain from the exact translation of an author's text. "The best of the modern artists who have illustrated books," he opined, "have had better taste than to invade the author's show with literal illustrations of his text."[54]

AARON DOUGLAS AS SELF-CRITIC

Erwin's critical assessment of the AIGA exhibition that included Douglas's *God's Trombones* illustrations serves to highlight the significance with which Aaron Douglas evaluated this commission. Because few Harlem Renaissance artists commented on their production in illustration, Douglas's rare self-assessment aids in more fully reconstructing the medium's artistic reception. In line with African American critics from Locke to Bennett, Douglas revealed a certain critical ambivalence in discussing his illustrative work. In enumerating his illustration credits in 1927, he listed his dust jacket designs in groups by publisher, emphasizing quantity: "I have made jacket designs for six books published by Alfred A. Knopf. I have made the jacket and other decorations for *Kongo* written by Rene Maran and published by Charles and Albert Boni. I am now working on the illustrations and decorations for three books that Harper Brothers are going to publish."

By contrast, he reserved estimation of quality for his series of interior book illustrations. "My best work so far," he judged, "is the group of illustrations for James Weldon Johnson's 'God's Trombones.'" As noted at the beginning of this chapter, Douglas ended his discussion with the self-effacing remark "that a partial conclusion on the basis of what little I have accomplished up to date would be quite premature."[55] By examining his *God's Trombones* commission and his further statements about this print medium, we can surmise that Douglas's

critical ambivalence related to his desire to be esteemed as a painter as well as an illustrator and his worry that illustration work could carry the taint of commercialism.

Indeed, his *God's Trombones* illustrations consistently garnered him favorable response, and they were often characterized in subsequent biographies as the works that introduced his artistry to the American public before he embarked on his painting career.[56] On the whole, these illustrations followed the trends in modern book decoration articulated by Erwin in the AIGA catalogue, particularly in balancing close emulation of the text with autonomous visual expression and also in resisting illusionism. For example, Douglas captured the cadence, sense of movement, and some of the imagery in Johnson's poetry, while resisting the literal illustration of his text. In *The Creation*, Douglas animated the space with the large fragmented hand of God, a series of circles that lead to a point in the distance, and parallel bands that sweep swiftly across the sky, thereby providing an abstracted visual experience for the reader that expanded on Johnson's more specific imagery (see fig. 63):

> And the light that was left from making the sun
> God gathered it up in a shining ball
> And flung it against the darkness,
> Spangling the night with the moon and stars.
> Then down between the darkness and the light
> He hurled the world;
> And God said: That's good![57]

Most significantly in modernist terms, Douglas rendered his imagery in unmodulated silhouettes of varying tones from black to white, so that his scene would not interrupt the flatness of the text and page design.

However, Douglas's *God's Trombones* illustrations were reproduced using the halftone reproductive form known as the gelatine process, so that the subtle tonal gradations of Douglas's original gouache drawings could be effectively transmitted. Erwin had disparaged the halftone illustration in his catalogue essay, and his critique was reflected in the selection of illustrations for the exhibition. Of the 76 sets of illustrations on view, only 18 were reproduced using halftone processes, and the most common reproductive form was the line engraving. For the purist critics and artists, the line engraving was the only reproductive process that could most successfully match the printed page, with its "lattice-work of type," as W. A. Dwiggins called it. "To attempt to weld halftone and type into a harmonious whole," he argued, "is as futile as to attempt to

combine in the same design the mesh of burlap and the reticulations of a fly's eye." He continued, "when the lines and dots of a picture become so fine that the normal eye can no longer see them as lines and dots . . . the picture is ruled out, aesthetically, as unfit for use with type printed on book-paper."[58]

Clearly, Douglas was not a purist when it came to the halftone illustration. In fact, as self-critic in 1927, he assessed as his best illustrative work the *God's Trombones* compositions that could translate formidably in print through halftone reproduction but which retained aesthetic value as original gouache paintings. Perhaps most attractive to the artist in the *God's Trombones* commission from Viking was the freedom to explore a variety of ideas in Johnson's poetry, providing eight full page illustrations rather than one cover design encapsulating all of the book's themes. Further, rather than having to incorporate text into a dust jacket design, Douglas could focus on the imagery alone in each of his *God's Trombones* illustrations. To emphasize the separation between image and text, he surrounded each illustration with a dark, rectilinear band akin to the frame of a painting, as if to emphasize the proximity of the gouache medium to easel paintings in oil. Significantly in this light, his *God's Trombones* scenes were the only illustrative compositions to which he returned as an easel painter in a series of full-color paintings in oil on masonite between 1927 and 1935.[59] Significantly as well, Douglas retained the gouache on paper originals from which the *God's Trombones* book illustrations were reproduced; they are now held in the Walter O. Evans Collection of American Art. Painted in varying shades of blue and white, these gouache compositions represent carefully composed original works of art that Douglas employed strategically. Working as both a painter and an illustrator, he utilized varying tones of blue to further his exploration of color, while also employing value relationships that would reproduce effectively in black and white.

In this way, he could claim status as a painter, while also producing work that constituted successful modern design within the field of illustration. For Douglas was not content to play the role of illustrator alone. In letters and written reflections, he assumed conflicting attitudes toward his work in illustration. On the one hand, he viewed his early work in the medium as an important contribution to his artistic development that could adequately substitute for an art education abroad:

I had hardly reached the city before I was called upon to prepare cover designs and drawings and sketches to be used for illustrating texts of various kinds for both the *Crisis* and *Opportunity* magazines. This work soon convinced me that it was unnecessary to go all the way to Paris to master the

fundamentals of the art of painting and that a more reasonable course was to remain in America, and particularly in New York, and carry on my work.[60]

Elsewhere, he worried that illustration work in commercial venues would sully his artistic reputation. Rather than embracing the connection some critics made between modern illustration and commercial culture, his sentiments seemed closer to the "Golden Age" illustrators before him, who sometimes feared their illustrative work would carry the taint of commercialism. For example, he was increasingly annoyed by commissions in commercial illustration that he regarded as diverting attention from his more creative pursuits and as unworthy of the artistic status he wished to achieve: "I've been considerably upset this week. I have been ducking these commercial people. Literally running from money. There's good and bad money. The situation is this, if these fellows should give me work it would be the sort they don't want or can't do. I'm sharpening my teeth for the meat, not scraps and bones."[61]

On occasion, both Douglas and his mentor, Charles S. Johnson, characterized commercial artistic activity as a short-cut to fortune that would sully the artist's reputation. In 1927, Johnson wrote that Douglas "distinguishes himself from the majority of Negro artists by refusing to admit that his art education is complete . . . foregoing a comfortable position as art teacher in the high school in Kansas City to continue his studies, and sacrificing other comforts rather than prostitute his abilities in hack commercial work."[62] Similarly, Douglas resolved, "I shall . . . avoid cheap and premature notoriety. I have set in for solid attainment. That takes time."[63]

In his adversary attitude to the commercial market, Douglas contrasted markedly with E. Simms Campbell, the African American illustrator whose work most successfully gained admittance into the mainstream journals, including *Judge,* the *Saturday Evening Post,* and *Esquire.* Rather than resisting the artistic label of illustrator, Campbell "always . . . had a persistent yearning to do magazine illustrations, covers, cartoons, caricatures."[64] From his first commission to decorate a commercial sign for a St. Louis grocer, Campbell capitalized on the fertile modern relationships between business, advertising, and art.[65] Though Campbell's business savvy opened opportunities in commercial venues, his work in illustration did not gain the recognition of critics in the black or mainstream presses. Instead, journalists, primarily in black-authored publications, reported on his story as a successful businessman. Valuing artistic reputation over commercial opportunity, Douglas realized that no critical apparatus existed to evaluate the specializations in commercial work or illustra-

tion of Campbell and other Harlem Renaissance artists. He, therefore, resisted limitation to these media, often using his work in illustration to prepare for eventual commissions in painting, which were sure to garner him more substantive critical response and carry more cultural capital.

CONCLUSION: THE POLITICS OF ILLUSTRATION

The dearth of critical response to illustration in the 1920s and early 1930s suggests the medium functioned as a double-edged sword for artists associated with the Harlem Renaissance—a creative opportunity that could nevertheless mark the illustrator's work as derivative of the text. In the light of contemporary criticism that prized the illustrator as an "accompanist" and illustration as "embellishment" that should "closely follow" its text, the relative silence in the black press on the work of modern black illustrators takes on political dimensions. At the nascent historical moment in the 1920s, when African American artists sought to assert their cultural independence, and when that independence was fraught with countless directives from advisers, patrons, and publishers, the task of the illustrator must have resonated with shades of an earlier culture of dependence and subservience. Given the politics of illustration, Gwendolyn Bennett comfortably praised a folk artist for "carefully preserv[ing] the tenor of an author's text" in his illustrations, while seemingly unwilling to characterize the illustrative art of Aaron Douglas as taking a similarly supporting role, choosing instead to remain silent in assessing that body of his work.

Yet, simultaneously, critics in both the black and mainstream presses valued autonomous illustration that acted as more than a slavish translation of its text. That critical commentary revealed the tactics Harlem Renaissance illustrators employed to circumvent problematic or even racist texts. When illustrators verged toward caricature, however, critics debated the viability of their independence from mimetic representation.

Alain Locke and Aaron Douglas held conflicting attitudes toward illustration, particularly in relationship to its commercialism. Douglas created jacket designs with specific commercial dimension, yet he held advertising illustration in great disdain, diverging from those critics in the mainstream press who saw fertile connection between book illustration and advertising art. Though Alain Locke readily valued the broadly circulated illustrations of Douglas and James L. Wells, he hoped for more prestigious opportunities for young black artists in the media of painting and sculpture, revealing his regard for conventional artistic hierarchies that distinguished between fine and commercial art.

In their critical ambivalence toward illustration broadly and commercialism specifically, Locke and Douglas also demonstrated their artistic and cultural savvy. For it was less the medium of illustration and more the limitation to the medium that they seemed to resist. They perceived that for black American artists to limit themselves to illustration meant contending in part with the taint of commercialism or the perception of subservience to a text, which carried specific cultural liability for black artists. Yet, Locke's critical engagement with the medium and Douglas's prolific illustrative production suggest their sympathies with those critics who asserted illustration's power as an extraordinarily creative visual medium that demanded collaboration as well as independence.

Critical Themes in
Harlem Renaissance Illustration

Remaking the Past, Making the Modern: Race, Gender, and the Modern Economy

With its carefully crafted markers of race and gender, as well as class, Joyce Carrington's stunning cover image for the *Crisis* of September 1928 boldly asserted the modernity of African American identity (see fig. 4).[1] Wearing a modern, bobbed hairdo and popular neo-Egyptian jewelry accented in an emerald green, Carrington's attractive female figure stood as an icon of contemporary fashion and upper-middle-class status. Attesting to her exotic "bronze" beauty, a "primitive" palm tree swayed in the background at right. While she connected with the modern Egyptomania of urban culture, she also traced her roots to ancient Egypt, symbolized by the pyramid in the background at left. In this way, she made a meaningful connection to this ancient culture beyond the faddish mimicry displayed in modern mainstream advertising. Instead, she drew an assertive connection to Egypt that embodied the reclamation of ancient ancestry in this northern African region—a privileged heritage that could sustain due membership in America's modern economy.

In this chapter, I use Carrington's image as a catalyst to explore two related themes animating a number of Harlem Renaissance illustrations. First, many artists, as well as cultural critics, called upon a usable past in order to celebrate a connection between ancient origins in Egypt and contemporary participation in the modern industrial environment. Rewriting racist stereotypes that blacks had no past but remained stunted as evolutionary children, these artists and writers transgressively asserted a blood connection to ancient Egypt as the originating site of civilization in the West. Bolstered by the civilizing gifts that they had offered to modern culture, they argued their right to participate as equal citizens in America's democracy. In emphasizing this basis for equal citizenship and economic success, Harlem Renaissance illustrators used a variety of visual techniques from modern advertising to further suggest the modern eco-

nomic status of African American figures. Second, in assigning gender to the modern African American citizen, illustrators often privileged male figures with modern identity and evidence of economic success, while relegating female figures to function allegorically as timeless ideals. However, women artists consistently devised a specific female type to which they assigned modern identity: the young, brown-skinned, fashionably garbed woman, usually with bobbed hair. On the one hand, this figure drew strength from the nascent African American beauty culture, but as a light-skinned type, she represented the extremely restricted access of black women to American standards of beauty, as well as consumer citizenship.

FROM USABLE PAST TO MODERN COMMERCE

Many black American illustrators reclaimed global connections to an illustrious past in ancient Egypt in their efforts to make black identity modern in Harlem. By creating a "usable past," they subverted the largely uncontested, racist narrative perpetuated in mainstream American culture that those of African descent had no history, but remained in a precivilized state as the "brown children of the world," in the words of Charlotte Mason, one of the white patrons of Harlem Renaissance writers.[2] In rewriting their cultural origins, black artists recast their past as an ancient, generative force that could bolster a new and rightful participation in America's modern commercial economy. Drawing in part on examples of magazine advertising and product design, Harlem Renaissance illustrators developed new visual strategies particularly suited to their reading audiences, whose attention needed quick capture. In their new visual language, ancient pyramids and temples became iconic signifiers of civilized Egyptian roots that could foster modern creativity and commercial success. For example, in his May 1928 cover of the *Crisis*, Aaron Douglas created a compelling cover image to draw the reader into this issue of the magazine (fig. 51). He presented two silhouetted African American figures among iconic representations of modern tall buildings. A bright arc form connects them in their modern environment with an illustrious past in ancient Africa, represented by the Egyptian pyramids in the background at left.[3] In this image, Douglas boldly drew direct lineage between ancient Egypt and modern African America. Because ancient Egypt was a global progenitor, which Europeans and Euro-Americans claimed as their illustrious ancestor, Douglas entered contested territory when reclaiming ties to this ancient culture. Long anticipating contemporary historian Martin Bernal's controversial proposition

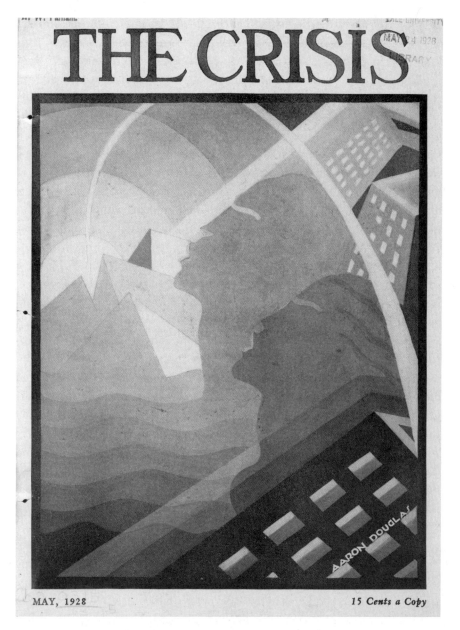

THE CRISIS

MAY, 1928

15 Cents a Copy

Figure 51. Aaron Douglas, *The Young Blood Hungers,* cover of the *Crisis* (May 1928). Yale Collection of American Literature, Beinecke Rare Book and Manuscript Library, Yale University.

of "the Afroasiatic roots of classical civilization,"[4] Douglas declared common
origins for non-black and black Americans—for Africans and Westerners. Rad-
ically asserting a bloodline to ancient Egypt, he mirrored the tactics of W. E. B.
Du Bois and other black writers of the period, who characterized the ancient
civilization of Egypt as Africa's great contribution to human history.

In his reappropriation of ancient Egyptian ancestry, Douglas claimed con-
temporary rights to commercial success for modern African Americans. His vi-
sual connection between a usable past and the modern economy becomes
clearer within the larger context of American advertising.[5] His juxtaposition of
modern and ancient cultures found parallel in mainstream magazine adver-
tisements, which often compared contemporary products with ancient monu-
ments to endow them with "the notion of timeless beauty" and utility.[6] For
example, in a *Vogue* ad of 1927 for Saks Fifth Avenue's line of women's shoes,
Raymond Loewy drew the reader's eye to a large, fashionable shoe held atop a
structure resembling an ancient, stepped pyramid (fig. 52). At the same time,
the structure suggests a futuristic tall building illumined by modern search-
light shafts that criss-cross the night sky. Typically for Art Deco designers and
advertisers, Loewy enhanced the modernity of the Saks product through the dy-
namic intersection of ancient and modernist styling. Similarly, Douglas illu-
mined his central figure with a modern searchlight shaft, which emphasized
the figure's interstitial position between the ancient pyramids and skyscrapers
gleaming with electric lights. Further, by comparing African American identity
to modern city buildings, he drew on a related technique of modern advertisers
who employed images of tall urban buildings to imbue their products and
those who used them with a savvy, modern sensibility.[7] In placing black figures
in close proximity with iconic tall buildings in his *Young Blood Hungers,* Doug-
las asserted their participation in American commercial culture, their moder-
nity heightened through connections to icons of contemporary advertising.

While some New Negro artists did not employ the modern Art Deco style in
their magazine illustrations, they nonetheless embraced the strategy of linking
ancient Egyptian origins with modern African American identity. One of the
most convincing illustrations in this category is Charles Dawson's August 1927
cover of the *Crisis,* titled *Drawing with Five Great Negro Buildings* (fig. 53). In this
drawing, he used the image of an ancient Egyptian temple in the background
to signify a usable past for contemporary African Americans. Two African
American figures parade across his composition in profile in a manner resem-
bling ancient Egyptian relief sculptures. In dress and gesture, the female figure
suggests ancient identity. Her headdress and breastplate appear Egyptian in
style, whereas the torch held above her head suggests the classical figure of Lib-

Figure 52. Raymond Loewy, *Metropolis*, 1927, advertisement for Saks Fifth Avenue, in *Vogue* (March 15, 1927). TM/©2006 Raymond Loewy by CMG Worldwide, Inc. www.RaymondLoewy.com.

Figure 53. Charles Dawson, *Drawing with Five Great Negro Buildings,* cover of the *Crisis* (August 1927). Yale Collection of American Literature, Beinecke Rare Book and Manuscript Library, Yale University.

erty that has for so long greeted immigrants in New York.[8] Donning a mortar board and contemporary dress, the male figure stands in for contemporary African American youths who, through their education, usher in an age of renewal that compares favorably with the pinnacles of ancient civilization.

In the background, Dawson pictured "Five Great Negro Buildings," as he called them. The four modern buildings were familiar to *Crisis* and *Opportunity* readers as contemporary institutions owned and operated by African Americans in the 1920s. For example, Dawson illustrated Poro College in the lower left, a school of "beauty culture," as it was advertised in the October 1927 issue of *Opportunity*.[9] In the lower right of Dawson's cover, he drew the building of the People's Finance Corporation in St. Louis.[10] Modeled after the pylon facade of an ancient Egyptian temple, Dawson's fifth "great Negro building" looms in the background as the progenitor of the contemporary businesses. In labeling it a Negro building, Dawson drew direct lineage between ancient Egypt and modern African America.

In his reappropriation of ancient Egyptian ancestry, Dawson further claimed contemporary rights to commercial success for modern African Americans through connection with American advertising that similarly linked modern products with ancient Egyptian motifs. For example, in a 1929 ad in *American Magazine* for Chrysler automobiles, the latest model appeared in the foreground, gaining prestige by association with the Egyptian temple pictured behind and the proclaimed Egyptian lotus-leaf styling of the car's front grill.[11] By reclaiming the ancient culture that provided an instant cachet for consumer goods in modern advertising, Dawson could promote contemporary black culture and economic endeavors as the "true" heirs of ancient Egypt.

In reclaiming ties to ancient Egypt, Dawson and Douglas joined many black American artists, writers, and cultural leaders who made it their project to express what they perceived as their rightful ancestry in this ancient culture in northern Africa. However, despite the geographical connections, asserting Egyptian origins as part of their African ancestry was anything but a benign claim for black Americans. To link Egypt with Africa, and therefore posit a blood relationship between African Americans and ancient Egyptians, transgressed conventional associations that limited African Americans to "precivilized" African ancestry and that refused to recognize ancient Egyptians as a people of color.[12] Not only did they claim common origins for Africans and Westerners, but they appropriated symbols that held potent historical associations for Euro-Americans. For example, for the founders of the American republic, many of whom were Freemasons, ancient Egyptian culture was a primary model, and ancient Egyptian motifs figured prominently in communi-

cating the nation's ideals of democracy and equality.[13] For example, the Great Seal of the United States carried the emblem of an unfinished Egyptian pyramid capped by an all-seeing eye, a Freemasonic symbol.[14] This visual reference, which has entered into American visual culture especially in engravings on currency, continues to help constitute a usable past for the nation with roots in ancient Egypt. When Douglas and other black American artists appropriated the familiar Egyptian pyramid and other ancient Egyptian motifs, they not only laid claim to rightful ancestry in this ancient culture, but also to rightful participation in the American democratic nation, which the pyramid had come to represent. Within the context of African American reclamation, therefore, the pyramid could also mark the disjuncture with American ideals of democracy and justice that black Americans had long experienced.

Among Harlem Renaissance illustrations, strategic references to ancient Egypt began to appear with frequency beginning in the early 1920s. Laura Wheeler was one of the first to include Egyptian-inspired imagery in her illustrations for *Crisis* covers. For the April 1923 issue (see fig. 24), she created a delicately silhouetted Egyptian female figure, wearing ancient costume and plucking an ancient angle harp, an instrument that figured regularly in ancient Egyptian reliefs and wall paintings. In her September 1924 cover, she depicted a group of ancient Egyptian figures: a male servant attending an elaborately dressed female figure with a tamed lion. Wheeler captioned the scene "The Strength of Africa," suggesting a new iconography in which the continent of Africa would find representation through ancient Egyptian forms. Here, she drew on Meta Warrick Fuller's important sculptural figure *Ethiopia*, created in 1921, in which she represented Africa in ancient Egyptian form as a partially mummified figure coming to life, wearing an ancient Egyptian headdress.[15]

As was true for Fuller in her sculpture, some illustrators emphasized the contributions of the ancient culture of Ethiopia, sometimes called Nubia during this period.[16] On the June 1927 cover of *Opportunity*, for example, readers saw Joseph C. Carpenter's muscular *Nubian with Tiger* presented as one of black America's ancestors. In this composition, Carpenter privileged the ancient civilization of Ethiopia, which had predated that of ancient Egypt. His "Nubian" figure may also suggest the reign of the Kushite or Ethiopian kings over ancient Egypt, suggested by the Egyptian mortuary temple in the middle distance.[17]

With his *Mask of Tut-Ankh-Amen* on the *Crisis* cover in September 1926, Aaron Douglas presented evidence that not only could readers claim "Nubian" ancestry, but ancient Egyptian kings could be counted among their forebears as well. Douglas drew the mask three-dimensionally, transcribing each detail of the original object with care. Thus, Tutankhamen's facial features, especially

his full lips, are highlighted and stand as evidence of this King's "Negroid" or African features.

Ancient Egyptian pyramids, in particular, became a common signifier of a civilized past for contemporary black citizens, appearing frequently on the covers of the black periodicals. For example, James L. Wells employed this strategy in his elegantly simplified linocut for the March 1931 cover of *Opportunity*, illustrating a contemporary black youth close to the picture plane who draws on his ancient heritage, given symbolic form by an Egyptian pyramid in the background. Similarly on the 1928 *Crisis* cover, Joyce Carrington's fashionable black woman connects with her ancient heritage, in the form of an Egyptian pyramid at left (see fig. 4). For Douglas's many illustrations, the ancient Egyptian pyramid read as a hieroglyph that signaled African America's civilized origins.

Pyramids could also suggest an illustrious past that would bolster the achievements of contemporary black citizens in the arts and other professional disciplines. Illustrators often visualized these narratives through allegorical figures. For example, in his July 1928 *Opportunity* cover, Wells presented two female figures who may be read as allegorical personifications of African American achievements in the arts (fig. 54). The foreground female figure, who bends forward toward a fragmented easel while holding a stylized brush, seems to represent the visual arts, while the figure playing a harp behind her suggests music. Their ancient, civilized heritage is visualized through the shorthand notation of two ancient Egyptian pyramids in the right background, as well as the harp the figure plays.

In related compositions, Harlem artists proclaimed contemporary cultural progress as springing from illustrious origins by alluding to the liberal arts, drawing on the tradition in Western art to personify the academic and artistic disciplines. Hale Woodruff's painting, reproduced on the August 1928 cover of the *Crisis*, cast African American figures in roles personifying (from left to right) architecture, literature, music, sculpture, and painting.[18] The African American architect at left builds a model in a Greek classical style, while underneath his model appears an African vessel carrying geometric designs. These figures in contemporary dress, who represent African American cultural achievement and progress, inherit a past inclusive of both African and Western classical traditions. In Bernie Robynson's *Progress*, on the July 1928 cover of the *Crisis*, a black female allegorical figure heralds a new era, blowing a horn and wearing ancient dress (fig. 55). In silhouette beneath her are a variety of representative types, whose achievements signify African American cultural progress, culminating in the lower right with personifications of the dramatic arts, literature, and music.

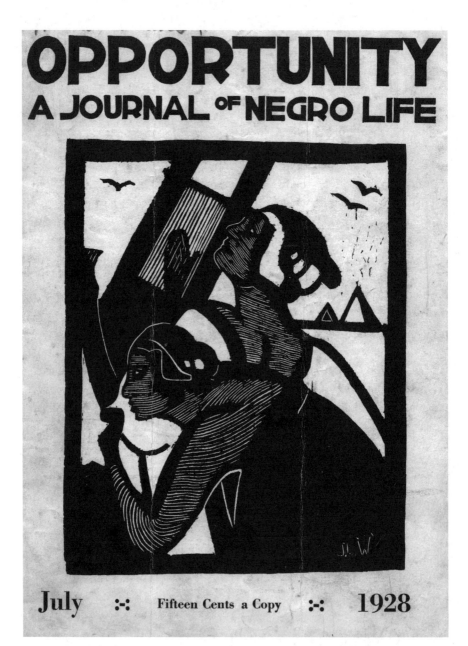

Figure 54. James Lesesne Wells, cover of *Opportunity* (July 1928). Camille Billops and James V. Hatch Archives, Manuscript, Archives, and Rare Book Library, Emory University. Reprinted by permission of the National Urban League, and printed with permission of the Estate of James Lesesne Wells.

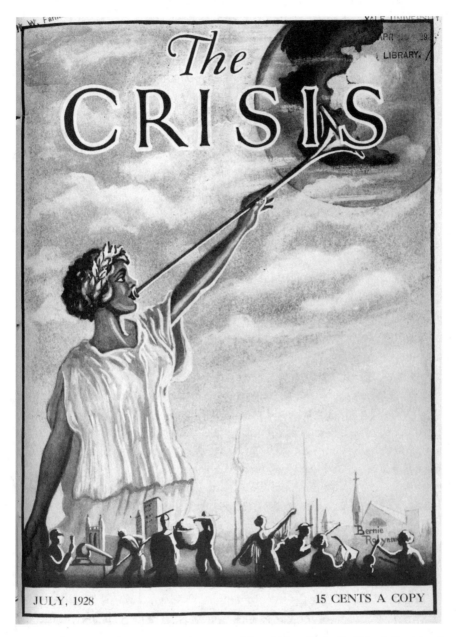

The

CRISIS

JULY, 1928 15 CENTS A COPY

Figure 55. Bernie Robynson, *Progress,* cover of the *Crisis* (July 1928). Yale Collection of American Literature, Beinecke Rare Book and Manuscript Library, Yale University.

In their use of allegorical figures to make didactic connections between a glorious ancient past and a contemporary era of renewal and promise, these illustrations connect with the popular dramatic form of pageantry, to which W. E. B. Du Bois turned his attention in the second decade of the century.[19] In creating his own pageants, Du Bois strategically appropriated the mainstream pageant, a form popularized by white Americans in publicly retelling and mythologizing events in American history that could serve as a usable past.[20] These pageants combined progressive reform ideals with classical imagery in costumes, stage sets, and posters in order to present a view of the nation that looked forward to a blessed future while drawing on a sanitized past. Not only did the pageants attempt to gloss over historical conflicts, like slavery and westward expansion, but they developed partly as a strategy to assimilate and "naturalize" the huge influx of immigrants during the first decades of the twentieth century.[21]

In writing and producing his first pageant in 1913, *The Star of Ethiopia*, W. E. B. Du Bois leveled critique at the mainstream pageants, which had excluded serious consideration of America's black citizens.[22] His pageant conveyed African American history in the form of a didactic fable that deemphasized the period of slavery in order to uncover an ancient and civilized heritage in Africa that radically served as the originating civilization for all mankind. When produced, the pageant visually claimed Egyptian origins, with "the stentorian voice of a herald proclaimed from the steps of a papier-mâché Egyptian temple."[23] Many of the costumes and headpieces also suggested inspiration from ancient Egypt. The narrative of his pageant was spoken by "four heralds, black and of gigantic stature."[24] They proclaimed what he perceived to be the greatest contributions of the African "race" to humanity. As history unfolded, the heralds introduced The Gift of Civilization, describing "how the meeting of Negro and Semite in ancient days made the civilization of Egypt the first in the world." Veiled figures paraded the gifts of Egyptian culture onto the stage, including "the Sphinx, Pyramid, the Obelisk." The God Ra then joined the Queen of Sheba and Candace of Ethiopia in a royal procession. Thus establishing the African "race" as the progenitor of Western culture, Du Bois traced "the transplantation of the Negro race over seas." The heralds announced the "Greatest Gift of black men to the world, the Gift of Freedom for the workers." Characters who represented slaves appeared on stage and began to free themselves, aided first by the figure of John Brown, then by Sojourner Truth, and finally by Frederick Douglass. This collaborative act of freedom made way for the final pageant, in which the gifts of Negro civilization were paraded across the stage.

The pageant was produced to huge audiences in New York in 1913, Washington, D.C., in 1915, Philadelphia in 1916, and finally in Los Angeles in 1925; Du Bois also revised it for the America's Making Exposition in New York in 1921.[25] Following the Philadelphia production, he felt assured that pageantry had an important role to play: "The great fact has been demonstrated that pageantry among colored people is not only possible, but in many ways of unsurpassed beauty and can be made a means of uplift and education and the beginning of a folk drama."[26]

Pageants caught on in the 1920s, particularly as dramatic forms for school children and college students. In 1930, Willis Richardson edited *Plays and Pageants from the Life of the Negro*, published by Carter G. Woodson's Associated Publishers for use in elementary, high school, and college classes. These pageants followed the didactic formula of Du Bois's production, with allegorical figures parading across the stage indicating African America's civilized ancestry, which gave rise to contemporary advancements in the arts and sciences. For example, in the pageant *Out of the Dark*, a classically garbed Chronicler begins his address to the audience by telling the history in Africa of black Americans, while focusing attention on "the progress of these folk here in America."[27] At the pageant's end, allegorical figures of Music, Literature, Science, and Art attest to the contemporary achievements of African American practitioners in these ancient fields, including Rosamond Johnson in music, Langston Hughes and Countee Cullen in literature, George Washington Carver in science, Henry O. Tanner in painting, and Meta Fuller in sculpture. Not only would the audience of this pageant hear how ancient tradition brought about contemporary cultural progress, but they would see this message visually. For, at the end of the pageant text, notes appear on how each character should be dressed. The Chronicler in a "long flowing Grecian costume of soft white silk," whose hair would be "bound with narrow ribbon [in a] Grecian effect," would convey the classical tradition, while the figures of Art, Literature, and Science would appear in contemporary dress. Further, these last three figures would wear iconic attributes that would trigger quick visual association with their discipline. Art would wear an "artist's smock and cap," Literature would don a "cap and gown," and Science would be dressed in "a chemist's laboratory apron."[28]

Many of the illustrations on the covers of *Crisis* and *Opportunity* functioned as visual pageantry. Through the aegis of classically garbed figures carrying torches and blowing horns, the gifts of African civilizations and modern black Americans were trumpeted and paraded across these covers, as if on a stage, didactically proclaiming the fruits of African American culture to contempo-

rary readers. Robynson's black, classically dressed trumpeting herald wore a crown of victory and called attention to black achievements in the arts and sciences, represented below by figures wearing clothing and carrying props to suggest their modern roles, as the graduate in cap and gown or the musician with her cello (fig. 55). Dawson's Egyptian torch-bearer paraded with a contemporary young graduate waving a banner with the *Crisis* masthead superimposed over the American flag (fig. 53). These figures didactically ushered in a new era predicting democracy and justice for American blacks. Similarly waving a banner to advertise Du Bois's *Star of Ethiopia* pageant, a black muse carried a laurel wreath as an ancient symbol of victory, didactically promulgating an age of renewal for black Americans.[29]

Other illustrations functioned specifically to illustrate pageants, as was the case for James L. Wells's boldly stylized prints accompanying the dramatic selections in Richardson's *Plays and Pageants from the Life of the Negro*. For example, he provided two illustrations for Edward McCoo's pageant, *Ethiopia at the Bar of Justice*. The first illustrates a time before the pageant has begun, when Ethiopia is barred from Justice by the figure of Opposition.[30] The other depicts the pageant's conclusion, when Ethiopia has gained rightful access to Justice (fig. 56). With allegorical figures who enhanced historical fact in the guise of a didactic fable, the pageantry form lent itself well to visual representation. Wells's bold Art Deco illustrations have made the clear pageant narrative of *Ethiopia at the Bar of Justice* even more emphatic. With stormy sky, dramatic contrasts between black and white, and sharply angled diagonal lines that direct the viewer's eye to the figure of Ethiopia, Wells's first illustration conveyed Ethiopia's despair. The figure of Opposition, with his rigid, vertical body and long horizontal arm, forms an unyielding anchor—the root of injustice that Ethiopia must endure. Wells's second illustration, by contrast, has removed all signs of despair (fig. 56). Composed almost entirely of vertical and horizontal lines that frame the central figure of Justice symmetrically, the illustration restored the even scales of justice to Ethiopia. Now at left, Ethiopia has gained her rightful hearing before Justice. Their skin color, significantly black, unites the pair, as does Ethiopia's loving gesture towards Justice. Thus, the white figure of Opposition is eclipsed by the two black figures, and his arm, once denying Ethiopia access to Justice, itself is denied and covered by Justice's halo.

While Wells marked his illustrations as modern through bold Art Deco styling, some of the other illustrations that visualized pageantry are more heavily weighted in their didacticism, with rather dry, academic messages conveyed through conservative, realistically detailed artistic styles. Despite their didactic form, they nonetheless suggested the idea of contemporary renewal by engag-

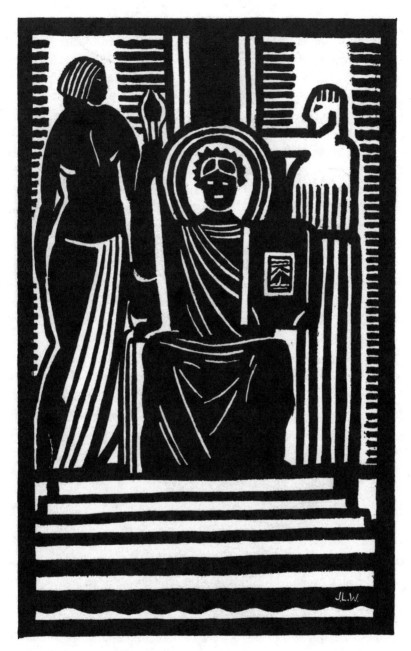

Figure 56. James Lesesne Wells, *Ethiopia at the Bar of Justice,* in Willis Richardson, ed., *Plays and Pageants in the Life of the Negro* (Washington, DC: Associated Publishers, 1930). Printed with permission of the Estate of James Lesesne Wells.

ing with forms of modern commerce. Each of the small figures at the bottom of Robynson's cover engage in various modern professions, from the scientist at left, to the actor, baseball player, writer, and musician at right (fig. 55). Similarly, Woodruff has illustrated men in modern artistic professions, from the architect at left to the painter at right.

As noted at the outset of this chapter, Dawson has suggested black participation in the modern economy by representing black-owned businesses, from Poro College to the People's Finance Corporation in St. Louis (fig. 53). These were businesses in which black Americans took great pride and which advertised actively in *Crisis* and *Opportunity*. In singling out professions in which blacks had excelled, from science to theater and music to baseball, or privileging black-owned businesses, each artist presented black American integration into American commerce, at the same time that they highlighted economic contributions that were distinctly racial.

This positioning of black commercial activity between integration and distinction also surfaced in W. E. B. Du Bois's 1929 *Crisis* article, "Business as Public Service." Here, he claimed that black Americans were uniquely poised to contribute the ideal of service to the American business community. He traced the service ideal as the most important gift that business had imparted to the world. In fact, he went so far as to say, "the only respect in which we surpass Rome, Egypt, Babylon, is the extraordinary service of modern business in transforming raw materials, transporting goods to consumers, applying power, adapting the forces of nature and supplying regularly the multitudinous physical wants of modern men."[31] He saw the dilemma facing the "forward-looking modern" person in American business as one of limiting the drive and desire for profit, while "preserv[ing] . . . the best and indispensable services of business and industry." Du Bois perceived the "American Negro" as particularly receptive to that service ideal:

> While he is subject to all the disadvantage of a group with small incomes in a land which worships wealth and gives it all power, nevertheless, this very absence of large incomes in his business group emphasizes social service as the object of his business and industrial life. . . . In other words, the colored business man is nearer the service ideal and even when his business grows to considerable size that ideal still stays in the forefront, because of public opinion and previous emphasis.[32]

In titling his *Crisis* cover *Drawing with Five Great Negro Buildings*, Dawson similarly suggested that black businesses had built upon traditions inherited

from past civilizations to fulfill the needs of its citizens and to foster their par-
ticipation in an American democracy enhanced by the services black busi-
nesses could render (fig. 53). His choice to illustrate Poro College in St. Louis
was effective in demonstrating the service ideal of Negro businesses. Annie
Turnbo Malone, the founder of Poro beauty products, had established Poro Col-
lege as "more than a business enterprise" but instead "consecrated to the uplift
of humanity—Race women in particular."[33] At the time that Dawson con-
tributed his drawing to Crisis, Poro College was experiencing a crisis of its own,
as Malone was fighting with her former husband for control of the company.
When a St. Louis court put Poro College into receivership, black communities
stood up in solidarity to support Malone in her fight to win back her business.[34]
Just two months after Dawson's cover image was published, Malone took out a
full-page ad in Crisis to thank the readers for their support. In their recognition,
she pledged, "I rededicate to my people, Poro College, and reconsecrate it to
the loving service of Negro Womanhood."[35]

FROM CLASSICAL IDEAL TO MODERN CONSUMER:
REPRESENTATIONS OF BLACK WOMEN IN ILLUSTRATION

In drawing connection between ancient Egyptian civilization and contempo-
rary black commerce, Dawson bestowed unusual recognition on a business
owned by a black woman. However, in his figural representations, Dawson
more typically accorded modern status in contemporary business to his male
rather than female figures. In his Drawing with Five Great Negro Buildings, only
his male youth embarked on a journey into America's economy (fig. 53). Here,
Dawson paralleled the tendency in contemporary texts to gender the modern
New Negro male. The "Negro of to-day" was insinuated by Alain Locke, for ex-
ample, as a male "moving forward under the control largely of his own objec-
tives."[36] Similarly, the Crisis announced in each issue the achievements of New
Negroes under the heading, "Men of the Month."[37] By contrast, Dawson
adopted a very different form of representation for his female figure in his Cri-
sis cover. She remained an allegorical ideal—a representation whose engage-
ment with modernity could happen only as an actor in a pageant. Other
illustrators similarly gravitated toward female allegorical types, who existed
within the illusory frame as classical muses—representations without modern
agency. For instance in Wells's 1928 Opportunity cover, allegorical women
wearing stylized headpieces represented modern achievements in the arts,
without acquiring specificity as modern players (fig. 54). For his Burden of

Black Womanhood, Douglas portrayed the suffering of black women—historical and modern—through a classically inspired allegorical figure, who held her burdens overhead iconically as Atlas had supported the globe (see fig. 11).

While on his *Crisis* cover Bernie Robynson balanced a large female allegorical herald with small representations of modern women assuming occupations in the arts (fig. 55), more frequently, illustrators represented modern black professionals and workers as male. For example, Hale Woodruff assigned specific modern dress and male identity to his black figures, who took on professional occupations in the arts.[38] Wells assigned his modern, urban "Negro Wage Earner" male identity in his jacket design for an Associated Publishers book (see fig. 38). And those artists providing covers on the theme of work for the *Messenger,* like Douglas and Wilbert Holloway, represented the labor of broad-shouldered steel workers and burly tunnel builders, not the work of women in factories or domestic situations.

One modern female type that gained currency on the covers of *Crisis* and in other print venues was the well-groomed, young middle-class woman, as represented in drawings and prints, as well as through photography. For example, on the cover of the *Messenger* in 1925, the reader found a soft-focus photograph of "Mrs. Charles M. Thompson" of Chicago, with her head and smiling face turned openly toward the viewer.[39] Another photograph of an attractive young woman smiling pleasantly graced the cover of *Crisis* in 1928.[40] These photographed women stood as "icons of race pride," embodying the qualities of self-fashioning that were central to the mission of racial uplift.[41] Further, as fashionably dressed women sporting the latest bobbed hairdos, they entered into the fray of modern commerce in the important roles of black female consumers, during a time when "consumer citizenship" was not generally proffered to the black American population in national advertising.[42] In their careful grooming and measured application of cosmetics, they also engaged successfully with modern beauty culture, from which they had been excluded in earlier, derogatory representations of black women as mammies or black female children as pickaninnies. However, despite their entry into modernity through beauty culture, they nonetheless represented a restrictive type, which privileged Europeanized facial features and light brown skin.

Women artists associated with Harlem Renaissance print culture gravitated almost exclusively to representations of middle-class, light-skinned women. Within the context of magazine covers, artists approached the type with some variation. Louise Latimer, who often contributed illustrations to *Crisis* in the 1910s and early 1920s, created images of proper, brown-skinned young ladies, dressed to replicate the standards of female beauty articulated in cover draw-

ings for the mainstream magazines by "Golden Age" illustrators like Charles Dana Gibson and Howard Chandler Christy. With her sailor's blouse and tie, Latimer's female figure for a 1923 cover suggests "the same type of modern girl who appeared on the cover of the *Saturday Evening Post*."[43] Her figure has also grown lush, long hair, again revealing an adaptation of mainstream beauty standards.

After the mid-1920s, younger women artists presented more modern female types with short, bobbed hair. Providing an especially stark contrast to Latimer's woman just three years later on an *Opportunity* cover, Gwendolyn Bennett depicted an urbane black American woman with her hair bobbed and wearing a fashionably short, tightly fitting evening dress (fig. 57). Though light-skinned, her facial features are racialized and her curly hair is not "tamed" with pomade. Her body sways sensually to the beat of music, and in her dance, she seems to connect with the primitivist scene behind her, which stretches across the cover in the form of a modernist Art Deco frieze. The scene lyrically illustrates palm trees and three tribal women stretching and dancing, which recall the text of Bennett's earlier poem of 1923, titled "Heritage." The first two stanzas read:

> I want to see the slim palm-trees,
> Pulling at the clouds
> With little pointed fingers. . . .
>
> I want to see lithe Negro girls,
> Etched dark against the sky
> While sunset lingers.[44]

Particularly in her sensuality and engagement with the primitivist theme, Bennett's woman articulates a different modern type from Latimer's—one who is more clearly racialized. At the same time, she exhibits a reserve that complicates a seamless relationship with her "primitive" past, as if to remind herself of her modern, "civilized" identity, which Countee Cullen had also invoked in his poem of the same title.[45]

Other women artists created female types that engaged even more clearly with modern fashion and cosmetics. In 1930, the young California artist Eleanor Paul drew a *Crisis* cover image of a sultry young woman using a dotted technique to suggest her light brown skin (fig. 58).[46] She wears a short hairdo of carefully coiffed curls, and her darkly painted, pursed lips balance her dramatic almond-shaped eyes and penciled arched eyebrows. Two years before, Joyce Carrington had adorned a *Crisis* cover with the image of a modern

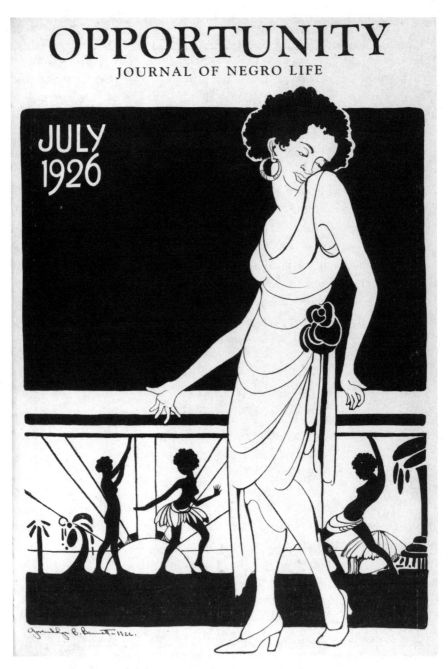

Figure 57. Gwendolyn Bennett, cover of *Opportunity* (July 1926). General Research & Reference Division, Schomburg Center for Research in Black Culture, The New York Public Library, Astor, Lenox, and Tilden Foundations. Reprinted by permission of the National Urban League.

Figure 58. Eleanor Paul, cover of the *Crisis* (May 1930). Yale Collection of American Literature, Beinecke Rare Book and Manuscript Library, Yale University.

African American woman, whose economic status is indicated through her highly fashionable appearance (see fig. 4). With an ancient pyramid in the background suggesting an illustrious heritage, Carrington also drew on the modern Egyptomania of the 1920s by portraying the woman in a stylized Egyptian-inspired bob with neo-Egyptian jewelry, each accoutrement signifying ultramodernity. Carrington also showed the modernity of her woman in her application of cosmetics. Her light brown facial skin (the image was printed in color) appeared evenly powdered, and her Europeanized features were enhanced with cosmetics, from her painted pursed lips, to her darkly penciled brows, to the thick liner and shadow around her eyes.

Each artist has variously endowed their African American women with markers of modern beauty and youth. In this regard, their female types represented a dramatic departure from stereotypical assumptions that youth, beauty, and modernity remained the exclusive rights of white women. In contemporary mainstream advertisements, for example, stylish young white women wearing the latest fashions often drew their modernity, in part, through juxtaposition with stereotypical images of blacks as representative of an older era kept alive in the segregated South, as in a *Publishers Weekly* advertisement comparing a modern white flapper and an elderly black butler.[47] Paul and Carrington's women defiantly collapsed that stereotypical polarity, with both youth and modern beauty well within their reach.

In their clear engagement with modern fashion and cosmetics, these illustrated women suggested relationship with the rise of African American beauty culture, embodied in the entrepreneurship of Annie Turnbo Malone, who founded Poro, and Sarah Breedlove, who later became Madam C. J. Walker.[48] Not only did these women work to their advantage the opportunity to move out of service positions into business ownership through beauty culture, but they provided many other black women the chance to become working agents for their companies. Getting under way at the turn of the century, these women held alternative philosophies to white-owned cosmetic companies that sold products to black women. Avidly against skin bleaching and the emulation of whiteness, they advocated the enhancement of black beauty as a way of "glorifying our womanhood," as one of Walker's ads promised.[49] Walker focused most of her early attention on hair growing tonics, but her addition of face powders and skin-care cosmetics in 1919 "indicated a turn toward a more modern sensibility."[50]

Carrington's modern female figure, in touting Egyptian ancestry and demonstrating her fashion know-how with neo-Egyptian jewelry and hair, suggested relationship with advertisements for black women's cosmetics, which

also capitalized on mainstream taste for Egyptian exotica. Connecting with the Eyptomania that pervaded American popular culture, these advertisements were *au courant*. From the late 1910s into the 1930s, an exotic appeal surrounded the notion of things Egyptian, especially in mainstream advertising images, from posters of Theda Bara's filmic interpretation of Cleopatra to magazine ads for Egyptian cigarettes. A new bronze ideal of female beauty gained mainstream cachet, particularly with the popularity of Egyptian-inspired suntanning. The first black-owned cosmetics firm to launch an Egyptianist advertising campaign was Kashmir Chemical Company, owned by Claude Barnett, who "address[ed] a more urbane, well-heeled consumer than did Walker and Malone."[51] His series of "Nile Queen" ads graced the back pages of many issues of *Crisis* in the 1910s and early 20s. With images of young brown beauties in ancient Egyptian garb, these ads made the profitable comparison that "the preparations used by Cleopatra, the Nile Queen, were of the same fine quality as those" sold by Kashmir.[52] These ads should be seen as a popular extension of the project to establish ancient Egyptian roots for modern African Americans and to find evidence of the Africanization of Egyptian culture, which, as we have seen, pervaded periodical articles, illustrations, and pageants. In a gendered aspect of this argument, some authors heralded classic Egyptian beauties as black-skinned and therefore ancestors to modern black women. A *Crisis* author once argued that Nefertiti, "'the most venerated figure of Egyptian history,' was a black woman of great beauty."[53] And a *New York Age* editorial later boasted, "Cecil B. DeMille may depict 'Cleopatra' how he pleases but we know and history tells us that she was a Negro woman and the prettiest of them all."[54] Therefore, when black women engaged with Egyptomania in fashion and particularly in cosmetics, it was with the understanding of a close connection to this ancient culture that white women could not claim.

During the 1920s, however, readers of black periodicals received conflicting messages from advertisements for Madam Walker's cosmetics. For example, her "Egyptian Brown Face Powder" advertised an "alluring perfection" achieving a "velvety-smooth complexion" that cast darkened skin as not only appealing but exotic (fig. 59).[55] While the Egyptianist taste for brown skin allowed lighter-skinned African American women a new place within modern fashion, darker skinned women were urged to buy Walker's "Tan-Off," a product developed after her death in 1919, which promised to "bleach out the blemishes in your skin."[56] Debates erupted among magazine and newspaper editors in black communities about skin-bleaching and hair-straightening products.[57] Did it not undermine race pride to bleach and straighten away distinctive African American features? How could the brown-skinned ideal on the magazine cov-

Alluring Perfection

What is more charming
than a velvety-smooth
complexion of lovely,
transparent tone com-
bined with silken hair,
lustrous, soft and
glowing?

Make this loveliness your own

USE

Madam C.J.Walker's

EGYPTIAN BROWN FACE POWDER

GLOSSINE

Clinging, invisible and ador-
ably perfumed. Imparts an
olive tint to fair complex-
ions and harmonizes be-
witchingly with the darker
skins. For sale by Walker
agents everywhere.

Oils and softens dry, brittle hair.
Imparts a rich, healthy lustre. In-
dispensable for bobbed or long hair
and unsurpassed in the opinion
of social leaders and well-groomed
gentlemen. For sale by Walker
agents and good drug stores.

Write for free sample

THE MME.C.J.WALKER MANUFACTURING COMPANY, INC.
640 N. West Street **Indianapolis, Ind.**

Figure 59. Madam C. J. Walker, advertisement for Egyptian Brown Face Powder, in the *Crisis* (January 1928).

ers and in advertisements fail to restrict dark-skinned women from entry into modern aesthetics of beauty?

African American women received widespread and conflicting messages of race pride mixed with racial erasure. In commercial print culture, the railings against skin bleaching of editors and writers, like George Schuyler, shared space with advertisements that pictured and privileged light-skinned women as the most valid consumers. In literary venues, the celebration of dark skin for both men and women in Locke's *New Negro*, especially in Winold Reiss's pastel portraits, intermingled with pervasive preferences for light-skinned women in other books. McKay and Bontemps's working-class male protagonists preferred "high yallers," while Nella Larsen and Jessie Fauset explored the lives of middle-class female types who could pass for white.

These conflicting messages surfaced as well in print venues for children. For not only did the light-skinned woman stand as a marker of refined race pride on the covers of black periodicals, the light-skinned girl provided a role model for young girls in children's periodicals and books. Children held a special place in modern black culture, as potential players in the nascent consumer culture but also as future New Negroes, who could become "race leaders." For these reasons, both W. E. B. Du Bois and Carter G. Woodson accorded special attention to children, who they felt needed early education about their ancestry and future social responsibility.[58] Woodson published a number of volumes for children and youth on African and African American history, and each year, Du Bois devoted one issue of *Crisis* to the subject of children.

In early 1920, Du Bois began publishing the *Brownies' Book*, which he edited with Jessie Fauset for the two years of its publication, to provide an integrationist periodical "to teach Universal Love and Brotherhood for all little folk—black and brown and yellow and white."[59] Children who read the stories and looked at the richly illustrated pages received divergent messages about their race if they were black, particularly those girls trying to reconcile their race and gender.[60] On the one hand, the journal aimed to instill in African American youth a sense of racial pride. Efforts to educate children about their heritage in Africa took form through adaptations of African stories and short essays that sought to "dispel the assumption that Africans [were] 'savages.'"[61] Other stories educated children about the poetry of Phillis Wheatley or the contemporary acting of Charles Gilpin. Many of the periodical's illustrations sought to correct a white-only image of American culture available to black children, from photographs of dark-skinned children, to an image of a black Santa Claus on a December cover, to humorous stick figures drawn by Laura Wheeler that showed schoolchildren with short curly hair and distinctive facial

features.[62] At the same time, the majority of the *Brownies' Book* interior and cover illustrations were filled with light-skinned children, especially girls, whose hair and facial features were decidedly Europeanized and whose activities suggested adoption of white bourgeois ideals and aesthetics of beauty, as in Wheeler's *Winding the May Pole* (fig. 60).[63]

Similarly in the advertisements that appeared in the *Brownies' Book*, children and parents were urged to purchase "colored dolls," yet they were also encouraged to think negatively about the color of their skin and texture of their hair in advertisements for Madam C. J. Walker's products. In almost every issue, children read: "Once upon a time there lived a Good Fairy whose daily thoughts were of pretty little boys and girls and of beautiful women and handsome men and of how she might make beautiful those unfortunate ones whom nature had not given long, wavy hair and a smooth, lovely complexion." Claiming the "results from the use of our preparations especially noticeable in the hair and skin of children," Walker's advertising campaign aimed a message of dissatisfaction with physical markers of race at impressionable young readers and their parents.[64] In the ad's illustration, the image of a white fairy with long, flowing hair flying over an enchanted landscape summoned mainstream beauty standards and imposed them on young black children. This "good" fairy would remove those "unfortunate" indicators of race and with her magic wand allow children to live happily ever after.

Summoning the image of a fairy represented good marketing, for the image of the fairy was ubiquitous in both black and non-black children's literature, and it figured in *Brownies' Book* illustrations. For example, Hilda Wilkinson provided a full-page illustration for Eulalie Spence's short play, *Tommy and the Flower Fairies.*[65] A benign tale of flowers coming to life as fairies in a little rich boy's dream, Wilkinson's image shows a young black boy surrounded by three white female fairies, with wings and long, flowing hair. Here, the message is sent that fairies bring luck and happiness not just to white kids but to black children too, though privileging an upper-middle-class boy in a stylish room where sumptuous draperies and upholstery are orchestrated into a total interior design scheme. While the periodical's images of magical brownies typically carried darkened skin, the fairies were white and came directly out of "Victorian fairy traditions."[66]

Other children's publications provided alternative interpretations of the fairy image. One surfaced on the pages of *The Upward Path: A Reader for Colored Children.* Published by Harcourt Brace in 1920 and compiled by Boston school principal Myron Pritchard and NAACP board chair Mary White Ovington, it consisted of stories and poems by black American writers for young

The Brownies' Book

Fifteen Cents a Copy
One Dollar and a Half a Year

MAY—1920

Figure 60. Laura Wheeler, *Winding the May Pole,* cover of the *Brownies' Book* (May 1920). Manuscripts, Archives & Rare Books Division, Schomburg Center for Research in Black Culture, The New York Public Library, Astor, Lenox, and Tilden Foundations.

readers wanting to "find a mirror of the traditions and aspirations of their race."[67] Illustrated copiously by Laura Wheeler, these stories and pictures served a less integrationist purpose and therefore asserted markers of race more frequently. Though the book privileged stories of middle-class young-sters, Wheeler did take efforts to physically racialize her images of children. Some stories sought to revise the Victorian ideals that so pervaded children's literature. For example, Fenton Johnson's story, "The Black Fairy," dispelled the notion that fairies were only white, focusing instead on Lily of Ethiopia, a fairy who was "black and regal."[68] Wheeler's illustration presented the dark fairy fly-ing in a lush forest, surrounded by little black pixies.[69] Much later, in 1935, Lois Jones provided the illustrations for a volume by Gertrude McBrown, titled *The Picture-Poetry Book,* published by Woodson's Associated Publishers. For McBrown's poems, Jones provided much more racialized illustrations of black children, their skin color and features obviously African American. A number of fairy poems graced the pages of the book. For one, "The Paint Pot Fairy," a poem describing a fairy painting fall colors onto the leaves of a tree, Jones de-cided to add her own kind of color to the tiny fairy, giving her black features and short curly hair (fig. 61). Though McBrown had not explicitly racialized the fairy, Jones saw the opportunity to interpret "color" broadly and to provide a fe-male fairy of color for her young readers, especially young girls.[70]

With the fairy and fairy tale as such compelling forms that promised happy endings and dreams come true, it is not surprising that they figured forcefully in Harlem Renaissance children's literature to encourage black children to dream and imagine their dreams fulfilled. In print venues for adults, however, women writers and illustrators sometimes turned to the fairy tale to mark the shattering disjuncture between childhood dreams and women's adult realities.[71] These stories and images usually focused on a modern, light-skinned African American woman, whose beauty resulted in part from her skin color but also from her fashionable dress and stylish hair. For example, in a 1925 *Crisis* issue, Ola Calhoun Morehead published a short story, "The Bewitched Sword," about a stylish young student, Mary, who wore "newly shingled hair." She had five dol-lars in her pocket—enough to buy a hat she'd seen in an advertisement for Bloch's department store. The girl rushed to the "L" station, boarded a "down-town car," and dreamed of her new hat with its "taffeta trimming" that would match "her new flannel coat." In her daydream, "she could hear the girls ex-claiming over it. They always admired her taste." At the store, she found just the hat she was looking for and decided to purchase it. The saleslady admired her choice and told her she'd gotten style along with a real bargain. Mary could barely contain her excitement as she boarded the uptown train for home:

Figure 61. Lois Jones, *The Paint Pot Fairy*, in Gertrude McBrown, *The Picture-Poetry Book* (Washington, DC: Associated Publishers, 1935; revised edition, 1968). Carter G. Woodson and Association for the Study of African American Life and History Library, Manuscript, Archives, and Rare Book Library, Emory University. Lois Mailou Jones Pierre-Noel Trust.

She had scarcely sat down to weave more dreams when suddenly, *"I won't sit by a nigger!"* And Mary felt her knees rudely jostled as a tall blonde woman strode past her into the aisle. Crash! fell Mary's dream towers and, instantly, she was swept back into the world of reality as eyes pinned themselves upon her—some pityingly, some quizzical, most of them unkind. With her lips tightly compressed, she felt the sharp point of the sword as it shot through her armor of happiness . . . A strange sword it was, too, pos-

sessing something of witchcraft, it could pierce iron; it could rend steel; it could break a heart of stone![72]

In this inverted fairy tale, the "bewitched sword" does not rend its magic to save the beautiful heroine but represents the racially prejudiced intervention that shatters her dreams to attain access to American consumerism and modern beauty culture. Morehead's story is effective in not overtly disclosing Mary's racial identity until the rude blonde utters her racial slur, so that the reader is as shocked as Mary.

Two illustrations accompany the story.[73] In the first, the fashionable Mary poses for the viewer with her modern "shingled" bob. Her light brown skin is indicated by a series of dots that provide a slight shading. The second illustration follows Mary to the department store, as she hands her hat to the saleslady behind the counter. Mary's facial skin is darker in this image, especially as compared to the clerk's bright white skin. However, Mary's short modern coat contrasts markedly with the high-collared Victorian dress of the clerk. Thus, the illustrations, which seek to underscore Mary's beauty and modernity, help to strengthen Morehead's shattered fairy tale; despite Mary's beauty and fashion sense, the "bewitched sword" of racism blocks and destroys her dreams.

In her short stories and novels, Jessie Fauset also employed the seemingly conservative form of the fairy tale, which she then inverted to mark the discrepancy between dream and reality for her female characters.[74] In the October 1920 issue of *Crisis*, Fauset contributed her short story "The Sleeper Wakes" with illustrations by her friend, Laura Wheeler (fig. 62). Her illustrations captured the climax of Fauset's story, in which Amy, who had passed for white, revealed her African American identity to her husband, Wynne, who in turn rejected her. After several months, Wynne returned to Amy, who supposed he had forgiven her and wanted to remarry; Wheeler depicted their reunion in her first illustration. Amy gradually realized, however, that Wynne wanted her not as a wife but as a kept woman. Shocked, she recoiled from Wynne, who asked the hurtful question,

> "What's the matter—I'm not rich enough?" Are you "waiting for a higher bidder?"
>
> At these words something in her died forever, her youth, her illusions, her happy, happy blindness. She saw life leering mercilessly in her face.

A tussle ensued, and as she fell to the floor, he called her "Nigger." When she remembered that, "She lay back again on the floor, prone"; this line formed

"She Lay Back Again on the Floor, Prone"

Figure 62. Laura Wheeler, second illustration for Jessie Fauset, "The Sleeper Wakes," in the *Crisis* (October 1920). Yale Collection of American Literature, Beinecke Rare Book and Manuscript Library, Yale University.

the caption for Wheeler's second illustration (fig. 62).[75] On the one hand, Amy's shattered youth and illusions formed Fauset's inversion of the fairy-tale myth. On the other, severing the connection with her youthful dreams allowed Amy to move forward without dependence on a man and into successful employment as a fashion designer.

Amy was a beautiful young woman, who had early on exhibited a flair for fashion. Wheeler capitalized on her stylish appearance in her first illustration, which highlighted Amy's dark bob and fashionable gown and shoes. Only moments later in the second illustration, Amy's bright enthusiasm literally fell away as she fell to the floor, seeing "life leering mercilessly in her face."[76] Though Wheeler's second illustration tended to mimic the overwrought drawings that illustrated fiction in mainstream, mass-market magazines, it nonetheless followed Fauset's inversion of the normative fairy tale in emphasizing the unrelenting racism that stood in the way of Amy's dreams. However, Wheeler chose not to illustrate later episodes in the story, when Amy moved toward personal and economic independence.

In this way, she revealed a reserve that many women artists shared in their representations of modern women that contrasted markedly with the production of male artists. When approaching the contemporary female figure, Aaron Douglas, for example, ranged in his choice of types. Unlike women artists, he depicted several female types from the working classes, including his evocative contour drawing of a waitress in *Fire!!* He created several representations of the female blues singer or dancer, from his early *Play de Blues* in *Opportunity* (see fig. 12) to his sensual blues dancer on the cover of Hughes's *Not Without Laughter* (see fig. 19). At the same time, he created evocative images of middle-class women in his *Crisis* covers, for example, the beautifully stylized profiles of women members of the NAACP in 1930.[77] While retaining his preference for the silhouetted type in this illustration, Douglas provided shorthand clues to the women's class and gender, as the dark figure wears a white beaded earring and each figure sports long eyelashes. Again, unlike women artists, Douglas suggested the range of skin color among NAACP women, from very dark with distinctive black physiognomy to very light with less racialized features. In his *Saturday Evening Quill* illustrations, Roscoe Wright similarly varied his representations of modern women, from the slim young *Della,* with fashionable bob, dress, and shoes, to the more amply built *Washwoman,* who labors over a washboard and tub. Perhaps the most outlandish female representation came (not surprisingly) from the pen of Richard Bruce Nugent, whose *Drawing for Mulattoes* parodied the primitivism of the modern flapper (see fig. 79). While Nugent's was the only representation of a modern flapper among Harlem Renaissance illustrations, photographs and cartoons of light-skinned flappers frequently animated the pages of the *New York Amsterdam News*. Especially in the cartoons of William Chase, the modern black flapper was satirized as narcissistic but also valorized as independent.[78]

While male artists illustrated a variety of contemporary female types, women illustrators limited their representations of modern female figures primarily to the middle-class girl and woman, often fashionable but always guarded. For example, in Gwendolyn Bennett's *Opportunity* cover (fig. 57), her stylish female figure sways slightly to music, but she does not dance the uninhibited steps of Nugent's contemporary flapper (fig. 79). In fact, she contrasted markedly with her white sister on the same month's cover of *Life*, the mainstream humor magazine, which paired a dancing white flapper with a series of stereotyped dancing black primitives.[79] By dancing the Charleston, the white flapper discarded her inhibitions and embraced an illusive primitive identity. By contrast, Bennett's stylized, Deco scene problematized the relationship between primitive identity and the modern black woman. Not only did women artists reject the modern flapper, they also failed to embrace the modern blues woman; likewise "none of the Harlem Renaissance women writers . . . fashioned a character after the blues queens."[80] Perhaps as did Fauset, in employing the restrictive fairy-tale trope, Wheeler, Carrington, and Bennett each utilized the fashionable, light-skinned type to mark the powerfully limited roles that black women could occupy successfully, as they walked the fine line between maintaining connection to their race and forging viable roles within American consumer culture.[81]

CONCLUSION

The work of Harlem Renaissance illustrators of the 1920s challenges scholars in art history and cultural studies to clarify cross-cultural negotiations. Their reclamation of ancient Egyptian ancestry illustrates an important paradigm, in which ties with an originating culture could help heuristically to circumvent local oppression. By reclaiming ancient Egyptian imagery, they created a usable past in visual form that disrupted the exclusivity of European claims to Egyptian ancestry and cultural dominance. Further, Harlem Renaissance artists drew on the language of advertising to characterize modernity as a moment ripe for black American participation in America's commercial economy.

While the reclamation of ancestry in ancient Egypt often served as a marker of parity with mainstream culture, it could also function as a sign of interstitial identity. Joyce Carrington employed allusions to ancient Egypt in order to explore the dynamic modern identity of her African American female figure, who could uniquely connect an ancient heritage with modern fashion. While her

light skin and European features reflected the severe limitations imposed on black women's entry into modern beauty culture, these qualities also emphasized her mixed-race identity, which resisted limitation to fixed racial classifications. Similarly, stories and illustrations of light-skinned women who experienced the fracturing of fairy-tale dreams seem at first glance conventional, with imagery mimicking the overwrought fiction illustrations in mainstream magazines. Yet they also functioned to emphasize the gap between human expectation and racial prejudice that Harlem Renaissance illustrators hoped to help close through their persuasive visual arguments for black involvement in modern consumer culture and the American democratic experiment.

Religion as "Power Site of Cultural Resistance"

In constructing a modern black expression, religion provided a "power site of cultural resistance," to borrow Coco Fusco's phrase, in which Harlem Renaissance illustrators disrupted the normative white identity of the Judeo-Christian artistic tradition in the West.[1] In Aaron Douglas's *Creation* of 1927, for example, he represented the figure of Adam as a black man (fig. 63). His application of African features to this biblical figure marked a radical appropriation, visually shifting the location of Judeo-Christian origins from a white Garden of Eden to a black African setting. By inverting the dominant color paradigm, in which blackness conjured visions of the devil and whiteness symbolized holiness, Douglas and other Harlem Renaissance artists challenged white religious preconceptions that excluded descendants of Africa from the "kingdom of heaven."

This chapter examines the work of Harlem Renaissance illustrators in the 1920s and early 1930s who explored Judeo-Christian subjects in their work.[2] Some challenged white religious tradition by highlighting the contribution of those described in biblical and early Christian texts as African or black-skinned. More daring were Aaron Douglas's illustrations, which colored biblical figures black who had been conventionally represented as white. In other cases, artists made visual associations between the modern experiences of black working-class citizens and a Christianity less dependent on specific biblical texts. In this body of art, artists often crossed racial barriers in creating a new iconography that connected the historical event of Christ's crucifixion with the contemporary atrocity of lynching. For example, non-black artist Prentiss Taylor provided an arresting image of a crucified black Christ for Langston Hughes's poem, "Christ in Alabama," in which the poet referred scathingly to the victims of southern lynchings as "Nigger Christ[s] / On the cross of the South" (fig. 72).

Figure 63. Aaron Douglas, *The Creation*, in James W. Johnson, *God's Trombones* (New York: Viking, 1927), copyright 1927 The Viking Press, Inc., renewed © 1955 by Grace Nail Johnson. Used by permission of Viking Penguin, a division of Penguin Group (USA) Inc. Library of James Weldon Johnson and Grace Nail Johnson, Manuscript, Archives, and Rare Book Library, Emory University.

Together, these illustrations and their texts challenged racially prejudiced religious beliefs, supposedly verified in ancient scripture, that black skin and identity were aberrant. They also challenged stereotypes that caricatured African American spirituality as a noncognitive impulse inherited through the African bloodline without conscious choice. Such stereotypes have obscured the pivotal occasions when African American artists embraced religious themes as a strategic and measured choice. Rather than revealing an innately religious "bent," Harlem Renaissance illustrators and writers used religious subjects in their creative work as emancipatory tools, rewriting the place of African American people within religious tradition and national politics. They further denied normative polarities between religion and the modern world that began during the Enlightenment and continued into twentieth-century scholarship in art and cultural studies. Mircea Eliade, for example, gives voice to this normative polarity when he argues that only those "in the 'primitive' and Asiatic societies" had access to a religious spirituality lost in the industrialized, modern West.[3] Rather than mimicking this false dichotomy between the primitive spiritual and the secular modern, the illustrations examined here suggest an interstitial position in which the experience of religion and spirituality formed an integral component of black modernism. In this artistic expression, black identity embodied a newly modern dynamic that could therapeutically reconnect religious history with contemporary spirituality and politics.

Sally Promey has referred generally to the outmoded ideas that held modernism and religion in an antithetical, binary relationship as the "secularization theory of modernity," which utilized a declensionist model to conclude that modernization would lead to religion's demise and "that religion represents a premodern vestige of superstition." "Within this framework," she continued, "the very notion of '*modern* religion' becomes an oxymoron."[4] In opposition to this secularization theory, Promey, David Morgan, Erika Doss, and other contemporary Americanist art historians have begun to reevaluate such restrictive definitions of modernism's relationship to American religions by understanding new ways in which religion has actually formed a fertile component of modernist art and culture.[5] Examining a variety of artistic and material forms in their *Visual Culture of American Religions,* Promey and Morgan posit methods in which religious images have functioned in American culture, two of which are particularly useful for the material in this chapter. They suggest that religious images can "help establish the social bases of communion by consolidating and reinforcing a range of allegiances."[6] They further assert that these "images identify individuals as members of kinship networks, communities, or nations."[7] This general rubric helps in understanding how

the artists I investigate contributed toward a new, racialized religious tradition, providing alternative visual images of a black Judeo-Christian community. Promey and Morgan also examine an iconoclastic mode in which religious images can function. "In the concrete act of violating the image," they maintain, "iconoclasts denature an icon, seeking to show that it is not transparent, but that it actually obscures the mental vision of those who venerate it."[8] Broadly interpreted, the images of black Christs that I consider at the end of the chapter were iconoclastic, in "violating" and replacing conventional white Christs with black youths who "denatured" and thereby critiqued the original, iconic images. In considering the strategic religious imagery of Harlem Renaissance illustrators, this chapter both benefits from and extends new scholarship on visual culture and American religions.

Before exploring these images, I want to review what little is known of the Harlem Renaissance artists' own religious affiliations. They seem to have been influenced by the variety of African American religious groups active in Harlem and other urban environments.[9] Middle-class African Americans who sought religious affiliation usually joined the black mainstream Christian denominations, most notably the African Methodist Episcopal and the black Baptist churches, whose worship styles tended to parallel the reserved practices of the white American denominations. By contrast, working-class blacks, especially southern migrants, tended to gravitate to the storefront churches affiliated with the Holiness and Pentecostal sects. They embraced the more demonstrative worship styles of the rural southern churches. Also catering to working-class congregants, a variety of Messianic sects emerged in northern cities, some affiliated with Christianity, others with Judaism and Islam. In addition to practicing distinctly black forms of worship, these sects concentrated their efforts in the areas of social protest and economic justice.

Most of the African American artists considered here came from middle-class backgrounds, and some of them may have attended mainstream churches in Harlem. In *Black Manhattan,* James Weldon Johnson implied that great numbers of Harlem inhabitants got "enjoyment out of church-going." He observed that, as both "a social centre" and "a club," the mainstream "Negro church" offered opportunities that white American culture did not provide for its black citizens:

> Going to church is an outlet for the Negro's religious emotions; but not the least reason why he is willing to support so many churches is that they furnish so many agreeable activities and so much real enjoyment. He is willing to support them because he has not yet, and will not have until there is

far greater economic and intellectual development and social organization, any other agencies that can fill their place.[10]

Aaron Douglas made little reference to his religious orientation. He came from Topeka, where the black churches played an important role in social reform,[11] so his family is likely to have attended one of the mainstream black churches there. He once implied that he also attended church in Harlem, sharing this and other experiences with his Harlem Renaissance colleagues: "I had the good fortune to be one of a small group of eight, ten perhaps a dozen young men and women who met in the streets, the libraries, the churches and the cabarets of Harlem."[12] However, rather than situating himself within a specific religious denomination, Douglas seems to have been more interested in philosophical positions outside of organized religion, for example, the mysticism of George Gurdjieff during the 1920s and the writings of Karl Marx in the 1930s.[13]

Perhaps outweighing the effects of their own denominational affiliations, Harlem graphic artists were influenced by the dialectical exchange of ideas held by black American cultural critics regarding what was most important about African American religion. For instance, while W. E. B. Du Bois proclaimed the emancipatory function of the black church during slavery, he was critical of the role of the northern urban church as accommodating the dominant culture rather than resisting social injustices. In fact, he accused black church leaders of being outmoded and corrupt. He wrote critically in 1912 that the officials of the church were too often "pretentious, ill-trained men and in far too many cases . . . dishonest and otherwise immoral." In the same essay he lamented the church's regressive messages: "Today the church is still inveighing against dancing and theatregoing, still blaming educated people for objecting to silly and empty sermons, boasting and noise, still building churches when people need homes and schools, and persisting in crucifying critics rather than realizing the handwriting on the wall."[14]

While an outspoken critic of the black church, Du Bois nonetheless recognized the centrality and promise of the Christian message for the African American community. He not only acknowledged the important black contribution to the ancient Judeo-Christian tradition, he also felt that the Christian message had great resonance with the contemporary working-class African American community. In his editorial in the December 1926 issue of the *Crisis*, Du Bois wove together biblical text and his own words, describing the infant Christ as "lying in a manger, down among lowly black folk,"[15] revealing his association of Christ's humble life and the lived experience of working-class black Americans.

With his interest in both the black contribution to the Judeo-Christian tradition and the participation of black Americans in a lived religious experience, Du Bois's views on African American religion pointed to both sides of a debate among other cultural critics that questioned the locus of black Christianity's origins. Was black Christianity born on the pages of scripture where those identified as black contributed to the white religious tradition? Or, did the distinctive black American religious practices among rural and working-class believers constitute the core of black Christianity as fundamentally different from white religion?

This debate often centered on worship styles. For those among the black bourgeois classes who attended mainstream Baptist or Methodist congregations, a refined worship style patterned after white Protestant services remained the norm. They tended to criticize "overt emotionalism as being distinctive of lower-class religion."[16] By contrast, for Langston Hughes and many others, the creative preaching and worship styles of black Americans had been crucial components of their cultural evolution; it was time to confront and refashion the stereotypes others had abandoned. Rather than viewing ecstatic worship as ridiculous, the demonstrative and emotive worship styles of "black folk" were to be celebrated: "their joy runs, bang! into ecstasy," Hughes wrote. "Their religion soars to a shout."[17]

"ETHIOPIA SHALL SOON STRETCH OUT HER HANDS UNTO GOD"

In the wake of this debate, Harlem Renaissance illustrators devised a variety of methods to reinvent tradition and reveal distinctive religious expression, sometimes emphasizing tradition, sometimes privileging modern experience. One method that challenged white religious tradition highlighted the contribution of those described in biblical and early Christian texts as African or black-skinned. Probably the most frequently illustrated passage in this vein was the adoration of Christ by the three kings; as early texts identified one of the kings as black-skinned, subsequent religious art traditionally represented him as a black man. Laura Wheeler's *Crisis* cover followed this model.[18] Held by Mary and protected by Joseph, the infant Christ is adored by the three Magi as they present their gifts to the baby. Wheeler illustrated Balthasar, the black-skinned king at left, according to a convention developed during the medieval period, when the kings had come to symbolize the three parts of the known world:

Africa, Asia, and Europe. Never diverting from Western artistic conventions, however, Wheeler's black king is placed at the greatest distance from the Christ child, who interacts most with the kneeling white king.

Charles S. Johnson, editor of *Opportunity*, adopted strategies similar to Wheeler's by reproducing Western religious art that incorporated black figures. For example, he adorned the cover of his December 1927 issue with a reproduction of a Flemish Renaissance painting of the *Adoration of the Magi*.[19] The painting conveys in meticulous detail each distinguishing feature of Balthasar, from his tightly curled hair and beard, to his dark skin and hands, his full lips, and his exoticizing gold earring. Placed within the context of a cover design for *Opportunity*, the scrupulous image became an argument for locating African participation within the Judeo-Christian tradition.[20] In their magazine cover designs, Wheeler and Johnson emphasized a well-established tradition within Western art for contact between a black man and the infant Christ.

By contrast, in her *Opportunity* cover illustrating the Adoration of the Kings, Gwendolyn Bennett departed from conventional religious paintings (fig. 64). Dividing her composition into two sections, Bennett placed the two white kings at left, while Mary and Christ stand at right allied with Balthasar kneeling below. Beyond his darkened skin and curly black hair, Bennett emphasized Balthasar as the youngest king, an attribute usually given to King Melchior. Further, by accentuating his musculature with dark parallel lines and gracing him with an athletic pose, Bennett has suggested that the African king is a nimble youth whose bright future still lies ahead, in contrast to that of the older white kings. The figure of Mary, who turns her head in the direction of Balthasar, suggests her bestowal of favor on this African youth, connecting the infant Christ in her arms symbolically with the African continent.

Perhaps even more transgressive, white artist Charles Cullen arranged his *Opportunity* cover illustration in a circular format in which Balthasar occupied the most prominent position, his head extending above the circular frame.[21] Cullen depicted one white king in partial view behind Balthasar, but omitted the other white king altogether. Seated below Balthasar, Mary gazes down at the infant Christ, whom she holds in her arms. Both Christ and Joseph, who appears in the lower right, tilt their heads up toward Balthasar, privileging him with their gazes. In this composition, Cullen seems to have suggested that the future of humankind rested as much on the shoulders of this strong, young black king as on Christ himself.

The methodologies exemplified by Wheeler and Johnson, who highlighted African participation in the Christian tradition, or by Bennett and Cullen, who

Figure 64. Gwendolyn Bennett, cover of *Opportunity* (January 1926). General Research & Reference Division, Schomburg Center for Research in Black Culture, The New York Public Library, Astor, Lenox, and Tilden Foundations. Reprinted by permission of the National Urban League.

reinterpreted the participation of Africans within the same tradition, drew on a style of biblical exegesis now known as Ethiopianism. The practice of this interpretive method began in the late eighteenth and early nineteenth century by "English-speaking African" theologians, who reconsidered specific passages in scripture to indicate the imminent "rise of Africa."[22] More than a theological tool, Ethiopianism filtered into a variety of expressions in the nineteenth century, from "slave narratives" and orations of "slave preachers," to "sermons and political tracts of the sophisticated urban elite."[23] Many of Ethiopianism's African and African American practitioners used as a point of origin a passage in Psalms (68:31): "Princes shall come out of Egypt; Ethiopia shall soon stretch out her hands unto God." This passage indicated to Ethiopianists that through their relationship with God those of African descent would soon "experience a dramatic political, industrial, and economic renaissance."[24] This renaissance would come about through a renewed self-awareness based on reinterpreting the key participation of African people in the Bible, which defied conventionally negative assessments of black-skinned figures in biblical stories.

Emerging in the Hebrew Bible in the book of Genesis, the seeds for interpreting black skin as a curse stemmed from the narrative of Noah's sons, Shem, Ham, and Japheth. The key episode occurred after Noah had planted his first vineyard:

> And he drank of the wine, and became drunk, and lay uncovered in his tent. And Ham, the father of Canaan, saw the nakedness of his father, and told his two brothers outside. Then Shem and Japheth took a garment, laid it upon both their shoulders, and walked backward and covered the nakedness of their father; their faces were turned away, and they did not see their father's nakedness. When Noah awoke from his wine and knew what his youngest son had done to him, he said, "Cursed be Canaan; a slave of slaves shall he be to his brothers." He also said, "Blessed by the Lord my God be Shem; and let Canaan be his slave. God enlarge Japheth, and let him dwell in the tents of Shem; and let Canaan be his slave." (Gen. 8:21–27)

Conventionally interpreted, Ham's curse for staring at his father in a drunken state, rather than turning away in modesty, was to father the black-skinned or "Hamitic races," including descendants of Ethiopia, Egypt, and Palestine.[25]

By contrast, Ethiopianist writers reinterpreted black skin as a gift and those of African descent as eventual prophets. One of the most influential proponents of Ethiopianist thought was Edward W. Blyden, whose *Christianity, Islam*

and the Negro Race of 1887 Aaron Douglas had studied carefully.[26] Ethiopianist
scholars like Blyden frequently cited the New Testament figure of Simon of
Cyrene, the black man who so empathized with Christ's suffering on the road
to Calvary that he stepped in to carry Christ's cross. Blyden described Simon's
deed as no sacrifice, but an honor:

> In the final hours of the Man of Sorrows, when His disciples had forsaken
> Him and fled, and only the tears of sympathizing women . . . showed that
> His sorrows touched any human heart; . . . what was the part that Africa
> took then? She furnished the man to share the burden of the cross with the
> suffering Redeemer. Simon, the Cyrenian, bore the cross after Jesus.
> "Fleecy locks and dark complexion" thus enjoyed a privilege and an honour,
> and was invested with a glory in which kings and potentates, martyrs and
> confessors in the long roll of ages, would have been proud to participate.[27]

At the turn of the century, African American writers and poets from Paul
Laurence Dunbar to W. E. B. Du Bois adopted Ethiopianist strategies in their
creative work.[28] Du Bois's *Star of Ethiopia* pageant, first performed in 1913,
used Ethiopianist exegesis broadly to reinterpret key contributions of Africans
in western history as gifts. For example, he reconceived the "Gift of Civiliza-
tion" and the "Gift of Freedom" as contributions to history that descendants of
Africa could claim.[29] His pageant's title had been inspired by the passage in
Psalms that had given rise to Ethiopianist interpretation, "Princes shall come
out of Egypt; Ethiopia shall soon stretch out her hands unto God." Du Bois
later asked Aaron Douglas to illustrate this passage on the cover of the May
1927 issue of the *Crisis*, which he edited for the NAACP. In his image, Douglas
featured the large star of Ethiopia shining over an Egyptian pyramid, the star
and pyramid both functioning as symbols of Africa. Douglas represented the
privileged descendants of Africa through the iconic image of two dark, flame-
like hands that reach up toward the star.

Ethiopianist strains may be readily detected in other illustrations by Doug-
las. For example, his *Crucifixion* features the figure of Simon of Cyrene loom-
ing large as the most prominent figure (fig. 65). This dark man heaves Christ's
heavy cross over his shoulders, with legs striding wide to support his load.
Only upon closer examination is the small, light, haloed figure of Christ appar-
ent underneath the spread legs of Simon. Douglas created this composition as
one of a set that would illustrate James Weldon Johnson's collection of poems
God's Trombones. Douglas's *Crucifixion* illustrated Johnson's poem of the same
title, drawing particularly on the verse devoted to Simon of Cyrene:

Figure 65. Aaron Douglas, *The Crucifixion,* in James W. Johnson, *God's Trombones* (New York: Viking, 1927), copyright 1927 The Viking Press, Inc., renewed © 1955 by Grace Nail Johnson. Used by permission of Viking Penguin, a division of Penguin Group (USA) Inc. Library of James Weldon Johnson and Grace Nail Johnson, Manuscript, Archives, and Rare Book Library, Emory University.

> Up Golgotha's rugged road
> I see my Jesus go.
> I see him sink beneath the load,
> I see my drooping Jesus sink.
> And then they laid hold on Simon,
> Black Simon, yes, black Simon;
> They put the cross on Simon,
> And Simon bore the cross.[30]

Johnson's shift from passive to active voice, from "They put the cross on Simon," to "And Simon bore the cross," has Ethiopianist implications. For example, Blyden's argument that Simon's burden be reconceived as "a privilege and an honour" and ultimately an African contribution to the Christian narrative, seems present in Johnson's final transmogrification, in which Simon actively bears the cross. Douglas's illustration elaborates on Johnson's shift through Simon's vigorous stride, his readiness to bear Christ's load, and his active gaze toward God's light above. In Ethiopianist form, Douglas has reconceived Simon as a model of human suffering who links Christ's sacrifice with the experiences of African Americans.

In Douglas's *Crucifixion* and in Ethiopianist exegesis, Simon was cast as Christ's truer disciple, in contrast to his white followers, who would often betray their teacher's trust. For African American poet Countee Cullen, Simon had been the only one in Christ's orbit to own up to his responsibility. In his poem, "Colors," he wrote caustically:

> Yea, he who helped Christ up Golgotha's track,
> That Simon who did *not* deny, was black.[31]

The one who did deny his association with Christ was Simon Peter, one of Jesus's disciples whose denial was but another form of betrayal Christ experienced from his white followers. Like Cullen, Douglas has also portrayed Simon as a black hero who acted for Christ, shown in isolation and abandonment below; he risked association with Christ when others would not.

Ethiopianist strategies may also be found in the work of black American writers during the 1920s. Perhaps one of the most poignant applications of Ethiopianist interpretation is expressed in Zora Neale Hurston's one-act play, *The First One*. Published in Charles S. Johnson's collection of literature and art titled *Ebony and Topaz*, Hurston's play reinterpreted Noah's curse against his son Ham. Employing an Ethiopianist reversal, Hurston cast Ham as Noah's fa-

vorite son, to whom he had willed his fields and flocks, to the irritation of Ham's brothers (Shem and Japheth) and their wives. As if borrowing from the New Testament parable of the prodigal son, Hurston described Shem and Japheth as hard-working, whereas Ham was usually late, always ready for a good time, and could often be found laughing, singing, dancing, and "twanging [on] a rude stringed instrument." On the night of the fateful curse, Ham's wife, suggestively named Eve, poured wine for Noah, who would soon become drunk. When Noah retired to his tent, Ham followed his father and was heard by the others "laughing raucously inside the tent." Amused by what he had seen, he emerged from the tent, guffawing: "Our Father has stripped himself, showing all his wrinkles. Ha! Ha! He's no young goat in the spring. Ha! Ha! . . . The old Ram, Ha! Ha! Ha! He has had no spring for years! Ha! Ha!"[32]

Shem's and Japheth's wives see their opportunity to wrest Noah's wealth from Ham, urging their husbands to cover Noah and tell him how he had been mocked. But, they were not prepared for Noah's wrath, who cursed the culprit who had behaved so disrespectfully, not knowing in his drunken stupor that the culprit was his favorite son: "No, he shall have no part in my goods—his goods shall be parcelled out among the others. . . . He shall be accursed. His skin shall be black! Black as the nights, when the waters brooded over the Earth! . . . Black! He and his seed forever. He shall serve his brothers and they shall rule over him. . . ."[33]

Fearing their father's anger would lead to their own demise, Noah's sons and wives revealed the identity of Ham as the one who had mocked him. Noah could scarcely believe what had befallen him and his favorite son. However, despite his pleadings with Jehovah, his curse prevailed. Ham had turned black. His brothers ran from him in horror; even his mother could not look him in the eye. Unable to find further remedy, Noah banished him from the family: "Arise Ham. Thou art black. Arise and go out from among us that we may see thy face no more, lest by lingering the curse of thy blackness come upon all my seed forever."[34]

Not surprisingly in Hurston's sea of reversals, Eve's was the voice of reason:

Ham, my husband, Noah is right. Let us go before you awake and learn to despise your father and your God. Come away Ham, beloved, come with me, where thou canst never see these faces again, where never thy soft eyes can harden by looking too oft upon the fruit of their error, where never thy happy voice can learn to weep.[35]

Whether applying Ethiopianist interpretation to the black king at Christ's nativity, Simon the Cyrenian, or Ham, the "father" of black-skinned progeny,

African American artists and writers subverted conventional religious assessments of blackness as evil, reconceiving black-skinned biblical figures as occupying pivotal roles in scripture, their blackness allowing them greater human capacity than their white counterparts.

"BLACK GODS"

When Aaron Douglas wrote to Langston Hughes in 1925, "Let's also make gods. Black gods. Disconcertingly black. Variations of black,"[36] his declaration moved beyond Ethiopianist biblical interpretation, which limited itself to reassessing the value of those already identified as black within the pages of scripture. Instead, Douglas critiqued the Christian tradition, which had come to know itself as white, which pictured the son of God with white skin and soft locks of blond hair, which characterized whiteness as purity and holiness. For Douglas, African Americans needed to reconceive religious tradition, creating Christian gods in their own image. Flying in the face of conventionally white representations, Douglas's black Adam gazes at the brown hand of God (fig. 63), his black shepherds follow the star to Christ's manger (fig. 66), his black angel Gabriel blows the millennial trumpet (fig. 67), and his black Prodigal Son lives it up in a Harlem cabaret. These works challenged tradition by inserting the modern black American into ancient Judeo-Christian narratives.

Douglas's black biblical players fulfilled the function of scriptural commentary, filling in the text's absences to create a more inclusive tradition that contemporary black Americans could readily embrace. In this light, he learned from W. E. B. Du Bois, who, as editor of the *Crisis,* often commissioned illustrations from Douglas. They worked together on the December 1926 issue, Douglas providing its cover illustration and Du Bois writing a related editorial. Douglas's illustration was given the title from scripture: "And there were in the same country shepherds abiding in the field" (fig. 66). However, his black shepherds, who stare up at the star that will guide them to Christ, seem to have evolved less from scripture alone and more directly from Du Bois's editorial, which appeared just inside Douglas's cover. Interspersing scripture with his own writing, Du Bois quoted passages from the New Testament book of Luke, editorializing on the biblical text in his own words. For the reader's clarification, he printed the biblical text in italics and his own words in Roman characters. He began:

THE CRISIS

XMAS 1926

DECEMBER, 1926 — Double Number — 15 Cents a Copy

Figure 66. Aaron Douglas, *"And There Were in the Same Country Shepherds Abiding in the Field,"* cover of the *Crisis* (December 1926). Yale Collection of American Literature, Beinecke Rare Book and Manuscript Library, Yale University.

And there were in the same country shepherds abiding in the field, keeping watch over their flock by night—ignorant, black and striving shepherds . . . [in] fields of harm and hunger.

The angel of the Lord, whom Du Bois described at the end of his editorial as "the lone, lean, brown and conquered angel," calls out to the shepherds:

Behold I bring you good tidings of great joy which shall be to all people and na-tions and races and colors. *For unto you is born in this day in the city of David a Saviour* which is Peace. *And this shall be a sign unto you;* ye shall not find Peace in the Palaces and Chancelleries, nor even in the League of Nations and last of all in the Church; but *wrapped in swaddling clothes and lying in a manger,* down among the lowly black folk and brown and yellow and among the poor white who work.[37]

Du Bois's insertions into a remote biblical text served to make the ancient Christmas narrative relevant for his African American readership. For Du Bois, Christ was born both long ago in Bethlehem and in 1926 among "lowly black folk and brown and yellow and among the poor white who work." Du Bois's was both a biblical and a political message, interpreting Christ as a historical figure and a modern emissary of peace.

Douglas may also have been influenced by views on religious art from voices even further on the periphery of organized religion in Harlem than Du Bois's. Particularly in his "coloring" of white religion, he may well have re-sponded to Marcus Garvey's protest movement of the early 1920s, officially embodied in his Universal Negro Improvement Association (UNIA).[38] While his movement was addressed primarily to working-class African Americans, his public orations, marches, and conventions were covered widely in a variety of New York presses, including the *New York Times* as well as black newspapers and periodicals. Garvey established a close association with the recently formed African Orthodox Church, a Messianic sect in which black congregants were urged to worship a God of their own color; only then could they perceive them-selves, made in a black God's image, as good and not aberrant. In the opening parade of the UNIA Convention of August 1924, marchers carried "paintings of a black Madonna and child [and] an Ethiopian Jesus."[39] Enframing the month-long proceedings were two overtly religious ceremonies, in which visu-alizing a black God animated the rhetoric of those who spoke. Adorning the platform at the first service "was a large painting of an Ethiopian Christ and a black Madonna framed in gold," where speaker

Bishop George Alexander McGuire of the African Orthodox Church urged the audience to name an international day when all the negroes of the world should tear the pictures of a white Madonna and a white Christ out of their homes and make a bonfire of them. "Then let us start our negro painters getting busy," he exclaimed, "and supply a black Madonna and a black Christ for the training of our children."[40]

Garvey's oration to the convention delegates repeatedly emphasized the insidiousness of religious imagery that excluded members of his race:

When I was about to leave the house [of an associate] I noticed a picture on the wall. . . . What was it? . . . [It showed a] white man sitting at [a] desk [who] was God. The two white women on either side were white angels; the woman on the right side was the Virgin Mary, the child below was the Son of God, Jesus Christ. . . . And that was [in] a colored woman's house. I looked and said, "where is the other picture?" I turned to the other side of the wall, but the other picture was not there. But the idea was there. The idea was in that home. There was another picture of a hideous, monstrous creature that was the devil. . . . But the artist did not hang that picture. That picture was created in the minds of all the Negroes all over the world and for hundreds of years. They encased that picture in their minds and kept it in their skulls.[41]

In an elaborate gesture designed to "correct" the negative color-coding of the images Garvey described, the convention concluded with a "unique ceremony in the form of divine service for the canonization of the Lord Jesus Christ as the Black Man of Sorrows, and also the canonization of the Blessed Virgin Mary as a black woman."[42] While tied to biblical tradition, Garvey and McGuire questioned how that tradition could be adapted to emancipate psychically their contemporary black American followers.

With similar concerns, Aaron Douglas created religious works that made biblical texts relevant for modern black communities. Especially in his illustrations for James Weldon Johnson's *God's Trombones* of 1927, his viewers were met with "black gods." Setting the stage for a radical retelling of Judeo-Christian narratives, Douglas's black Adam appeared as humanity's ancestor—a figure Douglas wielded to correct the negative biblical associations with black skin that Garvey and others protested (fig. 63). In his subsequent illustrations, readers encountered this black Adam's progeny—not the cursed "sons of Ham," but key biblical figures normally pictured white, including Moses and

the angel Gabriel (fig. 67). In his scene of *The Prodigal Son,* Douglas fully trans-
formed the remote parable, recasting the wayward youth and his urban
temptresses as modern black revelers in a Harlem cabaret. He further modern-
ized biblical narratives through the lens of black religious expression. To this
end, in some of his illustrations, he placed biblical figures in the context of con-
temporary black worship. For example, his *Judgment Day* featured the winged
angel Gabriel of scripture, but placed among praying figures in the background
who raise their hands to receive the holy spirit, a gesture from contemporary
black religious practice (fig. 67).

Douglas's balance of ancient tradition and modern expression in these il-
lustrations paralleled Johnson's objectives in writing *God's Trombones,* a collec-
tion of poems based on his discovery of the poetry, as he called it, of the black
preaching style. Here was a literary form extending back to the beginning of
slavery in America that blended tradition and modernity, intellect and ecstasy.
Johnson, a writer and cultural critic of W. E. B. Du Bois's generation, hoped in
these poems to "fix something of . . . the old-time Negro preacher," whom he
felt was "rapidly passing."[43] Stemming from sermons he had witnessed as a
child, and on occasion as an adult, his poems were based on subjects and
rhythmic patterns Johnson felt were typical of the African American preacher.
"The old-time Negro preacher has not yet been given the niche in which he
properly belongs," Johnson wrote in his introduction to *God's Trombones.*[44] Too
often subjected to comic stereotypes, the "Negro preacher" was "the first shep-
herd of this bewildered flock . . . who for generations was the mainspring of
hope and inspiration for the Negro in America," Johnson reassessed. The black
preacher was intelligent, even a "genius," able to stir congregants to ecstasy
with his modulating voice and colloquialisms. According to Johnson, "He
preached a personal and anthropomorphic God, a sure-enough heaven and a
red-hot hell."[45] Further, he asserted that the language of black American
preachers occupied a position between scriptural verse and spoken black
dialects:

> The old-time Negro preachers, though they actually used dialect in their or-
> dinary intercourse, stepped out from its narrow confines when they
> preached. They were all saturated with sublime phraseology of the Hebrew
> prophets and steeped in the idioms of King James English, so when they
> preached and warmed to their work they spoke another language, a lan-
> guage far removed from traditional Negro dialect. It was really a fusion of
> Negro idioms with Bible English.[46]

Figure 67. Aaron Douglas, *The Judgment Day*, in James W. Johnson, *God's Trombones* (New York: Viking, 1927), copyright 1927 The Viking Press, Inc., renewed © 1955 by Grace Nail Johnson. Used by permission of Viking Penguin, a division of Penguin Group (USA) Inc. Library of James Weldon Johnson and Grace Nail Johnson, Manuscript, Archives, and Rare Book Library, Emory University.

With his *God's Trombones*, Johnson reversed comic stereotypes of the African American preacher, reinterpreting him as a pivotal figure who possessed the power to link religious tradition with the modern world.

In his illustrations for Johnson's poems, Douglas visualized the preacher's connection between tradition and modernity by blending a distancing archaism with a mode of humanization and intimacy. In his *Creation* (fig. 63), he included features that suggested archaic styles. The vast sense of space, the hierarchy of scale in which Adam is overshadowed by God's immense hand, and the representation of God through a stylized hand alone are all reminiscent of Byzantine or western medieval art. At the same time, Douglas achieved a sense of intimacy with the large hand that shelters the tiny figure—a hand assuming a shape similar to Adam's own hand. In his later painted version, God's hand further resembled Adam's in its brown color, though Douglas chose a more inclusive, lighter shade of brown for the hand of a God whose children came in many colors. In this space of human intimacy, Douglas was responding to Johnson's characterization of God as a being with human emotions and motivations, based on the language of Negro preachers. In his "Creation" poem, Johnson imagined God was motivated to create humanity because he was lonely and sought community with others:

> And God stepped out on space,
> And he looked around and said:
> I'm lonely—
> I'll make me a world.
>
> . . .
>
> Then God sat down—
> On the side of a hill where he could think;
> By a deep, wide river he sat down;
> With his head in his hands,
> God thought and thought,
> Till he thought: I'll make me a man![47]

In animating the space with a series of circles that emanate from a distant point and parallel bands that sweep across the sky, Douglas also captured the cadence, sense of movement, and immediacy of Johnson's poem:

> And the light that was left from making the sun
> God gathered it up in a shining ball
> And flung it against the darkness,

> Spangling the night with the moon and stars.
> Then down between the darkness and the light
> He hurled the world;
> And God said: That's good![48]

Further working the interstices between ancient tradition and modern black expression, Douglas juxtaposed signs of ancient and modern identity in his *Let My People Go*. As his visual focus, Douglas chose the most dramatic part of Johnson's poem based on the Exodus narrative, when the God of Israel parted the waters of the Red Sea so his chosen people could escape their lives of enslavement in Egypt. At left, Douglas has shown the Egyptian Pharoah's soldiers in a chaotic frenzy, as the waves of the Red Sea swell over them. At right, Moses and the Israelites safely cross the sea before the waves fill up the path God had created.[49] His Egyptian soldiers resemble figures in both ancient Egyptian and Greek art; their composite poses are reminiscent of ancient Egyptian wall paintings and reliefs, while their lively, lyrical silhouettes recall Attic Greek black figure vase paintings. By contrast, Moses' pose with arms held open is based on a familiar gesture used by some contemporary African American worshipers, demonstrating their ecstatic embrace of the Holy Spirit. Connecting his ancient figures with Moses, who suggests modern identity, Douglas constructed a shaft of light emanating from the upper left and shining down onto the prophet, an attribute he employed frequently to symbolize the close connection God established with his black followers. A black kneeling, worshipping figure is similarly bathed in a shaft of light in his *Judgment Day* (fig. 67).

Johnson's poem "Let My People Go" similarly balanced tradition and modernity. While he maintained ties to the biblical narrative in Exodus, in some of his phrasing he alerted the reader to the black preacher's storytelling methods. For example, he used the black preacher's technique of repetition, intoning the refrain, "Let my people go," at the end of almost every verse. He also repeated phrases for emphasis: "Therefore, Moses, go down, / Go down into Egypt," or later, "And Pharaoh looked at Moses, / He stopped still and looked at Moses." Johnson's God was also part biblical and part preacher, sometimes distant and at other times intimate. On the one hand, Johnson characterized God as a stern, unyielding, but fair judge, who spoke in clear, direct prose:

> And God said to Moses:
> I've seen the awful suffering
> Of my people down in Egypt.

I've watched their hard oppressors,
Their overseers and drivers;[50]

But when God felt emotion and a more intimate connection with his peo-
ple, Johnson wrote his lines in a form of black dialect:

The groans of my people have filled my ears
And I can't stand it no longer;
So I'm come down to deliver them
Out of the land of Egypt.[51]

In the light of Johnson's poetry, Aaron Douglas's *God's Trombones* illustra-
tions fell between religious tradition and vernacular expression, reflecting
Johnson's aim to reintroduce the black preacher as a therapeutic treasure in
black American history who crafted a remote ancient text into a vivid and dis-
tinctive contemporary expression.

"ON THE CROSS OF THE SOUTH"[52]

In other cases, artists of the 1920s and 30s focused more exclusively on the ver-
nacular religious expression of working-class African Americans. These artists
often made suggestive connections between the ancient suffering of Christ and
the contemporary injustices experienced by blacks in America. In this vein,
some artists developed a new iconography that linked Christ's crucifixion with
the lynching of African American men. This theme captured the attention of a
diverse group, its potency cutting across racial barriers. From the hands of white
artists, such as Prentiss Taylor, to African American artists, such as Zell Ingram,
the act of lynching was portrayed as a vernacular crucifixion. The connections
were made directly: as Christ had been unjustly accused and crucified by the will
of a crowd, so innocent black victims in the South were hunted and killed by
mobs of white racists who sought to obliterate the black male populace.

Further politicizing associations between southern lynching and Christ's
crucifixion, Ingram's and Taylor's illustrations responded specifically to the
renowned Scottsboro case, in which eight young African American men were
unjustly convicted of rape and sentenced to death.[53] For these artists, the cor-
rupt legal system in Scottsboro, Alabama, had operated more as a mob than
through the scales of justice. The court's mistreatment of the "Scottsboro
Boys," as they came to be called, seemed no less heinous than Christ's fate at

the hands of those who cried for his crucifixion. In the imagery of Ingram and Taylor, the Scottsboro Boys became the vernacular Christs of the South.

Spurred by the radicalism of the American Left, Ingram and Taylor expressed unorthodox political associations between the Christological narrative and the lynching of black men in America's South, in response to the "legal lynching" of the Scottsboro Boys in 1931. However, their illustrations also attest to a broader literary and art-historical context. Artists and writers associated with the Harlem Renaissance increasingly drew comparisons between the suffering of Christ and the tribulations experienced by African American working-class people. These themes appeared in illustrations, short stories, and poems, which were published in black American journals, such as the *Crisis* and *Opportunity*, and later in politically left literary magazines. In these venues, artists and writers repeatedly characterized black Americans as direct descendants of Christ, sharing a kinship of oppression and injustice with their ancient ancestor.

Frequently in graphic art, poems, and short stories of the 1920s and early 1930s, comparisons were drawn between Christ and black Americans. For example, Douglas sometimes suggested a privileged proximity between working-class black worshipers and the figure of Christ. In his *Feet o' Jesus,* he illustrated a short poem that had been composed by Langston Hughes using a black vernacular dialect. Douglas's image featured a black man at the center, whom the viewer imagined at the foot of Christ's cross, his head tipped up and arms outstretched mimicking Christ's crucified pose. Douglas achieved an intimacy and emotive quality in this figure's pose that humanized Christ's crucifixion and articulated the outstretched arms of emotive black worshipers, corresponding with the vernacular language Hughes used in the accompanying poem:[54]

> At the feet o' Jesus,
> Sorrow like a sea.
> Lordy, let yo' mercy
> Come driftin' down on me.
> At the feet o' Jesus
> At yo' feet I stand.
> O, ma little Jesus,
> Please reach out yo' hand.[55]

Hughes's language began by referring to Jesus in the third person, then shifted in the third line to the more personal second person. In the end, Hughes created a bond between supplicant and Christ that crossed history.

Douglas's black figure, who assumed the pose of the crucified Christ, likewise raised his head as if to implore Jesus across time in Hughes's words: "Please reach out yo' hand."

Beyond establishing a connection across time between African American worshipers and Christ, Roscoe Wright's *Negro Womanhood* emphasized the experience of suffering shared by black Americans and Christ (fig. 68). At the center of his *Crisis* cover of January 1928, Wright presented a black female figure assuming the pose of Christ at his crucifixion. He has thereby associated the burdens of black and female identity in the 1920s with Christ's agony on the cross, and further, with the history of slavery in America, as represented by the chain at right. In his radically modern black female crucifixion, Wright has suggested an ancestry of suffering and ultimate redemption that modern black women might claim.

Employing a marker of suffering shared by Christ and black Americans, artists often invoked Christ's road to Calvary. In his *On de No'thern Road* (see fig. 26; 1926), Aaron Douglas depicted a black migrant who carries his belongings over his shoulder and strides toward a road that will lead him away from the rural South, symbolized by the natural setting surrounding him. The road winds into the distance and terminates in the northern city, taking the form of a sunburst. Douglas has drawn parallels between this black migrant and Christ's road to Calvary. The migrant's pose, with his knapsack heaved over his shoulder and legs splayed wide, suggests connection with Christ's gait as he made his way to Calvary with his cross on his back. His pose further anticipates Douglas's figure of Simon of Cyrene, who carries Christ's cross on the road to Calvary in his *Crucifixion* (fig. 65). Thus, Douglas suggests an association between his migrant's pilgrimage north and the burdensome road to Calvary.

The visual connection between Douglas's migrant and the road to Calvary was supported textually by Langston Hughes's vernacular poem, "Bound No'th Blues," which Douglas's image accompanied in the October 1926 issue of *Opportunity* and later in the *Opportunity Art Folio* in December. Hughes began his poem with lines describing the road north of the southern black migrant:

> Goin' down de road, Lord,
> Goin' down de road.
> Down de road, Lord,
> Way, way down de road.
> Got to find somebody
> To help me carry this load.[56]

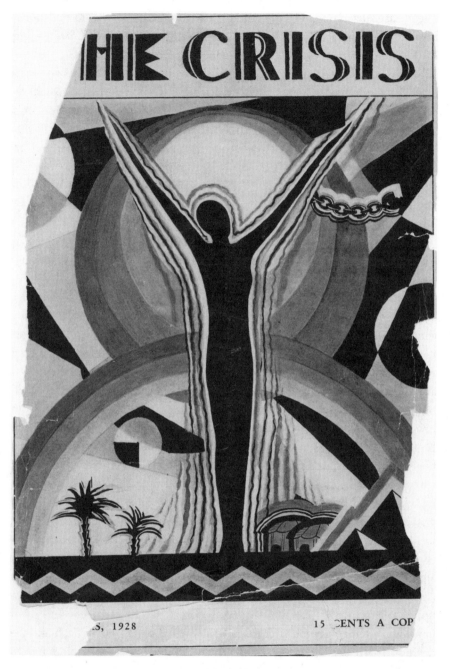

THE CRISIS

..S, 1928 15 CENTS A COP

Figure 68. Roscoe Wright, *Negro Womanhood,* cover of the *Crisis* (January 1928). General Research & Reference Division, Schomburg Center for Research in Black Culture, The New York Public Library, Astor, Lenox, and Tilden Foundations.

The phrase "down de road," in combination with the lines, "Got to find some-body / To help me carry this load," call to mind Christ's road to Golgotha and his meeting of Simon of Cyrene, who helped shoulder his load.

The road to Calvary was more clearly invoked by other black poets and writ-ers to describe a process of suffering experienced by African Americans that re-sembled Jesus's pain. Such an allusion can be found in Zora Neale Hurston's short story "Sweat," published in 1926 in the radical literary journal, *Fire!!*[57] Hurston told of Delia, a black "washwoman" from Florida who suffered from too much work and an abusive husband. In painting a word picture to describe her tribulation, Hurston alluded to Christ's experience: "Delia's work-worn knees crawled over the earth in Gethsemane and up the rocks of Calvary many, many times during these months."[58] In using the phrases, "down de road," or "up the rocks of Calvary," Hughes and Hurston drew on colloquial epithets that linked Christ's road to Calvary with the roads of suffering traveled by working-class African American citizens.

Increasingly in the 1930s, writers and poets employed the political metaphor of a reactivated Christ engaged in walking the road to Calvary again. Published sometimes in *Opportunity* and the *Crisis*, these stories and poems appeared with more frequency in literary periodicals supporting the labor movement. Using the symbol of a contemporary Christ walking among the oppressed, these liter-ary works critiqued the social acquiescence of mainstream religious denomina-tions and argued for politicizing the Christological narrative. In order to imagine a socially responsible Christianity, Langston Hughes and other writers began to ask if Christ's historical acts of sacrifice on behalf of humanity's salva-tion continued to have effect. He needed to be recast, in their view, as one who still walked the earth shouldering the load of suffering experienced by the work-ing classes, especially those of African American identity. In these literary works, it often took an African American citizen to release Christ from his iconic role on the cross, allowing his life and commitment to social action to re-sume symbolically on the road to Calvary. In "Get Off that Rusty Cross," a short story published in 1931 in *Contempo: A Review of Ideas and Personalities,* an African American preacher doubted that Jesus's ancient acts of redemption con-tinued to have effect. "Jule, the Negro preacher . . . saw that this redeeming cer-tainly was a temporary job. The world was now full of sin, full of flesh and the devil. . . ."[59] He decided to make a pilgrimage to find Christ, to implore him to make his presence known in the world again. After searching for forty days, Jule finally found Christ. "Then he dropped mechanically to his worn out knees, stretched out his hungry arms . . . and shouted rather faintly: 'Jesus, oh, Jesus, get off dat rusty cross of yours, and go de way to Calvary again!'"[60]

In his 1935 short story "On the Road," Langston Hughes further imagined that Christ would want to be freed from his incarceration on the cross, and that through the aegis of a poor black man, he might be able to walk the road to Calvary again.[61] Hughes's protagonist was an unemployed African American man, a vagrant named Sargeant, with no place to sleep and nothing to eat. Hoping to find a warm bed in a town he was passing through, Sargeant knocked on the door of the minister's house but was refused. Then he walked toward the town's church, thinking surely he would find shelter there, but the doors were locked. He yelled out, hoping to wake someone inside, and began banging, pushing on the door with his body. Gradually townspeople and then the police gathered. Despite the efforts of the fervent crowd to beat at Sargeant and pull him away from the church, he held firmly to a pillar by the front door. With the crowd pulling at Sargeant, and Sargeant pulling on the pillar, the stone edifice of the church, including its crucifix, began to crack and break apart, finally falling in a heap of rubble on the ground. Sargeant crawled away from the mess and continued down the road in search of shelter. Hughes described his protagonist's surprise when he suddenly heard footsteps next to his own:

Sargeant thought he was alone, but listening to the crunch, crunch, crunch on the snow of his own footsteps, he heard other footsteps too, doubling his own. He looked around and there was Christ walking along beside him, the same Christ that had been on the cross on the church—still stone with a rough surface, walking along beside him just like he was broken off the cross when the church fell down.

"Well, I'll be dogged," said Sargeant. "This here's the first time I ever seed you off the cross."

"Yes," said Christ, crunching his feet in the snow. "You had to pull the church down to get me off the cross."

"You glad?" said Sargeant.

"I sure am," said Christ.

They both laughed.

"I'm a hell of a fellow, ain't I?" said Sargeant. "Done pulled the church down!"

"You did a good job," said Christ. "They kept me nailed on a cross for near two thousand years."[62]

In his short story, Hughes critiqued mainstream religion's emphasis on Christ's crucifixion. That iconic representation could not approximate the force of an image in which Christ lived and walked actively down the road in the

company of a black man. This living image called to mind not only Christ's road to Calvary but his entire life, which he had devoted to inverting dominant forms of power relations that oppressed the poor and working classes.

In the same year that Hughes wrote this story, African American artist E. Simms Campbell exhibited his work *I Passed along This Way*.[63] Like Hughes's story, Campbell's composition pairs an African American male figure with Christ walking down the road. While Christ is making his way to Calvary, his cross on his back, an African American figure swings into his path, hanging by his neck from a rope that extends from the left. In Campbell's dark scene, the lynched African American figure seems to grow out of Christ's cross, suggesting a kinship of suffering and sacrifice between both men. On the one hand, his title, *I Passed along This Way*, articulated the voice of the lynched victim. Through his suffering at the hands an eager white mob, this black victim had walked in Christ's footsteps on the road to his own "Calvary." On the other hand, the title was an empathic phrase uttered to the lynched victim by a reactivated Christ, as one who continued to suffer oppression as he walked down the road to Calvary again.

Campbell was one of many artists and writers to confront the horror of lynching in their work, connecting it with Christ's experience of suffering and injustice. These illustrations appeared in *Crisis* and *Opportunity* in conjunction with news reports on lynchings, as well as short stories that sought to elucidate the brutality of southern mob violence. These journals were responding, on the one hand, to the increased frequency of lynchings after 1915, when the Ku Klux Klan had been revived in the South, and on the other, to news of the atrocities of mob violence against southern blacks published assiduously by the NAACP, which launched its antilynching campaign in 1919.[64] Members of the NAACP sought to dispel myths about the motivation behind white violence against blacks. In gathering lists of names of lynched victims along with news reports, they clarified that lynching only mythically preserved the innocence of white women. In actuality, it aimed at squelching potential economic freedom for southern blacks. As historian W. Fitzhugh Brundage has written:

> Rather than punish criminals, lynchers actually sought to crush black economic aspirations . . . and perpetuate white hegemony over a cowed and inarticulate black population. Once the myths were discredited . . . , lynching would be understood for what it was—a crude and brutal tool of white supremacy. Far from a defense of the hallowed traditions of civilization, lynching, blacks insisted, was an indefensible assault on them.[65]

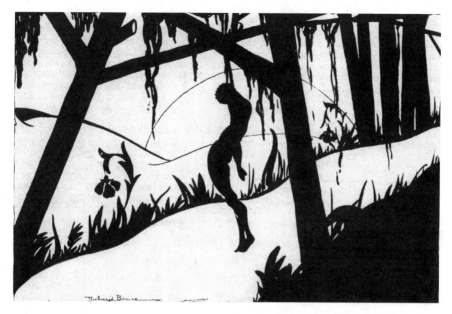

Figure 69. Richard Bruce Nugent, illustration for William V. Kelley, "Black Gum," in *Opportunity* (January 1928). Reprinted by permission of the National Urban League.

In the January 1928 issue of *Opportunity*, editor Charles S. Johnson continued the quest to dispel myths about lynching, using statistical data, artistic illustration, and literary contributions. On one page, he underscored the facts of southern lynchings by printing the names of those who had been lynched in 1927 and the southern towns in which they were killed. Above the list of names, he reproduced an ironic lithograph by George Bellows, titled *The Law's Too Slow!* (1923).[66] In Bellows's print, a ghoulish white man with a skeletal face stokes the fire that has been laid at the feet of a black man chained to a stake. A crowd of white people has gathered to view the lynching with prurient glee.

In the same issue of *Opportunity*, Johnson published a short story titled "Black Gum" by William V. Kelley, which carried an illustration by Richard Bruce Nugent (fig. 69).[67] The story and illustration described the lynching of a black man who had been hung by a rope from a black gum tree. The alleged crime had been against a white woman, a supposed rape pinned on the town judge's black servant, Elec Hines. Only at the story's end did the reader discover Elec's true fate, after learning the culprit of the crime was actually the judge's white son. Months after the crime had been committed and Elec had mysteriously disappeared, his father and younger brother were hunting in the

woods, whereupon their dogs led them to a black gum tree: "Above them, swinging from a barren limb, there was the bleached skeleton of a human being. A bit of silver about a fleshless wrist glistened in the moonlight. It was the identification tag worn by Elec Hines while in the military service of the country he loved to call his own."[68]

In this short story, the victim was not the white woman whose honor white men supposedly protected, but the young black man who was killed so brutally and senselessly. Rather than just retribution, lynching was portrayed as a lawless and vengeful act in which a human life was denied rightful citizenship.

In emphasizing this injustice in his illustration, Nugent drew visual association between the lynched victim and the crucified Christ. In the sweeping line of the swinging dead body, particularly in the protrusion of his hip, Nugent's lynched youth recalls traditional painted crucifixes, such as those from the late medieval period in Italy. Further, the limbs of the surrounding trees form cross shapes, with two branches in a cruciform configuration directly above the head of the lynched man, suggesting linkage to Christ's cross of crucifixion.

Other artists made more overt visual connections between Christ's crucifixion and southern lynchings. For example, white artist Charles Cullen drew bold associations between lynching and the crucifixion in his illustrations for Countee Cullen's *The Black Christ and Other Poems* of 1929.[69] Charles's striking jacket cover for Countee's anthology clarified the book's title for the reader. In a grid format, Charles alternated and repeated two images: a white crucified Christ and a black lynched victim swinging from the branch of a tree. By juxtaposing and repeating these images, Charles has suggested a symbiotic relationship between Christ and the lynched victim, the cross and lynching tree merging visually, the drops of sacrificial blood shared by each man. His cover illustration elucidated Countee's title for his anthology by implying visually that black victims of southern mob violence were the "black Christs" of the South.

Charles's powerful frontispiece to Countee's anthology grafted the two images from the jacket cover to one another (fig. 70). In this new composition, Christ's crucified body seems to grow up from the head of the lynched African American man, and the cross of crucifixion appears as a visual extension of the lynching tree. The visual interdependence of Christ and this lynched victim articulated the ancestral relationship Countee established between Christ and victims of southern lynchings in his ironic, rhymed poem, "The Black Christ." Poetically linking Christ's cross of crucifixion with the lynching tree, Countee wrote at the end of his first stanza:

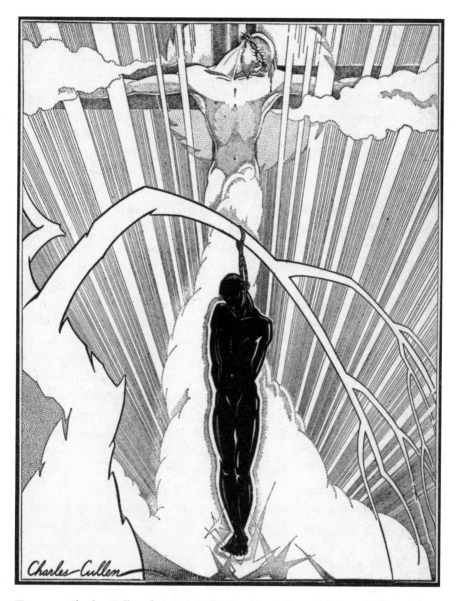

Figure 70. Charles Cullen, frontispiece for Countee Cullen, *The Black Christ and Other Poems* (New York: Harper and Brothers, 1929). Collection of the author. Copyrights held by the Amistad Research Center, Tulane University, administrated by Thompson and Thompson, Brooklyn, NY.

How Calvary in Palestine,
Extending down to me and mine,
Was but the first leaf in a line
Of trees on which a Man should swing . . .⁷⁰

By the 1930s, artists in the New York area increasingly approached the theme of lynching in their graphic work, painting, and sculpture. In 1935, as part of its antilynching campaign, the NAACP was able to prepare an entire art exhibition on the subject. Titled "An Art Commentary on Lynching," the exhibit was organized by Walter White, then secretary of the NAACP, and was shown at the Newton Galleries in New York City.⁷¹ The list of exhibitors was diverse and read as a veritable "who's who" in American art of the period.⁷² Among the artists were Peggy Bacon, George Bellows, Thomas Hart Benton, Elmer Simms Campbell, Malvin Gray Johnson, Reginald Marsh, and Isamu Noguchi. Several of these artists created work for the exhibition that linked lynching and Christ's crucifixion, including Campbell's *I Passed along This Way*, and Benton's *A Lynching*, which portrayed an urban scene of white workers hoisting a black victim up on a telephone pole, recalling the raising of Christ's cross in traditional religious art.⁷³ According to the NAACP's reports, such connections seemed "appropriate." For example, an NAACP newsletter described the entertainment at the exhibition's opening event. African American singer Edward Matthews had performed "several Negro spirituals, among them appropriately for the occasion, 'The Crucifixion.'"⁷⁴ By 1935, those in attendance at "An Art Commentary on Lynching" readily linked contemporary mob violence with an ancient occurrence of political injustice.

The case of the Scottsboro Boys in Alabama further spurred artists to associate the historical sacrifice of Christ with the contemporary lynching of black youths. The Scottsboro event began in April of 1931 when nine black boys between the ages of thirteen and nineteen jumped on a freight train in northern Alabama.⁷⁵ Irritated that the black youth were "stealing a ride," a group of white boys informed a stationmaster. Soon reports of the black boys' "crime" had ballooned, charging that they had gang-raped two white women who were also riding the freight train. The boys were arrested and jailed in nearby Scottsboro, Alabama. Crowds gathered at the jail and at the ensuing trials. Despite meager evidence and highly questionable testimony, four separate all-white juries convicted eight of the boys of rape and sentenced them to death. With the NAACP slow to react to what many were calling a "legal lynching," the Communist Party's International Labor Defense (ILD) stepped in to defend the Scottsboro Boys in repeated appeals for more than a decade, when finally the

last of the eight defendants was declared innocent and released after nineteen years in prison.

Some of the most scathing essays, poems, and illustrations criticizing the mistreatment of the Scottsboro Boys were published in leftist literary journals, such as *Contempo: A Review of Ideas and Personalities*. Many of the essayists asserted that the swift convictions of the African American youths constituted a "legal lynching." In a July 1931 issue, *Contempo* published the text of a speech delivered in New York's Town Hall by Theodore Dreiser, who described the scene before the courthouse in Scottsboro. "But is it not obvious," Dreiser exclaimed, "that these 10,000 people in the yard outside the courthouse, tumultuous in their mob-unity, and with a band of music blaring forth their conception of what is fair and necessary, made the trials of the remaining Negro defendants only slightly above a lynching in the ordinary sense of the word?"[76]

Editors devoted the December 1931 issue of *Contempo* to the Scottsboro case, in which writers continued to level the charge of "legal lynching." In his essay titled "Lynching by Law or by Lustful Mob," Lincoln Steffens wrote:

> The law did hurry, it got justice fast enough to satisfy the mob. The colored boys were convicted, one, two, three, and condemned to be killed, all according to the law. It was a righteous triumph, till, all of a sudden, the North came butting in upon the self-righteous, self-sacrificing, the proud and virtuous South, claiming that this was a legal lynching, and that to lynch by law was as bad as to lynch by the obscene hands of a lustful mob.[77]

One of the ILD attorneys for the defense who "came butting in" from the North was Carol Weiss King; she also likened the proceedings against the Scottsboro Boys to a legal lynching. After the black youths were convicted, King's statement aimed at the state of Alabama was published in *Contempo*:

> The Negro boys seek a new trial. If mob passion has abated, their innocence will be established. It remains to be seen whether Alabama will tolerate the legal lynching of nine innocent Negroes to allay the fury of affronted whites; whether justice will be utterly perverted to establish the guilt of nine innocent youngsters; whether the thirst for blood will only be slacked by the legalized murder of nine helpless Negroes.[78]

On the cover page of this issue of *Contempo*, Zell Ingram depicted an ancestor for the black boys in the Scottsboro jail (fig. 71).[79] His image was especially transgressive of white religious tradition, as it cast Christ as a black boy, rather

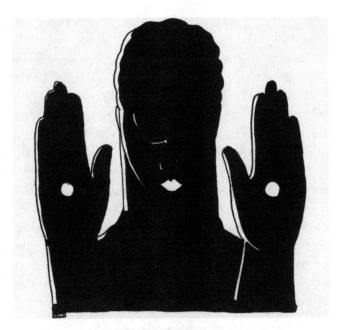

Figure 71. Zell Ingram, illustration for Langston
Hughes, "Christ in Alabama," on the cover of
Contempo (December 1, 1931).

than drawing comparisons between a lynched black man and a crucified white
Christ. Ingram's iconic image featured a black youth shown bust length, with
his eyes closed, head bowed down, and hands held up to reveal stigmata in the
center of his palms. Ingram's bust inverted the conventional color paradigm of
the white Christ with dark wounds where his palms had been nailed to the
cross. His black Christ bore white wounds, just as the Scottsboro Boys would
carry wounds of their abuse by a corrupt white legal system in the American
South. Therefore, Ingram's image further radicalized comparisons between a
suffering Christ and a lynched black man by pointing to the source of black
suffering in the South.

Ingram's black Christ was centered on *Contempo*'s cover page above
Langston Hughes's sardonic poem, "Christ in Alabama," which he wrote in re-
sponse to the Scottsboro case:

> Christ is a Nigger,
> Beaten and black—
> O, bare your back.
> Mary is His Mother—

Mammy of the South,
Silence your mouth.
God's His Father—
White Master above,
Grant us your love.
Most holy bastard
Of the bleeding mouth:
Nigger Christ
On the cross of the South.[80]

Key in Hughes's poem was his unorthodox tampering with the Christian tradition, whose most holy ancestors he recast as either black victims or white supremacists. For Hughes, the "legal lynching" of the Scottsboro Boys inspired him to construct the modern American Christ as a black victim of mob violence—one who was hated, beaten, and finally dismissed as a "nigger." His birth was no miracle but the result of a rape committed by God, cast as a white slave master, against his black female slave. While Hughes's poem met with surprisingly unanimous acclaim, given its controversial subject, in certain southern venues it was not tolerated. For example, one stop on his poetry reading tour of 1931 was in Chapel Hill, North Carolina, where "his sponsors . . . had been obliged to lower his fee when supporters had backed out of their commitment in retaliation against Hughes's *Christ in Alabama*."[81]

Hughes's blatant criticism of the Christian tradition in this poem stemmed in part from his sympathy with the Communist Party, many of whose members were highly critical of organized religion. In the following passage published in 1932 in another politically left literary journal, the *Rebel Poet*, Philip Rahv articulated the Party line that dismissed religion as ineffectual, extolling instead the labor movement's potential to cut across racial barriers:

Nothing is more symptomatic of the vitality and integrity of the revolutionary movement than the fact of late, due to the efforts of the Communists, Negro workers and intellectuals are being increasingly drawn into the class-conscious sector of the proletariat, thus concretely illustrating the solidarity of labor that cuts across national and racial frontiers and proclaiming that, like religion, all race prejudice is a vicious ideological opiate obfuscating the real issues confronting society.[82]

With the Party's position on religion widely known, northern black clergymen condemned the Communists' intervention in the Scottsboro Boys' de-

fense, "refusing . . . to allow ILD organizers to use their churches for Scotts-boro meetings."[83] Instead, the black clergy supported the NAACP, whose lawyers had attempted to wrest the youth's defense from the ILD until finally withdrawing from the case early in 1932, never having successfully gained the support of the defendants. With his Communist leanings, it is not surprising that when Hughes elected to publish his unorthodox stories of the Scottsboro Boys as black Christs, he offered them not to the NAACP's organ the *Crisis*, but to journals which more readily published the political views of the American Left, such as *Contempo* and *New Masses*.[84]

Hughes's radical reconstruction of the Christological narrative became all the more potent, as it occupied contested territory. Each side could claim Christ as an ancestor. For most southern whites who engaged in mob violence, Christ was their white savior, the supposed leader of their white supremacist move-ments. For the black clergy and other bourgeois members of the NAACP, Christ was the cornerstone of the black denominations of the church, which would help in the fight to bring equality for the African American community. For those with leftist leanings, Christ represented the "low down" worker who came to set the masses free—a revolutionary who had engaged in political resistance.

Hughes characterized Christ as one among many political activists in his poem "Scottsboro," which he published in his 1932 compendium, *Scottsboro Limited: Four Poems and a Play in Verse*. Despite the victimization of the eight black youth by the Alabama courts, Hughes wrote of them as revolutionary he-roes. They would face their deaths as had many before them who, on behalf of the oppressed, had fought for freedom:

> 8 BLACK BOYS IN A SOUTHERN JAIL.
> WORLD, TURN PALE!
> 8 black boys and one white lie.
> Is it much to die?
> Is it much to die when immortal feet
> March with you down Time's street,
> When beyond steel bars sound the deathless drums
> Like a mighty heart-beat as They come?
> Who comes?
> Christ,
> Who fought alone.
> . . .
> Gandhi.
> Sandino.

Evangelista, too,
To walk with you—
8 BLACK BOYS IN A SOUTHERN JAIL.
WORLD, TURN PALE![85]

Prentiss Taylor provided the illustrations for Hughes's *Scottsboro Limited*. A white artist who had been introduced to Hughes through Carl Van Vechten, Taylor had collaborated with Hughes on another collection of poems, titled *The Negro Mother*. While their previous publication had been successful financially, *Scottsboro Limited* was less popular because of its political content. Taylor felt, however, that their new collaboration could "be one of the finest aesthetic presentations of the tragedy."[86] In his lithographic illustrations, Taylor employed vernacular symbols that alluded to Christ's cross. In his *Scottsboro Limited*, which illustrated Hughes's play about the Scottsboro Boys, Taylor depicted the original nine youths riding on a freight train. Taylor once wrote to Hughes about his intent to foreshadow doom in the background: "There above their heads all the telephone wires like a gallows."[87] As a vernacular sign of Christ's cross, the telephone pole was another symbol of the youths' possible fate, the three boys with arms uplifted also suggesting linkage with Christ's body on the cross. In his *8 Black Boys,* which illustrated Hughes's poem "Scottsboro," Taylor orchestrated the Scottsboro Boys in a pantomime that expressed their captivity and relation to Christ's suffering. Bound to one another, they raise their hands as though crucified to the prison bars behind them, whose crossed bars are again allusive of Christ's cross.

Taylor's most explicit and transgressive image was his *Christ in Alabama* (fig. 72), illustrating Hughes's poem of the same title. When placed in the context of Hughes's sardonic critique of the Scottsboro case, Taylor's Christ may be identified as a black youth who faces death in a Scottsboro jail. However, like Hughes's poem, Taylor's lithograph also works on a broader level as a vernacular image lamenting the fate of all southern black Christs. The black figure of Mary at left is symbolic of many African American mothers who have mourned the injustice of their sons' exploitation by a corrupt legal system. The cotton growing at right serves to resituate the crucifixion scene in a vernacular setting in the American South. It further symbolizes the toil of African American workers in the southern fields. The cotton also provides a vernacular expression of the Christian Eucharist. As the loaf of bread represents Christ's bodily sacrifice, traditionally consumed during the liturgical event of the Eucharist, the cotton suggests the bodily sacrifice of black workers in the rural South—a visual icon of their exploited labor.

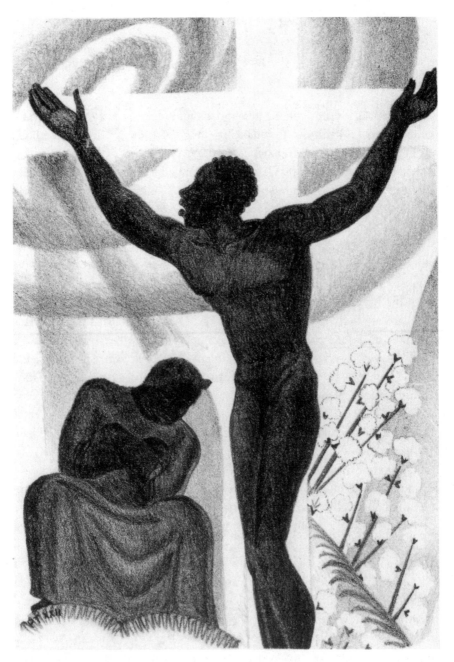

Figure 72. Prentiss Taylor, *Christ in Alabama,* in Langston Hughes, *Scottsboro Limited* (New York: Golden Stair Press, 1932). Collection of Roderick S. Quiroz.

CONCLUSION

During the 1920s and 1930s, Harlem Renaissance illustrators and writers employed strategies of resistance in their religious production that involved key reversals. In removing the "curse" from biblical figures of African descent, they overturned traditional Christian assessments of blackness as aberrant. Through their assertions of the Christological nature of suffering and injustice experienced by black citizens, exclusive claims to Christ by white Americans lost their force. Further, by replacing the fair-skinned Christ of Western religious art with contemporary black Christs, they radically created a god in their own image, whose commitment to relieving social oppression had not died on the cross. By using the vernacular image of a lynched black Christ, black and white American artists and writers crossed racial barriers to collaborate in their cultural and political attack against mob violence and to assert the Christological resonances of lynching.

In this body of art, black religious figures have been characterized as conduits between religious history and modernity. From a black Adam, to a black king at Christ's nativity, to a black Simon on the road to Calvary, to a black, lynched Christ, black participation in Judeo-Christian narratives suggested new possibilities for the experience of religion in America. These figures functioned to breathe new life into a remote and, for some, outmoded religious tradition. When seen through the lens of black experiences, this tradition could have new social and political meaning in modern America. The "disconcertingly black gods" of Douglas, Ingram, Taylor, and others worked the interstices between tradition and modernity, making religion matter in the complexity of the modern world.

Black and Tan:
Racial and Sexual Crossings in
Ebony and Topaz

Ebony and Topaz was issued in 1927 as a collection of essays, poetry, and illustrations compiled by Charles S. Johnson, the editor of *Opportunity*.[1] Though the volume has received little scholarly attention, it articulated the theme of racial hybridity that not only proved an integral component of Harlem Renaissance cultural production but marked the diversity of American modernism between the wars. Significantly, Johnson's editorial method in *Ebony and Topaz,* which promised minimal interference and direction, allowed his contributors freedom to broach controversial subjects shunned by the more conservative African American editors of the period, such as W. E. B. Du Bois. As a result, Johnson's compendium resisted limitation to the theme of racial uplift and challenged restrictive classifications of racial identity.

The most culturally subversive production came from two illustrators of *Ebony and Topaz*, Charles Cullen and Richard Bruce Nugent. Seemingly benign at first glance, their illustrations interrogated the interdependence between racial hybridity and alternative sexual orientations. On the one hand, these illustrations disrupted negative stereotypes of black identity by confounding racist connections between black skin and "primitive" identity. At the same time, they challenged prevailing tendencies within the African American community to fix black identity to a narrow ideal of racial uplift, a message that served to ossify rather than relax fixed categories of race.

Issued in magazine form, with an illustrated soft cover, *Ebony and Topaz* was published as a noncommercial extension of *Opportunity,* seeking to express a variety of creative responses to African American culture without the burden of appealing to a wide readership.[2] Johnson's editorial introduction emphasized the value in releasing his contributors' concerns with reader response, and he promised that they would maintain independence from their editor:

It is a venture in expression, shared, with the slightest editorial suggestion, by a number of persons who are here much less interested in their audience than in what they are trying to portray. This measurable freedom from the usual burden of proof has been an aid to spontaneity, and to this quality the collection makes its most serious claim.[3]

Beyond his explicit commitment to artistic freedom, however, Johnson rigorously refused editorial authority. He rarely cued the reader to his own specific opinions about the variety of subjects broached in *Ebony and Topaz*. In fact, W. E. B. Du Bois considered Johnson's lack of editorial dominance as the volume's greatest failing. He dismissed *Ebony and Topaz* as "a sort of big scrapbook, quite without unity, even of race," noting Johnson's refusal to limit the collection to a singular theme of racial uplift. Du Bois further revealed his preference for a fixed message: "If the whole thing had been split up into a half dozen little booklets, each with its artistic unity and clear spiritual message, the net result would surely have been greater and more valuable."[4] But Johnson would consistently emphasize freedom over propaganda in his editing of *Ebony and Topaz*, as well as *Opportunity*. In 1926, Johnson wrote in an *Opportunity* editorial, "This journal is designed to inform and interpret, both through sociological discussions, and through what it may offer of the cultural experiences of Negroes."[5] Resisting a unifying editorial voice, Johnson promoted critical inquiry, leaving the mode of interpretation to his contributors.

Johnson's editorial method can be elucidated by several prevailing attitudes toward African American identity that he faced in 1927. On the one hand, perceptions persisted among many Europeans and Euro-Americans that black identity was tied inherently to buffoonish or slovenly behavior. The refrain was heard even from Paul Guillaume and Thomas Munro in their *Primitive Negro Sculpture* of 1926. Despite their praise of "Negro" art, they asserted that "Negroes" shared primitive traits, including "passivity, lack of initiative and organization, intellectual backwardness, occasional irresponsibility of conduct."[6] On the other hand, Johnson faced attitudes from Alain Locke and others within the African American community in Harlem who wished to prove Guillaume and Munro's assumptions dead wrong. "This volume aims to document the New Negro culturally and socially," Locke wrote in his foreword to *The New Negro* of 1925. "There is ample evidence of a New Negro in the latest phases of social change and progress," he charged, countering claims that black Americans were halted permanently in their evolutionary process.[7] However, younger African American artists and writers, such as Langston Hughes, tired of Locke, who seemed more interested in proving parity between blacks and whites than

in exploring the distinctive qualities of African American cultural production. In 1926, Hughes wrote defiantly: "We younger Negro artists who create now intend to express our individual dark-skinned selves without fear or shame. If white people are pleased we are glad. If they are not, it doesn't matter. . . . If colored people are pleased we are glad. If they are not, their displeasure doesn't matter either."[8]

Opting instead to carve a separate space for the creative contributions to *Ebony and Topaz*, Johnson vowed, on the one hand, to leave "the usual burden of proof" behind, as he stated in his introduction. His promise was a notable jab at Locke and Du Bois as editors, who he felt constrained the creativity of black artists and writers by directing them to broadcast a specific, aspirational racial identity. In a pointed critique of Locke's *New Negro*, Johnson remarked wittily about *Ebony and Topaz*, "This volume, strangely enough, does not set forth to prove a thesis, nor to plead a cause, nor, stranger still, to offer a progress report on the state of Negro letters."[9] On the other hand, Johnson's critique of Locke was gentle and did not aim to alienate more conservative readers, as had Hughes. With fewer heavy-handed claims than Locke, but without the rancor of Hughes's criticism, Johnson allowed the writings and art of his contributors to evince a variety of themes. In this light, his editorial mode of anti-stance can be considered a strategy rather than a failing. Indeed, the political hybridity of Johnson's stance between Locke and Hughes reflects the cultural hybridity he sought to achieve in the pages of *Ebony and Topaz*. It further allowed freedom of expression for his contributors while also maintaining accessibility to a varied readership. Perhaps most importantly, Johnson made room for a plurality of racial identities rather than one "New Negro" persona. Convinced there was no single prescription for black American identity, he concluded in his introductory essay, "Those seeking set patterns of Negro literature will in all likelihood be disappointed for there is no set pattern of Negro life."[10]

It is not surprising, therefore, that the reader found a variety of contributions by authors and illustrators of varied racial backgrounds within the pages of *Ebony and Topaz*. For, central to Johnson's aims in compiling the collection was the mixed-race participation in exploring "the materials of Negro life." "It is significant," he continued in his introduction, "that white and Negro writers and artists are finding together the highest expression of their art in this corner of life."[11] Reflecting his inclusive aims, the list of contributors of fiction and poetry included precocious young black writers, such as Langston Hughes, Countee Cullen, and Zora Neale Hurston; popular white dramatists, such as Paul Green; and college student writers at Fisk University. Also seeking wide-ranging types of writing, Johnson supplemented the short stories and verse with

nonfiction essays on racial issues from anthropological and sociological perspectives by Julia Peterkin, E. Franklin Frazier, and George Schuyler, among others.

On a more subversive level, however, Johnson's writers and illustrators engaged with the kinds of subjects that were hotly debated on the pages of *Opportunity* and the *Crisis,* such as mixed-race identities and mixed-race sexual relations. Toward the center of the volume, for example, Johnson placed Elizabeth Barrett Browning's poem "The Runaway Slave at Pilgrim's Point." Radical for any time period, Browning's nineteenth-century, rhymed verses formed a diatribe against southern white slave masters written from the perspective of a young slave woman who had been raped by her white owner. In an incredible act of defiance, she killed the light-skinned child who resulted from the rape. Cloaked in Browning's elegant verse were themes that many conservative, middle-class African Americans wanted to avoid, from slavery, to sexual relations between whites and blacks, to rape, to mixed-race identity.

Indeed, the themes of mixed-race identity and shifting racial identities animated several key contributions to *Ebony and Topaz.* E. B. Reuter contributed a sociological study of mixed-race identity, "The Changing Status of the Mulatto," which was prefaced by Richard Bruce Nugent's *Drawings for Mulattoes.* While this essay and the preceding illustrations focused exclusively on mulatto identity, several authors of short stories used the theme of racial hybridity as a subtext. Careful to make explicit the interstitial skin color of the leading characters in his short story "General Drums," John Matheus described the skin color of Charlie as "the earth, color of khaki," and of Malissy as "olive brown," further clarifying her mixed-race heritage by alluding to her "squaw-faced grandma."[12] In other short stories, light-skinned characters experienced shifting racial identities, marked by their skin turning dark black. In Arthur Huff Fauset's short story "Jumby," the main character, Jean-Marie, was a young African American woman with light brown skin who lived on an island in the Caribbean. In the beginning, she feared her African heritage, afraid that through some curse her skin would turn black: "Suppose, now, that she had awakened to find herself bitten by a cobra, her limbs swollen double, and her pale amber brownness turned a hideous black!"[13] By the end of the story, however, she longed for reunion with her African past, expressed through a sexual relationship with her black lover, Babuji.

The most "taboo" component of *Ebony and Topaz,* however, was its illustrative material, which paired the theme of mixed-race identity with homosexual relationships and transvestitism.[14] The drawings of Charles Cullen, which illustrated the cover and several pages of the compendium, were particularly

subversive, because at first glance they seemed aspirational, as if complying with the theme of racial uplift that some readers may have expected (figs. 73 through 75). At the same time, Cullen's male figures could be read as double-sexed, with poses suggesting gay or bisexual activity (see especially fig. 75). Richard Bruce Nugent's *Drawings for Mulattoes* recounted a satirical history of mixed-race individuals that concluded in a nightclub, the figures' campy poses making allusion to the transvestites of Harlem's infamous drag balls (figs. 77 through 80).

Johnson was taking a considerable risk by including writings and art that engaged with mixed-race identity, homosexuality, and Harlem dance halls. These were themes that many social and literary critics of the period deemed most scandalous and immoral. Du Bois, for example, considered Carl Van Vechten's novel *Nigger Heaven* "a blow in the face" to respectable African Americans. He felt Van Vechten had written exclusively about the dregs of society who participated in Harlem's nightlife, with illicit references to "gin and sadism" and "one damned orgy after another."[15] Elsewhere, Du Bois and E. Franklin Frazier considered dancing in cabarets and interracial activity (especially involving same-sex relations) to be indicative of a neighborhood's slum status and therefore the worst of all vices.[16]

In the face of such straitlaced contemporary mores, Johnson did not make overt reference in his introduction to the more illicit themes of *Ebony and Topaz*. As was typical of his editorial method, he allowed his contributors the freedom to broach controversial subjects without commenting directly on their specific content. At times, Johnson's introduction seemed tangential, and even slightly cagey. For example, he spilled quite a bit of ink on his authors' choice of southern subjects, which editors like Locke had indeed avoided in large measure by focusing on the urban north. "The taboos and racial ritual are less strict," wrote Johnson in describing those African American writers who were turning anew to working-class characters in the South. He continued: "The sensitiveness, which a brief decade ago, denied the existence of any but educated Negroes, bitterly opposing Negro dialect, and folk songs, and anything that revived the memory of slavery, is shading off into a sensitiveness to the hidden beauties of this life and a frank joy and pride in it."[17] However, the southern folk subjects were not the most "taboo" components of the compendium, and Johnson's long discussion of this theme seems to have functioned to alert his readers to radical content without specifying its most illicit details.

In this context, Johnson's title choice for the compendium both allowed for controversial content while at the same time drawing little attention to it. On one level, the title suggested themes of racial uplift. Ebony and topaz were valu-

able natural resources that could be compared metaphorically to the social and artistic contributions of black Americans and those of mixed-race identity, whose skin might be described respectively as the color of ebony and topaz. However, "ebony" and "topaz" may have called to mind other referents. If the reader had conjured the color equivalents of ebony and topaz—"black" and "tan," a number of connections might have occurred. One association could have been drawn with contemporary jazz music. For in 1927, in collaboration with Bubber Miley, Duke Ellington composed, performed, and recorded the *Black and Tan Fantasy* with his orchestra. As a piece in two sections, *Black* was composed by Miley and *Tan* by Ellington, suggesting the racial identity of each musician.[18] On a more illicit level for some, "black" and "tan" would have called to mind the Black and Tan clubs in Harlem, which catered inclusively to black, white, and mixed-race patrons.[19] Ellington and Miley's composition referred explicitly to the Black and Tan clubs, which not only encouraged mixed-race relations but were also known as rare venues in which homosexual activity was tolerated.[20] While Johnson did not title his compendium "Black and Tan," he nonetheless left room for associations between *Ebony and Topaz* and the Black and Tans. Especially in conjunction with Cullen's cover illustration, Johnson's title gained the subtext of interracial, homosexual relationships, such as those sanctioned by Harlem's Black and Tan clubs (fig. 73).

Johnson's allowance for controversial subject matter and illicit innuendo in *Ebony and Topaz* held further significance than mere titillation. The references to mixed-race identity, homosexuality, and transvestitism actually supported Johnson's pledge to disengage narrow assumptions about racial identities. These were interstitial characteristics that necessarily complicated facile classifications of race, and gender as well. While Johnson did not feature these qualities as overt subjects of his compendium, the illustrations of Cullen and Nugent addressed this "taboo" material directly, radically disrupting the boundaries between white and black, male and female.

CHARLES CULLEN'S CODED IMAGERY

Printed in yellow and black on light green paper, Charles Cullen's cover illustration introduced the reader to his multivalent iconography (fig. 73). Inspired by Aubrey Beardsley's exotic imagery, as well as Art Deco design, Cullen's composition features two idealized nude figures, one black, the other light-skinned. In a natural setting of trees and stylized foliage, the muscular black male figure stands behind the light-skinned figure and arches his head back blissfully

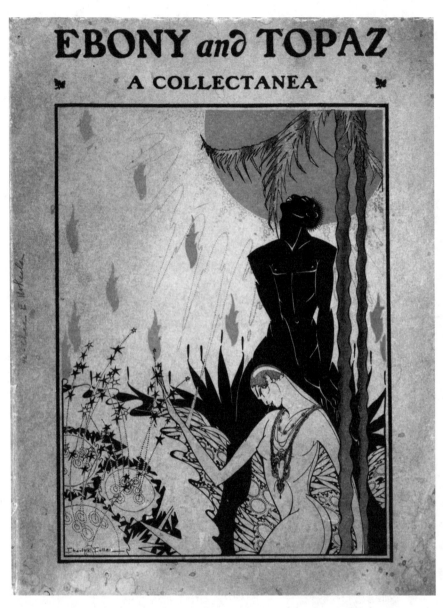

Figure 73. Charles Cullen, cover illustration for *Ebony and Topaz* (New York: *Opportunity* and the National Urban League, 1927). Yale Collection of American Literature, Beinecke Rare Book and Manuscript Library, Yale University. Reprinted by permission of the National Urban League.

toward a brilliant sun—symbolic of black America's bright future. However, the figure's blissful expression is not inspired by utopian ideals alone. His hands rest gently near the back of the light-skinned figure, who stands in front of the black youth, though on a lower register. This figure is less obviously sexed, seeming instead to possess both male and female attributes. On the one hand, the figure has shortly cropped hair and a muscular torso and buttocks, suggesting male identity. On the other, the sultry facial features, long delicate arms and fingers, elaborate necklaces, and one full breast mark the figure as feminine. The figure can therefore be read as double-sexed, or as male wearing female accoutrements, as would a transvestite. This ambiguous figure stands suggestively with its head in front of the groin area of the black figure behind, who in turn responds ecstatically.

In his interior drawings for *Ebony and Topaz*, Cullen celebrated idealized, nude forms of the black male body (figs. 74 and 75). These youthful, lean, muscular bodies glisten with reflected light, as if oiled for an ancient athletic event. In his frontispiece, as on the cover, two figures interact suggestively (fig. 74). The black male youth, whose figure stretches diagonally across the composition, displays his nude body before an ambiguously gendered figure in the lower left. With female accoutrements (bobbed hair and jewelry), the figure's chiseled chin and neck appear male, suggesting a man in drag who passionately gazes upward at his male lover. With the snake dangling from the lush foliage at right, Cullen drew association with the Garden of Eden, perhaps playfully recasting Eve as a transvestite. More suggestive still was Cullen's drawing in *Ebony and Topaz* that appeared also in Countee Cullen's collection of poems, *Copper Sun* (fig. 75). It features a black male youth kneeling on the ground, seeming to smell the sweet aroma of a plant. However, Cullen has charged the image with a kind of electrical current or aura that emits from the back of the kneeling figure, suggesting activity beyond the mere admiration of a flower. Behind the kneeling youth stands an ambiguously gendered figure, whose breasts mark the figure as female, though other attributes appear male. This figure's groin area is covered erotically by the energetic aura around the kneeling figure, whose suspended buttocks are temptingly within reach. Again, as in Cullen's cover illustration, the standing figure responds ecstatically, with head thrown back blissfully.

Charles Cullen was one of several non-black illustrators closely associated with Harlem Renaissance print culture.[21] He did magazine work, as well as book illustration, notably for Countee Cullen's collections of poetry. From historical publications to recent scholarship, writers have repeatedly misidentified Charles as a black artist and as Countee's brother. For example in 1927, one

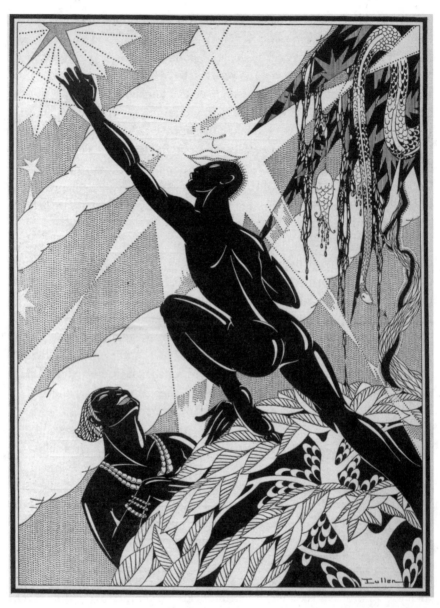

Figure 74. Charles Cullen, frontispiece illustration for *Ebony and Topaz* (New York: *Opportunity* and the National Urban League, 1927). Collection of the author. Reprinted by permission of the National Urban League.

Figure 75. Charles Cullen, untitled drawing for Countee Cullen, *Copper Sun* (New York: Harper and Brothers, 1927), reprinted in *Ebony and Topaz* (New York: *Opportunity* and the National Urban League, 1927). Yale Collection of American Literature, Beinecke Rare Book and Manuscript Library, Yale University. Copyrights held by the Amistad Research Center, Tulane University, administrated by Thompson and Thompson, Brooklyn, NY.

reviewer of Countee's *Copper Sun* seemed amazed that "one colored family can produce a poet and an artist as significant as Countee and Charles are."[22] Countee penned a letter in 1927 to another reviewer who had evidently made the same error. "Mr. Charles Cullen is not related to me," he stated, adding unequivocally, "He is not even colored."[23]

Charles typically published illustrations that accompanied poetry and prose by gay male authors, from Walt Whitman to Oscar Wilde to Countee Cullen.[24] Just as these texts coded gay sexuality and therefore operated differently depending upon the reader's response, Cullen's drawings allowed for multiple readings. At first glance, many readers of *Ebony and Topaz* may only have seen Cullen's drawings through the ideological lens of racial uplift. Even recent scholars, such as Walter Kalaidjian, have focused on Cullen's "utopian iconography . . . of uplifted black figures that strain toward a hopeful vista of dawning new prospects."[25] To end there, however, is to miss the multivalent iconography of Cullen's illustrations.

In the case of his drawings for a 1933 edition of Whitman's *Leaves of Grass*, Cullen lamented that some readers missed the complexity of his imagery (fig. 76). He commented in a letter to one of his colleagues, "Many of my most enthusiastic admirers have raved about these drawings in complete ignorance of their homo-sexual significance. I mention this fact because it was my original intent to soft-pedal while remaining essentially true to the Whitman text. I should regret it if my drawings were too obvious."[26] His remarks clarify his desire to communicate gay content, hoping at the same time that his drawings would retain subtlety, allowing for their public circulation.

While his drawings in *Leaves of Grass* often paired same-sex couples, as in the central embrace of two men in "O Captain! My Captain!" (fig. 76), the hybrid identities of the figures in his *Ebony and Topaz* drawings consistently neutralized the illicit sexuality of his imagery. In his cover and frontispiece for *Ebony and Topaz*, couples interacted in provocative ways, but with the safety valve of one figure who could be read as either male or female, allowing for the possibility of either straight or gay relations. At the same time, Cullen's double-sexed figures implied the possibility of bisexuality, which further complicated the assignation of one gender as over against another. By confusing the boundaries between "normal" and "aberrant" behavior, and between male and female genders, Cullen questioned the assumptions behind these conventionally fixed categories.

RICHARD BRUCE NUGENT'S BOTH/AND CHICANERY

Similarly, in another series of illustrations for *Ebony and Topaz*, Richard Bruce Nugent confounded conventional classifications of race and gender, delightfully expressing the interdependence of racial and sexual hybridity. In his four *Drawings for Mulattoes*, Nugent illustrated an interstitial racial type, aiming to

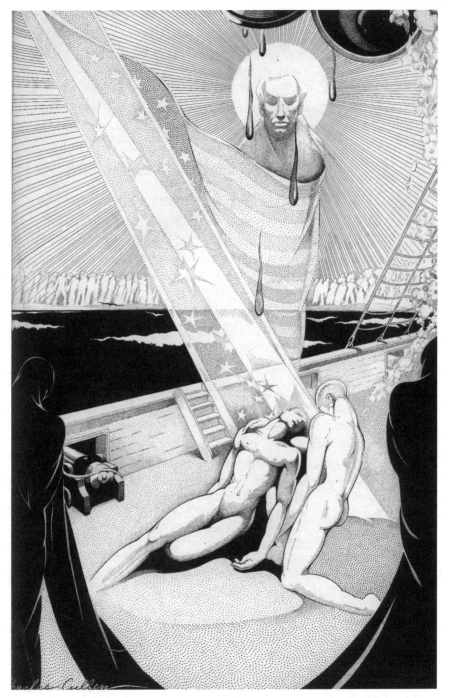

Figure 76. Charles Cullen, illustration for Walt Whitman, "O Captain! My Captain!" in *Leaves of Grass* (New York: Thomas Crowell, 1933).

destabilize conventional definitions of racial and gendered identities. His draw-ings charted the "evolution" of "mulattoes" from the African jungle to the mod-ern city, while at the same time satirizing such a conception of evolution. Portrayed as slipping between categories usually deemed oppositional, his mu-lattoes were double-raced and double-sexed, enjoying freedom from conven-tional classifications, while participating in a mongrel cultural event that crossed normative racial and gendered barriers. Further, Nugent made specific allusion to sites of interracial activity in his drawings, as several of his mulat-toes can be identified as drag performers associated with the famous costume balls in Harlem.

The series begins in a natural setting in *Drawing Number 1*, with three native ancestors of the mulatto striking dramatic poses (fig. 77). Rather than specific tribal African figures, Nugent's black natives appear stereotyped, as if on a Hol-lywood movie set, cueing the reader at the outset to read his imagery as tongue-in-cheek. Further, their bodies and headpieces are only suggested rather than carefully detailed, their identities masked by their flat, silhouetted forms. They stand among what appear to be palm trees, with fronds barely visible at the top of the composition. However, the trunks of these "trees" are carved intricately with mask-like imagery and therefore appear totemic. From these jungle ori-gins, the mulatto is born in *Drawing Number 2* as a wittily composed black and white Venus on a half shell. This tiny figure appears in front of a hybrid bust on the model of an ancient Janiform vase—half black and half white (fig. 78).[27] However, Nugent's assignation of color defies normative categories, with the black profile appearing as an ancient Greek bust, the white head as a tribal African mask. Further, the settings for each profile purposely disrupt conven-tional stereotypes that pitted nature against culture. In Nugent's topsy-turvy drawing, jungle nature forms the setting for ancient Greece, while culture (tak-ing the form of city buildings) provides the backdrop for tribal Africa.

Nugent's third and fourth drawings feature animated mulatto dancers who make their way into the modern world. In the third, Nugent's playful dancer is both primitive and modern. Her primitive half is black and nude; her modern half is white and dressed in a two-piece flapper costume, stockings, and a high-heeled shoe (fig. 79). Again, Nugent's background settings purposely confuse these stereotyped identities, with the primitive totemic structure at right be-hind the modern flapper, and a modern Art Deco chevron design behind the primitive dancer. In the final drawing, Nugent has again divided his composi-tion between black and white, specifying a modern cabaret setting, implied by the dancing figures and musical notation, but also the palm trees, which fig-ured in the Harlem cabaret murals that Nugent designed with Aaron Douglas

Figure 77. Richard Bruce Nugent, *Drawings for Mulattoes—Number 1*, in *Ebony and Topaz* (New York: *Opportunity* and the National Urban League, 1927). Collection of the author. Reprinted by permission of the National Urban League.

Figure 78. Richard Bruce Nugent, *Drawings for Mulattoes—Number 2*, in *Ebony and Topaz* (New York: *Opportunity* and the National Urban League, 1927). Yale Collection of American Literature, Beinecke Rare Book and Manuscript Library, Yale University. Reprinted by permission of the National Urban League.

Figure 79. Richard Bruce Nugent,
Drawings for Mulattoes—Number 3,
in *Ebony and Topaz* (New York:
Opportunity and the National Urban
League, 1927). Yale Collection of
American Literature, Beinecke
Rare Book and Manuscript Library,
Yale University. Reprinted by
permission of the National Urban
League.

(fig. 80). This composition features a large black head at the center, which has been revealed from behind a white female mask, a visual stereotype that can connote the act of passing for white. At the bottom of the composition, figures dance in a row uninhibitedly. They animate the poses of their native ancestors in *Drawing Number 1*, with the complication that their specific identities are masked by both black and white silhouettes.

Nugent's imagery disrupted expectations regarding the racial identity and social status of the "mulatto." On the one hand, he affirmed preconceptions that mulattoes were literally half-black and half-white and therefore, on a social hierarchy, somewhere in between black and white. On the other hand, he confused these assumptions by tricking the stereotypes, particularly in *Drawing Number 2*, in which he divided the composition along color lines but defied normative racial associations (fig. 78). In a light-hearted and humorous way, Nugent's method paralleled the sociological study of mulatto identity that followed his drawings in *Ebony and Topaz*. Titled "The Changing Status of the Mulatto," the article was written by Dr. E. B. Reuter, professor of sociology at the University of Iowa.[28] Reuter asserted that, despite the number of light-skinned mulattoes who had achieved leadership positions in the nation at large and within African American communities, readers should not conclude that mulattoes were biologically or intellectually superior to those of purely African descent:

> The significance of this distribution of superior men has commonly been misunderstood. It seems on first blush to be somehow indicative of an underlying difference in capacity, to imply a marked superiority rooting in the fact of a white ancestry and relationship. . . . The mixed ancestry of so many Negro leaders has given support to the biological bias at the same time that it has served as evidence to prove the incapacity of members of the Negro group.

In summarizing his arguments, Reuter emphasized that the behavior and intellectual capacity of individuals depended not on their racial origins but on their historical, economic, and environmental conditioning. "The fact that the mulattoes have in the past produced more prominent men," he concluded, "should be understood as a simple and obvious consequence of the historic circumstances that have favored them."[29]

Reuter's scholarly essay and Nugent's playful drawings seem, at first glance, to have little in common, save their connection to mulatto identity. Yet Nugent's method was akin to Reuter's in portraying mixed-race characteristics

Figure 80. Richard Bruce Nugent, *Drawings for Mulattoes—Number 4,* in *Ebony and Topaz* (New York: *Opportunity* and the National Urban League, 1927). Collection of the author. Reprinted by permission of the National Urban League.

as learned, not innate, and as cultural and political rather than biological. He did this most effectively by playing the trickster with visual stereotypes, reversing assumptions associated with the stereotypes. In his *Drawing Number 2*, for example, he has dismantled the connection that the stereotypes demanded between black skin and primitive identity, or white skin and civilization (fig. 78). By reassigning skin color to reverse the stereotypes, Nugent has revealed how arbitrary the connections were in the first place, ultimately making fun of the "truths" about racial identity that Americans had learned and assumed to be driven by nature.[30]

The tenor of Nugent's self-appointed role as trickster related to his unconventional lifestyle, which he lived openly by 1920s standards. Raised in Washington, D.C., Nugent moved to Harlem as a young man quite secure in his homosexual identity. While many of the Harlem Renaissance writers were gay or bisexual, none lived their sexuality as openly as Nugent, who spoke and wrote candidly about his homosexual encounters and his preference for white or "Latin" men.[31] He had found early in his life that "he didn't like to have jobs," as Thomas Wirth has said.[32] Instead, he became a vagabond of sorts, living promiscuously from man to man, stopping to shower and "wash his shirts" at the apartment of Aaron and Alta Douglas.[33] He was known for his outlandish dress; in the words of Steven Watson, he went "tieless, underwearless, sockless—and sometimes even shoeless—wearing a single gold bead in one pierced ear."[34] Writing to Langston Hughes in 1927, Carl Van Vechten reported seeing Nugent at an *Opportunity* awards dinner "with his usual open chest and uncovered ankles. I suppose soon he will be going without trousers," he quipped.[35]

In 1926, Nugent wrote what has been assessed as "the first literary work on an openly homosexual theme to be published by an Afro-American writer."[36] He published it in Wallace Thurman's short-lived avant-garde journal, titled *Fire!! A Quarterly Devoted to the Younger Negro Artists*. It was a stream-of-consciousness piece, titled "Smoke, Lilies, and Jade," about Alex, who discovers his lust for another man, androgynously named Beauty, while also maintaining love for his girlfriend, Melva. Nugent's story was radical, both in its exploration of love between two men and in its consideration of bisexuality. In a final daydream about his relationships with Melva and Beauty, Alex declares, "one *can* love two at the same time."[37]

His protagonist's statement points to Nugent's own delight in creating characters who were two things at once. This quality permeates his *Drawings for Mulattoes*, in which figures are both black and white, male and female, primitive and civilized. He employed his "both/and" chicanery in his first

drawing, asking his viewer to perceive forms as both positive and negative. Together with a playful and subtle erotic element, Nugent's eye trickery further cued the viewer to read the series as tongue-in-cheek. As Thomas Wirth has written, "Eroticism is an element in nearly all of Nugent's work."[38] From the phalluses he painted on the walls of "Niggerati Manor," where he lived with Wallace Thurman and Langston Hughes, to his more private drawings of fanciful male orgies, Nugent carried his own sexual audacity into his art. Within this context for eroticism, many of the forms in Nugent's *Drawing Number 1* may be interpreted as phallic (fig. 77). While the totemic palm trees that dominate Nugent's composition may be seen as phallic in their own right, much of the "carving" on the totems appears phallic as well. Reading these phallic forms depends on the viewer's ability to shift perspective, perceiving the black totems against a white ground, but also white totems on a black ground.

Nugent and Douglas used the same technique in several Harlem cabaret murals, which unfortunately no longer survive. They were executed in red and blue, so that viewers could perceive one scene in red on a blue ground, or another in blue on a red ground. One view afforded them African scenery, but in the other perspective, "the scene shifted to the modern city."[39] Similarly in Nugent's *Drawing Number 1,* the first white form on the left appears as a totemic shaft, its right edge carved with openings for the eyes and mouths of masklike forms. However, if one shifts perspective to view the black ground to the right of the white totem as a positive image, the forms that read as openings on the white shaft now appear as projections from a new black totem. Many of these dark forms are shaped as phalluses in varying states of erection. The interlocking black/white masks and phallic forms may be Nugent's playful way of suggesting the sexual activity that would produce a racially mixed child or mulatto, while at the same time it alludes to his own sexual activity with, and preference for, white men.

Nugent's delight in allowing the viewer to see two forms at once found its greatest resonance in terms of gender. His primitive ancestors in *Drawing Number 1* are silhouetted in black and ambiguously gendered. With decorative headpieces, they could be male performers in a ritual. However, their full breasts suggest female anatomy. Similarly, the newly born Venus-mulatto in *Drawing Number 2* is not only half white and half black but also appears hermaphroditic, with a female breast and wide hip at left, but a flat male chest and a muscular leg and buttocks at right (fig. 78). His primitive/flapper in *Drawing Number 3* may also be read as double gendered (fig. 79). While the white half wears decidedly female garb, the primitive half at left appears androgynous, possessing both a female breast and a muscular thigh suggesting male anatomy.

In his *Drawings for Mulattoes*, performance plays a key role in Nugent's de-piction of gender hybridity. In *Drawing Number 3*, the transformations from black to white, primitive to civilized, and male to female occur while the figure dances before the viewer (fig. 79). In his *Drawing Number 4*, the dancers at the bottom of the composition perform in a row on the dance floor or stage of a Harlem cabaret (fig. 80). The looming heads above also draw associations with performance, calling to mind the linked theatrical masks of tragedy and comedy.[40]

Performance came naturally to Nugent, as an outgoing personality and also as a professional actor and dancer. Despite his disdain for jobs, his love of the theater and dance held his interest long enough to be cast as one of the denizens of Catfish Row in *Porgy*, which ran on Broadway and toured through-out the country and in London from 1927 to 1929. He also danced in a produc-tion of *Run Little Chillun'* in the early 1930s.[41] But performances in Harlem cabarets, especially in the Black and Tan clubs, held a special allure for Nugent, as rare venues where homosexual activity was not only condoned but cele-brated, and where gays and lesbians of varying racial backgrounds could inter-act. Nugent remembered fondly the different clubs catering to a variety of homosexual preferences. He recalled one speakeasy that accommodated, in his words, "rough queers . . . the kind that fought better than truck drivers and swished better than Mae West."[42] Some of the most gender-bending Harlem entertainment occurred in nightclubs and at costume balls, where men imper-sonated women and women took on the guise of men through dress. High-lighting the costume balls held at Hamilton Lodge and the Savoy Ballroom was the beauty contest, in which, as Eric Garber writes, "the fashionably dressed drags would vie for the title of Queen of the Ball."[43] Nugent reveled in the gen-der fluidity Harlem's nightlife afforded, declaring "'male' and 'female' imper-sonation was at its peak as night club entertainment. . . . The famous Hamilton Lodge 'drag' balls were becoming more and more notorious and gen-der was becoming more and more conjectural."[44]

Several of Nugent's drawings published in venues apart from *Ebony and Topaz* may be read through the lens of "conjectural" gender, and more specifi-cally, drag performance.[45] His androgynous figure appearing in *Fire!!* is perhaps his most obvious published drag performer (fig. 81). The figure's campy pose is heightened by its facial features, which seem applied cosmetically. With full, pursed lips, a winking eye, and dramatically arched eyebrows etched in white, the figure seems to flirt coyly over its raised shoulder with an imagined audi-ence. The decorative border at left curves under the figure's feet and provides him/her with a kind of runway from which to perform in drag. The border may

Figure 81. Richard Bruce Nugent, untitled drawing for *Fire!!* (November 1926).

also be read as an outlandish primitive head, with bulging eyes that pop out toward the androgynous figure, and a gargantuan mouth that opens to reveal a row of triangular teeth. There is a playfully erotic quality about Nugent's primitivist mask, which appears so taken with the young man in drag as to swallow him whole.

Published on the March 1926 cover of *Opportunity*, Nugent drew a primitivist figure sporting a hoop earring, with a palm tree at left. His figure wears exaggerated signs of femininity, which prompted Thomas Wirth to read it as a "man in drag."[46] With its facial features applied cosmetically and its earring worn as a costume, both the gender and primitivism of this figure appear performed. Indeed, the line between the signs of primitivism and gender are blurred in Nugent's drawing, with dark lips, dramatic eyebrow and triangular smudge on the cheek suggesting both feminine cosmetics and primitivist facial paint. Likewise, the earring reads as a sign of femininity as much as a primitivist accoutrement.

In the light of these drawings, one might also read Nugent's *Drawing for Mulattoes Number 4* as a veiled drag performance inspired by Harlem's costume balls (fig. 80). While the white mask looks decidedly female, with a fashionably bobbed hairdo and pursed lips, the black head appears more androgynous, resembling as much the ovoid head of an African American male youth as that of a female figure. The figure's hair is also ambiguously styled, with bangs suggesting a female bob, but short tightly curled hair at the top of the head, resembling the cropped hair of an African American male. As George Chauncey has discovered, most of the cross-dressed performers at Harlem's costume balls were young, working-class African American men, who would be eager to win the beauty contest with its modest monetary prize.[47] While some of the drag queens were actually white, many more were black youths masking as white, impersonating their favorite white actresses.[48] In this context, one might read Nugent's white mask as such a costume. The dancing figures at the bottom of his composition may also allude to the dancing contestants at the Hamilton Lodge ball. The only accessories Nugent has drawn distinctly are the high-heeled shoes, which, together with the dancer's stereotyped, campy steps and poses, typify drag performance. Cavorting riotously, they alluded loosely to newspaper illustrations of cross-dressed dancers at Harlem's costume balls. Published in the *New York Amsterdam News*, one cartoon carried the caption, "And, Girls, How They Carried On!"[49] Beyond caricatures, however, Nugent's dancers are silhouetted, either black against white or white against black, camouflaging their racial and gender identities to privilege their active dancing. With constant, energetic movement,

they resist fixation, occupying instead an interstitial status—what Nugent has deemed most delightful about mulatto identity.

In his *Drawings for Mulattoes,* Nugent satirized presumptions about mixed-race identity in order to dismantle the fixity of racial identity and to complicate assignations of gender and sexuality. Rather than carrying their identities as evolutionary burdens, his interstitial figures performed their racial, gendered, and sexual identities, wearing them as costumes that they might just as easily throw off. In the process, Nugent radically disengaged the body from pre-scribed racial and gendered characteristics. As "clothing" for the body, race and gender could be worn at will and in startling combinations.

Johnson's *Ebony and Topaz* provided a print venue for uninhibited artistic expression. Rather than alienating certain readers, however, the compendium contributions operated on several levels. Most strategically, the coded imagery of Cullen and Nugent could be deciphered differently depending on the reader's orientation. As a whole, the compendium challenged a variety of Americans to rethink an easy inclination to ground identity in unexamined and ossified definitions of race, gender, and sexuality. Though easily over-looked, Johnson's warning that there was "no set pattern of Negro life" flew in the face of those on both sides of the color line who, with starkly different mo-tivations, had worked so hard to define and thereby fix African American iden-tity. His freedom from this "burden of proof" opened space in *Ebony and Topaz* for progressive critical inquiry that sought to question how Americans could move outside restrictive classifications of race, which in turn could foster emancipated attitudes toward gender and sexuality.

"To Smile Satirically":
On Wearing the Minstrel Mask

In his *Plays of Negro Life* of 1927, Alain Locke assessed the pulse of the African American dramatic arts. "Forced to laugh outwardly and weep inwardly, the Negro has until lately only been in the position of successful clowning," he wrote, referring to black American minstrels and entertainers of the nineteenth and early twentieth centuries. However, he predicted the situation would change for emerging black dramatists. For them, "there will come the power to smile satirically and reflect with ironic composure."[1] In 1927, Locke saw seeds of a new theater, in which black actors and playwrights could begin to convey their art through satire and irony, without having to resort to clowning and mimicry.

Understanding from Eric Lott, Mel Watkins, and others that African American clowning and mimicry have always involved satire and irony, we might now want to modify Locke's argument.[2] Yet his metaphor of smiling satirically is particularly evocative, for it is this act that has animated the "signifyin(g)" tricksters whom Henry Louis Gates Jr. has identified at the core of black vernacular expression since its earliest emergence in the United States.[3] Smiling satirically, they have used "the language of trickery" that "presupposed an 'encoded' intention to say one thing but to mean quite another."[4] Their vernacular riffing seemed to preserve uneven power relationships, when, in actuality, their adroit use of figurative language reversed and challenged dominant power arrangements.

One of the ways that African Americans have used "the language of trickery" for parodic effect has involved donning masks, both literal and behavioral. African American writers have repeatedly used phrases such as "wearing the mask" to describe behavior learned during the period of slavery to outwardly accommodate their white masters, while at the same time reversing power re-

lationships with ironic language. Employing slave tales to illustrate his argu-
ments, Mel Watkins has characterized humor as a masking technique that
African American slaves wielded to "signify on" their masters. In one tale,
Watkins emphasized the slave's seeming humility, which the slave subse-
quently transformed into a joke:

> "You scoundrel, you ate my turkey," the master admonishes.
>
> "Yes, suh, Massa, you got less turkey but you sho nuff got mo' Nigger,"
> the slave replies.[5]

Watkins perceived how slyly this African American used self-effacement to
mask "a calculated ploy to acquire a prized treat knowing full well that the ac-
quisition can be achieved with impunity. So who is the butt of the joke?"
Watkins asked knowingly. "In fact, who is the aggressor?"[6] Indeed, what en-
abled the slave to take the turkey with impunity was his satirical reliance on the
central tenet of slavery, that as the "massa" owned the turkey, he also owned the
man; the slave and turkey were equivalent as property.

During the early twentieth century, "wearing the mask" continued as a
trope shared by African American writers and artists to parody presumptions
that black American identity amounted to savagery on the one hand or clown-
ish buffoonery on the other. In Langston Hughes's poem "The Jester" of 1925,
the masked trickster seems to perpetuate the stereotype of the black buffoon:

> In one hand
> I hold tragedy
> And in the other
> Comedy—
> Masks for the soul.
>
>
>
> I am the Black Jester,
> The dumb clown of the world,
> The booted, booted fool of silly men.
> Once I was wise.
> Shall I
> Be wise
> Again?[7]

In the last four lines, however, Hughes has threatened to disturb the stereo-
type, particularly in his use of the word "wise." On the one hand, the poet may

have drawn on the colloquialism operating then and now that indicated a kind of subversive knowledge—to be wise to an event or someone's behavior, perhaps without their knowing. Hughes could also have used "wise" to connote a cocky jokester's attitude, as for example a "wiseacre." On the other hand, beyond colloquial references, the poet may also have alluded to the Black Jester's ancient past: "*Once* I was wise." In another poem of 1925, "The Negro Speaks of Rivers," Hughes felt deep connections to a past in Africa, which he described metaphorically as remembered experiences with ancient rivers, from the Euphrates to the Congo and the Nile.[8] His use of the phrase "Once I was wise" in "The Jester" may also suggest a remembered experience of ancient wisdom and culture, which the sly jester threatens to reenact from behind his mask.

HARLEM RENAISSANCE ILLUSTRATORS WEAR THE MASK

This chapter explores the relationship between ideas expressed in Hughes's "Black Jester" and two Harlem Renaissance illustrators, James Lesesne Wells and Aaron Douglas. They also employed masked figures who seemed to confirm negative stereotypes about black primitivism at the same time that they confused stereotypical definitions of race. Their tricksters wore their identities as masks that they might just as easily have thrown off, as if to ask Hughes's incendiary question, "Shall I be wise again?"

The visual masking of Wells and Douglas found context within the larger body of illustrative work by Harlem Renaissance artists, who used masks in a variety of ways. Douglas incorporated masks in many of his drawings, as for example his *Krigwa Players Poster* (see fig. 9). In this composition, the Africanist mask held by the central figure, along with the figure's masklike face, revealed Douglas's new interest in black Americans' rich heritage in Africa, while these references to African masks also accommodated Douglas's mentors and patrons who urged him toward a primitivist visual vocabulary. Illustrators also used masks to comment on cultural formations of identity during the 1920s. In the case of Richard Bruce Nugent's *Drawing for Mulattoes—Number 4* (see fig. 80), the central figure's white mask, which has been removed to reveal a black head behind, could connote the act of passing for white, a theme that many Harlem Renaissance authors addressed in their books and stories.[9] Masking also represented a stylistic preference among many Harlem Renaissance illustrators, including Douglas, Nugent, and Wells. Each adopted an Art Deco–inspired, silhouetted style in which the bodies of their figures were flat, black, and masklike.

In some cases, Harlem Renaissance artists used masks as signs of trickery. This chapter considers two sets of illustrations by Wells and Douglas that

evince their playful "mastery" of the mask.[10] Wells's illustrations of 1929 for Vachel Lindsay's poem, "Congo," presented stereotyped scenes of masked black natives that, in turn, parodied the savage stereotypes articulated in Lindsay's text (figs. 82 and 83).[11] In his 1927 series of illustrations for Eugene O'Neill's play *The Emperor Jones*, Douglas cast O'Neill's protagonist as a masked dancing figure (fig. 87).[12] While his masked dancer seemed to confirm the negative stereotypes governing O'Neill's characterization of black primitivism, Douglas also used the mask "to smile satirically" at O'Neill's text.

In these illustrations, Wells and Douglas each faced the dilemma of creating images for white-authored texts that, to varying degrees, revealed racist attitudes. In seeming to accommodate while at the same time circumventing these texts, Wells and Douglas drew on the complicated masking tradition of blackface minstrelsy. In illustrating Eugene O'Neill's *Emperor Jones*, for example, Douglas wore the mask of minstrelsy. His first drawing illustrating the play features the Emperor with thick white lips in an agile dance step—signs to read the figure as a minstrel (fig. 87). As Eric Lott and W. T. Lhamon Jr. have explained, minstrelsy was a nineteenth-century American tradition of theft and counterfeit, in which white men "blacked up" to imitate African American entertainers.[13] When black performers entered the minstrel tradition, they too were required to black up, to protect audiences from contact with "authentic" blackness. Black comedians of the early twentieth century, such as Bert Williams, engaged subversively with the double counterfeit, blacking up for their stage performances ultimately to parody white imitation of black behavior. Similarly, by wearing the minstrel mask and dancing the bent-knee minstrel step, Douglas's figure of Emperor Jones could parody O'Neill's racist tale of an upstart black man who regressed atavistically to savagery.

The complicated acts of masking that Wells and Douglas depicted, and in which they themselves engaged, represented a critical component of the project to make black modern in Harlem Renaissance illustration. As Houston Baker has observed, "it is, first and foremost, the mastery of the minstrel mask by blacks that constitutes a primary move in Afro-American discursive modernism."[14] By transforming the minstrel mask from a symbol of nonsensical behavior to a sign of trickery, these artists assigned modern identity to an outmoded stereotype. Black minstrels, in the hands of Wells and Douglas, represented newly modern forms whose hybrid identity was designed "to give the trick to white expectations,"[15] while at the same time delighting those who had already discounted the demeaning stereotypes behind blackface minstrelsy. "Smiling satirically," they wielded their black minstrels as doubling devices, seeming to fix categories of race, while at the same time freeing up the meaning of race behind the masks. The particularities of their flat, black minstrels

thus remained fluid rather than fixed, effectively denoting the act of masking rather than the mask itself as representative of modern black identity.

"THE GOOD OLD MUMBO-JUMBO, SIZZ-FIZZ, AND BOOMLAY-BOOM"

While the masked black figures in the graphic work of James L. Wells suggest African masks in a generic way, they also connect with blackface performance. Each form of masking is juxtaposed in his linoleum cut illustrations for a 1929 reprinting of Vachel Lindsay's poem "The Congo."[16] On the one hand, his illustrations called to mind stereotypes of Africans and black Americans perpetuated at that time in mainstream culture. In these images, Wells presented tribal African figures, costumed as if on a movie set, who gather in generic rituals to ward off evil spirits (figs. 82 and 83). On the other hand, Wells included a scene of African masks and sculpture (fig. 84), which suggests a crowded ethnographic display, indicating the influence of Wells's visits to the African collections at the Brooklyn Museum.[17] What compelled Wells to shift between sophisticated African design and broad visual stereotypes of Africans?

This question may be approached by understanding something of Wells's commission, or perhaps more accurately his predicament, in illustrating Vachel Lindsay's poem. Richard Powell and Jock Reynolds have revealed that Wells was commissioned by "*The Golden Book*'s art director, Ralph Rockafellow . . . to illustrate writings for which his artistic talents . . . were best suited."[18] No doubt, Rockafellow imagined that Wells's linoleum cuts would provide an air of authenticity to Lindsay's poem, which claimed on the one hand to be "a study of the Negro race," and on the other, stereotypically confirmed "their basic savagery" and "their irrepressible high spirits." He intended the poem to be read aloud and cued the reader's sound effects in italicized phrases to the right of each stanza. "*With a great deliberation and ghostliness,*" he instructed the reader to repeat his hackneyed incantation:

> Be careful what you do,
> Or Mumbo-Jumbo, God of the Congo,
> And all of the other
> Gods of the Congo,
> Mumbo-Jumbo will hoo-doo you,
> Mumbo-Jumbo will hoo-doo you,
> Mumbo-Jumbo will hoo-doo you.[19]

The Congo

Nicholas Vachel Lindsay

**A Study
of the
Negro Race**

I. Their Basic Savagery

FAT BLACK BUCKS in a wine-barrel room,
 Barrel-house kings, with feet unstable,
 Sagged and reeled and pounded on the table,
 Pounded on the table,
Beat an empty barrel with the handle of a broom,
Boom, boom, BOOM,
With a silk umbrella and the handle of a broom,
Boomlay, boomlay, boomlay, BOOM.
THEN I had religion, THEN I had a vision.
I could not turn from their revel in derision.
THEN I SAW THE CONGO, CREEPING THROUGH THE BLACK,
CUTTING THROUGH THE JUNGLE WITH A GOLDEN TRACK.
Then along that riverbank
A thousand miles
Tattooed cannibals danced in files;
Then I heard the boom of the blood-lust song
And a thigh-bone beating on a tin-pan gong.
And "BLOOD!" screamed the whistles and the fifes of the warriors,
"BLOOD!" screamed the skull-faced, lean witch-doctors;
"Whirl ye the deadly voo-doo rattle,
Harry the uplands,
Steal all the cattle,
Rattle-rattle, rattle-rattle,
Bing!
Boomlay, boomlay, boomlay, BOOM!"
A roaring, epic, rag-time tune
From the mouth of the Congo
To the Mountains of the Moon.
Death is an Elephant,
Torch-eyed and horrible,
Foam-flanked and terrible.
BOOM, steal the pygmies,
BOOM, kill the Arabs,
BOOM, kill the white men,
Hoo, Hoo, Hoo.
Listen to the yell of Leopold's ghost
Burning in Hell for his hand-maimed host.
Hear how the demons chuckle and yell
Cutting his hands off, down in Hell.
Listen to the creepy proclamation,
Blown through the lairs of the forest-nation,

Figure 82. Page layout for Vachel Lindsay, "The Congo," with illustrations by James Lesesne Wells, published in the *Golden Book Magazine* (September 1929). Printed with permission of the Estate of James Lesesne Wells.

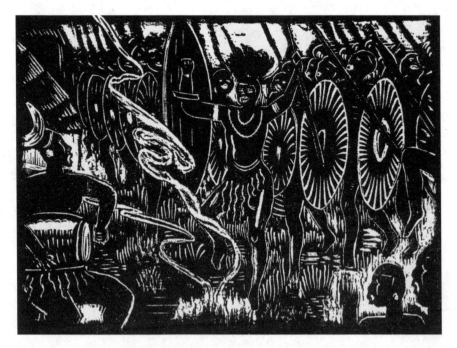

Figure 83. James Lesesne Wells, illustration for Vachel Lindsay, "The Congo," published in the *Golden Book Magazine* (September 1929). Printed with permission of the Estate of James Lesesne Wells.

Lindsay began his poem by imagining his encounter with "the Negro race," beginning in deep, dark Africa:

> Then I saw the Congo, creeping through the black,
> Cutting through the jungle with a golden track.
> Then along that riverbank
> A thousand miles
> Tattooed cannibals danced in files;
> . . .
> And "Blood!" screamed the whistles and the fifes of the warriors,
> "Blood!" screamed the skull-faced, lean witch-doctors;
> "Whirl ye the deadly voo-doo rattle,
>
> . . .
> Rattle-rattle, rattle-rattle,
> Bing!
> Boomlay, boomlay, boomlay, BOOM!"[20]

Figure 84. James Lesesne Wells, *Demon Masks*, illustration for Vachel Lindsay, "The Congo," published in the *Golden Book Magazine* (September 1929). Printed with permission of the Estate of James Lesesne Wells.

Lindsay instructed the reader to chant the last lines with *"a rapidly piling climax of speed and racket."* Not only did he suggest the origins of black Americans in Africa to be savage and violent, but he characterized their speech and incantations as nonsensical, albeit rhythmical and entertaining. In the next section of his poem, he traced the "race" to the United States, where he encountered happy minstrels and daring gamblers:

> Wild crap-shooters with a whoop and a call
> Danced the juba in their gambling-hall
> And laughed fit to kill, and shook the town,
> And guyed the policemen and laughed them down
>
> A negro fairyland swung into view,
> A minstrel river
> Where dreams come true.
>
> Just then from the doorway, as fat as shotes
> Came the cake-walk princes in their long red coats,
> . . .
> And they pranced with their butterfly partners there,
> Coal-black maidens with pearls in their hair . . .[21]

Lindsay instructed the reader to chant the refrain at the end of this section *"with a touch of negro dialect."* In the final section, titled "The Hope of Their Religion," Lindsay charted the cleansing effects of Christianity, which would wash away the savagery of "Negroes" in the city and the African tribes in the Congo:

A good old Negro in the slums of town
Preached at a sister for her velvet gown.
Howled at a brother for his low-down ways,
His prowling, guzzling, sneak-thief days.

And they all repented, a thousand strong.
From their stupor and savagery and sin and wrong.

Twas a land transfigured, 'twas a new creation.
Oh, a singing wind swept the negro nation

Redeemed were the forests, the beasts, and the men,
And only the vulture dared again

To cry, in the silence, the Congo tune:
"Mumbo-Jumbo will hoo-doo you . . ."[22]

Lindsay was, in fact, an intensely religious Midwesterner who hoped to spread the gospel of Christ through his creative work.[23] But he was also a seasoned entertainer, and "The Congo" was one of his early poems, which, beginning in 1914, he performed himself with great success. In that year, Macmillan Publishers agreed to publish the poem in a collection if Lindsay would promote the book in New York, reciting his poetry "as a modern troubadour."[24] The ploy succeeded, creating "the picture of him that caught the public imagination—that of a vagabond, an American minstrel, whose great lines came to him in sweeps and were shouted to the clouds and stars."[25] It was thus as an "American minstrel" that Lindsay gained recognition, calling his poetry in performance a "higher vaudeville," by which he meant that "poetry ought . . . to be primarily an entertainment—and not only that, but a popular one."[26]

By 1929, when the *Golden Book Magazine* reprinted "The Congo" with Wells's illustrations, Lindsay had aspirations to move beyond his public performances to study philosophy. However, when he went on the lecture circuit, audiences cared less for his discussions of Swedenborg; "what they wanted from Lindsay was the good old Mumbo-Jumbo, Sizz-Fizz, and Boomlay-BOOM."[27] In fact, Lindsay's highly dramatic intonation and performance of his poem appears to have been its most illustrious feature. As Susan Gubar has commented, "the listeners who laughed at Lindsay's first performance were probably not tickled so much by its racism as by his flamboyantly weird delivery, just as those who made it his signature act were less enthralled by its mes-

sage, more by the frenzied rolling of his eyes, the shooting of his hands, the ris-
ing of his voice to a whoop or a yelp and its falling to a whisper."[28] Because of
his hilarious performance, "The Congo" was "ludicrous in the transparency of
its racism," as Gubar observed.[29] With his extreme stereotypes and feigned
"Negro dialect," Lindsay made obvious for his largely non-black audiences his
distance from the people he claimed to study, as well as his willingness to en-
gage in self-mockery.[30]

Faced with illustrating the caricatured, "transparently" racist lines of this
fading American minstrel, Wells was no doubt familiar with Lindsay's infa-
mous "Congo" performances. He was probably also aware that Langston
Hughes was one of his greatest fans. Hughes credited Lindsay with discovering
him as a young Negro poet in 1925, when he was busing tables at the Wardman
Park Hotel in Washington, D.C., the city where Wells lived. As Hughes wrote
in his autobiography, *The Big Sea:*

> I was thrilled the day Vachel Lindsay came. I knew him, because I'd seen
> his picture in the papers that morning. He was to give a reading of his po-
> ems in the little theater of the hotel that night. I wanted very much to hear
> him read his poems, but I knew they did not admit colored people to the
> auditorium.[31]

When he saw Lindsay in the hotel dining room, Hughes left three of his po-
ems with him, hoping that he would have time to read and critique them.
Much to his surprise, Hughes discovered the next day that Lindsay had read
Hughes's poems aloud at his recitation the night before, the newspaper carry-
ing an article that announced, "Vachel Lindsay had discovered a Negro bus boy
poet!"[32] A few years later, at the time of Lindsay's death in 1931, Hughes paid
him tribute: "His work was a living encouragement of the original and the
American in the creation of beauty."[33]

Hughes likely responded positively to Lindsay's broad caricatures because of
his comic delivery and his obviously counterfeit expression of "Negro" life,
which Wells found himself in the complicated position of authenticating in the
Golden Book Magazine. His resulting method of illustration comes into focus by
considering where he followed "The Congo" text, and where he deviated from it.
Three of Wells's linoleum cuts for Lindsay's poem illustrated stereotyped views
of "natives" in the jungle. The first featured nude black figures dancing in a row,
which probably followed Lindsay's line on the same page: "Tattooed cannibals
danced in files" (fig. 82).[34] The other two "native" scenes were more generic but
seemed to capture the caricatured flavor of Lindsay's lines. One illustrated tribal

warriors dancing at right, while others are seated at left beating on drums. The other illustrated tribal warriors with shields and drums gathered around an open fire, and carried the caption, "Boomlay, boomlay, boomlay, BOOM," a chant Lindsay repeated throughout his poem (fig. 83).[35] Wells also included an illustration of dancing black minstrels, which carried a caption from Lindsay's text: "Coal-black maidens with pearls in their hair."[36]

By contrast to the illustrations that corroborated Lindsay's poem, two linoleum cuts would find no textual parallel. In the first, Wells has presented two elegant, highly stylized heads, which may be based loosely on African sculpture (fig. 82). Their effect was to remind readers of the sophisticated African origins of the "Negro race" supposedly under study in this poem, particularly when compared with his hackneyed images of dancing savages. The other illustration also worked against his stereotyped images of minstrels and savage warriors (fig. 84). Here, a number of African heads, masks, and figurines are crowded together, as if in a display case at an ethnographic museum. Wells's two images have the effect of correcting and satirizing the extreme stereotypes of African life in Lindsay's poem, which Wells himself visualized in his other illustrations that more closely followed Lindsay's text.

Attesting to the corrective effect of these linocuts, the *Golden Book*'s art director, Ralph Rockafellow, attempted to minimize their strength in the final layout by sizing them to about one-fourth the dimensions of the more stereotypical illustrations. He also printed each one twice, one forward and the other in reverse as mirrored images, ultimately diluting their visual impact. Further, as if to "primitivize" Wells's image of the ethnographic display, he appended a caption to it that read "Demon Masks" (fig. 84). While these words were not taken from Lindsay's text, they fit its tone and represented the editor's gloss on Wells's image. How differently readers must have responded to a reprinting of the same linocut in a different publication. In the October 1929 issue of the *New Masses*, editors increased the image size and used instead the more sober caption, "African Masks" (fig. 85).[37]

It seems that Wells must have realized the difference between reading Lindsay's poem on the printed page and experiencing the author's outlandish minstrel performance of it. For in cold typeface, the savage stereotypes stood unmediated, without the mockery the performance afforded. As if to recreate in print Lindsay's intonations and ridiculous dialect, Wells included ironic details in the illustrations that seemed to accommodate while actually satirizing "The Congo." Each of these four illustrations features at least one dancing figure, each consistently kicking one leg up with the knee bent, while keeping its weight on the other leg. While the step calls to mind stereotypical renditions of

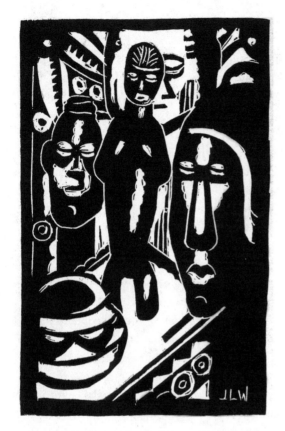

Figure 85. James Lesesne
Wells, *African Masks,* published
in *New Masses* (October 1929).
Houston Public Library.
Printed with permission of the
Estate of James Lesesne Wells.

Native American dancing, it also alludes to blackface minstrels who danced a
particular step called "knock Jim Crow."[38] Nineteenth-century representations
of blackface minstrels illustrated this dance step: with arms overhead, weight
on one leg, and knee slightly bent, the dancer lifted the other knee up (as if to
slap it), kicking his foot in toward his body (see, for example, fig. 86). Wells an-
imated his "coal-black maidens" using the bent-knee step, he cross-dressed
them in women's clothing in minstrel fashion, and he adorned one of them
with a top hat, further typifying minstrel costume. Even his "natives" suggest
blackface minstrelsy. For, in each scene, his natives dance the bent-knee step,
from his "tattooed cannibals" (fig. 82) to the central warrior in his "Boomlay"
scene (fig. 83). In one "savage" scene, the native to the far right dances the min-
strel step and wears a top hat. In these scenes, Wells has filtered the imagery
through the lens of blackface minstrelsy, satirizing the counterfeit expression
of Lindsay's poem. By employing visual signs of minstrelsy, Wells recreated the
author's outlandish minstrel performance, while further mocking the hack-
neyed stereotypes at the heart of his poem.

AMERICAN MINSTRELSY

Wells thereby evinced some of the complexity with which he and other black American artists employed representations of minstrelsy. In this case, Wells called upon the trope to invoke the minstrel performance of Lindsay as a means of distancing himself from the broad caricatures and "transparently" racist stereotypes operating in the poet's language. For other artists, donning the minstrel mask involved a more pointed circumvention of seriously racist texts. In both cases, however, black artists engaged subversively with the American tradition of blackface minstrelsy, with its complicated history of theft and counterfeit.[39] Though it began in the early nineteenth century as a mixed-race endeavor, by the middle of the century it consisted primarily of white men who wore outlandish garb and masked their faces with burnt cork or black grease-paint to imitate and parody black behavior and entertainment.[40] While the exaggerated costumes and deep facial blacking helped white audiences to understand the crucial trope of impersonation with which blackface performers engaged, it frequently seemed necessary to underscore the counterfeit. For example, some covers of minstrel songbooks made the doubling obvious, with white minstrels pictured twice: in street clothes and in blackface costume. As contemporary accounts made clear, "there was not an audience in America that would not have resented, in a very energetic fashion, the insult of being asked to look at the dancing of a real negro."[41] To highlight the difference between white performer and black character, white actors increasingly stereotyped their minstrel roles as nonsensical buffoons, who were often depicted in illustrations with grossly distorted physiognomy. Thus, by the mid-nineteenth century, the minstrel mask of blackness became one of the primary ways in which white Americans allowed themselves to engage with black identity, all the while stereotyping and thereby distancing the humanity of black Americans. In the eloquent words of Ralph Ellison from his 1958 essay, "Change the Joke and Slip the Yoke,"

> This mask, this willful stylization and modification of the natural face and hands, was imperative for the evocation of that atmosphere in which the fascination of blackness could be enjoyed, the comic catharsis achieved. The racial identity of the performer was unimportant, the mask was the thing . . . and its function was to veil the humanity of Negroes thus reduced to a sign, and to repress the white audience's awareness of its moral identification with its own acts and with the human ambiguities pushed behind the mask.[42]

When a few black performers reentered the minstrel tradition in the middle of the nineteenth century, they did so subversively, having to assume the double-counterfeit of blacking up, which would allow white audiences safe distance from the physical proximity of the black body. One of the first black minstrels to appear before exclusively white audiences was William Henry Lane, better known as Juba, who was discovered by P. T. Barnum as a replacement for the white performer in blackface, John Diamond (fig. 86).[43] According to convention, Barnum could not let Juba appear on stage as himself, but would require him to extend the same counterfeit as Diamond had assumed in blackface. To this end, a contemporary account clarified, Barnum "greased the little 'nigger's' face and rubbed it over with a new blacking of burnt cork, painted his thick lips with vermillion, put on a woolly wig over his tight curled locks, and brought him out as the 'champion nigger-dancer of the world.'"[44]

Further evincing the absurdity of the double counterfeit, Eric Lott has brought to light a playbill for one of Juba's New York performances in 1845, which highlighted the complexity of his task as a dancer:

> The entertainment to conclude with the Imitation Dance, by Mast. Juba, in which he will give correct Imitation Dances of all the principal Ethiopian Dancers in the United States. After which he will give an imitation of himself—and then you will see the vast difference between those that have heretofore attempted dancing and this wonderful young man.[45]

The subtleties required of black entertainers and artists of the nineteenth and early twentieth centuries are made explicit in this 1845 playbill. Yes, Juba could dance before a white audience, just as long as he maintained the normalizing counterfeit of imitation. Therefore, he could not initiate his own mode of dancing without first filtering his movement through the white stereotype of black dance. This is not to say that Juba had no room to burlesque whites imitating blacks.[46] However, Juba's mocking would have to be subtle, always conforming to the trope of white imitation—which is to say, white control of black expression.[47]

At the turn of the twentieth century, the comedic team of Bert Williams and George Walker began to explore further the subversive power of Juba's double counterfeit, blacking up for their stage performances ultimately to parody white imitation of black behavior.[48] According to Houston Baker, blacking up represented the comedians' tactic to manipulate and change the cultural meaning of the minstrel mask. Baker remarked upon "what a reversal the black entertainers Bert Williams and George Walker effected when they advertised

"JUBA," AT VAUXHALL GARDENS.

Figure 86. Juba (William Henry Lane), nineteenth-century en-
graving. The Harvard Theatre Collection, The Houghton Li-
brary.

themselves as 'Two *real* Coons.'"[49] By advertising themselves as "real coons"
but maintaining the trope of impersonation, Williams and Walker playfully
threatened to reveal but ultimately masked the theft and counterfeit at the root
of blackface minstrelsy.[50]

Early twentieth-century writers and poets employed the mask of minstrelsy in a variety of ways, sometimes figuratively wearing the mask to hide pain and subversion. Gwendolyn Bennett used the minstrel mask as a metaphor for the way African Americans had camouflaged their suffering in the final stanza of her poem, "Heritage:"

> I want to feel the surging
> Of my sad people's soul
> Hidden by a minstrel-smile.[51]

Paul Laurence Dunbar constructed his renowned poem "We Wear the Mask" around the trope of minstrelsy. More than hiding suffering with a smile, wearing the mask for Dunbar functioned to shield black Americans from exposing their wounds to the dominant non-black culture:

> Why should the world be overwise,
> In counting all our tears and sighs?
> Nay, let them see us, only see us, while
> We wear the mask.[52]

In Dunbar's poem, wearing the mask suggested African American experiences of double identities, masking themselves for whites, shedding the mask in the company of blacks. While Dunbar's masking seems primarily a defensive strategy, other writers and musicians associated with black vernacular forms, such as the blues, used to their advantage what W. E. B. Du Bois characterized as the black American double consciousness. More than defense mechanisms, masking and doubling could function as empowering acts of reversal, as the following blues lyrics demonstrate:

> Got one mind for the white folks to see,
> 'nother for what I know is me;
> he don't know, he don't know my mind.[53]

As the black minstrel, this blues singer has two identities—one blacked up for white folks, the other unmasked for black Americans. Though she masks her intellect from whites, perpetuating stereotypes of buffoonery, she reveals her cunning to her black audience.

DOUGLAS'S DANCING MINSTREL

In writing to Alta Sawyer, his future wife, Aaron Douglas seemed content to wear his mask with his German art teacher, Winold Reiss, but was quick to reveal his strategy to Alta. Though satisfied with his relationship with Reiss, he was mindful of the role he had to play with his teacher: "While everything is going well one must not forget to be careful. . . . My tactics are these, smile, assume a look of dumbness graduated to the occasion, keep eyes and ears open and say as little as possible. No one knows better than a Negro the real power of a smile."[54]

Douglas's letter is important, as it makes clear his masking "tactics," hiding his intellect from his European teacher with a minstrel smile. We can imagine Douglas in a similar relationship with Eugene O'Neill's play, casting the Emperor Jones as a dancing minstrel to mirror his role in illustrating the playwright's drama. In a task that approximated Juba's "Imitation Dance," Douglas was asked to authenticate the primitivism of a white American author. His dancing minstrel acted as a sign for his complex role of outward accommodation masking interior subversion. Just as Juba's dance functioned to protect the trope of imitation but allowed room for burlesquing, Douglas's minstrel could mimic O'Neill's stereotypes while parodying them at the same time.

Ten years later, in 1936, Douglas made clear his disdain for O'Neill's play, linking it to the tradition of blackface minstrelsy:

> In all the American drama, there is scarcely a Negro role that might be called intelligent, sympathetic or lovable. In the movies he is invariably represented as a docile lackey, a bombastic fool or an unbelievable monster. Occasionally some genius comes along and wraps all these misrepresentations into one, as for example Eugene O'Neill's "Emperor Jones." In the last Negro number of the *New Theatre Magazine*, George Sklar makes the following very pertinent observation: "For the American theatre has never really given up its minstrel-show conception of the Negro."[55]

In his illustrations for O'Neill's *Emperor Jones*, Douglas anticipated his scathing critique of the playwright's "misrepresentation" in 1936. However, when he created these illustrations in 1926–27, he veiled his disdain with seeming congruency. For at first glance, Douglas's illustrations for O'Neill's *Emperor Jones* seem to mirror the playwright's stereotyped tale of an upstart black man who regressed atavistically into savagery. The play charted the demise of "Emperor" Brutus Jones, a convicted killer who had escaped prison in

the United States and fled to an island in the West Indies. There, he tricked the native inhabitants into crowning him their leader and, by instituting exorbitant taxes, bilked them out of their money for his own gain. As the play opened, the audience saw Jones in his court—the location of Douglas's first illustration (fig. 87). Jones strutted around the stage wearing a flashy uniform with "patent leather laced boots with brass spurs, and a belt with a long-barreled, pearl-handled revolver in a holster." Despite his somewhat outlandish costume, "there is something not altogether ridiculous about his grandeur," wrote O'Neill in the stage directions; "he has a way of carrying it off."[56]

O'Neill thereby set the stage for complicating his character of Brutus Jones, who regressed to savagery by the play's end but began in his court as a strategist. He also complicated Jones's speech. Using black dialect, Jones often spoke nonsensically, while at the same time revealing how shrewdly he calculated his affairs. Addressing his partner-in-crime, the Cockney trader Smithers, Jones asserted: "I done de dirty work fo' you—and most o' de brain work, too, fo' dat matter—and I was wu'th money to you. . . ." At other times, though, O'Neill used Jones's primitive speech to parody his feelings of superiority over his black subjects. For example, when he learned of their imminent insurrection, he boasted contemptibly before escaping into the forest: "Think dese ignerent bush niggers, dat don't got brains enuff to know deir own names even, can catch Brutus Jones? . . . It's a shame to fool these black trash around heah, dey're so easy. You watch me, man. I'll make dem look sick."[57]

O'Neill would soon chide his protagonist for his upstart strivings. His reign as emperor was short and his confidence only a facade. When he learned of his subjects' imminent insurrection, he ran into the forest, quickly losing his way. He began to be haunted by visions of his past experiences and crimes. At first, he reacted aggressively to his visions by shooting at them with his revolver, which Douglas illustrated in his second composition. But, as Jones ran further into the forest, he succumbed to his terror and was haunted by what O'Neill called "Little Formless Fears," which he embodied for the audience "creep[ing] out from the deeper blackness of the forest," as he wrote in his stage directions. Douglas illustrated this scene in his third image (fig. 88).

Finally so weakened mentally by his fears and visions of past crimes, Jones was overcome: "Oh Lawd, Lawd!," he cried; "Lawd Jesus, heah my prayer! I'se a poor sinner, a poor sinner! I knows I done wrong, I knows it!" "He throws himself on his knees," O'Neill wrote in his stage directions, "and raises his clasped hands to the sky—in a voice of agonized pleading,"[58] a gesture which Douglas illustrated in his final image (fig. 89). Jones was then visited by a succession of visions, from a slave auction, to a slave ship, to a clearing by a river in the Congo,

Figure 87. Aaron Douglas, *The Emperor,* illustration for Eugene O'Neill, *The Emperor Jones,* in Alain Locke and Montgomery Gregory, eds., *Plays of Negro Life* (New York: Harper and Brothers, 1927). Courtesy of Special Collections, University of Houston Libraries.

Figure 88. Aaron Douglas, *Forest Fear,* illustration for Eugene O'Neill, *The Emperor Jones,* in Alain Locke and Montgomery Gregory, eds., *Plays of Negro Life* (New York: Harper and Brothers, 1927). Courtesy of Special Collections, University of Houston Libraries.

Figure 89. Aaron Douglas, *Surrender,* illustration for Eugene O'Neill, *The Emperor Jones,* in Alain Locke and Montgomery Gregory, eds., *Plays of Negro Life* (New York: Harper and Brothers, 1927). Courtesy of Special Collections, University of Houston Libraries.

each leading him further back to the savagery O'Neill perceived at the root of African identity. In the final vision in the Congo, Jones saw a primitive stone altar at the foot of a tree. "Then, as if in obedience to some obscure impulse, he goes into a kneeling, devotional posture before the altar," O'Neill instructed the actor.[59] A "Congo Witch Doctor" then sprang from behind the tree, followed by a crocodile god, whose "eyes, glittering greenly, fasten upon Jones."[60] Douglas

recorded the encounter between Jones and the crocodile god in his last illustra-
tion (fig. 89). Coming briefly to his senses, Jones then shot at his vision, which
quickly dissipated. After this final regression to savagery, Jones was easily cap-
tured and killed by the island inhabitants not far from the place where he had
embarked on his escape into the forest.

That O'Neill humanized and complicated his black protagonist supported
Van Wyck Brooks's appraisal, "The Negro was to reappear in *The Emperor Jones*
and other plays,—for O'Neill was deeply concerned with the fate of this race."[61]
Nonetheless, O'Neill maintained dehumanizing black stereotypes at the center
of his plot. Repeatedly, he characterized those of African descent as hopelessly
primitive. He clearly viewed the native islanders as nearly subhuman, atavisti-
cally closer even than Jones to their primitive roots in Africa. For example, in
his stage directions describing Jones's native island killer, O'Neill wrote: "Lem
is a heavy-set, ape-faced old savage of the extreme African type, dressed only in
a loin cloth."[62] Though O'Neill cast Jones as a former Pullman car porter, who
prided himself on learning the manners of those well-to-do white people he at-
tended, Thomas Pawley has observed that his protagonist "has [only] aped the
behavior of those he served. . . . The culture he has acquired is only a ve-
neer, . . . which is insufficient to harness his primitive impulses."[63]

At every turn, O'Neill reminded his audience that Jones was a pretender,
one who always fell short of the mark O'Neill held up. Upon meeting Jones at
the beginning of the play, as Shannon Steen has written, the audience encoun-
ters him as "the powerful man who speaks English, but an English distinctive
for its rolling patois; . . . the rich man who wears clothes that signify power, but
in a grotesque parody of that sign."[64] He is an emperor with no subjects, a
clever strategist who loses his way, whom O'Neill has portrayed through the
lens of minstrelsy. His speech is nonsensical, "characterized by omissions,
substitutions, additions, and distortions of standard English phonemes."[65] His
reactions to his frightening visions in the forest echo minstrelsy's stereotypes;
in one case O'Neill instructed, "Jones's eyes begin to roll wildly. He stutters."[66]

In employing minstrelsy's stereotypes and mocking the "Emperor's" attempt
to make something of himself, O'Neill validated what James Weldon Johnson
had written a decade earlier about the white "literary ideal of the American Ne-
gro," whose "efforts to elevate himself socially are looked upon as a sort of ab-
surd caricature of 'white civilization.'"[67] The implications O'Neill's caricature
held were not lost on other black critics, such as Benjamin Brawley, who tired of
white writers' stereotypes of blacks as "inferior, superstitious, half-ignorant" and
with white writers who refused to engage with the "immense paradox of racial
life."[68] And, when the play was produced in Harlem in the 1930s, as Jeffrey

Stewart has noted, black audiences found O'Neill's caricatures ridiculous.[69] As Langston Hughes remembered of a Lincoln Theater performance:

> The audience didn't know what to make of The Emperor Jones. . . . And when the Emperor started running naked through the forest, hearing the Little Frightened Fears, naturally they howled with laughter. "Them ain't no ghosts, fool!" the spectators cried from the audience. "Why don't you come on out o' that jungle—back to Harlem where you belong?"[70]

Another outspoken critic of O'Neill's play was Charles Gilpin, the black American actor whom O'Neill had chosen for the leading role in the first productions of The Emperor Jones.[71] Because Gilpin objected to "some of the play's more racist lines and epithets,"[72] he changed some of them in performance, for example substituting "black baby" for "nigger."[73] In some accounts, O'Neill is said to have chided Gilpin harshly: "If I ever catch you rewriting my lines again, you black bastard, I'm going to beat you up."[74] When Gilpin persisted in changing O'Neill's lines during the London production of the play, O'Neill's response was telling. Rather than entertain the revisions of this actor, whom he had so highly respected, he dropped Gilpin from the play, leading to the ultimate demise of the actor's career.[75]

In placing O'Neill's play within the context of developments in African American drama, Alain Locke was more slyly critical than Gilpin. In his introduction to Plays of Negro Life, the compendium that contained O'Neill's play and Douglas's Emperor Jones illustrations, he judiciously praised white dramatists who had used black American subjects. He began his essay by praising O'Neill, Ridgely Torrence, and Paul Green for realizing the value of black American material in creating a national dramatic literature.[76] However, he predicted that black American dramatists would soon regain control of black expression. "Eventually there is destined to rise a national Negro Theatre," Locke wrote, "where the black playwright and the black actor will interpret the soul of their people in a way to win the attention and admiration of the world." Reserving his most biting commentary for this eventuality, Locke asserted basic differences between the material white and black Americans could legitimately draw from. "The drama that will refine and entertain, that may even captivate us before long, is likely to be the uncurdled . . . folk feeling of a people who have after all a different soul and temperament from that of the smug, unimaginative industrialist and the self-righteous and inhibited Puritan." At the end of his essay, Locke suggested that the moment was ripe for change within the black American theater. "Forced to laugh outwardly and weep in-

wardly, the Negro has until lately only been in the position of successful clowning," he wrote, as noted at the beginning of this chapter. However, "with better emotional compensation," he predicted of the near future, "there will come the power to smile satirically and reflect with ironic composure."

Locke's introduction to his *Plays of Negro Life,* which began with initial masking but gave way to pointed critique and then to new directions, may have served as a model for Douglas's method in illustrating *The Emperor Jones.* "Smiling satirically," Locke initially gave some of his non-black readers what they may have expected, allowing the subsequent critique less sting but ultimately more weight. Many of his black readers, conversely, may have understood his method and perhaps chuckled when they recognized it. Similarly, Douglas's illustrations appeared so thoroughly to imitate O'Neill's play, that his subsequent subversion would attain palatability for some, knowing nods from others. Charting Brutus Jones's progression from strutting emperor (fig. 87), to fugitive in the forest, to haunted creature in despair (fig. 88), to surrendered victim (fig. 89), Douglas followed O'Neill's course for Jones from leader to "savage." Douglas also followed O'Neill's instructions for Jones's dress, uniformed in the first two drawings, but clothes removed in the last two, suggesting his regression from civilization.

Upon closer inspection of the first illustration, however, Douglas's Emperor is not a mimetic reflection of O'Neill's Emperor, but instead departs from the playwright's stage directions with his agile dance step (fig. 87). Together with the Emperor's dark, masklike face, thick white lips, and pseudo-military costume, this dancing figure recalled the blackface minstrels of mid-nineteenth-century America. The bent-knee posture approximated the dancing that blackface minstrels appropriated from black dancers in the nineteenth century, and it was in this stance that blackface minstrels were frequently represented in illustrations. When Juba and other black performers reentered the minstrel tradition at mid-century, they too were depicted in the bent-knee posture (fig. 86). By the early twentieth century, the bent-knee pose was commonly assigned to the popular dancing of black Americans, as in Winold Reiss's *Interpretation of Harlem Jazz I* (c. 1925; fig. 90).

On the one hand, the minstrel step that Douglas assigned his Emperor seemed to confirm the buffoonery of O'Neill's character. On the other, it critiqued O'Neill's assignation of black savagery to Jones by gesturing toward white minstrelsy's caricature of black identity. Moreover, the Emperor's dancing pose was a sign of the vernacular form of black entertainment that white Americans had appropriated—a sign of the theft at the heart of minstrelsy. It is one of several symbols of vernacular culture that Douglas used to revise

Figure 90. Winold Reiss,
*Interpretation of Harlem
Jazz I*, c. 1925. Private
collection. Reproduced
with permission of the
Winold Reiss Estate.

O'Neill's ultimate assessment of the savagery of black identity, pointing instead
to distinctive forms of black cultural expression that had gained popularity and
esteem during the 1920s. For example, in his first illustration, Douglas has fea-
tured a variety of moving elements that suggest a unifying blues or jazz beat
(fig. 87). In fact, the entire room is topsy-turvy with movement, as if in accom-
paniment of Jones's dance. The floor slopes down to the right, its contrasting
tiles appearing to undulate; the bands of water roll in the distance; the throne
behind Jones seems to dance along with the figure; and the carpet beneath
Jones's feet juts out in varying angles from the throne behind. This syncopated
movement suggests a modern jazz rhythm.

Douglas's icons of syncopation found precedent in his *Play de Blues* of
1926, in which they related specifically to black American music (see fig. 12).
The drawing illustrated Langston Hughes's vernacular poem called "Misery,"
in which an urban nightclub performer sings the blues. In Douglas's illustra-
tion, the swaying blues singer and her accompanist tilt their heads toward a set
of wavy bands, which picture music as they roll out of the upright piano. As in

his Emperor Jones composition, no figure or object stands still, each responding to the beat of the blues tune.

In his final Emperor Jones illustration, Douglas also referenced a familiar expression of black vernacular culture. In his pose of surrender, Jones kneels down in fear before the crocodile god, yet his head is tipped upward, his arms stretched up in prayer to a different god (fig. 89). This pose articulated a religious gesture particularly of working-class black Christians who practiced evangelical worship styles, in this case crying out to receive the holy spirit. In assigning this posture to Jones, Douglas resisted O'Neill's atavistic characterization of the Emperor. In the moment when Jones had regressed furthest into savagery in O'Neill's text, transfixed by signs of pagan rituals—the altar, witch doctor, and crocodile god, Douglas defiantly maintained Jones's connection with black Christianity. Thus, in his first and last illustrations for Emperor Jones, Douglas has cued the viewer to see specific vernacular expressions of music and religion, which can be read as circumventing O'Neill's stereotypes of black identity. While O'Neill cast Jones as a fake, who wore his civilization as a costume that fell off in the forest to reveal his savagery, Douglas authenticated Jones as a "real coon" (as Williams and Walker advertised themselves), one who danced black and worshipped black.

The bent-knee stance of Douglas's Emperor Jones may be read further as a sign of flexibility, both physical and intellectual, that signified autonomy from white conventions that would fix black identity to a stereotype. Physically, the Emperor's pose is a study in arrested movement, which at the same time defies the notion that one could arrest movement. In its extreme angularity and rhythm but also its fluidity and balance, the pose mitigated against fixity in time or space, implying continuous movement and slippage from outside constraints. Taken as an intellectual sign, the pose suggested a refusal to choose one idea over another, resisting the urge toward mental fixity or certainty. In a letter to Alta Sawyer of 1925 or 26, Douglas expressed a similar desire to keep his ideas in motion rather than fixed, always balancing objective standards with subjective experiences as if in an intellectual dance:

In my judgment the essence of happiness is to be found in the approaching balance or poise between the objective and the subjective consideration of life's experiences. I say poise rather than point advisedly. For the point is the sign of death. It is the end. In other words, the fixation of habits and judgments is the sure sign of mental decay. Therefore we must keep our habits and judgments in motion around the balance point of our life's experiences.[77]

In his argument for intellectual poise or his refusal to allow fixity in his Emperor's dance step, Douglas enacted a cultural strategy to resist rigid racial relationships and hierarchies, a tactic that contemporary scholars have perceived in the bent-knee dance steps of black Americans. For example, W. T. Lhamon has identified the bent-knee pose as "a vernacular anti-stance" that has resurfaced periodically in the Black Diaspora. The bent-knee pose in Lhamon's argument repeatedly embodied a cultural strategy that resisted fixation and assured flexibility:

> The chief distinguishing gesture of African-American body retentions in New World dance is the bent knee. . . . This "kneebone bent" is a move nurtured by the same Gullah community on the Georgia Sea Islands that carried "Knock Jim Crow" to us. . . . Jim Crow's bent knee was an African-American posture teaching nimble motion. His bent knee fostered coexistence and survival rather than rigid relations and extermination.[78]

Similarly, Ann Douglas has considered the cultural significance of African American dancers in the 1920s, who could "keep two, three, even four distinct and different rhythms going at once, each performed by a separate part of the dancer's body. . . . Zora Neale Hurston called it 'the rhythm of segments.'"[79] Dancing to complex rhythms meant, for Ann Douglas, "the African-American performer can't be 'caught.'"[80] This kind of physical movement of balance and poise embodied the will to slip from the constraints of rigid categories of race that perpetuated stereotypes of black identity.

Aaron Douglas further emphasized his act of masking and his move to resist fixation by silhouetting the dancing minstrel-Jones.[81] Aside from the bright white stripes of his jacket and his bright white lips that stand out against his blackface mask, his entire form remains black. As a masked silhouette, Douglas's figure will not disclose his identity in three dimensions, never mimetically replicating O'Neill's caricatured protagonist. Further, Douglas masked the boundaries between the dancing figure, his throne behind, and the rug and checkerboard tile beneath, as forms overlay one another. With the ambiguous silhouette, Douglas has masked the particularities of his Emperor's identity and surroundings, allowing distance from rather than dependence on O'Neill's text.

The distinction between Douglas's dancing silhouette and the body of O'Neill's character became clearer for the reader by comparing Douglas's illustration with a photograph of Paul Robeson in the role of Brutus Jones, also published in Locke's *Plays of Negro Life*.[82] The specificity of Robeson's costume and the substance of his body, which casts shadows behind him, fell away in Doug-

las's ambiguous silhouette. The reader was therefore free to perceive Douglas's figure on its own terms rather than in relationship to the actor's body.

Douglas's guile in casting his Emperor Jones as a flat, black, dancing minstrel becomes even more apparent in comparison with a drawing by his teacher Winold Reiss, mentioned above and titled *Interpretation of Harlem Jazz I* (c. 1925; fig. 90). At first glance, the compositions seem very similar, Douglas appropriating the stance of Reiss's black dancer at right. However, his reversal of the dancer's position, facing and kicking in the opposite direction from Reiss's dancer, is one of several revisions Douglas made to his teacher's image. First, Douglas simplified Reiss's composition, focusing on just one dancer and eliminating the plethora of background images that Reiss includes, such as the cabaret table and glass, the liquor bottle, the leg of another cabaret dancer, as well as the African masks. By eliminating Reiss's specific details, which clearly set his scene in a Harlem cabaret while also situating the dancers' roots in Africa, Douglas allowed Jones's exact identity and setting to remain less fixed. Further, while Douglas suggested the military jacket and patent leather boots O'Neill specified for Jones's costume, his apparel is more abstracted than the suit, hat, and tie of Reiss's dancer. As a flat black silhouette, Douglas's figure will not disclose the borders between his jacket and pants, or between his skin and his costume. By comparison, Reiss's dancer discloses these borders explicitly.

In his use of the silhouette in his Emperor Jones illustrations, Douglas similarly deflected attention away from the black body of Jones, instead privileging the flat surface of his shadow. In this light, Douglas may have drawn on his experience with theatrical staging. Having created set designs for theater groups in Harlem, he undoubtedly consulted with the lighting technicians to coordinate desired stage effects.[83] One popular effect in contemporary staging was the tableau scene, in which characters would freeze their movement in front of a brightly lit backdrop.[84] Because the actors were lit from behind, their forms appeared flat, black, and unmodulated against the light background screen or wall. Two photographs of tableau scenes illustrated Locke's *Plays of Negro Life;* one was staged for O'Neill's *Emperor Jones.*[85] It portrayed one of Brutus Jones's visions in the forest, in which he imagined himself as a slave auctioned off to the characters at right. Despite the racial identity of the actors, both black and white, all figures appear similarly black and flat against the light ground, though their contours are etched with precision. Thus the tableau lighting both revealed and obscured the bodies of the actors.

This tableau scene provided a brief respite from the audience's scrutinizing gaze on Jones's body, which, as he removed each layer of clothing in the forest, became O'Neill's site of African savagery.[86] For O'Neill, it was Jones's half-naked

black body that held his primitive identity. By refusing to allow Jones's corporeal body to come under his viewer's gaze, particularly in his last two illustrations where Jones has removed his clothing (figs. 88 and 89), Douglas dismissed O'Neill's racist preoccupation with the "savage" bodies of African American men. By obscuring the full, muscular body with a flat silhouette, Douglas shifted focus from O'Neill's eroticized fetish to an iconic sign of ambiguity.[87]

In only two instances did Douglas allow for a sense of dimensionality in his drawings of Jones. The white stripes of Jones's military jacket in the first two illustrations suggest the barrel curve of his chest (figs. 87). And, his white lips in the first illustration bring dimension to that area of his face. Though the lips appear as a physical sign of the character's race, they are so exaggerated in size and shape that they more readily call to mind the counterfeit, blacked-up faces of black minstrels and comedians, whose lips and skin around their mouths were lighter than their grease-painted faces, achieving the cosmetic effect of pitch black faces with thick white lips. Therefore, in the few cases when Douglas highlighted the third dimension in white, he emphasized Jones's minstrel costume—the sign for Douglas's parody of O'Neill's stereotypes rather than the actual body of Jones.

By disengaging the physical signs of race from the African American body and transferring them to the silhouette and minstrel mask, Douglas confounded the tendency of Euro-Americans to construct "ethnic Otherness" as a palpable characteristic "located in the body" of the Other, as Coco Fusco has explained.[88] Instead, Douglas's silhouettes functioned to make the body ambiguous and therefore not decidedly Other. At the same time, he exaggerated physical signs of race that, because of their hyperbole, circumvented the body and pointed to blackface costume. Thus, in accordance with the counterfeit of minstrelsy, the Emperor's thick lips and pitch black skin signified Douglas's parody of O'Neill's stereotyped expression of black identity and rigid system of racial hierarchy.

CONCLUSION

When Aaron Douglas and James L. Wells employed the minstrel's bent-knee pose, they "smiled satirically," in the words of Alain Locke. They replaced stereotyped caricatures with savvy tricksters who parodied whites imitating blacks. In their perpetual movement and ambiguous identities, the dancing tricksters functioned as emblems for maintaining autonomy from conventions that would fix racial identity. While Wells's dancing cannibals or Douglas's

dancing minstrel seemed to corroborate negative stereotypes of black primi-
tivism, at the same time, each artist was "signifying on" racial stereotypes. Just
as Douglas employed the silhouette and minstrel pose to parody O'Neill's view
of black life, Wells used the minstrel step to pin the stereotypes of black behav-
ior back on Vachel Lindsay's minstrel performance. By manipulating the min-
strel mask, Douglas and Wells refashioned black figures as newly modern in
their acts of masking. For their dancing minstrels performed their racial identi-
ties, wearing them as stereotyped costumes that they could also throw off as
modern actors. By tricking stereotypes of race and reconceiving them as mod-
ernist masquerade, these artists have played the role of Langston Hughes's
Black Jester. Threatening to expose his own act of masking, Hughes's Jester
disclosed his identity as both black and modern: "Once I was wise. Shall I be
wise again?"

A Brief Conclusion:
On Making Black Modern during
the Renaissance and Beyond

In their project to make black modern in Harlem Renaissance print culture, New Negro illustrators created new representations of African American identity and culture that had far-reaching implications. Aaron Douglas and Richard Bruce Nugent deployed their modern illustrations to destabilize stereotypes that African Americans were "intellectually backward" and closer to nature. Their ambiguous, silhouetted, Afro-Deco forms complicated normative polarities between primitive and civilized Africa, antiquity and modernity—dualities that had fixed presumptive distinctions between a privileged Western culture and an exotic, primitive "Other." By blurring boundaries between inside and outside, Douglas and Nugent questioned a monolithic construction of culture, instead asserting a new model of cultural hybridity.

In the hands of Joyce Carrington and Charles Dawson, making black modern meant reclaiming an ancient Egyptian heritage that segued powerfully into a claim for participation in America's modern culture and commerce. They further drew on the language of modern advertising to characterize modern black men and women as actively engaged in American professionalism and consumer culture. Similarly, Gwendolyn Bennett and Zell Ingram sought to reclaim religious origins to express a more relevant, modern religion. Rather than exploring African spirituality, however, Douglas, Ingram, and several non-black artists crossed racial barriers to confront the Christian tradition in America, which had come to know itself as white. Through radical refashioning, they reinterpreted the meaning of blackness in the Judeo-Christian scriptures, and they dramatically recast Adam and Christ as black men whose contemporary suffering connected them metaphorically with their religious ancestors, creating a powerful modern bond between African America and the ancient Judeo-Christian tradition. In their reclamation of ancient culture and Judeo-Christian

roots, New Negro illustrations provide persuasive evidence of ways in which history and religion garnered strategic significance in interwar American culture.

For Douglas and James L. Wells, black modernism could also involve parody of those who perpetuated stereotypes about black behavior that originated in the nineteenth-century practice of blackface minstrelsy. These stereotypes of the crooning "darky" or the treacherous and libidinous young "Buck" circulated not only in early twentieth-century American print culture but also through blackface performances in American films, notably *Birth of a Nation* (1915) and *The Jazz Singer* (1927). Douglas and Wells engaged subversively with these stereotypes, seemingly confirming them on one level, while ultimately satirizing them and exposing their racist premises. Their subversive modernism may be conceived as another component of what Henry Louis Gates Jr. and Mel Watkins have identified as a black vernacular mode in storytelling, literature, music, and humor, which revised debased images of black behavior through parody, thereby subverting normative race and power relationships in America.

In exploring modern intersections of race and gender, black illustrators tended to reinscribe the masculinity of New Negro identity that Du Bois and Locke had engendered in their book and magazine editorials. For example, E. Simms Campbell, Dawson, and Hale Woodruff most often pictured black American workers and professionals as men who had gained full participation in America's cultural economy. However, women illustrators like Carrington and Laura Wheeler Waring created alternative images of female New Negroes—most often light-skinned, middle-class women who engaged profitably in American commercialism. While their light skin and European features reflected the severe limitations imposed on black women as they entered into modern beauty culture, they also represented the success of the burgeoning black cosmetics businesses in helping to establish a feminine ideal of bronze beauty that filtered into the American mainstream. Their light brown skin also implied mixed-race identity, a subject explored in connection with gender fluidity and gay identity by Nugent and Charles Cullen. Their illustrative work constituted the most sexually daring among Harlem Renaissance illustrations, and it served to further disrupt narrow definitions of race, as well as gender and sexuality.

The new brands of modernism developed by New Negro illustrators not only had important application to a broad range of cultural ideas but they circulated substantially in American print culture, especially in the black magazines, in which black artists found the most frequent opportunities to publish their work. While fewer black illustrators found exposure in mainstream book

publishing ventures, a rich network of mixed-race relationships fostered the publication of stunning modernist illustrations and dust jacket designs by Douglas, Miguel Covarrubias, and Winold Reiss. This large body of illustrative work provides crucial evidence of the ubiquitous interwar American art form of illustration, an important though neglected modernist medium uniquely able to connect art, text, advertising, and commercial culture. Repeatedly Harlem Renaissance artists wielded the illustration as a device to promulgate new representations of black identity on magazine covers and dust jackets— modern forms with wide circulation and hybrid roles as works of art and as advertisements. They refresh our memories of huge numbers of interwar American illustrations that await investigation as the largely undiscovered jewels of American print culture.

Several areas within the purview of Harlem Renaissance illustration also warrant further investigation. For example, while Theresa Leininger-Miller has made important inroads into the study of Albert Smith and Laura Wheeler Waring's illustrations, their work bears greater scrutiny in embodying conservative styles yet promoting important modern themes. In each case, a careful investigation into their representations of gender as it intersects with race is in order. The unusual career of E. Simms Campbell also awaits further study. Chameleon-like in his broad stylistic and thematic repertoire, he is the illustrator who, in the early 1930s, developed the most persuasive vernacular mode in his scenes of urban workers and rural musicians. They anticipate the striking working-class vernacular style of Jacob Lawrence's illustrations of 1947 for Langston Hughes's One-Way Ticket.[1] Campbell went on to find commercial success in mainstream magazines with conventionally rendered cartoons of alluring white women, but he seems largely to have abandoned his early vernacular work. Careful study of the range of his illustrations could bring his life and work into better focus.

Another important body of illustration requiring greater understanding is the work by Lois Jones and James L. Wells for Carter G. Woodson's Associated Publishers.[2] Not only did they provide book illustrations for the Associated Publishers' studies of black history and social science, but Jones provided many illustrations for one of the association's journals, Negro History Bulletin, beginning in the late 1930s. Many of these illustrations were intended as educational tools for children, suggesting New Negro children's illustrations as another promising area of investigation.

Two other broad areas come to mind as potential targets of further study. First, how did the work of Harlem Renaissance illustrators intersect with the thematic aims of paintings and sculpture by black artists from the 1920s

through the 1940s? Are there iconographic seeds planted in New Negro illustrations that continue and develop in painting and sculpture? For example, the suitcase appears as an iconic form in a variety of Harlem Renaissance illustrations, suggesting several interpretations from migration to homecoming.³ How did this symbol evolve, for example, in the work of Jacob Lawrence, and how is his use of it made resonant in the context of Harlem Renaissance illustration?

Second, what are the broader implications of the study of print culture for American painting and sculpture? For example, as we have seen, references to ancient Egyptian art and architecture surfaced in New Negro illustrations as well as Euro-American advertising images in order to emphasize the modernity of African American identity and American commercial products. In his 1927 painting, *My Egypt*, Charles Demuth similarly drew comparisons between the grandeur of ancient Egyptian architecture and the modernity of the American industrial landscape, at the time when Douglas, Raymond Loewy, and others were engaged with this association in American print culture.⁴ How were illustrations, advertising imagery, and paintings in dialogue with one another and what were the patterns of thematic migration from one medium to another?⁵

Finally, what has been the legacy of efforts to make black modern in Harlem Renaissance illustration? From the 1940s through the present, many black artists have pursued illustration, printmaking, and works on paper—activities that become more resonant within the context of the strong tradition of illustrative art during the Harlem Renaissance.⁶ Some artists continued to create illustrations following the thematic concerns of New Negro artists. For example, Allan Rohan Crite created religious illustrations from the 1940s through the 1990s, which extend the religious iconography begun during the Harlem Renaissance. In his 1944 publication, *Were You There When They Crucified My Lord: A Negro Spiritual in Illustrations,* Crite pictured this spiritual by combining holy figures in ancient garb with contemporary working-class folks in an urban setting.⁷ He set the procession of a black Christ on the road to Calvary in his own Boston streets, with apartment buildings, factories, and a telephone pole providing a contemporary backdrop for this ancient narrative.

Both Jacob Lawrence and Romare Bearden began their young careers in Harlem during the Renaissance. For his *Migration of the Negro* series, Lawrence spent long hours in the Harlem branch of the New York Public Library, soaking up history and imagery in black print culture. As a young art student in the 1930s, Bearden contributed drawings to issues of *Opportunity*. With this early exposure, it is significant that both artists maintained connection to the medium of illustration on paper. Beyond creating specific illustrations for Langston Hughes's poetry, Lawrence's work never strayed far from the

medium in its broadest sense, with his early work often produced in conjunc-
tion with text and his continued choice throughout his career of tempera on pa-
per to develop his vernacular modernism. In his engagement with magazine
illustrations in his adventurous collage work, Bearden has also developed a
modernist discourse through connection to illustration.

In her use of the paper silhouette, contemporary artist Kara Walker makes
connection to the paper medium of illustration as well as to the silhouetted
forms of illustrations by Douglas, Nugent, and Wells.[8] Thematically, her work
contributes to ongoing forms of subversion in African American cultural pro-
duction that found earlier expression among New Negro illustrators. As recent
inheritors of their strategies, Walker, together with Michael Ray Charles, Glenn
Ligon, Kerry James Marshall, Adrian Piper, and many other artists continue the
modernist project of Harlem Renaissance illustration by satirizing racial
stereotypes and destabilizing normative assignations of race and gender.

Notes

Preface and Acknowledgments

1. David Bailey and Richard Powell, *Rhapsodies in Black: Art of the Harlem Renaissance* (Berkeley: University of California Press, 1997).

2. The exhibitions include Bailey and Powell, *Rhapsodies in Black,* and Lowery Sims, *Challenge of the Modern: African-American Artists 1925–1945* (New York: Studio Museum in Harlem, 2003). For isolated studies of the illustrations of Aaron Douglas, Albert Smith, and James Wells, respectively, see Amy Kirschke, *Aaron Douglas: Art, Race, and the Harlem Renaissance* (Jackson: University Press of Mississippi, 1995), Theresa Leininger-Miller, *New Negro Artists in Paris: African American Painters and Sculptors in the City of Light, 1922–1934* (New Brunswick: Rutgers University Press, 2000), 202–40, and Richard Powell and Jock Reynolds, *James Lesesne Wells: Sixty Years in Art* (Washington, DC: Washington Project for the Arts, 1986). For a short but very well integrated presentation of Harlem Renaissance literature, illustration, photography, painting, and sculpture, see Barbara Haskell, *The American Century: Art and Culture, 1900–1950* (New York: Whitney Museum of American Art and W. W. Norton, 1999), 187–95.

3. Anne Elizabeth Carroll, *Word, Image, and the New Negro: Representation and Identity in the Harlem Renaissance* (Bloomington: Indiana University Press, 2005) and Martha Jane Nadell, *Enter the New Negroes: Images of Race in American Culture* (Cambridge, MA: Harvard University Press, 2004). Both authors look at the relationships between image and text in Harlem Renaissance publications. Carroll's most interesting contribution lies in her analysis of early manifestations of these relationships in *Crisis* and *Opportunity,* particularly in seeing the editors' employment of photography as a critical component of their textual editorializing. Nadell's most interesting considerations are of illustrated books during the 1930s and 1940s, for example, Zora Neale Hurston, *Mules and Men* (Philadelphia: J.B. Lippincott Co., 1935), illustrated by Miguel Covarrubias, and Langston Hughes, *One-Way Ticket* (New York: Alfred A. Knopf, 1949), illustrated by Jacob Lawrence. As each scholar comes from the literary tradition, they excel in articulating the "interartistic" (Nadell's term) connections between word and image. However, Nadell's image analysis, particularly of the Harlem Renaissance illustrations, offers little new insight and often depends heavily on previous art-historical scholarship, including Kirschke's monograph on Douglas.

4. For example, David Levering Lewis (*When Harlem Was in Vogue* [New York: Penguin, 1997 (1981)]) perceives white patronage as primarily exploitative of black authors of the Harlem Renaissance, whereas George Hutchinson (*The Harlem Renaissance*

in Black and White [Cambridge, MA: Harvard University Press, 1995]) interprets these relationships as largely productive.

5. Michele Bogart, *Artists, Advertising, and the Borders of Art* (Chicago: University of Chicago Press, 1995); Rebecca Zurier, *Art for the* Masses: *A Radical Magazine and Its Graphics, 1911–1917* (Philadelphia: Temple University Press, 1988).

6. See, for example, Bogart, *Artists, Advertising and the Borders of Art;* Haskell, *American Century;* Wanda Corn, *The Great American Thing: Modern Art and National Identity, 1915–1935* (Berkeley: University of California Press, 1999); and Terry Smith, *Making the Modern: Industry, Art, and Design in America* (Chicago: University of Chicago Press, 1993).

7. On American modernism and racial diversity, see, for example, Ann Douglas, *Terrible Honesty: Mongrel Manhattan in the 1920s* (New York: Farrar, Straus and Giroux, 1995).

8. For her argument that American modernist art between the wars ranged stylistically from varied forms of realism to abstraction, its modernism sometimes revealed through content and at others through style, see Erika Doss, *Twentieth-Century American Art* (New York: Oxford University Press, 2002), 35–117.

9. See W. J. T. Mitchell, "Word and Image," in *Critical Terms for Art History,* ed. Robert Nelson and Richard Shiff (Chicago: University of Chicago Press, 1996), 47–57; Mitchell, *Picture Theory: Essays on Verbal and Visual Representation* (Chicago: University of Chicago Press, 1994), and Mitchell, *Iconology: Image, Text, Ideology* (Chicago: University of Chicago Press: 1986).

10. Walter Benjamin, "The Work of Art in the Age of Mechanical Reproduction," in *Illuminations,* ed. Hannah Arendt (New York: Schocken Books, 1985 [1968]), 217–51.

11. Benjamin, "The Task of the Translator," in *Illuminations,* 69–82.

Introduction:
Making Black Modern in the Medium of Illustration

1. Aaron Douglas to Langston Hughes, December 21, 1925; Langston Hughes Papers, Part 1: Correspondence, Box 51, Aaron Douglas Folder, James Weldon Johnson Memorial Collection of Negro Arts and Letters, Yale Collection of American Literature, Beinecke Rare Book and Manuscript Library, New Haven, CT. This passage from the letter has been quoted previously by Richard J. Powell, *The Blues Aesthetic: Black Culture and Modernism* (Washington, DC: Washington Project for the Arts, 1989), 24.

2. Elizabeth Luther Cary, "The Fine Art of Illustrating," *New York Times* (February 28, 1932).

3. Gwendolyn Bennett, "The Ebony Flute," *Opportunity* (October 1926): 322–23. Bennett was describing the plain blue dust jacket with cursive white lettering for Carl Van Vechten's *Nigger Heaven* (New York: Alfred Knopf, 1926).

4. John P. Davis, review of Isa Glenn, *Little Pitchers* (New York: Alfred Knopf, 1927), in *Opportunity* (July 1927): 214.

5. The term, "New Negro," was used to distinguish from old conceptions and stereotypes of black identity and was popularized in *The New Negro: An Interpretation,* ed. Alain Locke (New York: Albert and Charles Boni, 1925).

6. Paul Gilroy, *The Black Atlantic: Modernity and Double Consciousness* (Cambridge, MA: Harvard University Press, 1993).

7. For a discussion of the critical reception of the art in the Harmon Foundation exhibitions, see Mary Ann Calo, "African American Art and Critical Discourse between the Wars," in *American Quarterly* 51, 3 (September 1999): 580–621. For a thorough study of the Harmon Foundation exhibitions, see Gary Reynolds and Beryl Wright, eds., *Against the Odds: African-American Artists and the Harmon Foundation* (Newark: Newark Museum, 1989).

8. Charles S. Johnson, "Blackness and Whiteness," *Opportunity* (April 1928): 100.

9. Ibid., 100. The lines came from Hughes's poem titled "Dream Variations."

10. Letter from Aaron Douglas to Alta Sawyer, n.d. (written sometime in 1925), Aaron Douglas Papers, Box 1/1, Folder: Correspondence, Aaron Douglas to Alta Sawyer 1924–1926, #1–10, letter #2, Schomburg Center for Research in Black Culture, New York, NY, quoted in Kirschke, *Aaron Douglas*, 67.

11. "William Sells Book to Harlem," *Publishers Weekly* (April 14, 1928): 1623.

12. Aaron Douglas to Alta Sawyer, n.d., Box 1, Folder 2, Aaron Douglas Papers, as quoted in Kirschke, *Aaron Douglas*, 59.

13. Lois Jones's statement, source unidentified, in Tritobia Hayes Benjamin, *The Life and Art of Lois Mailou Jones* (San Francisco: Pomegranate Artbooks, 1994), 7.

14. Ibid.

15. Elmer A. Carter, "E. Simms Campbell—Caricaturist," *Opportunity* (March 1932): 82.

16. Arna Bontemps, "The Campbell Kid: E. Simms Campbell," in *We Have Tomorrow* (Boston: Houghton Mifflin, 1945), 1.

17. Powell and Reynolds, *James Lesesne Wells*, 10.

18. "Survey," *Opportunity* (July 1928): 217.

19. Helen Langa, *Radical Art: Printmaking and the Left in 1930s New York* (Berkeley: University of California Press, 2004).

Chapter 1. Strategizing from Spaces Between:
Aaron Douglas and the Art of Illustrating

1. David Bailey and Richard Powell, *Rhapsodies in Black: Art of the Harlem Renaissance* (Berkeley: University of California Press, 1997); and Lowery Sims, *Challenge of the Modern: African-American Artists 1925–1945* (New York: Studio Museum in Harlem, 2003). For the most comprehensive study of Douglas's life and work, see Amy Kirschke, *Aaron Douglas: Art, Race, and the Harlem Renaissance* (Jackson: University Press of Mississippi, 1995).

2. Langston Hughes, "The Negro Artist and the Racial Mountain," *Nation* (June 23, 1926): 694.

3. James Porter, *Modern Negro Art* (1943), as quoted in Kirschke, *Aaron Douglas*, 78.

4. Richard Powell, *Black Art: A Cultural History* (London: Thames and Hudson, 2002 [1997]), 44.

5. Aaron Douglas to Langston Hughes, dated December 21, 1925. Langston Hughes Papers, Part 1: Correspondence, Box 51, Aaron Douglas Folder, James Weldon Johnson Memorial Collection of Negro Arts and Letters, Yale Collection of American Literature, Beinecke Rare Book and Manuscript Library, Yale University, New Haven, CT.

6. Ibid.

7. Richard Dyer, "Seen to Be Believed: Some Problems in the Representation of Gay People as Typical," in *The Matter of Images: Essays on Representations* (London and New York: Routledge, 1993), 22.

8. For his discussion of what he calls the "in-betweenist" types, see Dyer, 31–38.

9. Ibid., 31 and 23.

10. Ibid., 37.

11. Ibid., 38.

12. Alain Locke, "The New Negro," in *The New Negro: An Interpretation*, ed. Alain Locke (New York: Albert and Charles Boni, 1925), 4.

13. Kirschke, *Aaron Douglas,* 8–11.

14. Douglas's creation of a new approach to Western primitivism should be seen in connection with the vernacular paintings of the late 1930s and early 1940s by African American painter William H. Johnson, whom Richard Powell has characterized as discovering a "primitive within," which transformed the normative position of the Western primitivist in search of the primitive Other; see Powell, "'In My Family of Primitiveness and Tradition:' William H. Johnson's *Jesus and the Three Marys*," in *Critical Issues in American Art,* ed. Mary Ann Calo (New York: Westview Press, 1998), 285–94.

15. Interview with Aaron Douglas conducted by Ann Allen Shockley, November 19, 1975, Black Oral Histories, Fisk University Special Collections, Nashville, TN, as quoted in Kirschke, *Aaron Douglas,* 46.

16. Georgia Douglas-Johnson, "The Black Runner," in *Opportunity* (September 1925), frontispiece.

17. Other examples of his early realism include his *Self-Portrait* published in *Opportunity* (September 1925) and his *Mulatto* published on the cover of *Opportunity* (October 1925). Following his teacher Winold Reiss's precedent, he presented detailed, three-dimensionally conceived heads in these portraits, with bodies sketched minimally. In each work Douglas emphasized volume and specific detailing, contrasting sharply with the silhouetted, flat, ambiguous figures that would animate his new primitivist style.

18. The phrase is from Houston Baker, *Modernism and the Harlem Renaissance* (Chicago: University of Chicago Press, 1987), 33.

19. Paul Guillaume and Thomas Munro, *Primitive Negro Sculpture* (New York: Harcourt Brace, 1926), 9.

20. Jeffrey Stewart, "Black Modernism and White Patronage," *International Review of African American Art* 11, 3 (1994): 44.

21. Guillaume and Munro, *Primitive Negro Sculpture,* 9.

22. As Ann Douglas has stated, "It is one thing to be in search of the 'primitive,' as white artists of the 1920s were; another thing to be told, as the black New Yorkers were, that you are the primitive, the savage 'id' of Freud's new psychoanalytic discourse, trailing clouds of barbaric, prehistoric, preliterate 'folk' culture wherever you go"; see her *Terrible Honesty: Mongrel Manhattan in the 1920s* (New York: Farrar, Straus and Giroux, 1995), 98.

23. Lester A. Walton's article in the *New York World*, reprinted in "Aaron Douglass [sic], Topeka Boy and Former Lincoln High Teacher Here, Wins Fame in New York as Artist," *Kansas City Call* (November 4, 1927): B1.

24. Jeffrey Stewart, *To Color America: Portraits by Winold Reiss* (Washington, DC: Smithsonian Institution Press, 1989), 57.

25. Aaron Douglas, Speech, "Harlem Renaissance," ca. 1970, Box 3, Folder 3, Aaron Douglas Papers, Fisk University Special Collections, Nashville, Tennessee, as quoted in Kirschke, *Aaron Douglas*, 62.

26. For his suggestions that Reiss may have used the plates in Fechheimer's volume (published in Berlin in 1922) to serve as a racialized model for the hair of some of his black female figures, see Jeffrey Stewart, *To Color America*, 49–50.

27. For the artist's use of the ancient "Egyptian form" in his work, see Interview of Aaron Douglas by L. M. Collins, July 16, 1971, Black Oral Histories, Fisk University Special Collections, Nashville, as quoted in Kirschke, *Aaron Douglas*, 77.

28. Alain Locke, "The Legacy of the Ancestral Arts," in Locke, *The New Negro*, 254–55.

29. Ibid., 254.

30. Langston Hughes, "Negro Artist and the Racial Mountain," 693.

31. Ibid., 694.

32. Langston Hughes, *The Big Sea* (1940; rpt., New York: Hill and Wang, 1993), 325.

33. Countee Cullen, "Heritage," in *The New Negro*, 250–51.

34. For his image of a primitive figure wearing a long hoop earring standing in front of ancient Egyptian pyramids and figures resembling those in ancient Egyptian paintings, see Douglas's *Sahdji*, an illustration for Richard Bruce Nugent's short story of the same name in Locke's *The New Negro*, 112.

35. For her discussion of Douglas's emulation of this pose and other aspects of ancient Egyptian art, see Kirschke, *Aaron Douglas*, 76–77.

36. Aaron Douglas, *Invincible Music: The Spirit of Africa*, illustration in the *Crisis* (February 1926).

37. Douglas used the same set of wavy, parallel bands to visualize the sound of music in another illustration, *Play de Blues*, discussed later in this chapter (fig. 12) and in Chapter 5.

38. Douglas was probably influenced by Winold Reiss's rendering of hair on several of his African American figures (as for example *Two Harlem Girls*, c. 1924), which in turn was likely influenced by his study of Egyptian art, especially in Fechheimer's *Kleinplastik der Ägypter*; see Jeffrey Stewart, *To Color America*, 50.

39. Kirschke, *Aaron Douglas*, 83.

40. As quoted in Lester Walton, "Aaron Douglass [sic], Topeka Boy."

41. Langston Hughes, "Misery," *Opportunity* (October 1926): 315.

42. Langston Hughes, "Lonesome Place," *Opportunity* (October 1926): 314.

43. Langston Hughes, "The Negro Speaks of Rivers," in Locke, *The New Negro*, 141.

44. Aaron Douglas, *'Cruiter*, illustration for John Matheus's play *'Cruiter*, in *Plays of Negro Life: A Source-Book of Native American Drama*, eds. Alain Locke and Montgomery Gregory (New York: Harper and Brothers, 1927), facing 194.

45. Matheus, *'Cruiter*, in Locke and Gregory, *Plays of Negro Life*, 188.

46. Ibid., 189.

47. Alan Freelon, *A Jungle Nymph*, cover illustration for the *Crisis* (June 1928).

48. Lois Jones, *A Water Color Decoration*, cover illustration for *Opportunity* (August 1928).

49. Arthur Huff Fauset, "Jumby," in *Ebony and Topaz: A Collectanea*, ed. Charles S. Johnson (New York: *Opportunity* and the National Urban League, 1927), 15.

50. Ibid., 20.

51. Aaron Douglas, *Luani of the Jungles*, illustration for Langston Hughes's short story of the same name in *Harlem* (November 1928).

52. Langston Hughes, "Luani of the Jungles," *Harlem* (November 1928), 7, 11.

53. For his brief analysis of four primitivist stories written by Hughes in 1926, "Luani of the Jungles" among them, see Arnold Rampersad, *The Life of Langston Hughes*, vol. 1: 1902–1941, *I Too Sing America* (New York: Oxford University Press, 2002 [rev. ed.]), 140.

54. Aubrey Bowser, "Book Review: Harlem Isn't Africa," *New York Amsterdam News* (June 12, 1929): 20.

55. Walter Benjamin, "The Work of Art in the Age of Mechanical Reproduction," 1936, in *Illuminations*, ed. Hannah Arendt (New York: Schocken Books, 1985 [1968]), 222–23.

56. Ibid., 240–41.

57. For Reiss's interior designs in New York City for the Busy Lady Bakery (1915) and the Crillon Restaurant (1920), see Jeffrey Stewart, *To Color America*, 30–33.

58. At this major show of art and industrial design, Reiss exhibited two mirrors and Douglas exhibited two decorative, painted panels; see *An International Exposition of Art in Industry*, exhibition catalogue (New York: Macy's, 1928), 74.

59. For an in-depth discussion of Douglas's two advertising illustrations for *Nigger Heaven*, see Charles Scruggs, "Crab Antics and Jacob's Ladder," in *Harlem Renaissance Re-examined: A Revised and Expanded Edition*, eds. Victor Kramer and Robert Russ (New York: Whitston, 1997), 167–95.

60. Alfred Knopf's ad for Carl Van Vechten, *Nigger Heaven* (New York: Alfred A. Knopf, 1926), in *Publishers Weekly* (June 26, 1926): 2008.

61. Hubert H. Harrison, "Homo Africanus Harlemi," *New York Amsterdam News* (September 1, 1926): 20.

62. Wallace Thurman, "Fire Burns: A Department of Comment," *Fire!!* (November 1926): 47–48.

63. Alfred Knopf's ad for Carl Van Vechten, *Nigger Heaven*, in the *Messenger* (September 1926): 288.

64. In Van Vechten's words, Harlem was "the gallery of this New York theatre"; Van Vechten, *Nigger Heaven*, 149.

65. Kirschke, *Aaron Douglas*, 48.

66. Helen Dryden, "Literary Cloaks and Suits," *Advertising Arts* (July 1931), 50–53.

67. Aaron Douglas to James Weldon Johnson, June 6, 1927. James Weldon Johnson Papers, Correspondence, Series I, Folder 132 (Aaron Douglas), James Weldon Johnson Memorial Collection of Negro Arts and Letters, Yale Collection of American Literature, Beinecke Rare Book and Manuscript Library, New Haven, CT.

68. James Weldon Johnson, *The Autobiography of an Ex-Colored Man* (New York:

Dover Publications, 1995), 90. Douglas illustrated the jacket for the 1927 Knopf edition of Johnson's book, which had first been published anonymously in 1912.

69. For a study of Johnson's novel as embodying the tactics of the jokester, see Alessandro Portelli, "The Tragedy and the Joke: James Weldon Johnson's *The Autobiography of an Ex-Coloured Man*," in *Temples for Tomorrow: Looking Back at the Harlem Renaissance*, ed. Genevieve Fabre and Michael Feith (Bloomington: Indiana University Press, 2001), 143–58.

70. Rudolph Fisher, *The Walls of Jericho* (New York: Alfred A. Knopf, 1928), 256.

71. Ibid., 257.

72. Ibid., 258.

73. Ibid., 108. These lines are spoken by Fisher's character, Miss Agatha Cramp, who was modeled after the white patron of numerous black artists and writers, Charlotte Mason; see David Levering Lewis, *When Harlem Was in Vogue* (New York: Penguin, 1997 [1981]), 230.

74. Fisher, 128.

75. Robert Russ, "'There's No Place Like Home:' The Carnival of Black Life in Claude McKay's *Home to Harlem*," in Kramer and Russ, *Harlem Renaissance Re-examined*, 358.

76. Claude McKay, *Home to Harlem* (1928; rpt., Boston: Northeastern University Press, 1987), 300–01.

77. Ibid., 220–22.

78. Aaron Douglas to Langston Hughes, December 21, 1925.

79. Arna Bontemps, *God Sends Sunday* (New York: Harcourt Brace, 1931; rpt., New York: Washington Square Press, 2005), 73, 79.

80. Ibid., 161.

81. Hughes, "Negro Artist and the Racial Mountain," 693. Arnold Rampersad suggested that the title of Hughes's first novel "captured the power of the blues to mirror pain but also to mock it," in *The Life of Langston Hughes*, Vol. 1: 1902–1941, *I, Too, Sing America* (New York: Oxford University Press, 2002 [rev. ed.]), 174.

82. Langston Hughes, *Not Without Laughter* (New York: Alfred A. Knopf, 1930; rpt. New York: Simon and Schuster, 1995), 59–61.

83. Hughes, *Not Without Laughter*, 296.

84. For her statement, which she draws from Sterling Brown's observations, see Cheryl Wall, "Whose Sweet Angel Child? Blues Women, Langston Hughes, and Writing during the Harlem Renaissance," in *Langston Hughes: The Man, His Art, and His Continuing Influence*, ed. C. James Trotman (New York: Garland, 1995), 43.

85. I am borrowing the word from Hughes, "Negro Artist and the Racial Mountain."

86. Aaron Douglas to Langston Hughes, December 21, 1925.

Chapter 2. From Racial Uplift to Vernacular Expression: Commercial and Little Magazine Illustrations

1. Abby Arthur Johnson and Ronald Maberry Johnson, *Propaganda and Aesthetics: The Literary Politics of African-American Magazines in the Twentieth Century* (Amherst:

University of Massachusetts Press, 1991 [1979]), 35. They write that circulation of the *Crisis* "peaked in 1919, with issues of about 95,000 copies. From then on the statistics declined, to less than 65,000 copies in 1920, and under 30,000 in 1930."

2. Ibid., 48–50.

3. Ibid., 62.

4. For his estimate that every American magazine, as well as book, was viewed by at least three to four people, see Rowland Elzea, *Nostalgic Journey: American Illustration from the Collection of the Delaware Art Museum* (Wilmington: Delaware Art Museum, 1994), 3.

5. Ibid., 6.

6. Anne Carroll, "'Sufficient in Intensity:' Mixed Media and Public Opinion in *Opportunity*," *Soundings* 80, 4 (Winter 1997): 609; Richard Robbins, *Sidelines Activist: Charles S. Johnson and the Struggle for Civil Rights* (Jackson: University Press of Mississippi, 1996), 47; Nancy J. Weiss, *National Urban League, 1910–1940* (New York: Oxford University Press, 1974), 221.

7. For Du Bois's claims for a substantial working-class audience, which may have been exaggerated, see Johnson and Johnson, *Propaganda and Aesthetics*, 35.

8. For the *Messenger*'s association with the Brotherhood of Sleeping Car Porters, see Johnson and Johnson, *Propaganda and Aesthetics*, 57.

9. Elzea, *Nostalgic Journey*, 6. The late Rowland Elzea staged many important exhibitions of American illustrations at the Delaware Art Museum, which houses much of Howard Pyle's work.

10. Rowland Elzea, "That Was 'Life'," in *The American Magazine, 1890–1940* (Wilmington: Delaware Art Museum, 1979), 14.

11. Chris Fauver, "Art of the Illustrator," in *The Art of the Illustrator: Works from the Kelly Collection of American Illustration* (Washington, DC: Federal Reserve Board, 1997), 9.

12. Ibid., 9.

13. Frank Hoffman, *"Jim, I don't know why I love you, but I do—desperately,"* illustration for Edmund Ware, "The Hard Guy," *Ladies' Home Journal* (February 1928), 15. These illustrators of serialized fiction, including Hoffman but especially Frederic Gruger and Saul Tepper, were extremely popular among the reading public and garnered as much attention as the authors whose stories they illustrated; see James Cox and John Evans, "Introduction," in Evans, *American Illustrators: The Twenties: Adventure, Suspense, Romance and Humor* (New York: Grand Central Art Galleries, 1979), 6.

14. Martex towel advertisement, *Ladies' Home Journal* (January 1928).

15. For the "illustrations by pupils of the Ethical Culture School," see Herbert W. Smith, "A Teacher Forges New Tools," *Survey Graphic* (June 1927): 255–58.

16. Arthur Kellogg, "Behind the Levees," *Survey Graphic* (June 1927): 277–82, 290.

17. For an in-depth discussion of the *Crisis*, W. E. B. Du Bois as editor, and the way imagery functioned in the magazine, see Anne Carroll, *Word, Image, and the New Negro: Representation and Identity in the Harlem Renaissance* (Bloomington: Indiana University Press, 2005), Chapters 1 and 3. For a recent article on images of women and family in the *Crisis*, see Amy Kirschke, "Du Bois and *The Crisis* Magazine: Imaging Women and Family," *Source: Notes in the History of Art*, 24, 4 (Summer 2005): 35–45.

18. W. E. B. Du Bois, "Editorial," *Crisis* (November 1910): 10, as quoted in Johnson and Johnson, *Propaganda and Aesthetics*, 33.

19. Johnson and Johnson, *Propaganda and Aesthetics*, 35.

20. Placing "Pictures" at the top of the contents page began in 1913 and ended in 1921; see Carroll, *Word, Image, and the New Negro*, 23.

21. Several covers also featured drawings of young, middle-class women, which I will discuss in Chapter 5.

22. Carolyn Kitch, *The Girl on the Magazine Cover: The Origins of Visual Stereotypes in American Mass Media* (Chapel Hill: University of North Carolina Press, 2001), 95.

23. C. M. Battey, *Madonna,* cover photograph, *Crisis* (December 1919).

24. W. E. B. Du Bois, "The Gospel According to Mary Brown," *Crisis* (December 1919): 41.

25. *The Three Wise Men of Our Day,* reprinted from *L'Illustration,* 1914, after the design by Lucien Jonas, in *Crisis* (December 1919): 68–69.

26. By November 1920, the NAACP issued press releases in support of antilynching legislation, which they characterized as "a nation-wide campaign to end, by invoking the power of the federal government, the greatest shame in the United States"; see, for example, "Senator France, Representative Dyer to Urge Federal Anti-Lynching Law," NAACP press release, November 29, 1920, NAACP Papers, Part 7: The Anti-Lynching Campaign, 1912–1955, Series B: Anti-Lynching Legislative and Publicity Files, 1916–1955, Library of Congress (Microfilm, Reel 26, Frames 407–08).

27. "The Real Causes of Two Race Riots," *Crisis* (December 1919): 59–62. The photograph of the lynching appears on p. 61.

28. The photograph is reproduced in James Allen et al., *Without Sanctuary: Lynching Photography in America* (Santa Fe: Twin Palms Publishers, 2000), plate 97.

29. Smith lived in Paris until his death in 1940. Not only a successful printmaker and painter, Smith was an accomplished musician, performing professionally during the last years of his life. For a rare and in-depth discussion of Smith's art during his Paris years, see Theresa Leininger-Miller, *New Negro Artists in Paris: African American Painters and Sculptors in the City of Light, 1922–1934* (New Brunswick, NJ: Rutgers University Press, 2001), Chapter 7.

30. W. E. B. Du Bois, "The Social Equality of Whites and Blacks," *Crisis* (November 1920): 16.

31. Psalms chapter 130, verse 17, as cited in the *Crisis* (November 1920): 17.

32. For revisionist analyses of the Ashcan School, see Erika Doss, *Twentieth-Century American Art* (Oxford and New York: Oxford University Press, 2002), 35–51; Rebecca Zurier, et al., *Metropolitan Lives: The Ashcan Artists and Their New York* (Washington, DC: National Museum of American Art and New York: Norton, 1995).

33. For a very informative recent article on *Crisis* illustrations that Wheeler Waring produced in Paris, see Theresa Leininger-Miller, "'A Constant Stimulus and Inspiration:' Laura Wheeler Waring in Paris in the 1910s and 1920s," *Source: Notes in the History of Art,* 24, 4 (Summer 2005): 13–23. The most extensive discussion of Laura Wheeler Waring's life and work is found in James V. Herring, "Laura Wheeler Waring," and James Porter, "The Work of Laura Waring" in the exhibition catalogue *In Memo-*

riam: Laura Wheeler Waring 1887–1948: An Exhibition of Paintings (Washington, DC: Howard University, Gallery of Art, 1949), unpaginated.

34. Laura Wheeler, *"Ruth Is Not Coming Out of College,"* illustration for Willis Richardson, *The Deacon's Awakening,* in the *Crisis* (November 1920): 13.

35. See for example Reiss's pastel portrait of Alain Locke in *The New Negro: An Interpretation,* ed. Alain Locke (New York: Albert and Charles Boni, 1925), facing 6.

36. W. E. B. Du Bois, "Criteria of Negro Art," *Crisis* (October 1926): 296.

37. The printed symposium appeared in selected issues of the *Crisis,* beginning in March 1926 and ending in November of that year.

38. "The Negro in Art: How Shall He Be Portrayed: A Symposium," *Crisis* (March 1926): 219.

39. Albert Smith, *A Negro Family under the Protection of the NAACP,* cover illustration for the *Crisis* (June 1925).

40. The conservative stylistic features of some Harlem Renaissance illustrations connect with the naturalism of many Harlem Renaissance paintings of the 1920s and 1930s, such as that found in the work of Malvin Gray Johnson. As Jacqueline Francis has astutely observed, stylistic "experimentation carried special risks for African-American artists." Modernist stylizations of the human body "sometimes ran opposite black cultural nationalist goals of rehabilitating a commonly debased black figure." In this light, for some black artists, "naturalism was preferable, especially that which idealized its black figural subjects and challenged racist visual stereotypes"; see Francis, "'Trying to Do What Artists of All Races Do': Malvin Gray Johnson's Modernism," in *Climbing up the Mountain: The Modern Art of Malvin Gray Johnson,* ed. Kenneth Rodgers (Durham: North Carolina Central University Art Museum, 2002), 79–80.

41. Du Bois, "Peace," *Crisis* (December 1926): front page.

42. Roscoe Wright, *African Witch Mask and Fetish Design,* cover of the *Crisis* (March 1928); Raymond E. Jackson, *Drawing,* cover of the *Crisis* (February 1930).

43. Celeste Smith, *Excelsior,* frontispiece illustration in the *Crisis* (January 1929).

44. Johnson and Johnson, *Propaganda and Aesthetics,* 36–37.

45. Charles S. Johnson, "The Rise of the Negro Magazine," *Journal of Negro History* (January 1928): 20.

46. For a close reading of the ways in which Johnson used photographs as well as Douglas's illustrations in *Opportunity,* see Carroll, "'Sufficient in Intensity,'" 607–40, and Carroll, *Word, Image, and the New Negro,* Chapters 2 and 3.

47. Charles S. Johnson, "Editorials," *Opportunity* (August 1926), 239; as quoted in Johnson and Johnson, *Propaganda and Aesthetics,* 52.

48. Johnson, "Rise of the Negro Magazine," 19.

49. Carroll, *Word, Image, and the New Negro,* 93.

50. Reiss's primitivist section headings were replaced by Aaron Douglas's more simplified decorations in January 1927.

51. Arthur Huff Fauset, "The Negro's Cycle of Songs—A Review," *Opportunity* (November 1925): 333.

52. Langston Hughes, "Bound No'th Blues," *Opportunity* (October 1926): 315; also published in *Opportunity Art Folio* (December 1926). In the 1920s, Langston Hughes and Zora Neale Hurston began to write in a vernacular language, approximating the

spoken black dialects, especially of the rural South, and countering the aims of many black intellectuals to rise above black working-class subjects and styles of speech. Henry Louis Gates Jr. has written of Hughes that he "undertook the project of constructing an entire literary tradition upon the actual spoken language of the black working and rural classes—the same vernacular language that the growing and mobile black classes considered embarrassing and demeaning, the linguistic legacy of slavery"; see his "Preface: Langston Hughes (1902–1967)," in *Langston Hughes, Critical Perspectives Past and Present*, eds. Henry Louis Gates Jr. and K. A. Appiah (New York: Amistad, 1993), xi.

53. Ad for *Opportunity Art Folio* in *Opportunity* (December 1926), 369.

54. Richard Powell, "Re/Birth of a Nation," in *Rhapsodies in Black: Art of the Harlem Renaissance*, eds. David Bailey and Richard Powell (Berkeley: University of California Press, 1997), 29.

55. As a promising young writer, Bennett also contributed to *Opportunity* her monthly column, "The Ebony Flute," a detailed report on contemporary culture in Harlem that she initiated in 1926. For the most extensive biography of Bennett, which considers her art as well as her writings and poetry, see Sandra Govan, "Gwendolyn Bennett: Portrait of an Artist Lost," Ph.D. dissertation, Emory University, 1980. See also Govan's article, "Kindred Spirits and Sympathetic Souls: Langston Hughes and Gwendolyn Bennett in the Harlem Renaissance," in *Langston Hughes: The Man, His Art, and His Continuing Influence*, ed. C. James Trotman (New York: Garland, 1995), 75–85.

56. For a discussion and examples of Lois Jones's early work in design, see Tritobia Hayes Benjamin, *The Life and Art of Lois Mailou Jones* (San Francisco: Pomegranate Artbooks, 1994), 6–11.

57. Richard Powell and Jock Reynolds, *James Lesesne Wells: Sixty Years in Art* (Washington, DC: Washington Project for the Arts, 1986), 10.

58. Nugent's March 1926 cover of *Opportunity* is discussed in Chapter 7. His primitivist illustration in the October 1927 issue of this magazine appeared on page 289.

59. Charles Cullen, illustration for Antonio Jarvis, "Bamboula Dance," in *Opportunity* (December 1928).

60. For a very brief biography of Mahlon Blaine, see Judith Friebert, *The Ardent Image: Book Illustration for Adults in America, 1920–1942* (Toledo: Ward M. Canaday Center, University of Toledo, 1995), 22.

61. Doris Kirkpatrick, review of Caroline Singer and Cyrus LeRoy Baldridge, *White Africans and Black* (New York: W. W. Norton, 1929) in *Opportunity* (December 1929): 385–86.

62. Elmer A. Carter, "E. Simms Campbell—Caricaturist," *Opportunity* (March 1932): 82.

63. One example of Campbell's Americana appeared on the November 1930 cover of *Opportunity*, illustrating a young boy looking longingly at a goose hanging in a store window.

64. For Romare Bearden's *Opportunity* illustrations, see his cover image of tall buildings for the March 1932 issue and his *Eighth Avenue Market, New York City,* sketches in the January 1935 issue (22).

65. Sondra K. Wilson, *The* Messenger *Reader: Stories, Poetry, and Essays from* The Messenger *Magazine* (New York: Modern Library, 2000), xix.

66. Adam McKible, "Our (?) Country: Mapping 'These "Colored" United States' in *The Messenger*," in *The Space and Place of Modernism: The Russian Revolution, Little Magazines, and New York* (New York: Routledge, 2002), 39–58. It should be noted that McKible categorizes the *Messenger* as a little magazine, whereas for my purposes, I see it more in connection with *Crisis* and *Opportunity* than with the black little magazines, like *Fire!!* or the *Saturday Evening Quill*.

67. Ibid., 42.

68. Ibid., 47.

69. George Schuyler, "New York: Utopia Deferred," *Messenger* (October-November 1925): 345, as quoted in McKible, "Our (?) Country," 48.

70. See, for example, Wilbert Holloway, "Aframerican Snapshots," *Messenger* (August 1927), 253.

71. Alain Locke, "Propaganda or Aesthetics?" *Harlem* (November 1928): 12.

72. Wallace Thurman, "Negro Artists and the Negro," *New Republic* (August 31, 1927): 37.

73. Most recently, Martha Nadell has considered both *Fire!!* and *Harlem* in her *Enter the New Negroes: Images of Race in American Culture* (Cambridge, MA: Harvard University Press, 2004), Chapter 3, and Chapter 6 of Anne Carroll's *Word, Image, and the New Negro* is devoted to *Fire!!*

74. Allan Freelon, untitled woodcut, in *Black Opals* (June 1928): 11.

75. Gwendolyn Bennett, "The Ebony Flute," *Opportunity* (April 1928): 122.

76. Bennett, "The Ebony Flute," *Opportunity* (February 1928): 56.

77. For an overview and specialized articles on American little magazines, see *Little Magazines and Modernism*, ed. Suzanne Churchill and Adam McKible, a special issue of *American Periodicals: A Journal of History, Criticism, and Bibliography*, 15, 1 (2005).

78. Suzanne Churchill and Adam McKible, "Introduction," in *Little Magazines and Modernism*, 4.

79. Yvor Winters, "Drifting Deer," with untitled woodcut by Max Weber, in *Broom* (August 1922): 30.

80. James Wells, *Cottonfield*, linoleum cut illustration in *New Masses* (October 1928): 7.

81. In addition to publishing the "Negro" edition of *Palms* (October 1926), Idella Purnell was interested in the little magazine *Black Opals*, copies of which found their way to her desk in Guadalajara and are now held among her papers at the Harry Ransom Humanities Research Center, University of Texas at Austin.

82. Zell Ingram, illustration for Langston Hughes, "Christ in Alabama," in *Contempo: A Review of Books and Personalities* (December 1, 1931): 1.

83. Thurman, "Negro Artists and the Negro," 37.

84. Zora Neale Hurston, "Color Struck," and "Sweat," in *Fire!!* (November 1926): 7–14, 40–45.

85. Langston Hughes, "Elevator Boy" and "Railroad Avenue," *Fire!!* (November 1926): 20–21.

86. Richard Bruce [Nugent], "Smoke, Lilies, and Jade," in *Fire!!* (November 1926): 33–34.

87. "Foreword," *Fire!!* (November 1926): front matter.

88. For her discussion of the autonomous illustrations in *Fire!!*, see Nadell, *Enter the New Negroes,* 76.

89. Countee Cullen, "The Dark Tower," *Opportunity* (January 1927): 25.

90. Thurman, "Negro Artists and the Negro," 37.

91. Aubrey Bowser, "Book Review: An Example for Harlem Writers," *New York Amsterdam News* (June 20, 1928): 16.

92. Aubrey Bowser, "Book Review: Wake Up, Harlem Writers!" *New York Amsterdam News* (July 9, 1930): 20.

93. "A Statement to the Reader," *Saturday Evening Quill* (April 1929): front matter.

94. Ralf Coleman, *The Girl from Back Home, Saturday Evening Quill* (April 1929): 27.

95. For his use of this epithet to describe the hybrid ethnicity of Eric Walrond, see David Levering Lewis, *When Harlem Was in Vogue* (New York: Penguin, 1997 [1981]), 128. For a study of Covarrubias's illustrations of blacks, see Amber Criswell, "'Enter the New Negro;' Illustrations of African Americans by Miguel Covarrubias, 1924–1929," M.A. thesis, University of Cincinnati, 2002.

96. Eric Walrond, caption for Miguel Covarrubias's illustration, in *Vanity Fair* (December 1924): 61.

97. Crowninshield's editorial in *Vanity Fair* (August 1914): 13, as quoted in Martha Cooper, "Light-Hearted from Cover to Cover: 'Vanity Fair,'" in *The American Magazine, 1890–1940,* Rowland Elzea, ed. (Wilmington: Delaware Art Museum, 1979), 51.

98. Unidentified staff writer's editorial, "Enter, The New Negro," *Vanity Fair* (December 1924): 61. On the first page of her book, Martha Nadell incorrectly attributes this passage to Eric Walrond (see her *Enter the New Negroes,* 1). However, it is clear from the content and layout of this double-page spread that this passage was written by a member of the editorial staff of *Vanity Fair.* At the end of this editorial text, Walrond is credited as "a talented Negro poet" responsible for having penned only "the captions for these eight drawings" ("Enter, The New Negro," *Vanity Fair,* 61).

99. The "Smart Winter Overcoats for Town and Country" could be found in the same issue of *Vanity Fair* (December 1924): 75, and the double-page spread of the newest automobiles also appeared in the same issue, 76–77.

100. For in-depth discussions of image and text in this special issue of *Survey Graphic,* see Carroll, *Word, Image, and the New Negro,* Chapter 4; Nadell, *Enter the New Negroes,* 34–53; Amy Kirschke, *Aaron Douglas: Art, Race, and the Harlem Renaissance* (Jackson: University Press of Mississippi, 1995), Chapter 2.

101. Paul Kellogg, "The Gist of It," *Survey Graphic* (March 1925): 627.

102. Alain Locke, "Enter the New Negro," *Survey Graphic* (March 1925): 631.

103. For their discussions of Reiss's "Harlem Types" and Locke's text, see Carroll, *Word, Image, and the New Negro,* 138–44 and Nadell, *Enter the New Negroes,* 45–48.

104. Alain Locke, "Harlem Types: Portraits by Winold Reiss," *Survey Graphic* (March 1925): 652.

105. Ibid.

106. Alain Locke, "The Legacy of the Ancestral Arts," in Locke, *The New Negro,* 266.

107. Locke, "Harlem Types," 653.

108. Winold Reiss, *Congo A Familiar of the New York Studios,* in "Harlem Types: Portraits by Winold Reiss," *Survey Graphic* (March 1925): 651.

109. Winold Reiss, *A College Lad,* in "Harlem Types: Portraits by Winold Reiss," 654.

110. Locke, "Enter the New Negro," 631.

111. "The Negro Prize Poem," *Forum* (August 1925): 239.

112. Langston Hughes, "The Weary Blues," *Forum* (August 1925): 239.

113. In Chapter 8, I discuss Douglas's drawings for *Theatre Arts* and Wells's linoleum cuts for *Golden Book,* both of which circumvented counterfeit expressions of black life by white authors. Douglas's *Fire!!* contour drawings were reproduced in Wallace Thurman, "Harlem: A Vivid Word Picture of the World's Greatest Negro City," *American Monthly* (May 1927): 19–20, and drawings by Richard Bruce Nugent·illustrated poems by Paul Eldridge in the same issue of *American Monthly,* 12.

114. For her clarification that Douglas's work never appeared in *Vanity Fair,* see Kirschke, *Aaron Douglas,* 90.

115. Edwin Clark's review of *Nigger Heaven,* "Carl Van Vechten's Novel of Harlem Negro Life," *New York Times* (August 22, 1926), was illustrated with Covarrubias's *A Charleston Lesson in the Great Metropolis,* which originally appeared in *Vanity Fair;* and John Chamberlain's review of McKay's *Home to Harlem,* "When Spring Comes to Harlem," *New York Times* (March 11, 1928), was illustrated with Covarrubias's *Rhapsody in Blue* from his *Negro Drawings* (New York: Knopf, 1927).

116. Review of James Weldon Johnson, *God's Trombones* (New York: Viking, 1927) and Eva Jessye, *My Spirituals* (New York: Robbins-Engel, 1927) in "Poetry and Eloquence of the Negro Preacher," *New York Times* (June 19, 1927).

Chapter 3. "Worth the Price of the Book":
Dust Jacket and Book Illustrations

1. Promotional blurb by Carl Van Vechten for Paul Morand, *Black Magic* (New York: Viking, 1929), in display ad for *Black Magic, New York Times* (June 2, 1929).

2. For an excellent, unusually wide-ranging and inclusive discussion of American illustration and advertising art from the turn of the century to the mid-twentieth century, see Michele Bogart, *Artists, Advertising, and the Borders of Art* (Chicago: University of Chicago Press, 1995).

3. Bogart, *Artists, Advertising, and the Borders of Art,* 243–48. For a survey of his illustrative work, see Fridolf Johnson and John Gorton, *The Illustrations of Rockwell Kent* (New York: Dover Publications, 1976).

4. James Boyd, *Drums* (New York: Charles Scribner's Sons, 1925), illustrated by N. C. Wyeth.

5. Voltaire, *Candide* (New York: Random House, 1928), illustrated by Rockwell Kent.

6. Guy Pene du Bois, "The Modern Art of Illustration," *Vanity Fair* (January 1925): 38.

7. W. A. Dwiggins, "Notes on the Structure of a Book," *Fifty Books Exhibited by the American Institute of Graphic Arts, 1926* (New York: John Day, 1927), 5.

8. Aaron Douglas, illustrations for *God's Trombones* (New York: Viking, 1927), in *Second Annual Exhibition of American Book Illustration, 1927–1928,* exhibition catalogue

(New York: American Institute of Graphic Arts, 1928). These AIGA shows also left room for artists working in more conservative styles or on color inserts, including N. C. Wyeth, Maxfield Parrish, and J. J. Lankes.

9. For example, the delightful Art Deco pen-and-ink drawings by Herbert Fouts for *Penny Show,* by Mary Davies, garnered inclusion in an AIGA exhibition of American Book Illustration. Without fixation to a specific caption from Davies's poetry, Fouts's evocative full-page, black-and-white images sprang from the text but embroidered on it, in the same way that his modernist compositions balanced the blocks of text aesthetically, while also exploring independent visual form. In an advertisement for several of his books, the publisher Henry Harrison relished that *Penny Show,* with Fouts's drawings, had been "chosen by Graphic Arts as one of the 50 best illustrated books of the year," an AIGA award sure to proffer the mark of distinction to his prospective buyers; see the ad for Henry Harrison publications in *Overland Monthly and Out West Magazine* (February 1930).

10. Bogart, *Artists, Advertising, and the Borders of Art,* 71. ·

11. For example, Thomas Cleland established a highly respected reputation during the 1920s as an illustrator of elaborate, multicolored advertisements for luxury commodities, such as the Cadillac, as well as meticulous decorations in books printed by specialty presses like the Pynson Printers. For examples of his varied work in illustration, see *The Decorative Work of T. M. Cleland* (New York: Pynson Printers, 1929).

12. For a more in-depth view into Kent's attitudes toward commercial and fine art in his own production, see Bogart, *Artists, Advertising, and the Borders of Art,* 243–55.

13. Particularly adept at self-promotion, Politzer provides a fine example of an artist who actively campaigned for business. He began advertising his services in *Publishers Weekly* in the mid-1920s, using a quarter-page ad adorned with the image of a generic book and several paint brushes. In the ad copy, he claimed his "jacket designs for books" would "compel attention," and that he was "adept at popular poster treatment"; see Irving Politzer, ad for jacket designs, *Publishers Weekly* (January 24, 1925): 303. Soon, his ads incorporated examples of his published jackets, which thus functioned doubly to promote the original book and to advertise his own successful designs. In his ad of June 1927, he could boast that his "jacket designs" helped to "create *more* sales" for his publishers; see the ad for his jacket designs, *Publishers Weekly* (June 18, 1927): 2365.

14. Bogart, *Artists, Advertising, and the Borders of Art,* 56.

15. Helen Dryden, "Literary Cloaks and Suits," *Advertising Arts* (July 1931): 50–53.

16. For modern silhouettes in popular dust jacket designs, see, for example, Carroll Snell's dust jacket design for R. H. Mottram, *Armistice and Other Memories* (New York: Dial Press, 1929) and Irving Pollitzer's dust jacket for R. T. M. Scott, *Aurelius Smith—Detective* (New York: E. P. Dutton, 1927).

17. J. J. Gould illustrated Cohen's *Assorted Chocolates* (New York: Dodd, Mead, 1922), and Freeman illustrated Cohen's *Carbon Copies* (New York: D. Appleton, 1932) and *Black to Nature* (New York: D. Appleton-Century, 1935).

18. Freeman's caricature of a homely bride in blackface on the contents page of *Black to Nature* is particularly troubling.

19. Ernest Rice McKinney, review of Julia Peterkin's *Black April* in *New York Amsterdam News* (April 6, 1927): 24.

20. Wallace Thurman, "Negro Artists and the Negro," *New Republic* (August 31, 1927): 38.

21. Little, Brown and Company, advertisement for Octavus Roy Cohen's *Florian Slappery Goes Abroad,* cover of *Publishers Weekly* (April 21, 1928).

22. George Hutchinson, *The Harlem Renaissance in Black and White* (Cambridge, MA: Harvard University Press, 1995), 344–45. For a detailed survey of the American publishing industry, but one that does not take into account the Harlem Renaissance, see John Tebbel, *Between Covers: The Rise and Transformation of Book Publishing in America* (New York: Oxford University Press, 1987).

23. Hutchinson, *Harlem Renaissance in Black and White,* 346.

24. Mary White Ovington, "Selling Race Pride," *Publishers Weekly* (January 10, 1925): 112.

25. Gwendolyn Bennett, "Ebony Flute," *Opportunity* (May 1928): 153. *Home to Harlem,* in fact, "became the first novel by a Harlem writer to reach the best-seller list"; see David Levering Lewis, *When Harlem Was in Vogue* (New York: Penguin, 1997), 224–25.

26. "William Sells Books to Harlem," *Publishers Weekly* (April 14, 1928): 1623.

27. Martha Nadell has clarified the amplification of illustrations in Locke's second edition of *The New Negro* in her *Enter the New Negroes: Images of Race in American Culture* (Cambridge, MA: Harvard University Press, 2004), 65–67.

28. For a discussion of the other major black publisher, William Stanley Braithwaite, see Hutchinson, *Harlem Renaissance in Black and White,* 350–60.

29. Woodson also established Negro History Week in 1926; see Katherine Capshaw Smith, *Children's Literature of the Harlem Renaissance* (Bloomington: Indiana University Press, 2004), 163. Smith is unusual in considering Woodson a part of the Harlem Renaissance.

30. Woodson was particularly eager to sponsor the research projects of young black scholars, including Zora Neale Hurston, whose anthropological study of former slaves in Florida and Alabama he published; see Hurston, "Cudjo's Own Story of the Last African Slaver," *Journal of Negro History* (1927), as cited in Jacqueline Goggin, *Carter G. Woodson: A Life in Black History* (Baton Rouge: Louisiana State University Press, 1993), 72.

31. Richard Powell and Jock Reynolds, *James Lesesne Wells: Sixty Years in Art* (Washington, DC: Washington Project for the Arts, 1986), 12. The authors note that Wells's image of the farmer, originally published in *New Masses* (October 1928), 7, responded stylistically to the "high contrast compositions of *New Masses* illustrators Jan Matulka, Louis Lozowick, and Rufino Tamayo" (12).

32. From copy on the back of the dust jacket for Lorenzo J. Greene and Carter G. Woodson, *The Negro Wage Earner* (Washington, DC: Association for the Study of Negro Life, 1930), in the Dust Jacket Collection, Harry Ransom Humanities Research Center, University of Texas at Austin.

33. For an earlier publication of James Wells's illustration of the waiter, see *New Masses* (August 1928): 17.

34. For example, Wells created the dust jacket design for Maurice Delafosse, *The Negroes of Africa: History and Culture* (Washington, DC: Associated Publishers, 1931).

35. Willis Richardson, ed., *Plays and Pageants in the Life of the Negro* (Washington, DC: Associated Publishers, 1930).

36. For example, Jones created the dust jacket design for Sadie Daniel, *Women Builders* (Washington, DC: Associated Publishers, 1931).

37. Capshaw Smith, *Children's Literature of the Harlem Renaissance*, 164.

38. Gertrude McBrown, *The Picture-Poetry Book* (Washington, DC: Associated Publishers, 1935), vii.

39. Ibid., 15.

40. For further discussion of Jones's racialized imagery, which contrasted starkly with McBrown's poetry that "bypass[ed] racial topics through fairy lore" (215), see Capshaw Smith, *Children's Literature of the Harlem Renaissance*, 214–19.

41. For Woodson's ongoing financial struggles, see Goggin, *Carter G. Woodson*.

42. Associated Publishers, "A Useful Library of Negro Literature," promotional flyer, ca. 1930. I am grateful to Randall Burkett, Curator of African American Collections, Manuscript, Archives, and Rare Book Library, Emory University, for bringing the Associated Publishers promotional brochure and flyer to my attention.

43. For an advertisement of "Dr. Elliot's five-foot shelf of books" (The Harvard Classics), with a photograph of the set, see *Forum and Century* 84, 4 (October 1930); for an advertisement for the Literary Guild of America, with its set of books pictured, see the Advertiser section in front matter of the *Bookman* (November 1929).

44. Hutchinson, *Harlem Renaissance in Black and White*, 373.

45. Myron Pritchard and Mary Ovington, *The Upward Path: A Reader for Colored Children* (New York: Harcourt, Brace and Howe, 1920).

46. Advertisement for Guillaume and Munro's *Primitive Negro Sculpture* (New York: Harcourt Brace, 1926) in *Opportunity* (October 1926): 332.

47. W. E. B. Du Bois, review of W. C. Seabrook's *The Magic Island* (New York: Harcourt Brace, 1929), in "The Browsing Reader," *Crisis* (May 1929): 161, 175.

48. Hutchinson, *Harlem Renaissance in Black and White*, 374–77. In describing the range of Harlem Renaissance writing published by Harcourt Brace, Hutchinson said the firm "was demonstrably receptive to a broad range of black writing, 'high' and 'low,' 'propagandistic' and 'artistic'" (377).

49. For this statement by George Doran, quoted without citation of its original reference, see Tebbel, *Between Covers*, 231.

50. For Sydney Jacobs's statement, quoted without citation of the original reference, see Tebbel, *Between Covers*, 232.

51. Robert S. Josephy, "Planning the Book," *Borzoi Broadside* (September 1924): 40.

52. For Kauffer's creation of this Vorticist woodcut in the English artist colony of Blewbury, see Mark Haworth-Booth, *E. McKnight Kauffer: A Designer and His Public* (London: Gordon Fraser, 1979), 22–23. Though Kauffer's image was widely known and published, Blanche and Alfred Knopf may well have met the artist on one of their European scouting trips to find new authors, as he was an American artist working in England. They established a more formal relationship with him in the 1940s, when he returned to the United States and contributed illustrations for some of Knopf's books, including Langston Hughes's *Shakespeare in Harlem*.

53. Carl Van Vechten to Langston Hughes, May 17, 1925, Yale Collection of American Literature, Beinecke Rare Book and Manuscript Library, as reprinted in Emily Bernard, *Remember Me to Harlem: The Letters of Langston Hughes and Carl Van Vechten, 1925–1964* (New York: Alfred A. Knopf, 2001), 10–11.

54. Hughes to Van Vechten, May 18, 1925, Yale Collection of American Literature, Beinecke Rare Book and Manuscript Collection, as reprinted in Bernard, *Remember Me to Harlem,* 15.

55. Gwendolyn Bennett to Hughes, December 2, 1925. James Weldon Johnson Collection, Langston Hughes Papers, Box 14, folder 317, Yale Collection of American Literature, Beinecke Rare Book and Manuscript Library.

56. Frank Crowninshield, "Introduction," in Miguel Covarrubias, *Negro Drawings* (New York: Alfred A. Knopf, 1927), unpaginated.

57. I say at least seven, because there may well be other jackets that Douglas designed for Knopf. It is certain that he designed Knopf jackets for Hughes's *Fine Clothes to the Jew,* Johnson's *Autobiography of an Ex-Coloured Man,* Glenn's *Little Pitchers,* Multatuli's *Max Havelaar and the Coffee Sales of the Dutch Trading Company,* Woon's *Frantic Atlantic* (all of 1927), Fisher's *Walls of Jericho* (1928), and Hughes's *Not Without Laughter* (1930). I discovered his jackets for Woon's *Frantic Atlantic* and Multatuli's *Max Havelaar* in the collections of the Harry Ransom Humanities Research Center at the University of Texas at Austin, but others may well exist, which is an exciting prospect.

58. In addition to Woon's book, Douglas designed the jacket for Isa Glenn, *Little Pitchers* (New York: Alfred A. Knopf, 1927); he also designed the jacket for a translation of Multatuli, *Max Havelaar and the Coffee Sales of the Dutch Trading Company* (New York: Alfred A. Knopf, 1927).

59. Quoted from marketing text on the back of Aaron Douglas's dust jacket for Basil Woon, *The Frantic Atlantic* (New York: Alfred Knopf, 1927). Dust Jacket Collection, Harry Ransom Humanities Research Center, University of Texas at Austin.

60. Jack Perkins designed the dust jacket for Isa Glenn's *Transport* (New York: Alfred A. Knopf, 1929).

61. Alfred A. Knopf, advertisement for Walter White, *Flight* (New York: Alfred A. Knopf, 1926), and Langston Hughes, *The Weary Blues* (New York: Alfred A. Knopf, 1926), in the *Crisis* (May 1926), 41.

62. Alfred A. Knopf, "The Negro," advertisement for recently published books in *Opportunity* (September 1927), end matter.

63. Alfred A. Knopf, advertisement for Rudolph Fisher, *The Walls of Jericho* (New York: Alfred A. Knopf, 1928), and Wood Kahler, *Early to Bed* (New York: Alfred A. Knopf, 1928), in *Publishers Weekly* (June 23, 1928): 2507.

64. For Saxton's editorship and his responsibility for best-sellers, like James Thurber and E. B. White's *Is Sex Necessary?,* see Tebbel, *Between Covers,* 204, and Hutchinson, *Harlem Renaissance in Black and White,* 378.

65. Hutchinson, *Harlem Renaissance in Black and White,* 379.

66. Gwendolyn Bennett, "Ebony Flute," *Opportunity* (September 1927): 277.

67. Correspondence clarifies that Harpers' representatives dealt with Countee Cullen in making arrangements for the illustrations in his books. For example, for the

art director's desire to discuss the format of *Copper Sun* with Countee Cullen before consulting with the artist, see Arthur W. Rushmore to Countee Cullen, April 8, 1927, Countee Cullen Papers, Box 5, Folder 6, Amistad Research Center, Tulane University, New Orleans. I would like to thank my former student at the University of Houston, Elise Hill, for her excellent research on Charles Cullen.

68. Countee Cullen to Eugene Saxton, June 11, 1927, Countee Cullen Papers, Box 5, Folder 6.

69. "I wish you'd have 'Color' illustrated," Charles wrote to Countee, "I still receive favorable comments on 'Copper Sun' from all sides," in Charles Cullen to Countee Cullen, undated. Countee responded, "Acting on your suggestions in your last letter to me, I wrote Mr. Saxton about the possibility of having you do some illustration for future editions of 'Color'," in Countee Cullen to Charles Cullen, June 5, 1928. These letters are preserved in box 1, folder 18, Countee Cullen Papers. Amistad Research Center, Tulane University, New Orleans.

70. Charles Cullen to Countee Cullen, undated, Countee Cullen Papers, Box 1, Folder 18.

71. Ibid.

72. Arthur W. Rushmore to Countee Cullen, June 6, 1928, Countee Cullen Papers, Box 5, Folder 6.

73. Charles Cullen to Countee Cullen, undated, Countee Cullen Papers, Box 1, Folder 18.

74. Charles Cullen provided illustrations for the following books published by Henry Harrison of New York: *Grub Street Book of Verse* (1929), *Selected Poems of Benjamin Musser* (1930), and Marion Mills Miller's *The Picture of Dorian Gray: A Dramatization* (1931).

75. Charles Cullen's illustrations also alluded to the gay subtext of the poetry. Countee Cullen was gay, as probably was Charles Cullen, though very little is known of his life. For the gay subtext in Charles's illustrations for *Ebony and Topaz,* see Chapter 7.

76. Countee Cullen, "The Litany of the Dark People," in *Copper Sun* (New York: Harper and Brothers, 1927), 13.

77. For Douglas's illustrative circumvention of the problematic and sometimes racist themes in Eugene O'Neill's play in this collection, see Chapter 8.

78. Countee Cullen, ed., *Caroling Dusk: An Anthology of Verse by Negro Poets* (New York: Harper and Brothers, 1927).

79. Knopf often used W. A. Dwiggins's designs for typeface and dust jackets, for example, on the dust jacket of L. Andreyev's *The Little Angel,* one in Knopf's series of Borzoi Pocket Books; a copy of the jacket is held in the Dust Jacket Collection, Harry Ransom Humanities Research Center, University of Texas at Austin.

80. Padraic Colum, *Creatures* (New York: Macmillan, 1927). Boris Artzybasheff designed the dust jacket.

81. I want to thank Randall Burkett, Curator of African American Collections, Manuscript, Archives, and Rare Book Library, Emory University, for bringing to my attention this incredible piece of ephemera.

82. Walter White to Countee Cullen, July 14, 1927, Countee Cullen Papers, Box 6, Folder 13.

83. Quotation of Countee Cullen, used in Harper and Brothers' advertisement for *Home to Harlem* and other books, in *Opportunity* (April 1928), end matter.

84. Two-page ad for Harper and Brothers' books in *Publishers Weekly* (July 21, 1928): 224–25.

85. "William Sells Books to Harlem," *Publishers Weekly* (April 15, 1928): 1623.

86. Ibid.

87. For the six-foot-high reproductions of Edna Ferber's *So Big* brought out by Doubleday in 1924 for booksellers' windows, see Tebbel, *Between Covers*, 316.

88. "William Sells Books to Harlem," 1623.

89. Tebbel, *Between Covers*, 318.

90. Hutchinson, *Harlem Renaissance in Black and White*, 371. Albert Boni and Horace Liveright had founded Boni and Liveright in 1917, publishing the important Harlem Renaissance books *There Is Confusion* by Jessie Fauset and *Tropic Death* by Eric Walrond (Hutchinson, 367–71).

91. Alain Locke, ed., *The New Negro: An Interpretation* (New York: Albert and Charles Boni, 1925), xvii. The Bonis were the first of the white publishers to employ the young Douglas.

92. Robert W. Bagnall, review of Locke's *The New Negro*, in *Opportunity* (February 1926): 74.

93. For his discussion of Kellogg's commission of Reiss to illustrate the March 1925 *Survey Graphic* issue on Harlem, see Jeffrey Stewart, *To Color America: Portraits by Winold Reiss* (Washington, DC: Smithsonian Institution Press and the National Portrait Gallery, 1989), 47–49.

94. Alain Locke, "The Legacy of the Ancestral Arts," in Locke, *New Negro*, 266.

95. Locke, *New Negro*, 419–20.

96. Locke, "Legacy of the Ancestral Arts," 266.

97. For one of Boni's ads combining *The New Negro* and *Mellows*, see *Opportunity* (December 1925), end matter.

98. R. Emmet Kennedy, *Mellows: A Chronicle of Unknown Singers* (New York: Albert and Charles Boni, 1925), 19–20.

99. *Mellows* anticipated the publication of Eva Jessye's *My Spirituals* (New York: Robbins-Engel, 1927), a similar book of text, imagery, and songs from the St. Louis region, illustrated by the folk artist Millar of the Roland Company. This book is discussed briefly in Chapter 4.

100. W. C. Handy, ed., *Blues: An Anthology* (New York: Albert and Charles Boni, 1926), illustrations by Miguel Covarrubias.

101. For a brief biography of Handy, see Abbe Niles's "Introduction," in Handy, *Blues: An Anthology*, 18–21.

102. As Viking became established in 1925, it merged with the small firm of B. W. Huebsch; see Hutchinson, *Harlem Renaissance in Black and White*, 381, and Tebbel, *Between Covers*, 254.

103. W. E. B. Du Bois, review of James Weldon Johnson's *God's Trombones* (New York: Viking 1927) in the *Crisis* (July 1927): 159.

104. Carl Van Vechten, promotional blurb for Morand, *Black Magic*.

105. Ibid.

Chapter 4. Critical Ambivalence:
Illustration's Reception in Print

1. Langston Hughes, "The Negro Artist and the Racial Mountain," *Nation* (June 23, 1926): 694.

2. Alain Locke, "The Negro and the American Stage," *Theatre Arts Monthly* 10 (February 1926): 117.

3. Ibid., 118.

4. Aaron Douglas to Countee Cullen, June 12, 1927. Countee Cullen Papers, Box 5, File 9, Amistad Research Center, Tulane University, New Orleans.

5. Alain Locke, "Notes to the Illustrations," in *The New Negro: An Interpretation,* ed. Alain Locke (New York: Albert and Charles Boni, 1925), 419.

6. Ibid.

7. Alain Locke, "The Legacy of the Ancestral Arts," in Locke, *New Negro,* 264, 266.

8. Ibid., 266.

9. Locke, "The American Negro as Artist," *American Magazine of Art* 23 (September 1931), 210–20, as reprinted in Jeffrey Stewart, *To Color America: Portraits by Winold Reiss* (Washington, DC: Smithsonian Institution Press and the National Portrait Gallery, 1989), 177.

10. Locke, "Foreword," in Locke, *New Negro,* xxvi.

11. However, it should be noted that no cohesive body of art criticism developed in the black press to address Harlem Renaissance visual culture, nor was mainstream American art criticism "highly professionalized" during the early twentieth century, as Mary Ann Calo has acknowledged; see her "African American Art and Critical Discourse between World Wars," *American Quarterly* 51, 3 (September 1999): 586.

12. Michele Bogart, *Advertising, Artists, and the Borders of Art* (Chicago: University of Chicago Press, 1995), 78.

13. John Matheus, review of John Vandercook, *Black Majesty* (New York: Harper, 1928), in *Opportunity* (May 1928): 150.

14. Eugene Gordon, review of Taylor Gordon, *Born to Be* (New York: Covici-Friede, 1929), in *Opportunity* (January 1930): 22.

15. For her review of James Weldon Johnson, *God's Trombones* (New York: Viking, 1927), see Mary White Ovington, "Book Chat," *New York Amsterdam News* (July 27, 1927): 20.

16. For her review of Countee Cullen, *Copper Sun* (New York: Harpers, 1927), see Mary White Ovington, "Book Chat," *New York Amsterdam News* (October 25, 1927): 20.

17. "Tabloid Reviews," *Forum* (January 1, 1927).

18. Anonymous review of Cullen's *Copper Sun* in *San Francisco Chronicle* (August 7, 1927).

19. Gwendolyn Bennett, "The Ebony Flute," *Opportunity* (August 1926): 260.

20. Gwendolyn Bennett, "The Ebony Flute," *Opportunity* (January 1927): 28.

21. Gwendolyn Bennett, "The Ebony Flute," *Opportunity* (November 1927): 340.

22. W. E. B. Du Bois, "The Browsing Reader," *Crisis* (January 1928): 20. In this column, he reviewed Countee Cullen, ed., *Caroling Dusk: An Anthology of Verse by Negro Po-

ets (New York: Harper and Brothers, 1927), and Alain Locke and Montgomery Gregory, eds., *Plays of Negro Life: A Source-Book of Native American Drama* (New York: Harper and Brothers, 1927), among other books.

23. W. E. B. Du Bois, review of James Weldon Johnson, *God's Trombones* (New York: Viking, 1927), in the *Crisis* (July 1927): 159.

24. Robert W. Bagnall, review of Locke, *New Negro*, in *Opportunity* (February 1926): 74.

25. Ibid.

26. Countee Cullen, "The Dark Tower," *Opportunity* (January 1927): 25.

27. V. F. Calverton, "The Advance of the Negro," *Opportunity* (February 1926): 55.

28. Gwendolyn Bennett, review of Eva A. Jessye, *My Spirituals* (New York: Robbins-Engel, 1927), in *Opportunity* (November 1927): 339.

29. John P. Davis, review of Isa Glenn, *Little Pitchers* (New York: Alfred A. Knopf, 1927), in *Opportunity* (July 1927): 214.

30. As the March 1930 issue of *Opportunity* stated, "Vera Fulton is from Baltimore, Md., and has recently completed a biography of Frederick Douglass." Though *Opportunity* rarely identified a contributor's race, I assume that this author was African American, partly because *Opportunity*'s biographies of white contributors usually indicated their racial identity indirectly. In this issue, for example, the white dancer Irene Castle McLaughlin is characterized as having given "to Negro musicians their first real chance in the field of public entertainment." For these biographies, see "Who's Who," *Opportunity* (March 1930): end matter.

31. Vera Fulton, review of Harriet Beecher Stowe, *Uncle Tom's Cabin* (New York: Coward-McCann, 1930), in *Opportunity* (March 1930): 93.

32. James Daugherty, illustration of Tom and Eva, in Stowe, *Uncle Tom's Cabin*.

33. Fulton, review, 93.

34. As quoted in Langston Hughes, *The Big Sea* (New York: Alfred A. Knopf, 1940; rpt., New York: Hill and Wang, 1993), 237.

35. Wallace Thurman, "Negro Artists and the Negro," *New Republic* (August 31, 1927): 37.

36. Countee Cullen, "The Dark Tower," *Opportunity* (January 1925): 25.

37. Anonymous critic, "If Jazz Isn't Music, Why Isn't It?" *New York Times* (June 13, 1926), reviewing Covarrubias's illustrations for W. C. Handy's *Blues: An Anthology* (New York: Albert and Charles Boni, 1926); and Aubrey Bowser, "Book Review: Picturesque and Picaresque," *New York Amsterdam News* (October 23, 1929): 20, reviewing Covarrubias's illustrations for Taylor Gordon's *Born to Be* (New York: Covici-Friede, 1929).

38. W. E. B. Du Bois, "The Browsing Reader," *Crisis* (July 1927): 160, reviewing Covarrubias's illustrations in "Dark Denizens of Harlem's Haunts," *Vanity Fair* (June 1927): 69.

39. Du Bois, review of Taylor Gordon, *Born to Be* (New York: Covici-Friede, 1929), with illustrations by Miguel Covarrubias, in "The Browsing Reader," *Crisis* (April 1930), 129.

40. Du Bois, "The Browsing Reader," *Crisis* (May 1929): 161.

41. Thurman, "Negro Artists," 38.

42. Wallace Thurman, "High, Low, Past and Present," *Harlem* (November 1928):

32, reviewing Captain Canot, *Adventures of an African Slaver* (New York: Albert and Charles Boni, 1928); and Countee Cullen, "The Dark Tower," *Opportunity* (February 1928): 52, reviewing Miguel Covarrubias, *Negro Drawings* (New York: Alfred A. Knopf, 1927).

43. Quotation from an advertisement for Taylor Gordon's *Born to Be,* taken out by its publisher, Covici-Friede, in the *New York Times* (October 6, 1929).

44. Elisabeth Luther Cary, "Present versus Past: Brooklyn Society of Etchers and Work Shown by the Institute of Graphic Art," *New York Times* (December 9, 1928).

45. Anonymous author quotes L. B. Siegfried, associate editor of the American Institute of Graphic Arts, in "Book Illustration Grows Steadily Better: The Second Exhibition of the American Institute of Graphic Arts Shows Encouraging Progress," *New York Times* (December 4, 1927).

46. Edward Alden Jewell, "Art in Advertising: Stimulating Annual Show Held by Art Directors Club—Work of Book Illustrators," *New York Times* (May 6, 1928).

47. J. Holroyd-Reece, "On Book Illustration," *Christian Science Monitor* (May 15, 1925).

48. Roger Fry, "*The Anatomy of Melancholy,* by Democritus Junior, Illustrated by E. McKnight Kauffer," *Dial* (August 1926).

49. Elisabeth Luther Cary, "The Fine Art of Illustrating," *New York Times* (February 28, 1932).

50. Ruth Vassos, "Vassophobia," *Contempo: A Review of Books and Personalities* (June 15, 1932): 3.

51. Jewell, "Art in Advertising."

52. Elisabeth Luther Cary, "Felicities and Pitfalls in Book Illustration, Revealed at Grand Central Palace," *New York Times* (September 11, 1927).

53. As an illustrator and caricaturist associated with the Harlem Renaissance, Miguel Covarrubias was an exception; as noted above, his illustrations and publications were discussed with considerable frequency in both the mainstream and black presses.

54. Thomas Erwin, "Introduction," *Second Annual Exhibition of American Book Illustration* (New York: American Institute of Graphic Arts, 1927), unpaginated.

55. Aaron Douglas to Countee Cullen, June 12, 1927. Douglas composed this short biography for inclusion in Cullen's *Caroling Dusk,* though it was ultimately deleted from the final publication. The jacket and book decorations Douglas mentioned for Rene Maran's *Kongo* never saw the light of day, because the book never seems to have been published by the brothers Boni.

56. Douglas was not alone in assessing these illustrations among his best in this medium. In subsequent biographies during his lifetime and later, this series has often captured the attention of his admirers. For example, one article pronounced that Douglas "first attracted notice by his beautiful illustrations for James Weldon Johnson's book of poems, 'God's Trombones' . . . ;" see "The Art of Aaron Douglas," *Crisis* (May 1931): 159–60. Significantly, this article focused on Douglas's new production in painting: his mural commissions for that year at the Sherman Hotel in Chicago and Fisk University in Nashville.

57. James Weldon Johnson, *God's Trombones: Seven Negro Sermons in Verse* (New York: Viking, 1927), 18.

58. W. A. Dwiggins, "Notes on the Structure of a Book," *Fifty Books Exhibited by the American Institute of Graphic Arts, 1926* (New York: John Day, 1927), 5.

59. For color reproductions of Douglas's oil paintings based on his *God's Trombones* illustrations, including *Noah's Ark* (c. 1927, oil on masonite, Fisk University Art Museum), *The Crucifixion* (1927, oil on board, Collection of Mr. and Mrs. William H. Cosby), *Go Down Death* (1927, oil on masonite, Collection of Professor and Mrs. David Driskell), and *The Creation* (1935, oil on masonite, The Gallery of Art, Howard University), see Mary Schmidt Campbell, *Harlem Renaissance: Art of Black America* (New York: The Studio Museum in Harlem and Harry N. Abrams, Inc., 1994 [1987]), plates 30, 32, 33, 35. I would like to thank my University of Houston colleague in graphic communications, Beckham Dossett, for her invaluable advice in helping me to understand Douglas's choice of colors and hues in his gouache originals, in which he balanced aesthetic decisions with practical concerns for their reproducibility in black and white.

60. Aaron Douglas, "Harlem Renaissance," speech, c. 1970, Aaron Douglas Papers, Box 3, Folder 3, Fisk University, Nashville, as quoted in Amy Kirschke, *Aaron Douglas: Art, Race, and the Harlem Renaissance* (Jackson: University of Mississippi Press, 1995), 12.

61. Aaron Douglas to Alta Sawyer, n.d., Aaron Douglas Papers, Box 1, Folder 2, Schomburg Center for Research in Black Culture, New York, as quoted in Kirschke, *Aaron Douglas*, 59.

62. Charles S. Johnson's recommendation for Aaron Douglas for a Harmon Award, Harmon Foundation Papers, Box 42, Manuscript Division, Library of Congress, Washington, D.C., as quoted in Kirschke, *Aaron Douglas*, 59.

63. Aaron Douglas to Alta Sawyer, n.d., Aaron Douglas Papers, Box 1, Folder 5, Schomburg Center for Research in Black Culture, as quoted in Kirschke, *Aaron Douglas*, 60.

64. Elmer A. Carter, "E. Simms Campbell—Caricaturist," *Opportunity* (March 1932): 82.

65. Arna Bontemps, "The Campbell Kid: E. Simms Campbell," in *We Have Tomorrow* (Boston: Houghton Mifflin, 1945), 1.

Chapter 5. Remaking the Past, Making the Modern:
Race, Gender, and the Modern Economy

1. Joyce Carrington was a visual artist and poet who, to my knowledge, contributed only this one illustration to Harlem Renaissance publications.

2. Charlotte Mason to Alain Locke, 1927, Alain Locke Papers, Moorland-Spingarn Research Center, Manuscript Division, Howard University, Washington, DC, as quoted in Amy Kirschke, *Aaron Douglas: Art, Race, and the Harlem Renaissance* (Jackson, University Press of Mississippi, 1995), 46.

3. Douglas created his cover image in response to an essay by Marita Bonner titled "The Young Blood Hungers." Douglas's enervated scene suggests the "growing pains," as Bonner called them in her essay, of African American youth who had begun to experience freedom and craved more. In an almost stream-of-consciousness style, Bonner described young black Americans who were nourished by an illustrious ances-

try. While they had found some economic success, they still hungered for greater equality: "The Young Blood hungers. It's an old hunger. The gnawing world hunger. The hunger after righteousness"; Marita Bonner, "The Young Blood Hungers," *Crisis* (May 1928): 151, 172.

4. While the ancient Greeks and Romans had acknowledged their Egyptian roots, this biological and cultural debt to Egyptian civilization came to be increasingly suppressed by both Americans and Europeans, as Martin Bernal has explained. "For 18th- and 19th-century Romantics and racists," he wrote, "it was simply intolerable for Greece, which was seen not merely as the epitome of Europe but also as its pure childhood, to have been the result of the mixture of native Europeans and colonizing Africans and Semites"; see Martin Bernal, *Black Athena: The Afroasiatic Roots of Classical Civilization*, Vol. 1: *The Fabrication of Ancient Greece 1785–1985* (New Brunswick, NJ: Rutgers University Press, 1987), 2.

5. In my discussion of American advertising, I am indebted to Roland Marchand, *Advertising the American Dream: Making Way for Modernity, 1920–1940* (Berkeley: University of California Press, 1985).

6. Marchand, *Advertising the American Dream*, 127.

7. See, for example, the advertisement for Salon de Luxe shoes, utilizing a fantastic modernist image by John Vassos of tall buildings with a fashionable shoe perched atop the central structure, in *Vogue* (April 1, 1927): 10; and the advertisement for Williams Aqua Velva Shaving Cream showing a well-dressed man who has used the shaving cream, his urbanity compared with the view of a futuristic cityscape through the window behind him, in *Saturday Evening Post* (September 27, 1930): 161, as illustrated and discussed in Marchand, *Advertising the American Dream*, 257.

8. For her suggestion that Dawson "recast Liberty as a young black woman with Egyptian features and dress," see Donna Cassidy, *Painting the Musical City: Jazz and Cultural Identity in American Art, 1910–1940* (Washington, DC: Smithsonian Institution Press, 1997), 144.

9. Advertisement for Poro College, *Opportunity* (October 1927): end matter.

10. An advertisement appeared for the People's Finance Corporation in the *Crisis* (November 1927): 294.

11. Advertisement for Chrysler automobiles, *American Magazine* (April 1929): 83.

12. From academic circles to more popular venues, anxiety over the racial identity of ancient Egyptian people manifested itself in varying ways. With the rise of Aryanism in early twentieth-century academic circles, Egyptologists became increasingly dubious about the racial identity of ancient Egyptians, hesitant to imagine that Egyptian civilization had evolved to its pinnacle without "major stimuli from the north"; see Bruce G. Trigger, "Egyptology, Ancient Egypt, and the American Imagination," in *The American Discovery of Ancient Egypt*, ed. Nancy Thomas (Los Angeles: Los Angeles County Museum of Art, 1995), 32. They came to believe instead that significant numbers of white-skinned northern migrants had mixed with native Egyptians to produce, what was for them, a nonthreatening, neutrally colored ancient civilization. In the late 1980s, historian Martin Bernal wrote critically and controversially on post-Enlightenment constructions of antique cultures. He contended that the fear of "race" mixing within the "mother" civilization was especially pronounced during the early decades of the twenti-

eth century, when the birthplace of western civilization came to be "fabricated" as a pu-
rified ancient Greece, washed clean of both Egyptian and Phoenician/Semitic influ-
ences (see Bernal, *Black Athena*). For another more recent African author who
attempted to restore civilized origins to African culture, see Cheikh Anta Diop, *The
African Origin of Civilization: Myth or Reality*, trans. Mercer Cook (New York: Lawrence
Hill, 1974). For her recent discussion of the racial constructions of ancient Egyptian
identity, see Renee Ater, "Making History: Meta Warrick Fuller's *Ethiopia*," *American Art*
17, 3 (Fall 2003).

13. During the nineteenth century, Egyptian styles were implemented for impor-
tant American icons, most forcefully in the colossal Washington Monument, which
took the form of an ancient Egyptian obelisk. It should be noted, however, that Egyptian
styles did not outweigh the influence of ancient Greece and Rome; the sculptural pro-
grams for the U.S. capitol, for example, found sources almost exclusively in ancient
Greece. For further reading on America's artistic ties with ancient Egypt, see Trigger,
"Egyptology, Ancient Egypt, and the American Imagination."

14. Trigger, "Egyptology, Ancient Egypt, and the American Imagination," 26.

15. For a ground-breaking study of Fuller's sculpture, see Ater, "Making History."

16. In *Crisis*, for example, Du Bois conflated Nubia and Ethiopia in one of his edito-
rials on the cultural contributions of ancient Ethiopian civilization; see Du Bois, "Nu-
bia," *Crisis* (May 1925): 38. For a discussion of the actually separate identity of Nubia as a
sophisticated, ancient culture developed over 500 years before the ancient Egyptians,
see Michael Botwinick, *Africa in Antiquity: The Arts of Ancient Nubia and the Sudan*
(Brooklyn: Brooklyn Museum, 1978).

17. For "the reign of the Kushite kings in Egypt from 712 to 664 BCE," see Ater,
"Making History." The built structure in Carpenter's illustration looks like a reconstruc-
tion of the terraced temple of Queen Hatshepsut from the fifteenth century B.C.E., Deir
el Bahari; see S. Giedion, *The Eternal Present: The Beginnings of Architecture* (New York:
Pantheon Books, 1964), 428.

18. Hale Woodruff, *An Oil Painting*, reproduced on the cover of the *Crisis* (August
1928).

19. For her discussion of pageantry as it related to Meta Warrick Fuller's *Ethiopia*,
see Ater, "Making History."

20. For a history of American pageantry, see David Glassberg, *American Historical
Pageantry: The Uses of Tradition in the Early Twentieth Century* (Chapel Hill: University of
North Carolina Press, 1990).

21. As Linda Nochlin has aptly written, "the pageant could serve as an instrument
of pacification, Americanization and patriotic indoctrination for the unwashed and, in
many ways, unwanted foreigners flooding our cities"; see her article, "The Paterson
Strike Pageant of 1913," *Art in America* 62 (May-June 1974), 67.

22. W. E. B. Du Bois, *The Star of Ethiopia*, 1913; reprinted in *The Oxford W.E.B. Du
Bois Reader*, ed. Eric Sundquist (New York: Oxford University Press, 1996), 305–10. For
two rare studies of this pageant, see David Krasner, "'The Pageant Is the Thing:' Black
Nationalism and *The Star of Ethiopia*," in *A Beautiful Pageant: African American Theatre,
Drama, and Performance in the Harlem Renaissance, 1910–1927* (New York: Palgrave
Macmillan, 2002), 81–94; and Freda L. Scott, "*The Star of Ethiopia*: A Contribution to-

ward the Development of Black Drama and Theater in the Harlem Renaissance," in *The Harlem Renaissance: Revaluations,* eds. Amritjit Singh et al. (New York: Garland, 1989): 257–69.

23. David Levering Lewis, *W. E. B. Du Bois, Biography of a Race, 1868–1919* (New York: Henry Holt, 1993), 460.

24. The text of the pageant is taken from Sundquist, *Oxford W.E.B. Du Bois Reader.*

25. For a discussion of *The Seven Gifts of Ethiopia to America,* Du Bois's revised pageant for the America's Making Exposition, see Ater, "Making History."

26. W. E. B. Du Bois, "The Drama among Black Folk," *Crisis* (August 1916): 173.

27. Dorothy C. Guinn, *"Out of the Dark:* A Pageant," in *Plays and Pageants from the Life of the Negro,* ed. Willis Richardson (Washington, DC: Associated Publishers, 1930; rpt., Jackson: University Press of Mississippi, 1993), 311.

28. Richardson, *Plays and Pageants,* 327–28.

29. Pageant Poster for *The Star of Ethiopia,* Washington, DC, performance, 1915, W. E. B. Du Bois Papers, Archives and Manuscripts Department, University of Massachusetts, Amherst.

30. The first illustration appears in Richardson, *Plays and Pageants,* 343. This illustration by Wells was published previously in the November 1928 issue of the *Crisis,* 366.

31. W. E. B. Du Bois, "Business as Public Service," *Crisis* (November 1929): 374.

32. Du Bois, "Business as Public Service," 375.

33. As quoted in Kathy Peiss, *Hope in a Jar: The Making of America's Beauty Culture* (New York: Henry Holt, 1998), 93.

34. Peiss, *Hope in a Jar,* 113.

35. Annie Turnbo Malone, "I Am Grateful Friends," in advertisement for Poro College, *Opportunity* (October 1927): end matter.

36. Alain Locke, "The New Negro," in *The New Negro: An Interpretation,* ed. Alain Locke (New York: Albert and Charles Boni, 1925), 10.

37. For her discussion of the "Men of the Month" sections in the *Crisis,* see Anne Elizabeth Carroll, *Word, Image, and the New Negro: Representation and Identity in the Harlem Renaissance* (Bloomington: Indiana University Press, 2005), 38–39.

38. If Woodruff assigned female identity to any of the figures, it was only to the sculptor, who wears a longer hairstyle. This would accord with the gender of contemporary black sculptors, who were primarily women, for example, Meta Warrick Fuller, May Howard Jackson, and Elizabeth Prophet.

39. Woodward Studios, photograph of Mrs. Charles M. Thompson, Chicago, cover of the *Messenger* (January 1925).

40. "Photograph from Life," cover of the *Crisis* (November 1928). The photographer was not credited.

41. Peiss, *Hope in a Jar,* 213.

42. Marchand, *Advertising the American Dream,* 64.

43. Carolyn Kitch, *The Girl on the Magazine Cover: The Origins of Visual Stereotypes in American Mass Media* (Chapel Hill: University of North Carolina Press, 2001), 95. Kitch was referring to the September 1916 *Crisis* cover photograph of a woman in the same kind of sailor-style outfit as Latimer's figure in her cover image, *Blossoms, Crisis* (May 1923).

44. Gwendolyn Bennett, "Heritage," published in *Opportunity* (December 1923): 371. The ellipsis in the first stanza is Bennett's.

45. For her comparison between Bennett's *Opportunity* cover illustration and Cullen's poem "Heritage," see Sandra Govan, "Gwendolyn Bennett: Portrait of an Artist Lost," Ph.D. dissertation, Emory University, 1980, 179.

46. Eleanor Paul was a young student artist from Sacramento, California, and she became the Art Editor of *Crisis*'s Youthport page beginning in January, 1930; see "Youthport," *Crisis* (January 1930), 26.

47. Advertisement for Corra Harris's *Flapper Anne* (New York: Houghton Mifflin, 1926), in *Publishers Weekly* (April 10, 1926).

48. For an incisive account of Malone and Walker's entrepreneurship and black women's beauty culture, see Peiss, *Hope in a Jar,* Chapters 3 and 7.

49. "Glorifying Our Womanhood," advertisement for Madam C. J. Walker's beauty products, *Messenger* (August 1925): end matter.

50. Peiss, *Hope in a Jar,* 113.

51. Ibid., 217.

52. Kashmir Chemical Company, advertisement for "Nile Queen" beauty products, *Crisis* (September 1920): back cover.

53. Kantiba Nerouy, "Tutankh-amen and Ras Tafari," *Crisis* (December 1924): 64.

54. Vere E. Johns, "Our Artificial Women," *New York Age* (May 12, 1934), as quoted in Peiss, *Hope in a Jar,* 220.

55. The advertisement appeared on the back cover of the *Crisis* (January 1928). It should be noted that this advertisement promotes brown skin for African American women, suggesting that dark black skin was not the most appealing.

56. See ad for Madam C. J. Walker's "Tan-Off," *Crisis* (October 1929): end matter.

57. For studies that address these issues, see Kitch, *Girl on the Magazine Cover,* and Peiss, *Hope in a Jar.*

58. For an excellent study of children's literature, its place in the Harlem Renaissance, and its importance for W. E. B. Du Bois and Carter G. Woodson, see Katharine Capshaw Smith, *Children's Literature of the Harlem Renaissance* (Bloomington: Indiana University Press, 2004).

59. Mission Statement, *Brownies' Book* (January 1920): front matter.

60. The journal was richly illustrated by Laura Wheeler, but also by Albert Smith and Hilda Wilkinson.

61. Capshaw Smith, *Children's Literature of the Harlem Renaissance,* 32.

62. Albert Smith's illustration of a black Santa Claus, *Jolly Old Saint Nicholas,* appeared on the *Brownies' Book* cover in December 1920, whereas Laura Wheeler's stick figure drawings of black children illustrated Jessie Fauset's poem "After School," *Brownies' Book* (January 1920), 30.

63. Laura Wheeler's illustration appeared on the cover of the *Brownies' Book* (May 1920).

64. The "colored dolls" were advertised in *Brownie's Book* (January 1920): end matter, for example, and Madam C. J. Walker's "good fairy" ad appeared in *Brownies' Book* (September 1920): end matter, as well as in many other issues.

65. Hilda Wilkinson, *Daffodil Dances before the Queen*, illustration for Eulalie Spence, *Tommy and the Flower Fairies, Brownies' Book* (March 1921): 123.

66. Capshaw Smith, *Children's Literature of the Harlem Renaissance*, 216.

67. "Introduction," in *The Upward Path: A Reader for Colored Children*, ed. Myron Pritchard and Mary White Ovington (New York: Harcourt Brace, 1920), ix.

68. Fenton Johnson, "The Black Fairy," in Pritchard and Ovington, *Upward Path*, 176.

69. Laura Wheeler, *The Black Fairy*, illustration in Pritchard and Ovington, *Upward Path*.

70. Capshaw Smith, *Children's Literature of the Harlem Renaissance*, 216–17.

71. For an insightful discussion of the fairy tale in Harlem Renaissance literature by women authors, see Mar Gallego, "Female Fancy in Jessie Fauset's *Plum Bun*," in her *Passing Novels in the Harlem Renaissance: Identity Politics and Textual Strategies* (New Brunswick: Transaction, 2003), 153–87.

72. Ola Calhoun Morehead, "The Bewitched Sword," *Crisis* (February 1925): 166–67.

73. The illustrations are signed only with the monogram, "MTB"; see Morehead, "Bewitched Sword," 167.

74. Gallego, "Female Fancy in Jessie Fauset's *Plum Bun*," 154. For her discussion of critics who dismiss the author's writing as conservative and miss "the parodic and subversive intentionality in Fauset's work" (156), see 154–57.

75. Jessie Fauset, "The Sleeper Wakes," *Crisis* (October 1920): 271.

76. Fauset, "Sleeper Wakes," 271.

77. Aaron Douglas, *Drawing for the NAACP Benefit, New York*, cover of the *Crisis* (January 1930).

78. See, for example, William Chase, "Flapperette" cartoon, *New York Amsterdam News* (October 31, 1928).

79. Unidentified cover illustration of *Life* (July 15, 1926), as illustrated in Angela Latham, *Posing a Threat: Flappers, Chorus Girls, and Other Brazen Performers of the American 1920s* (Hanover, NH: University Press of New England, 2000), 25.

80. Cheryl Wall, "Whose Sweet Angel Child? Blues Women, Langston Hughes, and Writing During the Harlem Renaissance," in *Langston Hughes: The Man, His Art, and His Continuing Influence*, ed. C. James Trotman (New York: Garland, 1995), 46.

81. For her argument that African American women were finding routes toward modernity through beauty culture, albeit extremely restricted routes, see Peiss, *Hope in a Jar*, 235.

Chapter 6. Religion as "Power Site of Cultural Resistance"

1. The quoted phrase is from Coco Fusco, *English Is Broken Here: Notes on Cultural Fusion in the Americas* (New York: New Press, 1995), 36. Fusco is discussing strategies employed by contemporary artists to reveal histories of "marginalized communities" in order to challenge "our vision of America and its cultures." In this effort, she argues,

"new alternative chronicles surface; these are the latest examples of how collective memories, those storehouses of identity, once activated, become power sites of cultural resistance" (36). I would argue that Harlem Renaissance artists engaged earlier in a similar activity, revealing alternative views of religious history and experience, in order to challenge and transform ways in which Americans defined the function and identity of the Judeo-Christian tradition in the context of American culture.

2. I will limit myself, in this chapter, to an investigation of art related to Judeo-Christian themes and to understanding how African American forms of Christianity influenced this body of art. In the future, it would be fruitful to investigate the influence of African American religious groups that associated themselves with Judaism and Islam.

3. Mircea Eliade, "The Sacred and the Modern Artist," in *Art, Creativity, and the Sacred,* ed. Diane Apostolos-Cappadona (New York: Crossroad, 1984): 182. The article was reprinted from *Criterion* (Spring 1964): 22–24. Eliade would include modern artists among those who stand outside what he would call the alienation of organized religion.

4. Sally Promey, "The 'Return' of Religion in the Scholarship of American Art," *Art Bulletin* 85, 3 (September 2003): 584.

5. Promey, Morgan, Doss, and others have contributed to the important collection of essays *The Visual Culture of American Religions,* eds. David Morgan and Sally Promey (Berkeley: University of California Press, 2001).

6. David Morgan and Sally Promey, "Introduction," in Morgan and Promey, *Visual Culture of American Religions,* 3.

7. Ibid., 6.

8. Ibid., 14.

9. For scholarly works providing background on African American religion, see in particular C. Eric Lincoln and Lawrence H. Mamiya, *The Black Church in the African American Experience* (Durham: Duke University Press, 1990); Milton C. Sernett, *Bound for the Promised Land: African American Religion and the Great Migration* (Durham: Duke University Press, 1997); Hans Baer and Merrill Singer, *African-American Religion in the Twentieth Century* (Knoxville: University of Tennessee Press, 1992); and Gayraud Wilmore, *Black Religion and Black Radicalism* (Garden City, NY: Doubleday, 1972).

10. James Weldon Johnson, *Black Manhattan,* introduction by Sondra Kathryn Wilson (New York: Da Capo Press, 1991), 165–66. Johnson's book was originally published in 1930.

11. Amy Kirschke, *Aaron Douglas: Art, Race, and the Harlem Renaissance* (Jackson: University Press of Mississippi, 1995), 2.

12. Aaron Douglas, foreword to "Dillard Speech," c. 1970, Aaron Douglas Papers, Box 1, Folder 1, Fisk University, as quoted in Kirschke, *Aaron Douglas,* 51.

13. For Douglas's interest in Gurdjieff, see Kirschke, *Aaron Douglas,* 52–54. For his self-avowed Marxism in 1934, see ibid., 121–24.

14. W. E. B. Du Bois, "The Negro Church," *Crisis* (May 1912); reprinted in *W. E. B. Du Bois: A Reader,* ed. David Levering Lewis (New York: Henry Holt, 1995), 260. A variety of scholars have maintained Du Bois's position. In 1964, E. Franklin Frazier wrote, "the Negro church and Negro religion have cast a shadow over the entire intellectual life of Negroes and have been responsible for [their] so-called backwardness"; see his *The*

Negro Church in America (New York: Schocken Books, 1974), 90. The book was first published in the United States in 1964.

15. W. E. B. Du Bois, "Peace," *Crisis* (December 1926): title page.

16. Lincoln and Mamiya, *The Black Church in the African American Experience*, 124. They are summarizing a study of black Christian denominations in Chicago by St. Clair Drake and Horace Cayton of 1945.

17. Langston Hughes, "The Negro Artist and the Racial Mountain," *Nation* (June 23, 1926): 693.

18. Laura Wheeler Waring, *The Adoration of the Magi*, cover of the *Crisis* (December 1929).

19. The caption for this painting, reproduced on the cover of the December 1927 issue of *Opportunity*, appears on the contents page: "The Adoration of the Magi—Flemish School (Courtesy of the Metropolitan Museum)." I have determined that this painting is the work purchased by the Metropolitan Museum of Art in 1871 and described as a "fifteenth-century work, School of Ghent" in Bryson Burroughs, *The Metropolitan Museum of Art Catalogue of Paintings*, 9th ed. (New York: Metropolitan Museum of Art, 1931), 117–18.

20. Du Bois inserted numerous reproductions of Western religious art in the pages of the *Crisis*. For one issue, he reproduced a wood relief of St. Philip baptizing the Ethiopian Eunuch; see the *Crisis* (April 1925): 253. He also reproduced Matthias Grünewald's *Meeting of Saints Erasmus and Mauritius* of c. 1517, both Early Christian saints and martyrs, the latter of Moorish descent; see the *Crisis* (December 1927): 328.

21. Charles Cullen, untitled cover of *Opportunity* (December 1928).

22. Wilson Jeremiah Moses, *The Golden Age of Black Nationalism, 1850–1925* (Hamden, CT: Archon Books, 1978), 156–158. For the writings of African American Ethiopianist scholars, see Joseph E. Hayne, *The Negro in Sacred History, or Ham and His Immediate Descendants* (Charleston, SC: Walker, Evans, Cogwell, 1887); Rufus Lewis Perry, *The Cushites, or the Descendants of Ham as Found in Sacred Scripture* (Springfield, MA: Wiley and Co., 1893); and Benjamin Tucker Tanner (Henry Ossawa Tanner's father), "The Negro in Holy Writ," unpublished manuscript, 1900. To my knowledge, art historians have not discussed the significance of Ethiopianism for Harlem Renaissance portrayals of Judeo-Christian narratives. I would argue that this method of biblical exegesis is consonant with the varied strategies among Harlem Renaissance writers and artists to reverse negative assessments of black identity. Further, I find Ethiopianism to be an understudied exegetical method, which has far-reaching implications, finding similarity, for example, with the Midrashic tradition in Judaism, in which biblical stories are amplified and teased out to find new meaning (see, for example, Michael A. Fishbane, ed., *The Midrashic Imagination: Jewish Exegesis, Thought, and History* [Albany: State University of New York Press, 1993]), and with feminist reappraisals of biblical texts, which seek to reassess references to women in the Bible, as well as understanding historically the absences of female participation (see, for example, Elisabeth Schüssler Fiorenza, *In Memory of Her: A Feminist Theological Reconstruction of Christian Origins* [New York: Crossroad, 1985]).

23. Moses, *Golden Age of Black Nationalism*, 156.

24. Ibid., 157.

25. Robert Hood, *Begrimed and Black: Christian Traditions on Blacks and Blackness* (Minneapolis: Fortress Press, 1994), 60.

26. Edward W. Blyden, *Christianity, Islam and the Negro Race* (Edinburgh: Edinburgh University Press, 1887; rpt. 1967). Many English-speaking Africans were practitioners of Ethiopianism, including Blyden, a West Indian of African descent who, in 1851, emigrated to Liberia.

27. Blyden, *Christianity, Islam and the Negro Race*, 155.

28. For his discussion of Dunbar's poem "Ode to Ethiopia" (158) and his argument for Du Bois's attempts "to fuse two complementary but substantially different mythological traditions"—Ethiopianism and "the European tradition of interpretive mythology, transplanted to American by its European colonizers" (156), see Moses, *Golden Age of Black Nationalism*, Chapter 8, "The Poetics of Ethiopianism: W. E. B. Du Bois and Literary Black Nationalism," 156–69.

29. W. E. B. Du Bois, *The Star of Ethiopia*, 1913; reprinted in *The Oxford W. E. B. Du Bois Reader*, ed. Eric J. Sundquist (New York: Oxford University Press, 1996), 305–10. For a rare study of this pageant, see Freda L. Scott, "*The Star of Ethiopia*: A Contribution toward the Development of Black Drama and Theater in the Harlem Renaissance," in *The Harlem Renaissance: Revaluations*, eds. Amritjit Singh et al. (New York: Garland, 1989): 257–69.

30. James Weldon Johnson, "The Crucifixion," in *God's Trombones: Seven Negro Sermons in Verse* (New York: Viking, 1927), 41.

31. Countee Cullen, "Colors," in *Copper Sun* (New York: Harper and Brothers, 1927), 11.

32. Zora Neale Hurston, *The First One: A Play in One Act*, in *Ebony and Topaz: A Collectanea*, ed. Charles S. Johnson (New York: *Opportunity* and the National Urban League, 1927), 55.

33. Ibid., 55.

34. Ibid., 57.

35. Ibid.

36. Aaron Douglas to Langston Hughes, December 21, 1925. Langston Hughes Papers, Part 1: Correspondence, Box 51, Aaron Douglas Folder, James Weldon Johnson Memorial Collection of Negro Arts and Letters, Yale Collection of American Literature, Beinecke Rare Book and Manuscript Library, Yale University.

37. Du Bois, "Peace."

38. Douglas had great respect for Garvey's influence in Harlem. In an unpublished paper he prepared for a "Negro Culture Workshop" at Fisk University, titled "The Harlem Renaissance," he remarked, "we must never forget the Garvey movement and its powerful influence on the outlook of the American black man, who soon began a belated search for his ancestral roots in far off Africa." See Aaron Douglas Papers, Archives of American Art, 1921–1973, microfilm reel 4520 (original papers held at Fisk University). The paper is undated, but was prepared during his years teaching at Fisk University from 1944 to 1966. For the religious implications of Garvey's movement, see Randall K. Burkett, *Garveyism as a Religious Movement: The Institutionalization of a Black Civil Religion* (Metuchen, NJ: Scarecrow Press, 1978).

39. "Garvey," *Opportunity* (September 1924): 284. On the same page, a photograph illustrates the processors who carry paintings of a black Madonna and Christ.

40. "Negroes Acclaim a Black Christ," *New York Times* (August 6, 1924): 3, col. 5.

41. This passage from Garvey's address was quoted in "Convention Addresses by Marcus Garvey, J. J. Peters, and Bishop George A. McGuire," *Negro World* (August 9, 1924); reprinted in *The Marcus Garvey and Universal Negro Improvement Association Papers*, Vol. 5: September 1922–August 1924, ed. Robert Hill (Berkeley: University of California Press, 1986), 647–48.

42. "Religious Ceremony at Liberty Hall that Corrects Mistake of Centuries and Braces the Negro," *Negro World* (August 9, 1924); reprinted in Hill, *Marcus Garvey and Universal Negro Improvement Association Papers*, 647–48.

43. Johnson, *God's Trombones*, 11.

44. Ibid., 2.

45. Ibid., 5.

46. Ibid., 9.

47. Ibid., 17, 19–20.

48. Ibid., 18.

49. Aaron Douglas, *Let My People Go*, illustration in Johnson, *God's Trombones*. In keeping with the general interest of 1920s cultural critics to identify Egyptians as Africans, Douglas "colored" the Egyptian soldiers black. Identifying Egyptians as black was part of the strategy of many African American cultural critics in creating a usable past. However in this religious context, allusion to Egypt on the part of African Americans could be problematic. Especially because they also identified with the Hebrews, Egypt as a slave-holding civilization becomes a troubling ancestor. For Moses and his people are also dark-skinned, suggesting the connection Douglas has made between God's ancient chosen people and contemporary African Americans. In this gesture he drew from African American preachers who, since the period of slavery in America, "believed that God had acted in history and within their own particular history as a peculiar people just as long ago he acted on behalf of another chosen people, biblical Israel"; see Albert J. Raboteau, *Slave Religion: "The Invisible Institution" in the Antebellum South* (New York: Oxford University Press, 1978), 317–18; as quoted in Baer and Singer, *African-American Religion*, 22.

50. Johnson, *God's Trombones*, 46.

51. Ibid.

52. This final section of the chapter first appeared in my article, "'On the Cross of the South': The Scottsboro Boys as Vernacular Christs in Harlem Renaissance Illustration," *International Review of African American Art*, 19, 1 (2003): 18–27. It has since undergone revisions.

53. For a thorough study of the Scottsboro case, see James Goodman, *Stories of Scottsboro* (New York: Pantheon Books, 1994). Other important studies of the case include Frankie Y. Bailey and Alice P. Green, "From Scottsboro to Chicago," in their *"Law Never Here": A Social History of African American Responses to Issues of Crime and Justice* (Westport, CT: Praeger, 1999): 111–22; and Robin D. G. Kelley, "In the Heart of the Trouble: Race, Sex, and the ILD," in his *Hammer and Hoe: Alabama Communists during the Great Depression* (Chapel Hill: University of North Carolina Press, 1990): 78–91.

54. Aaron Douglas, *Feet o' Jesus*, cover of *Opportunity* (October 1926).

55. Langston Hughes, "Feet o' Jesus," in *Selected Poems of Langston Hughes* (New York: Alfred A. Knopf, 1971), 17.

56. Published in "Two Artists," *Opportunity* (October 1926): 315 and in the *Opportunity Art Folio* (December 1926).

57. *Fire!! Devoted to Younger Negro Artists* (November 1926).

58. Zora Neale Hurston, "Sweat," *Fire!!* (1926): 42.

59. Anonymous author, "Get Off that Rusty Cross," *Contempo: A Review of Ideas and Personalities* (May 1931): 2.

60. Ibid.

61. Langston Hughes, "On the Road," *Esquire* (January 1935): 92, 154.

62. Ibid., 92.

63. "An Art Exhibit against Lynching," *Crisis* (April 1935): 106; Campbell's work was illustrated in the same issue of the *Crisis*, 102. This exhibition was sponsored by the NAACP and represented the organization's continued activism against lynching.

64. The NAACP engaged in two antilynching activities in 1919: the attempt to secure passage of federal law against lynching, and the publication of crimes against blacks in *Thirty Years of Lynching in the United States, 1889–1918;* see John Hope Franklin and Alfred A. Moss Jr., *From Slavery to Freedom: A History of Negro Americans,* 6th ed. (New York: McGraw Hill, 1988), 318–19.

65. W. Fitzhugh Brundage, "Introduction," in *Under Sentence of Death: Lynching in the South,* ed. W. Fitzhugh Brundage (Chapel Hill: University of North Carolina Press, 1997), 5.

66. One version of this lithograph is held in the collection of the Amon Carter Museum, Fort Worth; see Jane Myers and Linda Ayres, *George Bellows: The Artist and His Lithographs 1916–1924* (Fort Worth: Aman Carter Museum, 1988), 121–22. Bellows's print was also used to illustrate Mary Johnston's "Nemesis," *Century Magazine* (May 1923): 3–22.

67. William V. Kelley, "Black Gum," *Opportunity* (January 1928): 13–14, 27. Nugent's illustration appeared on p. 13.

68. Kelley, 27.

69. Though scholars have often assumed that Charles Cullen was Countee Cullen's brother, I supply evidence in Chapter 7 that Charles was no relation to Countee but was white.

70. Countee Cullen, *The Black Christ and Other Poems* (New York: Harper and Brothers, 1929), 69.

71. For recent analyses of this exhibition, see Helen Langa, "Two Antilynching Art Exhibitions: Politicized Viewpoints, Racial Perspectives, Gendered Constraints," *American Art* (Spring 1999): 11–39; and Margaret Rose Vendryes, "Hanging on Their Walls: An Art Commentary on Lynching: The Forgotten 1935 Exhibition," in *Race Consciousness: African-American Studies for the New Century,* eds. Judith Fossett and Jeffrey Tucker (New York: New York University Press, 1997), 153–76.

72. The exhibition seemed to represent both black and white artists so fairly, that James Lesesne Wells described the show as "the exhibition of blacks and whites" in a letter to Walter White, February 17, 1935, preserved in the *Papers of the NAACP, Part 7: The Anti-Lynching Campaign, 1912–1955, Series B: Anti-Lynching Legislative and Publicity Files, 1916–1955,* Robert L. Zangrando, editorial adviser, made available on microfilm by

Black Studies Research Sources: Microfilms from Major Archival and Manuscript Collections, eds. August Meier and John H. Bracey. Unfortunately, however, Wells was writing White to decline the invitation to participate.

73. Thomas Hart Benton, *A Lynching,* 1934, oil on canvas (water-damaged and lost), reproduced in the *Crisis* (April 1935): 106. For a discussion of the works in the exhibition by Benton, John Steuart Curry, and Isamu Noguchi, see James M. Dennis, *Renegade Regionalists: The Modern Independence of Grant Wood, Thomas Hart Benton, and John Steuart Curry* (Madison: University of Wisconsin Press, 1998), 62–63.

74. "Celebrities Jam Opening of Lynching Art Exhibit," article in typescript preserved in *Papers of the NAACP.* Further embellishing the opening event, Pearl S. Buck addressed the audience with an impassioned plea to bring an end to mob violence; her address was quoted in the same typescript.

75. My synopsis of the Scottsboro case comes from Goodman, *Stories of Scottsboro.*

76. "Humanitarianism in the Scottsboro Case," *Contempo: A Review of Ideas and Personalities* (Mid-July 1931): 1.

77. Lincoln Steffens, "Lynching by Law or by Lustful Mob. North and South: Red and Black," *Contempo: A Review of Ideas and Personalities* (December 1, 1931): 4.

78. Carol Weiss King, "Facts about Scottsboro," *Contempo: A Review of Ideas and Personalities* (December 1, 1931): 4.

79. For Langston Hughes's friendship with Cleveland artist Zell Ingram, and their trip together to Cuba, see Langston Hughes, *The Big Sea: An Autobiography* (New York: Thunder's Mouth Press, 1986), originally published in 1940; and Arnold Rampersad, *The Life of Langston Hughes,* Vol. 1: 1902–1941: *I, Too, Sing America* (New York: Oxford University Press, 1986), 200–13.

80. Langston Hughes, "Christ in Alabama," *Contempo: A Review of Ideas and Personalities* (December 1, 1931): 1. For Hughes's brief visit to see the Scottsboro Boys in Kilby Prison in Montgomery, Alabama, in early 1932, see Rampersad, *The Life of Langston Hughes,* 230–31. It was a dismal visit, however, as Rampersad recounts: "None of the Scottsboro boys . . . seemed even slightly interested as [Hughes] spoke of the greatness of the black race and the desire of many people to see them free. Someone asked for cigarettes . . ." (231).

81. Bruce Kellner, "Working Friendship: A Harlem Renaissance Footnote," in Ingrid Rose and Roderick Quiroz, *The Lithographs of Prentiss Taylor* (Bronx: Fordham University Press, 1996), 14.

82. Philip Rahv, review of Langston Hughes, *Scottsboro Limited: Four Poems and a Play in Verse* (New York: Golden Stair Press, 1932), in the *Rebel Poet* (August 1932): 7.

83. Goodman, *Stories of Scottsboro,* 67.

84. Ibid., 68.

85. Langston Hughes, "Scottsboro," in Hughes, *Scottsboro Limited,* unpaginated.

86. Prentiss Taylor to Langston Hughes, February 25, 1932, as quoted in Kellner, "Working Friendship," 15.

87. Prentiss Taylor to Langston Hughes, December 12, 1931, as quoted in Kellner, "Working Friendship," 13.

Chapter 7. Black and Tan: Racial and Sexual Crossings
in *Ebony and Topaz*

1. This chapter first appeared in my article, "The Case of *Ebony and Topaz*: Racial and Sexual Hybridity in Harlem Renaissance Illustrations," *American Periodicals: A Journal of History, Criticism, and Bibliography*, 15, 1 (2005), 86–111.

2. There were also a limited number of volumes issued in hard cover.

3. Charles S. Johnson, "Introduction," in *Ebony and Topaz: A Collectanea*, ed. Charles S. Johnson (New York: *Opportunity* and the National Urban League, 1927), 11.

4. W. E. B. Du Bois, "The Browsing Reader," *Crisis* (May 1928): 165.

5. Charles S. Johnson, "Editorials," *Opportunity* (June 1926): 174.

6. Paul Guillaume and Thomas Munro, *Primitive Negro Sculpture* (New York: Harcourt Brace, 1926), 9.

7. Alain Locke, *The New Negro: An Interpretation* (New York: Albert and Charles Boni, 1925), xv.

8. Langston Hughes, "The Negro Artist and the Racial Mountain," *Nation* (June 23, 1926): 694.

9. Charles S. Johnson, "Introduction," in Johnson, *Ebony and Topaz*, 11.

10. Ibid., 13.

11. Ibid., 11.

12. John Matheus, "General Drums," in Johnson, *Ebony and Topaz*, 29.

13. Arthur Huff Fauset, "Jumby," in Johnson, *Ebony and Topaz*, 15.

14. In this chapter, I do not consider Aaron Douglas's *Ebony and Topaz* illustrations for the short stories "Jumby" (14), "On the Road One Day, Lord" (22), and "General Drums" (28).

15. W. E. B. Du Bois, "Books," *Crisis* (December 1926): 81–82.

16. Kevin J. Mumford, *Interzones: Black/White Sex Districts in Chicago and New York in the Early Twentieth Century* (New York: Columbia University Press, 1997), 138.

17. Johnson, "Introduction," in Johnson, *Ebony and Topaz*, 12.

18. See Michael Erlewine et al., eds., *All Music Guide to Jazz*, 3rd ed. (San Francisco: Miller Freeman Books, 1998), 331–43; and Mark Tucker, *Ellington—The Early Years* (Champaign: University of Illinois Press, 1991).

19. For a history of Black and Tan clubs, see Mumford, *Interzones*, 30.

20. Ibid., 82–83.

21. For a short biography of Charles Cullen, see Cary Nelson, *Repression and Recovery: Modern American Poetry and the Politics of Cultural Memory, 1910–1945* (Madison: University of Wisconsin Press, 1989), 278–79.

22. *San Francisco Chronicle* (August 7, 1927); clipping in Countee Cullen Papers, Scrapbook II, Amistad Research Center, Tulane University, New Orleans.

23. Countee Cullen to Kathleen Tankersley Young, October 3, 1927; Countee Cullen Papers, Box 4, Folder 15, Amistad Research Center.

24. Cullen illustrated four volumes of Countee Cullen's poetry (*Ballad of a Brown Girl, Copper Sun, Color,* and *The Black Christ*), a 1933 edition of Whitman's *Leaves of Grass,* and a 1931 dramatization of Wilde's *The Picture of Dorian Gray,* in addition to a number of books and journals edited by Henry Harrison.

25. Walter Kalaidjian, *American Culture between the Wars: Revisionary Modernism and Postmodern Critique* (New York: Columbia University Press, 1993), 78.

26. Charles Cullen to A. J. Buttitta, editor of *Contempo: A Review of Ideas and Personalities*, March 4, 1933; *Contempo* Collection, Harry Ransom Humanities Research Center, University of Texas at Austin.

27. For her discussion of Nugent's drawings and the Janiform vase, see Susan Gubar, *Racechanges: White Skin, Black Face in American Culture* (New York: Oxford University Press, 1997), 107–12.

28. E. B. Reuter, "The Changing Status of the Mulatto," in Johnson, *Ebony and Topaz*, 107–10.

29. Ibid., 107; 110.

30. Nugent's trickery relates to the tradition of black American vernacular expression and humor that Henry Louis Gates Jr. has identified as "signifyin(g)." For his explanation of this mode of expression as "the language of trickery" that "presupposes an 'encoded' intention to say one thing but to mean quite another," see Henry Louis Gates Jr., *The Signifying Monkey: A Theory of African-American Literary Criticism* (New York: Oxford University Press, 1988), 52 and 82.

31. Wallace Thurman, Countee Cullen, and Alain Locke were among the gay writers and intellectuals associated with the Harlem Renaissance. Langston Hughes, though never open about his sexuality, seems to have had homosexual leanings as well.

32. Author's interview with Thomas Wirth, June 1997. For his recently published volume of Nugent's art and writings, see Thomas Wirth, ed., *Gay Rebel of the Harlem Renaissance: Selections from the Work of Richard Bruce Nugent* (Durham: Duke University Press, 2002).

33. Oral history interview with Nugent conducted by Jean Blackwell Hutson, April 14, 1982, preserved in the Schomburg Center for Research in Black Culture, New York.

34. Steven Watson, *The Harlem Renaissance: Hub of African-American Culture, 1920–1930* (New York: Pantheon Books, 1995), 90.

35. Carl Van Vechten to Langston Hughes, May 11, 1927, published in *Letters of Carl Van Vechten*, ed. Bruce Kellner (New Haven, CT: Yale University Press, 1987), 95–96.

36. Thomas Wirth, "Richard Bruce Nugent," *Black American Literature Forum* (Spring 1985): 16.

37. Richard Bruce [Nugent], "Smoke, Lilies and Jade," *Fire!!* (November, 1926): 39.

38. Wirth, "Richard Bruce Nugent," 16.

39. Ibid.

40. Gubar, *Racechanges*, 110.

41. Author's interview with Thomas Wirth.

42. Eric Garber's interview with Nugent, 1981, as quoted in Eric Garber, "A Spectacle in Color: The Lesbian and Gay Subculture of Jazz Age Harlem," in *Hidden from History: Reclaiming the Gay and Lesbian Past*, eds. Martin Duberman, Martha Vicinus, and George Chauncey Jr. (New York: Penguin Books, 1989), 323–24.

43. Garber, "Spectacle in Color," 325.

44. Richard Bruce Nugent, "On 'Gloria Swanson,'" Federal Writers Project, New York, reprinted in Wirth, *Gay Rebel of the Harlem Renaissance*, 221–23. "Gloria Swanson"

was a well-known black female impersonator who entertained cabaret audiences in Harlem.

· 45. Here, I draw on Ellen McBreen's intriguing analysis of Nugent's unpublished drawings for Oscar Wilde's *Salome;* she interprets several as men in drag. See her "Biblical Gender Bending in Harlem: The Queer Performance of Nugent's *Salome,*" *Art Journal* 57 (Fall 1998): 27.

46. Wirth, *Gay Rebel of the Harlem Renaissance,* 66.

47. George Chauncey, *Gay New York: Gender, Urban Culture, and the Making of the Gay Male World, 1890–1940* (New York: Basic Books, 1994), 257.

48. Ibid., 263.

49. "And, Girls, How They Carried On!" *New York Amsterdam News* (March 7, 1936), as cited in Chauncey, *Gay New York,* 262.

Chapter 8. "To Smile Satirically": On Wearing the Minstrel Mask

1. Alain Locke, "Introduction: The Drama of Negro Life," in *Plays of Negro Life: A Source-Book of Native American Drama,* eds. Alain Locke and Montgomery Gregory (New York: Harper and Brothers, 1927), introduction unpaginated.

2. See, for example, Eric Lott, *Love and Theft: Blackface Minstrelsy and the American Working Class* (New York: Oxford University Press, 1993); and Mel Watkins, *On the Real Side: Laughing, Lying, and Signifying—The Underground Tradition of African American Humor that Transformed American Culture, from Slavery to Richard Pryor* (New York: Simon and Schuster, 1994).

3. Henry Louis Gates Jr., *The Signifying Monkey: A Theory of African-American Literary Criticism* (New York: Oxford University Press, 1988).

4. Ibid., 52 and 82.

5. Watkins, *On the Real Side,* 32.

6. Ibid.

7. Langston Hughes, "The Jester," *Opportunity* (December 1925): 357. This poem was later published in Hughes, *The Weary Blues* (New York: Alfred A. Knopf, 1926), 53.

8. Langston Hughes, "The Negro Speaks of Rivers," in Alain Locke, ed., *The New Negro: An Interpretation* (New York: Albert and Charles Boni, 1925), 141.

9. Harlem Renaissance authors addressing the theme of passing included James Weldon Johnson, *The Autobiography of an Ex-Coloured Man* (Boston: Sherman, French and Company, 1912; reissued New York: Alfred A. Knopf, 1927); and Nella Larsen, *Passing* (New York: Alfred A. Knopf, 1929).

10. Houston Baker discusses what he calls the "mastery of form," or the mastery of the minstrel mask in his *Modernism and the Harlem Renaissance* (Chicago: University of Chicago Press, 1987), Chapter 3.

11. James Lesesne Wells, linoleum cut illustrations for Vachel Lindsay, "The Congo," in *Golden Book Magazine* (September 1929): 50–53.

12. Aaron Douglas, illustrations for Eugene O'Neill, *The Emperor Jones,* in Locke and Gregory, *Plays of Negro Life,* 334–72. Douglas had completed some of the illustra-

tions for his series before 1927, when Locke and Gregory's compendium was published. His *Emperor* (fig. 87) appeared in the second edition of Alain Locke's *New Negro;* and his *Emperor* and *Forest Fear* (figs. 87 and 88) appeared in Alain Locke's "The Negro and the American Stage," *Theatre Arts Monthly* 10 (February 1926): 112–20. In the caption for Douglas's first image, Locke wrote, "In a striking series of interpretative designs based on Eugene O'Neill's *Emperor Jones,* the young Negro artist, Aaron Douglas, has recaptured the dynamic quality of that tragedy of terror. There is an arbitrary contrast of black masses and white spaces; and the clash of broken line becomes highly expressive in suggesting the proximate collapse of the Emperor's throne and the fear it inspires" (117). In the caption for *Forest Fear,* Locke expressed, "The tropical jungle closing in on the defeated Brutus Jones is here suggested by Aaron Douglas with an utter simplicity of means, yet with no sacrifice of psychological verisimilitude. There is a sharply defined sense of dramatic design—of drama in design. This power is one often missing among men of greater skill but less vivid imagination" (118). Locke's concluding back-handed compliment revealed his anxiety, also expressed in *The New Negro,* that young African American artists might not compare favorably with more accomplished white artists.

13. Lott, *Love and Theft;* and W. T. Lhamon Jr., *Raising Cain: Blackface Performance from Jim Crow to Hip Hop* (Cambridge, MA: Harvard University Press, 1998).

14. Baker, *Modernism and the Harlem Renaissance,* 17. Surprisingly, Baker cites Booker T. Washington as an early master of the minstrel mask. Baker argues that Washington carefully composed his writings and addresses to white audiences, using familiar stereotypes to draw them in, while reversing the stereotypes once he had their attention. For example, he observed, "Thirty-two years after the Emancipation Proclamation, Booker T. Washington changed the minstrel joke by stepping inside the white world's nonsense syllables with oratorical mastery" (25).

15. Ibid., 49. Baker was asserting here that Charles W. Chesnutt evinced his modernity through his ability to surprise and reverse white stereotypes of black behavior.

16. Macmillan Publishers in New York originally published Vachel Lindsay's "The Congo" in 1914.

17. Richard Powell and Jock Reynolds, *James Lesesne Wells: Sixty Years in Art* (Washington, DC: Washington Project for the Arts, 1986), 12.

18. Ibid., 11.

19. Lindsay, "The Congo," 51.

20. Ibid., 50.

21. Ibid., 51–52.

22. Ibid., 52–53.

23. Don Cusic, "Vachel Lindsay," in *The Poet as Performer* (Lanham, MD: University Press of America, 1991), 12.

24. Eleanor Ruggles, *The West-Going Heart: A Life of Vachel Lindsay* (New York: W. W. Norton, 1959), 226, as quoted in Cusic, "Vachel Lindsay," 17.

25. Ruggles, *The West-Going Heart,* 233, as quoted in Cusic, "Vachel Lindsay," 17.

26. Conrad Aiken, "Vachel Lindsay," in *Profile of Vachel Lindsay,* ed. John T. Flanagan (Columbus, Ohio: Charles E. Merrill, 1970), 3; Aiken's essay was originally published in 1935.

27. Henry Morton Robinson, "The Ordeal of Vachel Lindsay: A Critical Reconstruc-

tion," *Bookman* (April 1932): 6–9; reprinted in Flanagan, *Profile of Vachel Lindsay*, 47–52. My quotation of Robinson's article was taken from Flanagan, 49. The article was written not long after Lindsay had committed suicide in 1931.

28. Susan Gubar, *Racechanges: White Skin, Black Face in American Culture* (New York: Oxford University Press, 1997), 141. In Chapter 4, titled "De Modern Do Mr. Bones (and All That Ventriloquist Jazz)," Gubar discusses the links between white modernism and minstrelsy, particularly in the work of Vachel Lindsay, T. S. Eliot, and Edith Sitwell.

29. Ibid., 140.

30. Ibid., 142. Though Lindsay's politics were quite liberal, from his pacifism during World War I to his outspoken position against lynching in the South, he nonetheless made clear his position as a white outsider in his attack on lynching, spoken obviously as a white to whites: "the only way to end lynching would be to thrust yourself into the thick of such a mob and make the men slay you instead of the Negro"; Ruggles, *The West-Going Heart*, 138, as cited in Gubar, *Racechanges*, 142.

31. Hughes, *The Big Sea: An Autobiography* (New York: Thunder's Mouth Press, 1986), 212. The original edition was published in 1940.

32. Ibid., 212.

33. Arnold Rampersad, *The Life of Langston Hughes*, Vol. 1: 1902–1941: *I, Too Sing America* (New York: Oxford University Press, 1986), 229.

34. Lindsay, "The Congo," 50.

35. The illustration and caption appear in Lindsay, "The Congo," 53; the chant is repeated on pp. 50, 51, and 52.

36. Lindsay, "The Congo," 52.

37. *New Masses* (October 1929): 28.

38. Lhamon discusses the minstrel dance, "knock Jim Crow," at length in his Chapter 4, "Finding Jim Crow."

39. The groundbreaking studies on minstrelsy include Robert C. Toll, *Blacking Up: The Minstrel Show in Nineteenth-Century America* (New York: Oxford University Press, 1974); Michael Rogin, *Blackface, White Noise: Jewish Immigrants in the Hollywood Melting Pot* (Berkeley: University of California Press, 1996); Lott, *Love and Theft;* and Lhamon, *Raising Cain.* Ann Douglas's Chapter 2, titled "Black Manhattan Wearing the Mask," contains perceptive interpretations of the legacy of minstrelsy and its relation to black American culture of the 1920s; see Ann Douglas, *Terrible Honesty: Mongrel Manhattan in the 1920s* (New York: Noonday Press, 1995). In his *Colored Pictures: Race and Visual Representation* (Chapel Hill: University of North Carolina Press, 2003), Michael Harris has provided a very useful analysis of nineteenth-century images of blacks in the context of blackface minstrelsy (39–82).

Rather than perceiving minstrelsy solely as evidence of the damaging ways in which white Americans have caricatured and distorted the appearance and cultural production of black Americans, scholars have complicated the phenomenon by asking why white Americans have been so enticed by black entertainment. Eric Lott, for example, considered the blackface ritual "in which whites are touched by the blacks they would lampoon" as evidence "of how precariously nineteenth-century white working people lived their whiteness" (Lott, *Love and Theft*, 4).

One of the first attempts to chart the tradition of minstrelsy appeared in Constance Rourke's *American Humor* of 1931. She determined three main comic types that originated in America: the Yankee, the Backwoodsman, and the Blackface Minstrel, though "none left a deeper print than the Negro in minstrelsy," she assessed; see Constance Rourke, *American Humor: A Study of the National Character* (New York: Harcourt Brace, 1931), 102. While she asserted "the [minstrel] songs and to a large extent the dances show Negro origins," at the same time she identified the comic minstrel exclusively as a white performer in blackface (83). Citing a nineteenth-century account, she elaborated on the national pride white Americans associated with minstrelsy: "The Ethiopian melodies well deserve to be called, as they are in fact, the national airs of America" (103, citing an unidentified account by Bayard Taylor, 1849). Rourke thus revealed the complexity of minstrelsy as a form stolen from black Americans and claimed as a national treasure by white Americans.

From a black American perspective, James Weldon Johnson also asserted minstrelsy's cultural contribution in his *Black Manhattan* of 1930: "Negro minstrelsy, as a popular form of professional entertainment, seems dead; nevertheless, its history cannot be reviewed without the recognition of the fact that it was the first and remains, up to this time, the only completely original contribution America has made to the theatre"; see James Weldon Johnson, *Black Manhattan* (1930, rpt. New York: Da Capo Press, 1991), 87. To be sure, Johnson believed that blackface "minstrelsy was, on the whole, a caricature of Negro life," and that "it fixed the tradition of the Negro as only an irresponsible, happy-go-lucky, wide-grinning, loud-laughing, shuffling, banjo-playing, singing, dancing sort of being" (93). However, he agreed with Rourke in asserting minstrelsy's black American roots: "Negro minstrelsy, everyone ought to know, had its origin among the slaves of the old South" (87). These origins were essential for Johnson, because they evinced a key contribution to American culture for which blacks could be held responsible.

40. Lhamon investigates the early years of minstrel performances in New York in order to discover the extent to which working-class whites and blacks actually collaborated in founding the minstrel tradition; see his chapter one. He clarifies that, while the roots of minstrelsy did indeed reside with distinctive forms of black entertainment, as Rourke and Johnson suspected, they were situated among northeastern blacks rather than southern slaves. He further clarifies that the racism and almost exclusive white control of minstrelsy in the mid-nineteenth century masked the early developments of the art form, which were more "racially" hybrid. During the 1820s in certain areas of New York City, Lhamon asserts, black and white minstrels performed before integrated audiences.

Lott explains that typically, four or five minstrels would perform "with facial blacking of greasepaint or burnt cork," costumed in outlandish garb, from torn rags, to oversized outfits, to mock military garb (5). Some "wench" numbers required cross-dressing, as women did not perform in minstrel shows.

41. Thomas Low Nichols, *Forty Years of American Life* (1864; 2nd ed., London: Longmans, Green, 1874), 369–70, as quoted in Lott, *Love and Theft*, 112.

42. Ralph Ellison, "Change the Joke and Slip the Yoke," in *Shadow and Act* (New York: Random House, 1964), 49. The essay was originally published in *Partisan Review* 25, 2 (Spring 1958).

43. Diamond was best known for his dancing of "negro break-downs"; see Lott, *Love and Theft,* 112.

44. Nichols, *Forty Years of American Life,* 369–70, as quoted in Lott, *Love and Theft,* 112.

45. 1845 playbill for a New York performance by Juba, uncatalogued playbills, Harvard Theatre Collection, as quoted in Lott, *Love and Theft,* 115.

46. The seeds for satire were already contained in the minstrel performance, which normally involved a "pompous and pretentious interlocutor," who would be the butt of the "end men's" jokes; see Nathan Huggins, *Harlem Renaissance* (New York: Oxford University Press, 1971), 250. His final chapter on minstrelsy is still a gem.

47. Eric Lott's speculations about Juba's dancing eloquently articulate the intricate dynamic:

> This performance seems, and probably was, astonishingly bold: the trusted counterfeiters mocked in return by a representative of those from whom they had stolen; a public display of black irony toward whites, all stammers and jerks and gracelessness, who had tried to become better blacks. Yet it also foregrounds minstrelsy as a safely imitative form: the notion of the black dancer "imitating himself" indicates minstrelsy's fundamental consequence for black culture, the dispossession and control by whites of black forms that would not for a long time be recovered (Lott, *Love and Theft,* 115).

48. For more on Bert Williams and George Walker and the history of black entertainment, see Langston Hughes and Milton Meltzer, *Black Magic: A Pictorial History of the African-American in the Performing Arts* (Englewood Cliffs, NJ, 1967; rpt. New York: Da Capo Press, 1990); Watkins, *On the Real Side;* and Gubar, *Racechanges,* especially 112–14.

49. Baker, *Modernism and the Harlem Renaissance,* 20. In explicating his method, Walker once quipped, "My idea was always to impersonate my race just as they are"; see Gubar, *Racechanges,* 114.

50. Effectively demonstrating Josephine Baker's mastery of the minstrel mask, Gubar discussed the infamous black American expatriate who sometimes performed in blackface, "Cross-eyed and thus willfully blind to the spectacle she has made of herself, she derisively displays herself as an antic figure of foolish fun. If the shuffling, grinning blackfaced minstrel ridiculed African Americans as lazy, superstitious, childish, or sexually loose, Baker's pose burlesques the mockers through self-mockery" (Gubar, *Racechanges,* 114–15).

51. Gwendolyn Bennett, "Heritage," *Opportunity* (December 1923): 371.

52. Paul Laurence Dunbar, "We Wear the Mask," in *The Book of American Negro Poetry,* ed. James Weldon Johnson (New York: Harcourt Brace, 1922), 71.

53. Anonymous blues lyrics, as quoted by Huggins, *Harlem Renaissance,* 261.

54. Aaron Douglas to Alta Sawyer, probably between 1925 and 1926; Letter #57, n.d., Aaron Douglas Papers, Folder: "Correspondence, Aaron Douglas to Alta Sawyer (Douglas) 1924–1926?, 1/6, #51–60," Schomburg Center for Research in Black Culture, New York. For her extensive quotation from this letter, see Amy Kirschke, *Aaron Doug-*

las: Art, Race, and the Harlem Renaissance (Jackson: University Press of Mississippi, 1995), 64.

55. Aaron Douglas, "The Negro in American Culture," in *Papers of the American Artists' Congress*, 1936; reprinted in Matthew Baigell and Julia Williams, *Artists against War and Fascism: Papers of the First American Artists' Congress* (New Brunswick, NJ: Rutgers University Press, 1986), 80.

56. O'Neill, *The Emperor Jones*, 338.

57. Ibid., 347.

58. Ibid., 362.

59. Ibid., 367.

60. Ibid., 369.

61. Van Wyck Brooks, *The Confident Years, 1885–1915* (New York: E. P. Dutton, 1952), 540, as quoted in Thomas D. Pawley, "The Black World of Eugene O'Neill," in *Eugene O'Neill in China: An International Centenary Celebration*, eds. Haiping Liu and Lowell Swortzell (Westport, CT: Greenwood Press, 1992), 137.

62. O'Neill, *The Emperor Jones*, 370.

63. Pawley, "The Black World of Eugene O'Neill," 147.

64. Shannon Steen, "Melancholy Bodies: Racial Subjectivity and Whiteness in O'Neill's *The Emperor Jones*," *Theatre Journal* 52, 3 (2000): 347. Steen argues, "O'Neill's character description[s] call to mind Homi Bhabha's formulation of the 'almost, but not quite' structure of the colonized subject. In 'Of Mimicry and Man,' Bhabha argues that colonial mimicry is a strategy characterized by a desire for a reformed, recognizable Other that resembles citizens of the home nation, but that inevitably reveals its true, uncivilized origins" (346–47). See also Homi Bhabha, "Of Mimicry and Man: The Ambivalence of Colonial Discourse," in *The Location of Culture* (New York: Routledge, 1993), 85–92.

65. Pawley, "The Black World of Eugene O'Neill," 143.

66. O'Neill, *The Emperor Jones*, 357. Pawley relates this clichéd response to the extension of minstrelsy in American movies of the first part of the twentieth century, "in which comic black actors would tremble violently at the mere mention of ghosts," many "noted for 'rolling and bucking' [their] eyes" (Pawley, "The Black World of Eugene O'Neill," 145).

67. Johnson, *The Autobiography of an Ex-Coloured Man*, republished and slightly corrected (Mineola, NY: Dover Publications, 1995), 79.

68. Benjamin Brawley, "The Negro in American Fiction," *Dial* 60 (1916): 445, as quoted in John Cooley, "In Pursuit of the Primitive: Black Portraits by Eugene O'Neill and Other Village Bohemians," in *Harlem Renaissance Re-Examined*, eds. Victor A. Kramer and Robert A. Russ, eds., 2nd revised and expanded edition (Troy, NY: Whitson Publishing, 1997): 93.

69. Jeffrey Stewart, "Paul Robeson and the Problem of Modernism," in *Rhapsodies in Black: Art of the Harlem Renaissance*, eds. David Bailey and Richard Powell (Berkeley: University of California Press, 1997), 96.

70. Langston Hughes, *The Big Sea* (New York: Alfred Knopf, 1940; rpt: New York: Hill and Wang, 1993), 258.

71. *The Emperor Jones* was first performed in New York in 1920 by the Province-town Players. O'Neill insisted that a black man play the role of Jones, rather than a white in blackface. He chose Charles Gilpin and championed him in the role, until he challenged some of O'Neill's racist lines; see Cooley, "In Pursuit of the Primitive," 84–86.

72. Ann Douglas, *Terrible Honesty*, 86.

73. Cooley, "In Pursuit of the Primitive," 86.

74. Arthur Gelb and Barbara Gelb, *O'Neill* (New York: Harper and Brothers, 1960), 449, as quoted in Cooley, "In Pursuit of the Primitive," 86.

75. When Paul Robeson later accepted the role of Brutus Jones, his strategy was to understand "Jones's emotions" as "not primarily Negro, but human"; see Robeson, "Reflections on O'Neill's Plays," *Opportunity* (December 1924): 369.

76. As Alain Locke wrote, "For pioneering genius in the development of the native American drama, such as Eugene O'Neill, Ridgely Torrence and Paul Green, now sees and recognizes the dramatically undeveloped potentialities of Negro life and folkways as a promising province of native idioms and source materials in which a developing national drama can find distinctive new themes, characteristic and typical situations, authentic atmosphere"; see his "Introduction: The Drama of Negro Life," in Locke and Gregory, *Plays of Negro Life*. The following quotations come from this unpaginated introduction.

77. Aaron Douglas to Alta Sawyer, probably between 1925 and 1926; Letter #61, n.d., Aaron Douglas Papers, Folder: "Correspondence, Aaron Douglas to Alta Sawyer (Douglas) 1924–1926?, 1/7, #61–70," Schomburg Center for Research in Black Culture, New York.

78. Lhamon, *Raising Cain*, 217.

79. Ann Douglas, *Terrible Honesty*, 105.

80. Ibid.

81. In leaving his forms unspecified and silhouetted, Douglas employed a strategy that he used in nearly all of his illustrations.

82. Locke and Gregory, *Plays of Negro Life*, facing 220.

83. In a letter to Alta Sawyer, Douglas described "a Little Theatre Group" that W. E. B. Du Bois was organizing (his Krigwa Players) and that he was designing "stage decorations" for the group; see Douglas to Sawyer, undated (but probably sometime between 1925 and 1926), Letter #56, Aaron Douglas Papers, Folder: "Correspondence, Aaron Douglas to Alta Sawyer (Douglas) 1924–1926?, 1/6, #51–60," Schomburg Center for Research in Black Culture. In 1927, Carl Van Vechten also wrote to Blanche Knopf about sets Douglas was designing for a show starring Ethel Waters; see Bruce Kellner, ed., *Letters of Carl Van Vechten* (New Haven: Yale University Press, 1987), 98.

84. In his use of the silhouette in his Emperor Jones illustrations, which seems to connect with his artistic activity in set design, Douglas may also have been interested in shadow plays, a popular theatrical form (see two illustrated publications on shadow plays that would have been available to him in New York: F. E. Chase, *Ballads in Black: A Series of Original Shadow Pantomimes* [Boston: Lee and Shepherd, and New York: Charles T. Dillingham, 1882]; and Winifred Mills, *Marionettes, Masks, and Shadows* [Garden City, NY: Doubleday, Doran, 1933]). Douglas's crocodile god silhouette seems particularly inspired by Chinese, Balinese, or Javanese shadow puppets (fig. 89).

85. The other tableau scene illustrated Paul Green's *In Abraham's Bosom*. The setting for the scene incorporated trees with clawlike branches that closely resemble the clawlike hands that Douglas used repeatedly in his illustrations and paintings, such as in his illustrations for Paul Morand's *Black Magic* (1929) and for his mural *Song of the Towers* (1934), part of his *Aspects of Negro Life* series for the Harlem Branch of the New York Public Library. Was he influenced by this set, or could he have designed it himself?

86. A still photograph from the London production of the play in 1925 caught the encounter between Jones, played by Paul Robeson, and the "Congo Witch Doctor," with whom Brutus is transfixed; this photograph is published in Charles Musser, "Troubled Relations: Paul Robeson, Eugene O'Neill, and Oscar Micheaux," in *Paul Robeson: Artist and Citizen*, ed. Jeffrey Stewart (New Brunswick, NJ: Rutgers University Press, 1998), 81–103. The article is useful in enunciating the improbable relationships Robeson had with O'Neill, with whom he got along well, and Micheaux, with whom he did not share the same philosophies during the 1920s.

87. In Douglas's deflection of the eroticized body onto the silhouette, I am reminded of a scene in Josephine Baker's movie, *Zou Zou* (1934), in which Baker dances with her own shadow. Andrea Barnwell has written of this scene:

> While on stage, alone, [Zou Zou] delights herself by creating an interplay between her body and her shadow cast on the stage curtain. By making shadow puppets, high kicking, doing the splits and dancing the Charleston she basks in the pleasure of her body's potential and her ability to create an interaction between the corporeal and that which is projected. . . . The importance of her performance, however, transcends the invasive male gazes . . .

See Andrea Barnwell, "Like the Gypsy's Daughter, or beyond the Potency of Josephine Baker's Eroticism," in *Rhapsodies in Black: Art of the Harlem Renaissance*, ed. David Bailey and Richard Powell (London: Hayward Gallery, and Berkeley: University of California Press, 1997), 85.

88. Coco Fusco, "The Other History of Intercultural Performance," in *English Is Broken Here: Notes on Cultural Fusion in the Americas* (New York: New Press, 1995), 44.

A Brief Conclusion: On Making Black Modern during the Renaissance and Beyond

1. For her consideration of Lawrence's vernacular illustrations for Langston Hughes's book of poetry *One-Way Ticket* (New York: Alfred A. Knopf, 1947), see Martha Jane Nadell, *Enter the New Negroes: Images of Race in American Culture* (Cambridge, MA: Harvard University Press, 2004), 140–59.

2. The Carter G. Woodson and Association for the Study of African American Life and History Library is now held in the Manuscript, Archives, and Rare Book Library at Emory University, housing a treasure trove of illustrated books, journals, and ephemera.

3. I am indebted to Theresa Leininger-Miller who, in her reading of this manuscript, made reference to the many appearances of the suitcase.

4. Here, I am indebted to Erika Doss who, in her reading of this manuscript, brought this connection to my attention. For a seminal study on Demuth's *My Egypt,* see Karal Ann Marling, "*My Egypt:* The Irony of the American Dream," *Winterthur Portfolio* 15, 1 (Spring 1980): 25–39.

5. For her important investigation of relationships between advertising imagery and interwar American painting, see Wanda Corn, *The Great American Thing: Modern Art and National Identity, 1915–1935* (Berkeley: University of California Press, 1999).

6. African American artists pursuing illustration, printmaking, and works on paper beyond the Harlem Renaissance include Allan Rohan Crite, Elizabeth Catlett, Charles White, Robert Blackburn, Dox Thrash, Jacob Lawrence, Romare Bearden, Glenn Ligon, and Kara Walker.

7. Allan Rohan Crite, *Were You There When They Crucified My Lord? A Negro Spiritual in Illustrations* (Cambridge, MA: Harvard University Press, 1944). For a recent exhibition and study of Crite's art, see Julie Levin Caro et al., *Allan Rohan Crite: Artist-Reporter of the African-American Community* (Seattle: Frye Art Museum in association with University of Washington Press, 2001).

8. For his connection of Walker and Douglas's silhouettes, see Michael Harris, *Colored Pictures: Race and Visual Representation* (Chapel Hill: University of North Carolina Press, 2003), 218–19. For a recent comprehensive study of Walker's work, see Gwendolyn DuBois Shaw, *Seeing the Unspeakable: The Art of Kara Walker* (Durham, NC: Duke University Press, 2005).

Index